MW00614869

Huihui

Huihui

Navigating Art and Literature in the Pacific

Edited by
Jeffrey Carroll
Brandy Nālani McDougall
Georganne Nordstrom

 University of Hawai'i Press
Honolulu

© 2015 University of Hawai'i Press
All rights reserved
Printed in the United States of America

20 19 18 17 16 15 6 5 4 3 2 1

Library of Congress Cataloging-in-Publication Data

Huihui : navigating art and literature in the Pacific / edited by
Jeffrey Carroll, Brandy Nalani McDougall, Georganne Nordstrom.
 pages cm
 Anthology of critical essays, poetry, short fiction, speeches,
photography, and personal reflections.
 ISBN 978-0-8248-3895-9 (alk. paper)
 1. Rhetoric—Oceania. 2. Aesthetics—Social aspects—Oceania.
3. Aesthetics—Political aspects—Oceania. I. Carroll, Jeffrey,
editor. II. McDougall, Brandy Nalani, editor. III. Nordstrom,
Georganne, editor.
 P301.3.O3H85 2015
 809'.899—dc23

 2014014762

University of Hawai'i Press books are printed on acid-free
paper and meet the guidelines for permanence and durability
of the Council on Library Resources.

Interior artwork by Carl Pao

Printed by Sheridan Books, Inc.

For Kanoa and Makani

—JC

For Kula, Maui, Craig, and Kaikainali'i,
ku'u mau home aloha

—BNM

For the places I grew up, Kahalu'u and Kailua, and to
Hervé and Keanu, for being with me throughout

—GMN

Contents

Part 2. Peleiake: Institutions

Part 3. Kūpuku: Community

PART 4. KE AWEAWE A MAKALI'I: WORD

Introduction

Ho'ohuihui: Navigating the Pacific through Words

Jeffrey Carroll
Brandy Nālani McDougall
Georganne Nordstrom

THE METAPHORICAL IN LANGUAGE is now a starting place for any of us who wish to write. When one wishes to write about the Pacific, the challenge may be to acknowledge some of the old metaphors—and then to add a new one, or more, for the sake of understanding and further work. When we think of the Pacific we can think in diagrammatic terms, for example, of circles, circles within circles, webs of open space; we can think of more pictorial metaphors, like far-reaching ropes, nets of enormous size, waves or nested ripples of ocean water; we can think of gestures on a human scale, of the embrace, the speech of welcome, the house of hospitality.

To this rich array of metaphors for the Pacific, its people and practices, its arts and rhetorics, we would add a new one. We have placed it in the position of title: *Huihui.*

Pukui and Elbert (1986) translate and define the word this way:

> hui.hui. 1. vi. Mixed, mingled, united, joined; to pool together, as to buy cooperatively. ho'o.hui.hui. Caus/sim. Ho'ohuihui lā'au, chemistry, pharmacist. Mea ho'ohuihui, alloy, anything mixed. Mea inu ho'ohuihui, mixed drink, punch. 2. n. Cluster, collection, bunch. (PPN fuhifuhi.) 3. n. Constellation. Nā hōkū o ka lani a me nā huihui ona (Isa. 13.10), the stars of the heavens of their constellations. 4. (Cap.) n. Pleiades. Also Huhui. (86)

We cannot avoid metaphor, even in trying to reach a simplicity of definition. Huihui can be understood, in translation, as the result of pooling—even perhaps by a pharmacist, or perhaps a mixer of drinks—the result of which may be something as attractive as punch or as untouchable and distant as the stars and constellations in the sky. Present in this short series of definitions are the small scale of the potion, the abstractions of unity and joining, and the enormous scale of the universe itself.

Pukui and Elbert also note that the word huihui can be identified as Proto-Polynesian, that is, occurring in other languages of Polynesia, and that it can be found in the Hawaiian-language translation of the Bible. The word huihui becomes multidimensional not only in its meanings, but in its uses as well. Its chemistry (its potential for joining or mingling) is increased by one: this collection, this pooling of work by writers both in and out of the Pacific, is intended to show the breadth and depth of the Pacific in the words of those who write about it.

We hope the potential of huihui can be realized in several ways, and perhaps in ways that we don't anticipate. The collection can be read in order, from front to back, to reveal movement of not only genre but perspective as well. It can be read selectively for its points of origin, or for certain authors, or the subject matter, or in the ways that the rhetorics and aesthetics of the Pacific, as addressed in this introduction, are present in these selections. "Rhetorics" and "aesthetics" are conceptual terms—like huihui itself—with many implications for the way we understand the uses of language and the effects of language on the human experience. They are much more than single words; they are only suggestive of a constellation of thoughts and acts in which the people of the Pacific participate.

In this way, the Pacific, or Oceania, itself is also huihui. Albert Wendt (1976) describes Oceania as being so boundless as to defy definition: "[Oceania is] so vast, so fabulously varied a scatter of islands, nations, cultures, mythologies and myths, so dazzling a creature . . . [that] only the imagination in free flight can hope—if not to contain her—to grasp some of her shape, plumage, and pain" (50). In "Our Sea of Islands," Epeli Hau'ofa (1999) also emphasizes the vastness of Oceania, challenging the colonial perspective that our countries are small and dependent ("islands in a far sea") by proposing that we view the Pacific from our ancestors' perspective that we are a "sea of islands" (31). The shift in our perceptions of Oceania, from boundlessness to insignificant and dependent to a return to "a sea of islands," represents a cre-

ative and scholarly anticolonial shift that recognizes the mana and beauty of Oceania, its lands, and its Indigenous peoples, despite the colonial impetus to devalue and recast the Indigenous Pacific as small, ugly, obscene, primitive, exotic, irrelevant. This anthology honors the rich cultural heritages of Oceania for their resilience and, to borrow Gerald Vizenor's term, survivance in their struggles against colonial and neocolonial systems of power and knowledge production; we recognize how the rhetorical and aesthetic have been and continue to be used as a means of cultural reaffirmation.

In recent years, there has been growing attention to the histories and development of cultural and regional rhetorics that challenges the dominance of Western and patriarchal rhetorical traditions and practices, work that has broadened, enriched, and complicated the field. Specifically, *Understanding African American Rhetoric: Classical Origins to Contemporary Innovations* (2003) and *African American Rhetoric(s): Interdisciplinary Perspectives* (2004), both edited by Elaine B. Richardson and Ronald L. Jackson II; *American Indian Rhetorics of Survivance: Word Medicine, Word Magic* (2006), edited by Ernest Stromberg; *Representations: Doing Asian American Rhetoric* (2009), edited by LuMing Mao and Morris Young; *Rhetorics of the Americas: 3114 BCE to 2012 CE* (2010), edited by Damián Baca and Victor Villanueva; *Rhetorica in Motion: Feminist Rhetorical Methods and Methodologies* (2010), edited by Eileen E. Schell and K. J. Rawson; and *Feminist Rhetorical Practices* (2012), edited by Jacqueline Jones Royster and Gesa Kirsch, are a representative sample of the groundbreaking work forging new inquiry and research.

This emergence of scholarship aimed at advancing our understanding of rhetoric as culturally bound coincides with similar discussions of aesthetics within the visual, written, and performance arts—themselves expressions of cultural and political identities and epistemologies. Such works include David Dorsey's *Formal Elements of the Black Aesthetic in Poetry* (1972); Steven Leuthold's *Indigenous Aesthetics: Native Art, Media, and Identity* (1998); *Literary Gestures: The Aesthetic in Asian American Writing*, edited by Rocío G. Davis and Sue-Im Lee (2005); Sarah Nuttall's *Beautiful/Ugly: African and Diaspora Aesthetics* (2007); Amy Abugo Ongiri's *Spectacular Blackness: The Cultural Politics of the Black Power Movement and the Search for a Black Aesthetic* (2009); Tobin Siebers' *Disability Aesthetics* (2010); Denise Cumming's *Visualities: Perspectives on Contemporary American Indian Film and Art* (2011); Michelle Raheja's *Reservation Reelism: Redfacing, Visual Sovereignty, and Repre-*

sentations of Native Americans in Film (2011); Dean Rader's *Engaged Resistance: American Indian Art, Literature, and Film from Alcatraz to the NMAI* (2011); Michelle Elam's *The Souls of Mixed Folk: Race, Politics, and Aesthetics in the New Millennium* (2011); Evie Shockley's *Renegade Poetics: Black Aesthetics and Formal Innovation in African American Poetry* (2011); Christopher Lee's *The Semblance of Identity: Aesthetic Mediation in Asian American Literature* (2012); Chadwick Allen's *Trans-Indigenous: Methodologies for Global Native Literary Studies* (2012); and Samantha Pinto's *Difficult Diasporas: The Transnational Feminist Aesthetic of the Black Atlantic* (2013). Aesthetics, as literary or artistic constructions, are examined in these texts as a means of both engagement with and resistance to dominant American culture. While the constructed nature of race, gender, sexuality, nationality, colonialism, and family, among other ideological apparatuses, has been examined within literature and art, discussions of rhetorics and aesthetics as constructed practices are still emerging.

Huihui: Navigating Art and Literature in the Pacific furthers articulates new frames for analysis and understanding of rhetorical and aesthetic practices; it is the first work to be devoted entirely to the aesthetics and rhetorics of Oceania. The lack of a body of work on the rhetorics and aesthetics of the region does not mean, however, that rhetorics and aesthetics have been absent from the abundance of literature—classical oratures, transnational exchanges and productions, and contemporary oral and written works—that the Pacific has given us. On the contrary, the lack of sustained attention to the rhetorics and aesthetics of the region is due primarily to colonial and neocolonial ideologies that continually negate and deny not only Indigenous knowledge and intellectual systems, but also cultural and political productions. Steven Winduo (2000) has asserted that Oceania needs to be "unwritten," or emptied of colonial imaginings, by its Indigenous Pacific scholars so that the region may be "filled with the cultural content that is of value to the Pacific people" in a way that "allows the value of knowledge to transform the negative consciousness of the Pacific people to a positive one" (607–608). Knowing that the project of unwriting must also interrogate and dismantle disparaging colonial literary standards, Vilsoni Hereniko and Sig Schwarz (1999) have emphasized that "the standards of [literary and artistic] judgment must come from inside Pacific islands cultures . . . [Critics] should be informed by the issues, viewpoints, forms of rhetoric and artistic modalities of Pacific cultures" (14). Nearly twenty years later, writers and scholars, such as those whose

work is included in this anthology, have taken up this call, negotiating and examining both Indigenous and colonial standards of aesthetic and rhetorical judgement and, in the process, contributing to the rich intellectual genealogies of the Pacific.

Part of this work has been to recognize how the boundaries between the political and the poetic, the rhetorical and the aesthetic, are often blurred within Indigenous knowledge productions. Haunani-Kay Trask (1999) captures this dynamic when describing her own work as "a confluence of creativities [wherein] art is a fluid political medium, as politics is metaphorical and artistic" (18). It is this blurring of boundaries that has enabled Pacific orators and writers to appeal to audience members simultaneously on a multitude of levels: the aesthetic and the rhetorical can be felt as a unified force, anchored in the literary traditions of Pacific peoples. Trask uses an example of oli to capture the very real and serious implications of a particular artistic mode and the expected rhetorical response: "Our Hawaiian chiefs, for example, announced war through the use of ominous metaphor; and woe to those who misunderstood the chiefly references" (18). The writers of this anthology similarly use a variety of genres and cross-genre forms, employing their vast inheritances of rhetorical and aesthetic strategies, to analyze how Indigenous and colonial rhetorics and aesthetics have been employed in various contexts, challenging colonial indoctrination through both thought and action.

Of course, these analyses of rhetorical and aesthetic strategies must also interrogate the very use of the terms "rhetorics" and "aesthetics" as they apply to Indigenous productions. Damián Baca (2010) and Malea Powell (2002) have both noted that rhetoric, in its basic form—notably not preceded by any adjectives (e.g., "other," "alternative," "minority") or followed by an "s" (as in "rhetorics")—is, by default, understood to imply Western rhetoric and is imbued with the values, ideologies, and lifestyle practices of Euro-Western culture. Adjectives such as "other," "alternative," and "minority" reinforce a hierarchy of rhetorics, and correspondingly of cultures, as each of those terms sets up a comparison to dominant ideological norms against which other rhetorics are either measured or denied. Similar arguments have been made with regard to aesthetics, which continue to be wielded by colonial powers to discount the value of Indigenous cultural and material productions and to reinforce systems of colonial silencing.

If we define "rhetoric" as discovering in any particular case all the available means of persuasion, and "aesthetic" as meaning not only the

nature of beauty, art, and taste, but also how one judges, perceives, defines, and reacts to beauty and taste, we must conclude that it is not the foundational definitions of these terms that are problematic. Quite the contrary, phrases such as "in any particular case" and "all the available means" imply a certain vastness in what rhetoric can potentially encompass. It is, rather, the dominance the West and East have assumed over definitions and defining that has limited understandings of rhetoric and aesthetic that is more encompassing. The relative absence of similar broad terms that could directly translate into rhetorics and aesthetics within the Indigenous languages of the Pacific further complicates these analyses; yet, as the works included in this anthology demonstrate, more specific cultural terms describing Pacific rhetorical and aesthetic strategies abound. To constrain our understandings of these terms within a foreign construct limits the ability to capture the epistemic potential of both rhetoric and aesthetic.

The goal of this book is to encourage reading, writing, and seeing through a Pacific or Oceanic lens. These processes counter the framing of rhetorical and aesthetic practices as always and only in response to a colonizing West or East, which inhibits rhetorical and aesthetic sovereignty. Scott Richard Lyons (2000) defines "rhetorical sovereignty" as "the inherent right and ability of peoples to determine their own communicative needs and . . . to decide for themselves the goals, modes, styles, and languages of public discourse" (449–450). Likewise, we assert that aesthetic sovereignty is the right and ability of peoples to define their own aesthetic standards and to determine how those aesthetic standards may fulfill and articulate the goals of their communities. Throughout Oceania, rhetorics and aesthetics are interwoven within ancestral, cultural, and historical memory, just as they also represent and reflect generations that have witnessed the devastation of lands and ocean, missionization, corporate imperialism, militarization, Asia-Pacific Economic Cooperation, the World Trade Organization, and other neocolonial and colonial manifestations. By recognizing the rhetorical and aesthetic sovereignty of the Indigenous peoples of the Pacific, *Huihui* contributes to the overturning of these hegemonic structures and the promoting of decolonization.

To approach a people's rhetorical or aesthetic sovereignty, the rhetorics and aesthetics employed need to be fully realized as culturally bound to the place in which they are enacted. Moving in this direction does not erase the colonial interactions Indigenous peoples have had with the West; rather, it works to position cultural practices—including

rhetorical and aesthetic practices—on equal footing with Western aesthetic and rhetorical practices. To accomplish this, we as scholars should not assume that if there is no adjective preceding or following the words "rhetoric" and "aesthetic" that the context is a Western frame. Instead, upon hearing "rhetoric" and "aesthetic" we should automatically ask to be physically and culturally located. We should likewise use terms that avoid comparison, and work to locate a people—their experiences, histories, cultures, and sovereignty. In the case of the works in this collection, that would be the rhetorics and aesthetics of the Pacific, in all of their varied cultural and geopolitical formations.

Makali'i: Identity

Makali'i, or the fine mesh or "tiny eyes" of the constellation Pleiades, is the cohesive, essential fabric of an organism, a body. Identity is the point of perspective that enables us to see and know the world and its parts. The self is perhaps the most common of these identities, but beyond that common starting point there are identities that are inseparable from the land, from others, from particular places—and from connections or relations among some or all of these points of origin. Rhetorics and aesthetics of identity tend to ask the question, "Who and what am I?" The answers are as various as those who ask the question, yet in this collection there arise strong commonalities that have to do not only with individual perceptions and knowledge, but also with strong relations with others and with the overarching presence of those who have come before us.

To that deceptively simple rhetorical question of "Who am I?" Alice Te Punga Somerville, in "Nau mai, hoki mai: Approaching the Ancestral House," answers, "I am home." Home is not so much a place as a locus of identity as it draws into oneself the past and ancestors. Michael Puleloa, in "The Fisherman," answers the question in a similar fashion, in a story of a photograph, a woman, and a young man returning home, his identity becoming multiplied through time and experience, yet finding in the past of this woman a way to bring the flow of time into a unified present.

Identity is often described in terms of "identification with"—yet our identities can just as easily be discovered by finding the opposition, or that *against* which we identify. Dan McMullin's "Tiki Manifesto" takes a marker of identity—one's very physical profile—and laments its having been stolen and devalued (and commodified) by an elusive

enemy. The answer, in addition to the aesthetic "manifesto," is given by Flora Devatine: ". . . And I who am still a woman woven . . . !" argues for a relentless onslaught of words, of language taken from the present, and from the present dominant language, and made to represent the vital point of the poet in relation to her life and world. Identity formation is the work of experience transformed into language. Thus, as in Selina Marsh's analysis, "Un/Civilized Girls, Unruly Poems: Jully Makini (Solomon Islands)," identity can be reclaimed from those who have taken it away and made it foreign, alien to the roots of a culture repressed or reshaped.

The work of language is not, of course, worked out on paper alone. Kalena Silva and Steven Winduo show us ways of turning the power of words into concrete public moments, much as we think of political speeches achieving immediate, widespread results and change. For Silva in "A Contemporary Response to Increasing Mele Performance Contexts," hula and the writing of mele are inseparable, a way to inculcate the past into the present in a way that combines the arts of the past with present needs to express culture—and so express the identities of that culture's citizens. Winduo's poem, "Pasin/Ways," is presented in two languages, a meeting of voices, of coming together in spirit and body, that mark a grand, regional identity of peoples, practices, and voices, an identity of a "way"—the Pacifik Way—that is predicated on points of relation, not difference.

Peleiake: Institutions

The Pleiades, or Peleiake, can mean "thick," "clustered," even "rank," as Pukui and Elbert (1986) tell us. So too are institutions. Institutions are organized, rule bound, power infused; they are presumably created by individuals, groups, collectives, for the purpose of bringing order to our lives. Popular examples of these institutions are schools, governments, and courts. There are other institutions that are less public but nevertheless exert tremendous power over our lives, like the family, because we believe in their promise to bring stability and meaning to our lives. Still less obvious institutions—like those of the media, of industry, of so many shapes and sizes—serve to codify what is "quality" in our lives, and it is against those qualities in our lives that we sometimes find ourselves positioned.

In this section of *Huihui* we see two public institutions, the state government and the museum, exerting control over a people. In "Cen-

tennial of the Overthrow Speeches, 'Iolani Palace, January 17, 1993,"
Haunani-Kay Trask and Mililani Trask engage in a very public rhetoric
against the authority of the state government to enforce the forced rela-
tion of the Hawaiian people to the state, a rhetoric fundamentally op-
positional to an institution that is thought to be unresponsive to those
who live under it. In Lisa King's "Sovereignty out from under Glass?
Native Hawaiian Rhetorics at the Bishop Museum," we see how an aes-
thetic of Indigenous display seeks to speak for a vexed relation of peo-
ple and state largely formulated by the latter.

This tension of the Indigenous and the colonizer—and the rhe-
torical and aesthetic responses it creates—takes other forms in this
section. In "Stealing the Piko: (Re)placing Kānaka Maoli at Disney's
Aulani Resort," Brandy Nālani McDougall and Georganne Nordstrom
look through the lens of a Disney version of Hawai'i and find an aes-
theticized history devoid of tension, its rhetoric of consumption over-
whelming history, while Jo Smith, in "The Many Different Faces of the
Dusky Maiden: A Context for Understanding Maiden Aotearoa," sug-
gests ways that sexist and racist stereotypes of native peoples can be
deconstructed through a reinterpretation of institutionalized images of
women, and a new rhetoric of Indigenous experience.

Arguments for reappraisal and for change may occur in forms
that are at once rhetorical and aesthetic—in their rigorous use of logic,
their appeal to the emotions, the power of the voices carrying them
forth to audiences chosen for their crucial role in this reappraisal and
change. Institutions, for all their power, can be taken on with the sight
and sound of language in virtually any form: Michael Puleloa's "Some-
thing in the Wind" combines the power of myth and collective action in
a fictional telling of resistance, while Chantal Spitz's "let's pull in our
nets" is a poetic manifesto of the rights of people to language, mean-
ing, and power, an answering to the institutions that are definitional to
the quality of life.

Kūpuku: Community

Kūpuku is yet another name for Huihui. It also carries with it the added
meaning of "cluster" and "thick" (Pukui and Elbert 1986), bringing to
mind how the individual stars of the Pleiades are clustered together,
sharing a space in the night sky, similar to the island nations that share
the Pacific. The third section of *Huihui*, "Kūpuku: Community," thus
turns its attention to the communities of the Pacific. A community is a

fabric woven together with stories—stories that give life to a people by conveying their history, culture, struggles, and resilience. Throughout this section, the authors weave together rhythmic poetic voices with scholarly research, once again demonstrating that the aesthetic and the rhetorical cannot be so easily disentangled and that the two, when mixed, compound both their aesthetic appeal and their rhetorical impact.

In "'I Lina'la' Tataotao Ta'lo': The Rhetoric and Aesthetics of Militarism, Religiosity, and Commemoration," Craig Santos Perez describes the price Guåhan (Guam) and its people have paid—in lives lost in wars not of their making, in destruction and desecration of land. Weaving the personal with the political, he makes present the death that colonial powers and their wars bring to a community and juxtaposes that with the story of the many ways Chamorros have fought and continue to fight to sustain their communities with words, poems, stories. Chantal Spitz of French-occupied Polynesia, a recent addition to the United Nation's list of non-self-governing territories, similarly recognizes the power embodied in a community's stories and their ability to reclaim history and reaffirm Indigenous identity. In "The Words to Speak Our Woes," Spitz details the stories of the colonizer that have been like a disease visited on the Tahitian people, but she calls on her Ma'ohi community to "speak the words of our history/take back our stolen voices," emphasizing how finding their collective voice creates a strong, healthy, vital community—one able to counter the centuries of dispossession and degradation.

In a distinguished lecture delivered in 2011, "All Things Depending: Renewing Interdependence in Oceania," Jonathan Kay Kamakawiwo'ole Osorio expands the definition of community to include all the Indigenous peoples of the Pacific. He builds on the experiences shared among Pacific nations people that Perez and Spitz bring to light—the commonalities among their cultures and worldviews and in the devastation colonization has brought to the Pacific. But, again, he emphasizes that by uniting their voices, this collective community can navigate its people. Like Osorio, Steven Winduo calls all the peoples of the Pacific together as one people—one community—in his poem "Pasin Pasifik / Pasifik Way," demonstrating again the rhetorical nature of the aesthetic. Winduo reminds the reader that the rhythm instruments do so much more than provide beat to some form of entertainment—they signal a meeting where "These voices of the Pasifik" will be heard.

In the next piece of this section, Gregory Clark and Chelle Pahinui illustrate the rhetorical power of hula—a tradition flagrantly misunderstood and misrepresented in the West. Drawing distinctions between Pacific peoples' and Westerners' perspectives of life, Clark and Pahinui explain hula as "an archive of ideology, connections, memories, and experiences" that can heal and reaffirm community. We close this section with a poem by Jeffrey Carroll about Chelle Pahinui's esteemed father-in-law, the famous slack-key guitarist and folk legend, Gabby Pahinui. As the poem travels through the events of Gabby's life, we get a glimpse of life in Hawaiʻi for a Hawaiian coming of age in the thirties and forties, and through Gabby we understand how the music simply cannot be silenced.

Ke Aweawe a Makaliʻi: Word

The final section, "Ke Aweawe a Makaliʻi: Word," focuses on the aesthetic and rhetorical crafting of words. The word aweawe means "tenacity" or "adhesiveness." As yet another name for Huihui, Ke Aweawe a Makaliʻi reflects on the way that the constellation's stars appear to be bonded or threaded to one another, collectively producing their light. The words of our contributors in this section may be perceived similarly as individual works that individually shine but that also speak to a collective contemplation of the power of words and language. Chantal Spitz's poem "I write (J'écris)," translated by Jean Anderson, reflects on the act of writing and its potential for furthering decolonization in French-occupied Polynesia. kuʻualoha hoʻomanawanui's critical essay "Ka Liʻu o ka Paʻakai (Well Seasoned with Salt): Recognizing Literary Devices, Rhetorical Strategies, and Aesthetics in Kanaka Maoli Literature" seeks to honor certain hallmarks of Hawaiian literature. Drawing from Hiapo Perreira's scholarship on Hawaiian oratory, she specifically examines aesthetic and rhetorical literary devices and traditions in various Hawaiian mele and moʻolelo. Albert Wendt's short story "First Class" illustrates the complexities of teaching (and learning) creative writing at the University of Hawaiʻi at Mānoa, where he held the English department's Citizen's Chair from 2004–2008. The dynamic between the professor and students he portrays reflects the tremendous diversity of knowledge and experience informed by place and culture in Hawaiʻi, while also showing the underlying tensions of such diversity. The next piece in this section recognizes Albert Wendt's deft command

of language and literary knowledge to bring the ancestral, mythological, and contemporary into dialogue. Focusing on Wendt's latest epic, Steven Gin's critical essay, "Adventures in Chronicling: The Relational Web of Albert Wendt's *The Adventures of Vela*," traces the intricate and interwoven narratives and their three chroniclers in *The Adventures of Vela*. Finally, Flora Devatine's poem "When will I be content with my words? When will I sound out my poem words?," translated by Jean Anderson, is a meditation on writing as craft, with words as the aesthetic tools and matter from which art is made.

Together, as stars in the same Pacific constellation, the contributors further illuminate how Pacific writers and artists skillfully consider and powerfully craft their words in Indigenous and imperialist languages. Aweawe may also mean the wake of a ship, however, and as the final section of the anthology, these chapters also provide us with moments of reflection to navigate through the multifarious imbrications of aesthetics and rhetorics as they shape our experiences and receptions of words.

As we write this, Hōkūleʻa is beginning its voyage to circumnavigate this vast honua, and leaving cultural and ecological revitalization and ancestral reconnection in its decolonial wake. Like hoʻokele, the authors featured in this collection navigate us through the storms, doldrums, and currents of Oceania, using their own rhetorics and aesthetics to establish and examine Indigenous continuity in all of its forms and to expose, analyze, interrogate, and resist colonial rhetorics and aesthetics. Separately, the authors in this anthology represent Tahiti Nui and Huahine of French-occupied Polynesia, Aotearoa/New Zealand, Sāmoa, Guåhan, Hawaiʻi, Tuvalu, the Marshall Islands, the Solomon Islands, Papua New Guinea, Canada, and the United States. Collectively, their words guide us over ocean routes; like the great waʻa, vaʻa, waka, proa, and sakman that once carried the ancestors of Oceania, they now, once again, carry the descendants of Oceania.

If we return to Pukui and Elbert (1986), the rewards of close reading—of even a single word's meanings—yield even more direction at this starting point in *Huihui*. "Cluster" and "bunch" suggest the organic, the edible—we certainly hope that the ʻono, or tastes, of these selections are favorable and pleasant—yet the last definition lifts our eyes to the skies again, to Huihui, to Makaliʻi, to Peleiake, to Kūpuku, to Ke Aweawe a Makaliʻi, the constellation known in Western terms as the Pleiades. It is visible to the naked eye, a cluster of light from many stars. It can sustain our gaze into the sky so we may know where we are. The

editors of *Huihui* hope that this cluster of work of the Pacific may be, in its own way, just as sustaining.

Works Cited

Baca, Damián. 2010. "*te-ixtli:* The 'Other Face' of the Americas." In *Rhetorics of the Americas: 3114 BCE to 2012 CE*, ed. Damián Baca and Victor Villanueva, 1–13. New York: Palgrave Macmillan.

Hauʻofa, Epeli. 1999. "Our Sea of Islands." In *Inside Out: Literature, Cultural Politics, and Identity in the New Pacific*, ed. Vilsoni Hereniko and Rob Wilson, 27–38. New York: Rowman and Littlefield.

Hereniko, Vilsoni, and Sig Schwarz. 1999. "Four Writers and One Critic." In *Inside Out: Literature, Cultural Politics, and Identity in the New Pacific*, ed. Vilsoni Hereniko and Rob Wilson, 55–64. New York: Rowman and Littlefield.

Lyons, Scott Richard. 2000. "Rhetorical Sovereignty: What Do American Indians Want from Writing?" *College Composition and Communication* 51, no. 3 (February): 447–468.

Powell, Malea. 2002. "Rhetorics of Survivance: How American Indians Use Writing." *College Composition and Communication* 53, no. 3:396–434.

Pukui, Mary Kawena, and Elbert, Samuel H. 1986. *Hawaiian Dictionary*. Revised and enlarged edition. Honolulu: University of Hawaiʻi Press.

Trask, Haunani-Kay. 1999. "Writing in Captivity: Poetry in a Time of Decolonization." In *Inside Out: Literature, Cultural Politics, and Identity in the New Pacific*, ed. Vilsoni Hereniko and Rob Wilson, 17–26. New York: Rowman and Littlefield.

Wendt, Albert. 1976. "Towards a New Oceania." *Mana Review: A South Pacific Journal of Language and Literature* 1, no. 1:49–60.

Winduo, Steven. 2000. "Unwriting Oceania: The Repositioning of the Pacific Writer Scholar within a Folk Narrative Space." *New Literary History* 31, no. 3 (Summer): 599–615.

Makaliʻi: Identity

...And I who am still a woman woven...!

FLORA DEVATINE
TRANSLATED BY JEAN ANDERSON

To Alberto the Argentine

 ... And I who am still a woman woven . . . !
What am I saying? cut from tapa cloth!
And like tapa, struck through with the fibers of orality!
What is it I want to do?
To write!
To carve myself into the wood!
And so I write
Following the grain of my bark,
Seeking out the meaning of my fiber and at the same time
Explaining, justifying
Why, I don't know!
And so I write
But I don't trust what I write,
Nor do I trust the usefulness of writing!

What's the point of it?
Is it worth the trouble of my saying it, writing it?

Should I be concerned about the meaning,
Or the impact of what I'm writing?
And so I write the way I speak
The way I speak the way I think
The way I think the way it comes to me

And it is written down!

.

And so I write

Seizing words,
Breathing life into words,

In intermittent sobs
And sighs of freedom!

Hiccuping little bubbles
Going back to the weeping waters
Of immemorial springs
To burst forth into awareness!

And so I write

To slake the words
Fara, pineapple

And passion fruit!
To make words blossom
Vanilla, tiare, anuhe

And maire rauri'i!

To inlay the words
With coral, with pearly shell, with pitipiti'o!

And so I write

About words
To dizzy their meaning!

And so I write

About feelings
To express the essence!

And so I write

 About writing
 To plumb the depths of writing!

And so I write

 To haunt and intoxicate words
 So that writing may be born!
 .

 Writing!

My head is filled with this word,
My pages, my conversations,
My computer screen.

 Writing! Writing!

What is it about writing
That made ancient civilizations defer to it
Found themselves upon it?

Why this obsession with words,
With what they carry?

 Nagging, irritating questions
 That never ease their grip, that cling to me!

 Like a prayer to recite,
 Like a sacrifice to offer up,
 Like a ritual to respect

Before every writing session!
 Like a knot to be untied and retied,
 Like a link to be understood,

Each and every time I want to write!

Going back to the question,
Deep into the question,

Thinking about the question,
Reviewing the question,

Once again asking the question,
Meditating on the question!

 This is like dancing round the fire,
 Circling around the crossing!

Taking up the weaving of mats
 Where you left off!

Climbing the path a little further
 Than where you last turned back!

Picking up the wall of coral blocks
 Where it collapsed!

Clearing a way through the impassable passage
Unblocking the river's course . . . !
. .

 And thus
Te-faʻa-toʻetoʻe-tane
"He who chills men"

 A coral reef
 A sizeable motu

 A whole world
 A whole scene
 A whole life

 A single word
 And tu-te-raʻi

 Everything is sky
 Everything is sea
 Everything is land
 Everything is full

The fullness of an egg
The fullness of life

The magical fullness of creation

Words that are all
Words that are special

 Words of pearly shell
 Of porcelain
On the skin of ocean's drums

Words that are keys
Words that are sparks
 Of gold
 Of fire
On the edge of the fields of poems

Words that tell stories
Words that move in convoy
Words that consent

That lash
That trill
That cradle
That murmur

Tucked here and there on the clef of freedom's songs

Words of sin
Words of distinction
Words of culture

Trinket words
Lessons in poetry

Lessons in words

 Marae words
 Museum words

Cathedral words
Adze words
To'ere words
'Aiha words
Azure words

 Pahi
 Canoe
 Paepae
 Boats
 Ships
 Sailboats

Zephyr words
Blizzard words

Spindly words
Grave words

Style words
Stele words

Echo words
Eclipse words

Blockhouse words
Bombproof words

 Blackballed
 Cannonballed

Zygotic words
Griotic words

Gregarious words

Peak words
Stubborn words

 Fau

Tuoua'i
Uraraunui

Flowering words
Fruiting words
Leafing words
Branching words

Sprouting words
Knotting words

Truncated words
Radical
Rooted

Rummaged words
Connected words

Flashy words
Drunken words

Convoluted

Passing words
Siring words

Birthed within
Poetic words
Artistic words

To the enchanted pen
Of charmed word

Note

Excerpt from *Tergiversations et Rêveries de l'Écriture Orale* (Pape'ete: Au Vent des Îles, 1998).

A Contemporary Response to Increasing Mele Performance Contexts

KALENA SILVA

LINGUISTS ESTIMATE THAT THERE ARE MORE THAN SIX THOUSAND languages spoken in the world today and, alarmingly, that 60 percent are at risk of extinction with the passing of their last speakers (Hinton 2001; Nettle and Romaine 2000). Of the estimated 300 North American indigenous languages spoken when the explorer Christopher Columbus arrived in 1492, some 210 survive; of the 210, about 175 are in the United States (Krauss 1996). Young, fluent speakers of a language are key to its continuing vitality among future generations. Of the 175 surviving indigenous languages in the United States, only about 20 have speakers below the age of eighteen (Krauss 1996). One of the 20 languages, Hawaiian has the highest immersion-school student enrollment and is the third-largest immersion language in the United States after Spanish and French (Wilson and Kamanā 2011).[1]

Since the renewed interest in Hawaiian language and culture (frequently referred to as the Hawaiian Renaissance) in the 1970s, increasing numbers of people—Hawaiian and non-Hawaiian alike—have been participating in activities with cultural knowledge bases associated with education; with the physical environment, including the land, ocean, and sky; and with the visual, healing, and performing arts. Generally, the activities are of two major types: evolving traditional (i.e., continuing uninterrupted with varying degrees of vitality from former times to the present, such as lei making, music, hula, and taro farming) and reemerging traditional (i.e., once abandoned, but now being revitalized through research in old Hawaiian-language sources and/or

among other Pacific Island peoples, such as celestial navigation, aquaculture, and kapa making). To a greater or lesser extent, the Hawaiian language is a component found in all these activities.

Aside from daily use in communication, perhaps nowhere else is Hawaiian a more important component than in the performing arts, that is, in music, hula, oratory, and mele, or poetic compositions—the focus of this essay. As composed and performed today, mele are a natural and increasingly valued extension of the vernacular use of Hawaiian and, like the activities listed previously, can be viewed as evolving or re-emerging traditional poetic/musical forms. Evolving traditional forms include mele associated with hula and mele that honor individuals; reemerging traditional forms include mele to welcome visitors and mele to lament a person's passing.

In this chapter, I provide a brief overview of the historical events that led both to the decline and to the current revitalization of Hawaiian, including circumstances that led to my own participation in revitalization efforts. Further, I describe mele I have composed for events within four contemporary contexts, including the traditional and contemporary significance of the events and the intent, meaning, and form of the mele.[2]

Historical Overview of the Hawaiian Language

Hawaiian is the first language of the Hawaiian Islands and has close linguistic ties to other Polynesian languages, especially those in eastern Polynesia, such as Māori, Tahitian, and Marquesan. Although the arrival in 1778 of the first foreigner, English explorer James Cook, was followed soon after by the arrival of other explorers and traders, no significant foreign community established itself in Hawai'i until the arrival of New England Calvinist missionaries in 1820—a year after many traditional religious practices had been abandoned due to societal changes of the time. King Liholiho Kamehameha II undoubtedly saw the arrival of the missionaries as an opportunity to learn more about the positive potential of this foreign religion but also, and perhaps more important, as an opportunity for his citizenry to learn to read and to write. In his dealings with foreigners, the king had already seen the power of ka 'elele waha 'ole, or the mouthless messenger. He permitted the missionaries to stay, Christianity took root, and Hawaiians, eagerly following the example of their beloved king, quickly learned how to use this new technology—the written word—transforming it to suit

Hawaiian needs and uses. Hawaiians' early literacy served as an important communication tool that greatly supported efforts leading to Hawaiʻi's recognition in 1843 as a member of the world's independent nation-states, the first non-Euro-American nation to be so recognized.

During nationhood in the nineteenth century, Hawaiian was the medium of education, commerce, and government. Foreigners and non–Native Hawaiians with Hawaiian citizenship communicated in the language (though many with ties to the United States sent their children to English-medium schools). A census report published in 1897 states that literacy rates among full-blooded and part Hawaiians over the age of six were 84 percent and 91.2 percent, respectively, placing Hawaiʻi among the most literate nations in the world at the time (Hawaii General Superintendent of the Census 1897).

In 1893, the Hawaiian nation's constitutional monarchy, led by Queen Liliʻuokalani, was overthrown by a group comprised mainly of American businessmen. The group formed a provisional government that produced English-only laws and policies that led to the near extinction of Hawaiian in the following years.[3] With political and socioeconomic pressures mounting to nullify Hawaiʻi's status as an independent nation and to make Hawaiʻi a part of the United States, the English-only educational policies resulted in the rapid decline in the number of young speakers of Hawaiian. Hawaiʻi's takeover by U.S. expatriates moved the nation inexorably toward annexation in 1898, to designation as a U.S. territory in 1900, and to designation as the fiftieth state of the union in 1959. Seeking to address the rapid decline in the number of Hawaiian speakers, in 1921, the University of Hawaiʻi began teaching Hawaiian as a second language; however, the Hawaiian-speaking population continued to plummet. Linguists estimate that the last Hawaiian-speaking children were born around 1920, though a few born and raised later in very isolated areas also spoke Hawaiian (Kimura 2012).

In the 1960s, several surviving Hawaiian-speaking kūpuna, or elders, grew increasingly concerned that Hawaiian was no longer being spoken by younger generations. Generally with little formal, mainstream education themselves, some took action and began teaching Hawaiian in their communities and in schools. Building upon the language and culture courses taught by kūpuna such as Alvira Mathews and Edith Kanakaʻole of Hilo, Hawaiʻi, the first Hawaiian-medium bachelor of arts degree program in Hawaiian studies was established at the University of Hawaiʻi at Hilo in 1978 with twelve student majors. As a result of the Hawaiʻi State Constitutional Convention held the same

year, Hawaiian was made an official language of Hawai'i, along with English, making Hawai'i the only state in the union to so recognize an indigenous language. Such official recognition has played a key role in later efforts to revitalize Hawaiian in its homeland.

In the late 1970s, some Hawaiian educators estimated that only two thousand Hawaiian speakers, most in their sixties and older, remained (.01 percent of a total Native Hawaiian population of about two hundred thousand). A survey conducted in 1983 revealed that only thirty-two children under the age of eighteen continued to speak Hawaiian as their first language; most were of families from the island of Ni'ihau.[4] In the same year, University of Hawai'i at Hilo Hawaiian Studies faculty led the start of the Pūnana Leo—the non-profit Hawaiian-medium preschools for children ages three to five.[5] Hawaiian studies students worked with kūpuna to teach the children and their families.

The 1980s also saw the repeal of the ninety-year-old law banning Hawaiian-medium education in public schools, the subsequent start of the K–12 public school Papahana Kula Kaiapuni Hawai'i, or Hawaiian Immersion School Program, and the establishment by the Hawai'i State Legislature of the Hale Kuamo'o Hawaiian Language Center at the University of Hawai'i at Hilo to meet the state's Hawaiian-language needs in both the public and private sectors. The Hale Kuamo'o produces the majority of curriculum material used in the Papahana Kula Kaiapuni Hawai'i, the first students of which graduated in 1999. Fully bilingual, many Kula Kaiapuni students have successfully completed undergraduate and graduate degree programs at universities including the University of Hawai'i at Hilo, the University of Hawai'i at Mānoa, and Loyola, Stanford, and Oxford Universities, their success providing powerful testament to their ability to transfer learning skills from Hawaiian to English.

The 1990s saw the University of Hawai'i Board of Regents' approval of the first master of arts degree in Hawaiian Language and Literature and the Hawai'i State Legislature's passing of the bill to establish the University of Hawai'i at Hilo's Ka Haka 'Ula O Ke'elikōlani College of Hawaiian Language (formerly the Hawaiian Studies Department). Ke'elikōlani College is now comprised of two divisions: Academic Programs and the Hale Kuamo'o. The Academic Programs Division includes two bachelor of arts degree programs (in Hawaiian studies and in linguistics), two master of arts degree programs, a graduate teacher certification program, and the first PhD in Hawaiian and Indigenous Language and Culture Revitalization. In a consortium partnership with

the nonprofit ʻAha Pūnana Leo, the college has recently established Hawaiʻi's first P–20 (preschool to doctorate) Hawaiian-medium education system, which received international accreditation from the World Indigenous Nations Higher Education Consortium in 2010.[6]

The road to the revitalization of Hawaiian has many twists and turns, roadblocks and potholes, but we persist. The prognosis for the health of Hawaiian improves yearly as increasing numbers of students and their families enter the P–20 Hawaiian-medium education system. While there were only some two thousand Hawaiian speakers left in the late 1970s, most of them sixty years of age and older, today we estimate that there are probably some eight thousand speakers—most below the age of thirty—a good indicator of the language's increasing vitality and of the likelihood that it will be sustained by future generations.

Circumstances Leading to My Participation in Hawaiian Revitalization

The youngest of three children born to a Hawaiian, Portuguese, Irish father and a Hawaiʻi-born Chinese mother, I was raised in an English-speaking household in Honolulu.[7] My father was born in Waiʻanae, Oʻahu, and as a child, I was often taken to visit family still living there. I looked forward to visits with my grandmother, Annie Kalipo McCandless Silva, to whom I felt particularly close. I vividly remember sitting by her side and seeing the great delight she took in Hawaiian conversations with relatives and friends of her generation and older—all of whom spoke Hawaiian as their first language. It appeared to me that although she emanated intelligence, warmth, and grace when speaking English, those characteristics were even more clearly evident in the ease with which she spoke Hawaiian. Associating those characteristics with Hawaiian and speakers of Hawaiian, at about eleven years of age, I decided I wanted to learn the language.

Phoning Grandma from our home in Honolulu one day, I asked if she would help me to learn Hawaiian. As she paused, then started to laugh, it occurred to me that this might have been a bad idea. She was not a language teacher, after all, so how would she teach me? As her laughter subsided, she said of course she would teach me. (Later, I came to realize that her laughter was due to the unexpected pleasure of hearing my request.) I was delighted that she was willing to help me to learn, but I had no idea how we might start. Somehow, though, she knew that by speaking to me, I would learn. So we proceeded, over the phone and

when the family got together, talking about her youth and our family, her passion for gardening, and my work at school.[8] It was difficult for me and sometimes frustrating for her. She often gently said to me, "'A'ole pēia e 'ōlelo ai" ("That's not how you say it").

A year or so after we started, I was accepted into the Kamehameha Schools as a seventh grader and, following the advice of my parents, took French instead of Hawaiian.[9] Grandma and I continued having our conversations, and in high school I completed four years of Hawaiian-language study. In 1971, I enrolled as an undergraduate at the University of Hawai'i at Mānoa and completed fourth-year Hawaiian there in my freshman year. My conversations with Grandma and study at Kamehameha had been time well spent—a precious personal and linguistic gift.

My formal study of Hawaiian at the university ended at the fourth-year level, as I majored in ethnomusicology and completed my bachelor's and master's there and my doctorate in music with emphasis in ethnomusicology at the University of Washington. I continued visiting with Grandma and by then had come to know other Hawaiian-speaking kūpuna. From my initial hire at the University of Hawai'i at Hilo in 1984 as an assistant professor of Hawaiian studies, through fifteen years as director of the College until the present, as a full-time professor, I have actively sought to deepen my knowledge of Hawaiian through research, teaching, and ongoing participation in the growing Hawaiian-speaking community. One very satisfying way in which I have brought my knowledge of Hawaiian and music together is in the composition of mele for various events.

A Response to Four Contemporary Mele Performance Contexts

In my work at the university and in the community, events sometimes provide the impetus for mele composition. I usually compose both the mele and its musical setting, but sometimes I compose the musical setting or hula for mele composed by others. An important part of the composing process is the paka, or constructive criticism of the mele, provided by knowledgeable peers. Soon after the paka is completed, the performing group is rehearsed and the mele is performed at the event. Though I would like to think they are marked by a good deal of reflection, my mele are generally not a private, highly personal medium of expression that may or may not be made public, as is the practice of some composers. All, for better or for worse, are destined for public performance.

Beyond considerations of the composing process, a major goal is to produce mele that resonate in the listener's ear through the use of poetic language based upon Hawaiian perspectives. Though that kind of language can sometimes be difficult for twenty-first-century audiences to access, the more it is discussed, used, heard, and understood, the stronger the resonance it generates. The huge repository of nineteenth- and twentieth-century Hawaiian-language sources (probably the largest of any indigenous people in the world) found in newspapers, government and personal documents, and sound recordings includes thousands of mele from that time and from antiquity, as recorded at that time. These sources are increasingly accessible online at websites like the bilingual Ulukau: The Hawaiian Electronic Library at Ulukau .org, created by cofounders Keʻelikōlani College and Alu Like, Inc. The mele are invaluable examples of traditional poetic language use and provide a solid foundation for contemporary Hawaiian-language composers and audiences alike.

I believe the best mele are rooted in an intrinsic Hawaiian worldview from which skillfully crafted poetic, rather than vernacular, language conveys meaning. Such mele contain thoughtful use of metaphor and simile; they include phrases from and allusions to older mele that support and elucidate meaning; they are deftly structured using meiwi, or poetic devices, including linked assonance, alliteration, enumeration and paired opposites for completeness, and restatement for emphasis, among other traditional devices; and, where appropriate, they contain kaona, or hidden meaning, to challenge the listener but also to delight him or her when the kaona is understood. As our knowledge and proficiency in Hawaiian increase, the quality of our mele improves. The quality of my own mele, of course, I leave to the listener (or, as presented here, the reader) to determine.

I present here ten mele I have composed for events that fall within four major contexts: educational (e.g., events at the university or Hawaiian immersion schools); hula; larger Hawaiian community; and family. Although each mele is presented in English translation, in several instances, the translation does not convey all the nuances of meaning found in the Hawaiian—a lamentable but unavoidable aspect of translation.

The Educational Context

Mele heahea (literally, "welcoming call chant"), a host's spontaneous, chanted welcome inviting approaching visitors to enter the host's home,

were commonly heard in traditional times, as hospitality was (and continues to be) an important aspect of daily living.[10] Over the past thirty years, opportunities to welcome visitors have increased dramatically as indigenous peoples, educators, and researchers locally and from around the world come to learn about Hawaiian language revitalization work. Keʻelikōlani College's mele heahea are precomposed so they can be chanted by students, faculty, and staff as a group (instead of spontaneously by an individual) and are most often heard at hoʻokipa, or formal welcomes of visitors to the university or to one of the college's laboratory schools. The faculty of Keʻelikōlani College's graduate Kahuawaiola Indigenous Teacher Education program wanted a mele heahea that could be used to welcome visitors to their program, so I composed the mele that follows. Mele heahea had become obsolete as Hawaiian-language knowledge and use declined; today, however, they are increasingly heard in this reemerging traditional form.

Hē Mai

**Mele heahea for the Kahuawaiola
Indigenous Teacher Education Program**

Hē mai, hē mai, hē mai!	Welcome, welcome, welcome!
Hē mai, e nā pua o ke kai loa, kai uli,	Welcome, descendants of the distant seas, the dark seas,
Kai pōpolohua mea a Kāne lā ē.	The sacred jet-black seas of Kāne.
He hua ko ka umauma o nā hiki,	A thought has compelled the travel of those who arrive,
He hua hoʻi ko ka honua nei ē.	A thought has likewise compelled the building of this place.
Eia ka leo e kipa mai ai,	Here is the voice inviting your visit,
Eia ka hale e hoʻolulu iho ai,	Here is the house in which you can rest,
Eia nō mākou nei ā!	We are here!

In some spheres of learning in former times, mele pule, or prayer chants, were recited as an appeal to the appropriate gods to inspire students in the learning process.[11] Today, however, students do not come from families where the indigenous Hawaiian religion is fully known, understood, or practiced, so mele pule no longer inspire students the way they once did. Yet, inspiration remains an important part of the

learning process, and other kinds of culturally based mele are being composed to inspire present-day students. I have described the mele that follows as a mele noi na'auao, or a poem requesting knowledge; though na'auao appears nowhere in the mele, the Hawaiian speaker hears it implied by the frequent references to the ao of the new day in relation to the school. The mele was composed for use in the Papahana Kula Kaiapuni Hawai'i, though I have heard that it is now also chanted by some hula schools and canoe clubs, with hale kula of the second to the last line replaced with hālau hula or hālau wa'a. Though not prayer chants, this mele and other contemporary ones like it do serve to inspire students in a culturally based way, so I regard them as examples of an evolving traditional form.

Aia i Kumukahi

Mele noi na'auao

Aia i Kumukahi ka lā e puka maila,	The sun rises at Kumukahi,
Ke ne'e a'ela nā kukuna i luna o ka 'āina.	Its rays move over the land.
Ke ho'opumehana nei,	Bringing warmth,
Ke ho'omālamalama nei,	Bringing light,
Ke ho'ōla nei i nā kini ē.	Bringing life and health to all.
Ua ao ka pō,	Night becomes day,
Ua eo ka pō i ke ao.	As light overcomes darkness.
Ua ao ka hale kula nei lā ē,	This school is filled with light,
E ola kākou a pau loa i ke ao ē.	Giving us all renewed life and health.

An important part of the education of Ke'elikōlani College students lies in their knowing about the kūpuna before us who, despite unimaginable obstacles, adversity, and hardship, led exemplary, productive lives. Princess Ruth Keanolani Kanāhoahoa Ke'elikōlani, the nineteenth-century chiefess after whom the college is named, is one such kupuna.[12] In the late 1990s, an Elementary Hawaiian class of mine composed the mele inoa below with my paka assistance. It was composed to a sung melody I composed for the mele. Using the grammatical structures the students had learned up until this composition, each of the verses focuses on an aspect of the life of the princess we discussed in class. Reflecting poetic and musical conventions with roots in both antiquity and the early nineteenth century, this mele can be considered an example of the evolving tradi-

tional mele inoa, or name chant, to honor and to praise individuals of note.

'O Ke'elikōlani 'Oe

Mele inoa for Princess Ruth Keanolani Kanāhoahoa Ke'elikōlani

He pua lei 'oe na nā mākua,	You are a cherished offspring of your parents,
Na Kekūanāo'a a me Pauahi,	Of Kekūanāo'a and Pauahi,
He mamo hiwahiwa na ke kupuna,	A precious descendant of your ancestor,
Na Pai'ea, na Kamehameha.	Of Pai'ea Kamehameha.
Aia i Honolulu kou home nani.	There in Honolulu is your beautiful home.
Hiehie nō 'oe i ka la'i Keoua.	Distinguished, you reside in the calm of Keoua.
Aia i Kailua 'o Hulihe'e,	There in Kailua is Hulihe'e,
I ka malu o ke kuahiwi 'o Hualālai.	Protectively watched over by Mount Hualālai.
Aia i Hilo ka wahine 'o Pele,	There in Hilo is the woman, Pele,
'Ohana 'aumakua no Ke'elikōlani.	Ancestral deity of Ke'elikōlani.
Kau a'e nō 'oe i ke olioli,	You raise your chanting voice,
A moe, moe mālie mai ka wahine o ka lua	And the woman of the crater falls blissfully asleep.
Ua nui ke aloha o nā Hawai'i	Hawaiians have deep affection
I ke ali'i wahine o ka lāhui.	For the chiefess of the people.
Ua kamaha'o kou leo aloha—	Your loving voice moves us—
He leo mana nui, he leo Hawai'i.	A powerful voice, a Hawaiian voice.
Panina:	Ending:
Ua kamaha'o kou leo aloha.	Your loving voice moves us.
'O Ke'elikōlani 'oe, e ō mai.	You are Ke'elikōlani, acknowledge your praise.
'O Ke'elikōlani 'oe, e ō mai.	You are Ke'elikōlani, acknowledge your praise.

In late October 1999, the United States hosted the Millennium Young People's Congress in Honolulu, with participation by one thousand young people, fifteen to eighteen years old, from 189 nations. The purpose of the congress was to set priorities to sustain and to improve life in the approaching new millennium. A University of Hawai'i at Mānoa music colleague, Professor Takeo Kudo, wrote to ask if I would compose the Hawaiian lyrics for the congress's theme song, explaining that the organizers wanted "a simple verse that expresses the closeness of Hawaiians to the earth and their oneness with nature." I agreed to write the song and, after some deliberation, decided the lyrics should remind participants about how all of humanity shares in the magnificence of our planet, no matter where we are from, who we are, or what we look like. The unstated implication in the song is that such beauty also requires all of us to take responsibility for its sustainability. The lyrics and accompanying melody I composed went beyond the "simple verse" originally requested, but I think were well received. A kind of mele pana, or historical/legendary place chant, this sung mele can be considered an example of this evolving traditional form.

He Ao Nani Ē

Mele pana for the Millennium Young People's Congress

No ka hikina he komohana,	Because there is east, there is west,
No ka 'ākau he hema ho'i,	Because there is north, there is south,
No ka lani he honua,	Because there is heaven, there is earth,
No ka uka he kai ho'i.	Because there are uplands, there are lowlands.
He ao nani ē.	It is a magnificent world.
Hui: 'O kanaka nui, 'o kanaka iki,	Chorus: Big people, little people,
'O kanaka loa, 'o kanaka poko,	Tall people, short people,
'O kanaka kea, 'o kanaka uli,	Fair-skinned people, dark-skinned people,
Nou a no'u, wehe ke ao.	For you and for me, a new day dawns.
He ao nani ē.	It is a magnificent world.

No ka ʻino he mālie,	Because there are storms, there is fair weather,
No ka ua he lā hoʻi,	Because there is rain, there is sun,
No ka wela he anuanu,	Because there is heat, there is cold,
No ka makani he lulu hoʻi.	Because there is wind, there is calm.
He ao nani ē.	It is a magnificent world.

The Hula Context

In early 1983, Auntie Māiki Aiu Lake phoned to tell me about the ʻūniki, or hula graduation ceremony, she was preparing for her student John Keola Lake later that year.[13] She was asking various members of the Papa Lehua, the first class she graduated in 1972, to assume various responsibilities in preparation for the ʻūniki to be held near Kahana, Oʻahu. "Yes, yes, of course, Auntie," I replied, honored and happy that I would be a part of the event. Complementing the focus of the ʻūniki on Keola Lake's graduation performance, I would perform Kū Ka ʻOliʻoli, a hula ʻulīʻulī, or sitting gourd rattle dance, Auntie Māiki had taught us. She further explained that members of the Papa Lauaʻe, a class she had graduated several years after ours, would be dancing three hula pahu, or drum dances, but that a newly composed mele was needed as they danced onto the performance area prior to the hula pahu proper. (Auntie Māiki impressed upon her students the importance of creativity and saw it as essential if hula was to be considered a living art.) Contemplating various poetic images that might be appropriate for such a mele, I decided upon the sound of moving water to reflect Auntie Māiki's teaching. She was a charismatic and inspirational teacher, and her voice—like the sound of water—could sometimes be soft and gentle, at other times forceful and booming. Auntie showed her students a way of life in hula, so in this mele, as the water cascades down the high cliff face, booming upon the surface of the pool below, the resulting spray sustains the swaying grove of lauaʻe ferns (figuratively, the dancers) growing there. Traditionally, mele pule to various gods of the hula are chanted to inspire dancers as they enter the performance area; though this mele honors Auntie Māiki, it is intended to inspire the dancers, so I consider it a part of the evolving traditional form.

He Hone Ka Puaʻi ʻOlāʻolā

Mele hula kaʻi pahu

He hone ka puaʻi ʻolāʻolā,	The gurgling flow sweetly appeals,
He hone ka puaʻi pūnāwai o uka.	The gurgling flow of the upland spring is soft and sweet.
Wai hāloʻi i ka malu o ka nahele,	The water forms pools in the shade of the forest,
Hālana, pāhihi i ka pali kiʻekiʻe,	Overflows, streams down the high cliff,
Koʻiawe ʻōliliko i ke kumu o lalo,	Sparkles brightly as it falls to the base below,
ʻUʻina pōhaku, nakolo wai ahu.	Rumbles on rocks, booms on the collecting water.
Ahuwale ka nolupē ulu lauaʻe,	The lauaʻe grove sways gracefully in the open,
Lau koʻiʻi i ka laʻi ʻehu wai lā ē.	Leaves kept fresh in the calm of the water spray.

The Larger Community Context

In 2006, Abraham Piʻianāiʻa was honored with a posthumous University of Hawaiʻi Regents Medal of Distinction Award.[14] Affectionately called Mr. P. by students, he was a University of Hawaiʻi at Mānoa geographer, teacher, and ocean explorer and one of the founders and first director of Mānoa's Hawaiian studies program in the late 1970s. A longtime friend of Mr. P.'s, University of Hawaiʻi at Mānoa professor of sociology Kiyoshi Ikeda e-mailed me one day asking if I would compose a mele inoa honoring his friend and colleague to be chanted at the award ceremony. Over the years while he was living, Mr. P. provided me with invaluable support, advice, and instruction—as a student in two University of Hawaiʻi at Mānoa geography courses he taught on the ship *Mariposa,* which sailed the South Pacific one summer; as a Hawaiian cultural representative in ceremonies held at the temple Taputapuātea on Raʻiātea; and as a graduate student seeking admission to the University of Washington, among many other undertakings. So I readily agreed to compose a mele in his honor. He had told me that his name—Piʻi-a-nā-iʻa, or Rise-of-the-fish—referred figuratively to warriors coming ashore from their canoes in a time of war. I

decided to compose a mele that played on fish names, the sounds of which resembled words that describe the many ways he had helped me and numerous others. He was the ulua who generated ulu, or inspiration in others; he was the 'ahi who ignited an ahi, or fire, passion, to burn within; he was the kūmū who helped to kuhikuhi, or point out potential paths in life, and so on. He left an indelible impression on the lives of so many. A mele inoa, this mele is an example of that evolving traditional form.

'O Ka Ulua 'Oe

Mele inoa for Mr. Abraham Pi'ianāi'a

'O ka ulua 'oe e ulu a'e ai ka hoi,
You are the ulua that inspires,

'O ke 'ahi 'oe e lapa ai ke ahi o loko,
You are the 'ahi that causes a fire to burn within,

'O ke kūmū 'oe e kuhikuhi mai i ke ala,
You are the kūmū that points out the path,

'O ka weke 'oe e wehewehe mai i ke ala,
You are the weke that opens up the path,

'O ka 'ama'ama 'oe e mālamalama ai ke ala,
You are the 'ama'ama that brings light to the path,

'O ka moano 'oe e manomano ai ka 'ike i ke ala,
You are the moano that brings great knowledge to the path,

'O ke ono 'oe e 'ono ai ke kole i ke ala,
You are the ono that makes exchanges so pleasant on the path,

'O ke kala 'oe e kala 'ia ai nā hemahema i ke ala,
You are the kala that ensures forgiveness of shortcomings on the path,

'O ka pua ho'i 'oe a nā i'a i pi'i i ka 'āina,
You are the progeny of fish who rose up onto the land,

I ke ala o ka pono o ka noho 'ana.
Who traveled over the path seeking justice and prosperity.

Ua noho mai 'oe, a ua pono ka lehulehu.
Because of the path of your life, we prosper.

Ua pono ho'i ka 'āina i ka Pi'i-a-nā-i'a!
Because of the Rise-of-the-fish, we are greatly blessed!

He inoa no Mr. P.
This is a name chant for Mr. P.

In early 1994, I was contacted by a representative of Dancing Cat Records, the production company of well-known pianist George Winston. The representative explained that Dancing Cat was about to release its first recording by the highly respected slack-key guitar and vocal artist Sonny Chillingworth. The company wanted to include in the liner notes a mele inoa honoring him that I had composed for the Second Annual Big Island Slack Key Guitar Festival, which was dedicated to Sonny and held in Hilo in 1991. I was happy to honor Sonny in that way and agreed without hesitation. The recording was released in 1994, the year Sonny passed away. Although I had composed the mele three years before, I had heard then of Sonny's battle with cancer. So, in addition to speaking about his ability to captivate people around the world with his prodigious musical talent, the end of the mele serves as a positive affirmation of the good health that everyone wished for him. Kamakou is the highest mountain on Moloka'i, where Sonny spent much of his youth and first began learning to play the slack-key guitar. A mele inoa, this mele is another example of that evolving traditional form.

'O 'Oe Ia E Sonny Chillingworth

Mele inoa for Sonny Chillingworth

'O 'oe ia e Sonny Chillingworth,	It is you, Sonny Chillingworth,
'O ke kupu'eu 'oe o ke kī hō'alu,	You, who are the wizard of the slack-key guitar,
Hoehoene ana me kahi hoa 'o ka leo,	Softly echoing its partner, your voice,
Ho'onanea ana ho'i i ka lehulehu.	Captivating the many who listen.
Hū wale mai nō ke aloha	Love wells up within
I ke keiki Hawai'i ka'ahele honua,	For the Hawaiian son who travels the world,
Honehone ana i nā kini o lāpana,	Creating sounds beautiful and appealing to the crowds in Japan,
Pa'ē ana i nā kupa o 'Eulopa.	Sounds resonating among the pressing throngs of distant Europe.
Ehuehu 'oe i ka la'i o Kamakou.	You are hale and hearty in the calm of Kamakou.
E kama 'ia ke aloha a pa'a	Love finds and envelops you

E ola loa nō ʻoe,	As you live long,
A kau i ka pūaneane.	Until the very extremity of life.
E ō mai i kou inoa,	Answer as you hear your name,
ʻO ke kupuʻeu ʻoe o ke kī	You, who are the wizard of the
hōʻalu.	slack-key guitar.

I knew that a dear friend, Norman ʻUmihulumakaokalani Naka-moto, had been in remission but was now once again fending off cancer. Norman had been a Catholic brother of the Carmelite Order, and in the mid-1970s, when we met in a hula class taught by noted kumu hula Kauʻi and Noenoe Zuttermeister, he was the executive director of the Catholic Youth Organization and living at the organization's Camp Hauʻula on the windward side of Oʻahu. Though my work in academia took me to Seattle and then to Hilo, we kept in touch over the years. So word from a mutual friend that he had died was not unexpected but was upsetting and saddening nonetheless. I was told that before his passing, Norman had planned his funeral, including the various parts of the service. He wanted me to chant "Māpu Ka Hanu," a mele we had learned during our training with the Zuttermeisters. I discussed the details with a niece of his who was coordinating the service and told her that, in addition to "Māpu Ka Hanu," I might also chant a mele kanikau, or a lament, for Norman. She thought that would be okay. On the day of the funeral, during the flight from Hilo to Hono-lulu, ideas for the kanikau flowed easily, and I wrote an English trans-lation without also writing out the Hawaiian. Norman's niece intro-duced me at the start of the funeral service and read the translation. After "Māpu Ka Hanu," I chanted the lament—spontaneously com-posed around the ideas I had formulated during the flight to Hono-lulu. The mele as presented is what I remember of it. Mele kanikau had become obsolete as Hawaiian-language knowledge and use de-clined; today, however, they are increasingly heard in this reemerging traditional form.

Kulukulu Ālia Paʻakai

Mele kanikau for Norman ʻUmihulumakaokalani Nakamoto

Kulukulu ālia paʻakai ka waimaka o mākou,	Our tears drip, drip, drip, water from encrusted salt ponds,
Kuʻu hoa o ka wā uʻi i kai o Hauʻula,	My friend of our youth on the beach at Hauʻula,

I ka home i kipa walea ai nā
 makamaka.
Makamaka 'ole ka hale e waiho
 wale maila.
Auē ke anu ē!
Ku'u hoa he pua, he mamo, he
 pulapula,
He lei hulu i ka 'ā'ī o nā
 kūpuna,
He pula kau i ka maka o nā
 loea.
Ua 'alo kāua i ka pai a ka leo,
I ke kuhi a ka lima,

I ka lelele a ka wāwae,
I ke kani a ka pahu.
Ua ha'alele akula 'oe—
Makamaka 'ole ka hale e waiho
 wale maila.
Auē ke anu ē!
Ua ha'alele akula 'oe i ka
 mehana o ka lā,
Ua ha'alele akula 'oe i ka 'ono
 o ka 'ai,
Ua ha'alele akula 'oe i ka pā o
 ka wai,
Ua ho'i akula 'oe i ke ao
 polohiwa a Kāne.
Ua pulu'elo akula 'oe i ke ala
 ho'i 'ole mai.
Makamaka 'ole ka hale e waiho
 wale maila.
Auē ke anu ē!
Auē nō kā ho'i ē!

At the home where friends
 visited and relaxed.
The house still stands but
 there's no one inside.
Oh, it feels so cold!
My friend—a well-loved
 descendant,
A feather lei worn around the
 necks of our ancestors,
A favored one affectionately
 nurtured by the masters.
We shared their exhortations,
Directing the gestures of our
 hands,
The positions of our feet,
The sounds of our instruments.
You've left—
And the house still stands but
 there's no one inside.
Oh, it feels so cold!
You've left behind the warmth
 of the sun,
You've left behind tasty delica-
 cies,
You've left behind sweet, cool
 water,
You've passed through the
 dark, wet clouds of Kāne.
Drenched, you make your way
 on the path of no return.
The house still stands but
 there's no one inside.
Oh, it feels so cold!
Oh, such grief!

The Family Context

In 1986, I took a semester's leave from my teaching position at the University of Hawai'i at Hilo to discuss progress on my doctoral dissertation with dissertation committee members at the University of Wash-

ington. While in Seattle, near the end of the semester, I received word that my grandmother had died. At ninety-seven years of age, she had lived a long, productive life, despite the difficulties of her final years caused by Alzheimer's disease. Family in Honolulu encouraged me to complete my work in Seattle, with assurances that Grandma's funeral would be held after I returned in three weeks. As tears fell, I immediately set about composing a mele reflecting briefly on three major phases of her life. The mele was sung at her funeral, but it falls short because I was, and continue to be, at a loss for adequate words to describe my debt and gratitude to her for so patiently and lovingly sharing her cherished first language with me those many years ago. The song can be considered a mele inoa or a mele kānaenae, a kind of poetic eulogy, both evolving traditional forms.

Wana'ao

Mele inoa/mele kānaenae for Annie Kalipo McCandless Silva

Wana'ao, ala a'e,	At dawn, you awakened,
Kahi kama lei aloha,	A beloved child,
He hi'ialo nō 'oe	Dear to the hearts
Na ka makua ē.	Of the elders.
Hui: Ua ho'i 'oe i ka home lani,	Chorus: You have returned to your heavenly home,
Ma laila nō e ola mau ai.	There to live life eternal.
Awakea, hana a'e,	At noon, you worked,
Kahi lei ha'aheo,	A proud woman,
He kumu pa'a nō 'oe	A firm foundation
No ka 'ohana ē.	For our family.
Ahiahi, maha a'e,	At dusk, you rested,
Kahi hulu kupuna,	A loved and respected grandmother,
He haipule nō 'oe	Serene in the worship
Na ke akua ē.	Of God.

In 2001, two days before my mother's eightieth birthday celebration, I decided to compose a mele inoa for her. Although the words came quickly, the tune did not, so on the evening of the birthday celebration, my nephew Jonathan sang the mele to the melody of the beautiful

standard also entitled "E Māmā Ē." Intelligent, warm, and gracious, my mother is the second-born of ten children and the first to be born in Hawaiʻi. I was always fascinated listening to her speak Cantonese with my grandparents, so much so that, for a couple of years as a child, I was allowed to attend Mung Lun Chinese School (after my regular school day) in downtown Honolulu. Mom retired after pursuing a successful career as an elementary school teacher and now, at ninety-two, continues to live independently in suburban Honolulu at our Salt Lake family home. A mele inoa, this is an example of that evolving traditional form.

E Māmā Ē

Mele inoa for Margaret Silva

E Māmā ē, kuʻu pua pakalana,	Mom, my fragrant Chinese violet,
Mōhala i ka ʻāina ʻo Hawaiʻi nei.	You blossom in our beloved land, Hawaiʻi.
E Māmā ē, paipai ʻoe,	Mom, with words of encouragement,
A lana kahi manaʻo pōpilikia.	You lift the burden of heavy spirits.
E Māmā ē, puʻuwai hāmama,	Mom, generous heart,
E lilo koke ai hua manakō.	Your mangoes are never long on the tree.
E Māmā ē, he akahai ʻoe,	Mom, modest, gentle, and unassuming,
I ke aloha o ke Akua Mau.	You reflect the love of our Eternal Father.
E Māmā ē, he hiwahiwa ʻoe,	Mom, so precious and esteemed,
He pouhana ʻoe no ka ʻohana nei.	You are our mainstay and our support.
E Māmā ē, kuʻu pua pakalana,	Mom, my fragrant Chinese violet,
E ola nō ʻoe a ola loa nō.	May your life be long and healthy.

Conclusion

As sociopolitical events of the nineteenth century led to the near death of the Hawaiian language in the twentieth century, the unthinkable, imminent loss of the first language of these islands propelled revital-

ization efforts that have seen measurable success over the past thirty years. Hawaiian is once again beginning to assert its importance in a wide variety of contexts in education, the physical environment, and the arts. The increasing availability of electronic Hawaiian-language sources from the nineteenth and twentieth centuries provides a strong foundation for current and future efforts to revitalize Hawaiian in its vernacular and poetic forms.

The majority of the ten mele I present here are examples of evolving traditional forms, though two—a mele heahea and a mele kanikau—are examples of reemerging traditional forms. The mele were composed for events within four contemporary contexts that reflect my own professional and personal interests; however, mele are being composed by others in a wide variety of contexts, including celestial navigation, seafaring, farming, kapa making, and the healing arts, among others. The increasing use of Hawaiian in poetry reflects the concomitant increasing strength of the vernacular and bodes well for the language's health in the coming years.

Notes

1. Though obviously not located in North America, Hawai'i is politically a part of the United States as its fiftieth state, so Hawaiian is included here among the indigenous languages of the United States.

2. This essay is based on the Marjorie Putnam Sinclair Edel Reading Series lecture I presented at the University of Hawai'i at Mānoa on April 21, 2011.

3. In 1896, a law passed under the Republic of Hawai'i required the exclusive use of English as the medium of instruction in public schools, making the use of Hawaiian in the schools illegal.

4. Of the thirty-two children, thirty were from families from Ni'ihau Island, as counted by Ni'ihauan Ilei Beniamina; the remaining two were the children of William H. ("Pila") Wilson and his wife, Kauanoe Kamanā—the first family outside of the Ni'ihau community to speak Hawaiian in the home in several decades.

5. Established as a nonprofit organization in 1983, the 'Aha Pūnana Leo currently oversees eleven Hawaiian-medium preschools located on five islands.

6. In late 2011, the World Indigenous Nations Higher Education Consortium secretariat was moved from Norway to Hawai'i.

7. Like the majority of Hawaiian children of my father's generation on O'ahu, he was raised hearing Hawaiian spoken between his parents, who, however, spoke to him and his siblings in English. A cousin of

my father's generation told me that he once overheard the manager of the Wai'anae Sugar Plantation, for which my grandfather worked as a machinist, tell my grandparents that they should speak English, and not Hawaiian, to their children. The manager made it clear that English, and not Hawaiian, was the language of success, a prevailing idea at the time.

8. My grandmother herself completed only a third-grade education because of her family responsibilities as the oldest of her siblings. She described how, while at school, she and her classmates had to be very careful not to speak Hawaiian, as they would be corporally punished for doing so.

9. The Kamehameha Schools were established in 1887 through the will of Princess Bernice Pauahi Bishop, which provided that students admitted preferably be of Hawaiian ancestry.

10. More formal than mele heahea and oftentimes precomposed, mele komo and mele kāhea—chants requesting and granting entrance, respectively—are recited in certain learning contexts (e.g., between students and teacher during hula training).

11. Several examples of such traditional mele pule have been recorded as used by hula practitioners in supplication to gods of the kuahu hula, or hula altar.

12. The college's full name, Ka Haka 'Ula O Ke'elikōlani, was composed by the college's professor Larry Kimura, who based the name on the proverbial saying "Ka haka 'ula a Kāne," or "The red [sacred] perch of Kāne." The saying is a figurative reference to a rainbow produced by the simultaneous appearance of two physical manifestations of the god Kāne as water and sunlight. In "Ka Haka 'Ula O Ke'elikōlani," the "red perch" figuratively refers to the venerable standard set by Princess Ke'elikōlani, who fully participated in nineteenth-century life through the valued language and culture of her ancestors—an estimable standard to emulate in the twenty-first century and beyond.

13. After Keola Lake's graduation, he opened his own school, Hālau Mele, and became a kumu hula of some note before his passing in 2008 at the age of seventy.

14. Mr. Pi'ianāi'a passed away in 2003 at the age of eighty-seven.

Works Cited

Hawaii General Superintendent of the Census. 1897. *Report of the General Superintendent of the Census, 1896*. Honolulu: Hawaiian Star Press.

Hinton, Leanne. 2001. "Language Revitalization: An Overview." In *The Green Book of Language Revitalization in Practice*, ed. Leanne Hinton and Ken Hale, 3–18. San Diego: Academic Press.

Kimura, Larry L. 2012. *He Kālailaina i ka Panina ʻŌlelo a ka Mānaleo Hawaiʻi: Ka Hoʻohālikelike ʻana i ka ʻŌlelo Mānaleo a nā Hanauna ʻElua, ʻo ka ʻŌlelo Kūmau a ka Makua a me ka ʻŌlelo Kūpaka a ke Keiki.* (Unpublished doctoral dissertation) University of Hawaiʻi at Hilo.

Krauss, Michael E. 1996. "Status of Native American Language Endangerment." In *Stabilizing Indigenous Language,* ed. Gina Cantoni, 16–40. Flagstaff: Northern Arizona University.

Nettle, Daniel, and Suzanne Romaine. 2000. *Vanishing Voices: The Extinction of the World's Languages.* Oxford: Oxford University Press.

Wilson, William H., and Kauanoe Kamanā. 2011. "Insights from Indigenous Language Immersion in Hawaiʻi." In *Immersion Education, Practices, Policies, Possibilities,* ed. Diane J. Tedick, Donna Christian, and Tara Williams Fortune, 36–49. Bristol: Multilingual Matters.

Un/Civilized Girls, Unruly Poems
Jully Makini (Solomon Islands)

SELINA TUSITALA MARSH

Civilized Girl

Cheap perfume
Six inch heels
Skin-tight pants
Civilized girl

Steel-wool hair
Fuzzy and stiff
Now soft as coconut husk
Held by a dozen clips

Charcoal-black skin
Painted red
Bushy eye-brows
Plucked and penciled

Who am I?
Melanesian Caucasian or
Half-caste?
Make up your mind

Where am I going—
Forward, backward, still?

What do I call myself—
Mrs Miss or Ms?

Why do I do this?
Imitation
What's wrong with it?
Civilization. (Sipolo 1981, 21)

Roviana Girl

Fine features
High cheekbones
Black as midnight
Blue-eyed and blonde
Tio—we are the same
Roviana all over.

Black and poor as I am,
Don't look down on me
My roots are bedded deep
on Roviana soil.

Brown-skinned or mulatto,
Imported blood
Slaves from headhunting days
Beach-comber and convicts
Flotsam and jetsam.

Sweet-talking our ancestors
Buying land with tobacco
and cheap trinkets
Now you buy me
with coffee and rice. (Sipolo 1986, 26)

"Civilized Girl," the title poem of Jully Makini's first collection of poetry, published in 1981 (Sipolo 1981)—the first by a Solomon Islands woman—is about a young urban-based Solomon Island girl questioning her identity. "Roviana Girl," published five years later in Makini's second collection, *Praying Parents* (Sipolo 1986), is about a village-based girl critiquing her changing society. In indigenous literature,

the urban-based civilized girl often serves as a trope for the ills of Westernization and colonization. She is implicitly contrasted with the traditional girl, who is based in the village and whose adherence to static traditional roles remains unquestioned (Irwin 1992). This traditional girl is seemingly typified in "Roviana Girl," but the girls in this poem are unruly and disrupt the stereotypes usually attributed to their kind. Their worlds are not as disparate as conveyed in patriarchal contexts, where male power brokers have a vested interest in keeping them apart and confined within masculinist paradigms. Indeed, key literary pieces published in the 1970s and 1980s indicate that the civilized girl is, more accurately, an indigenous masculinist trope used not only to critique Westernization, but also to curb any feminist urgings within or outside the community. Makini problematizes the trope of the much-maligned civilized girl and offers an alternative lens through which to view the realization of Solomon Islands independence. These two poems are used to examine Makini's poetic, gendered, postcolonial body as a site of contestation where conflicting forces of Westernization, tradition, and patriarchy battle for bodily dominance and ownership. Makini's poetry, the first published from a Solomon Islands woman's perspective, poses essential questions about personal identity formation that are also political and are aimed at the Solomon Islands nation.

Makini's first two collections reflect themes found throughout Pacific poetry in the late 1970s and early 1980s. They are anticolonial in sentiment, protest uncritical adoptions of Westernization and modernization, lament cultural losses, and deride neocolonialism. What set *Civilized Girl* apart was that at the time, it was one of a select few works (see Molisa 1983, 1987, 1989) that addressed the issue of double jeopardy (Davis 1981), the experience of both gender and race as simultaneous sources of discriminatory social and political practices. "Civilized Girl" is a case in point. As a generic Melanesian ("Charcoal-black skin"), the poetic persona has been subject to the civilizing mission of the West and its resultant colonization in the form of a British protectorate since 1893. As a "girl," she is subject to a type of oppressive patriarchy commonly exacerbated by colonialism (Jolly and Macintyre). Makini, along with other educated, creative, political, vocal, and visible Pacific women, have themselves faced this kind of double jeopardy in their quest for equal value in their newly independent societies (Care 2000; Irwin 1992; Jolly 1987, 1994; Kii 1992; Molisa 1983, 1987, 1989; Scheyvens 1995, 2003; Slatter 1980; Tongamoa 1988).

More than three decades later, Makini remains the only Solomon Islands woman to be the sole author of published poetry collections. Her work is significant in its difference in that it proffers a woman's perspective on development and modernity and examines patriarchy as well. Romantic invocations of the past common in poetry in the 1980s (Maka'a and Oxenham) are absent in Makini's work. Instead, searing critiques of the present are offered from a woman's perspective. Makini's first two collections are filled with poems concerned with physical and mental violence against women, predominantly within the context of marriage. In *Civilized Girl* these include "The Hypocrite," "Marriage," "A Man's World," "The Promise," "Spinning," and "Temperamental Man," and in *Praying Parents,* "Wife-Bashing," "After 5 Kids," "Husbands," "Widow's Thoughts," and "Anti-Climax." In both volumes, there is a strong emphasis on analyzing the plight of women who have been deceived, mistreated, repressed, silenced, and abused physically and emotionally.

"Civilized Girl," one of Makini's best-known poems, departs from the popular oppositional politics of the early 1970s, which romanticized indigenous traditions and vilified the colonizing West. It explores what happens when the indigenous female body encounters different influences as an effect of colonization. At the center of the poem is a young urban girl negotiating Western influences physically, mentally, and emotionally as she attempts to define herself in light of these competing forces. The poem poses questions about the changing nature of identity rather than stating black-and-white answers.

There are two speaking voices in the poem, divisible by a change in tone, poetic technique, and theme. The initial speaking voice, predominantly heard in the first half of the poem, is aligned with traditional, mainstream society—one that clings to a culture perceived as pure and unchanging. Its use of the third person conveys a distanced, impersonal, and authoritative tone. The structured uniformity of meter and rhyme with its resonating assonance in the first stanza alongside the short, terse, single-syllabic masculine ending lines reflects this tone and conveys objectivity and judgment. The mechanical rigidity of the first stanza reinforces that this is the voice of truth, leaving little room for other interpretations of this body.

The voyeuristic objectification of the girl in the first three stanzas suggests a more masculine voice. Her body reads like an inventory of Western femininity. Unnamed, she wears perfume, seductive clothing, high-heeled shoes, and heavy makeup—stereotypical accoutrements of

the sexually available, loose woman. Her perfume is "cheap." As the first word of the poem, it colors the remaining description, reducing the woman not only to a sexual object but also to a commercial one with cumulative overtones of prostitution. Metaphorically, she, and by extension the Solomon Islands, is open to a foreign penetration that controls her image; she figuratively pimps her indigenous self. Her once "Steel-wool hair / Fuzzy and stiff" is tamed into place ("Held by a dozen clips") while her natural "Bushy eye-brows" are "Plucked and penciled." The manipulation of her image suggests outside control even to the point where her blackness—that primary Melanesian signifier—is read over (her "Charcoal-black skin" is "Painted red"), a color evoking sexual licentiousness. The objective voice producing the loaded descriptions in the first half of the poem views this anonymous indigenous body as being controlled, erased, or obscured by the process of civilization and corrupted by Westernization.

It could be argued that this voice speaks from a patriarchal need to petrify the role of women in society, appealing to unchanging perceptions of what constitutes tradition and *kastom* (Irwin 1992). It cannot cope with the new woman of the postcolonial 1980s, influenced by Western culture, driven by ideas of independence, autonomy, and the associated freedoms and responsibilities that arise from partaking in the rapidly growing urban cash-based economy (Wulff 1994). Change, unstable and unpredictable, is perceived as dangerous. As such, bodily and (as evident in the second half of the poem) psychological metamorphoses of this type must be controlled. Here, control is exerted by attempting to discredit, negate, and stereotype the growing breed of urban indigenous woman who may question traditional norms surrounding the role of woman. The first voice in the poem attempts to control this image by paralyzing the girl, robbing her of movement and vitality. She is described as if she were a two-dimensional picture— parts of a whole that the reader must piece together. In stanzas 3, 4, and 5, her psyche also seems split as she tries to make up her own mind about her identity.

But the voyeuristic objectification of this girl is not the only means that society uses to control her. The act of naming is fraught with issues of power. The girl is anonymous except for the foreign noun "civilization"/adjective "civilized," evoking her colonial history, or her indigenous un-history. The word "civilized" connotes a particularly devastating racist ideology that has affected colonized people throughout the globe. The idea of civilization motivated zealous missionaries and provided a

justification for colonial conquest; it offered a rationale for infiltration and eventual physical, psychological, and spiritual domination of indigenous cultures (Edmund 1997; Langmore 1989). The *Concise Oxford Dictionary of Current English* (Allen 1990) defines civilization as "an advanced stage or systems of social development." Implicit in this meaning is a Western worldview in which a linear time frame of progressive development also aligns with moral and social development. In this definition, non-Western, nonindustrialized peoples are viewed as inferior and in need of civilizing. Consequently, to civilize means to "bring out of a barbarous or primitive stage of society . . . enlighten; refine and educate," and "to cause to improve from a savage or primitive stage of human society to a more developed one" (Hawkins 1988, 144). At the same time, civilization (with its desirable material and ideological developments) has been strategically sought by many Pacific leaders. The word "civilized" is a site of contested meaning, particularly in the Solomon Islands after two hundred years of foreign contact. As the first word of the title, and the final word of the poem, "civilized"/"civilizaton" is the frame through which we are made to view the girl at the center. But is there any room for irony?

If the voice of the first three stanzas is the same as that in the last three stanzas, the poem may be read as continuing its mockery of her disembodied image and publicly exposing the identity crisis inherent in one who seems to have adopted Western influences uncritically. Her confusion is publicly paraded, as is her prostituted self. In this light, endeavoring to be civilized is read as causing cultural, gendered, social, and mental schizophrenia. To aim to be civilized in this context is to recolonize the indigenous self: self-definition will always be foreign and will always define the indigenous self as inferior.

If the word "civilization" is used ironically, the tone of the speaking voice is sarcastic as it mocks the aping of Western ways. For the colonial agenda of civilization, the effects of such imitation were not to ensure the native equal status with the colonizer, but to create assimilated citizens of the nation who were, in Homi Bhabha's (1994) words, "in the ambivalent world of the 'not quite/not white'" (92). The short, clipped, metrical beat and the tight rhythmical structure (particularly in the first stanza) reinforce a sharp tone of scorn. Society implicitly derides the loss of indigenous innocence and cultural purity as it focuses on the corrupted body of this girl overwhelmed by Western symbolism. The last couplet, noting the mimicry of Western mannerisms and appearances, is thus read as a powerful rhetorical question "What's

wrong with it?" The answer clearly views civilization as a recolonizing form of ideology.

However, if the voice throughout the poem is that of the girl herself, and due to an uncritical adoption of Western influences she has accepted this imposed label laden with these particular meanings, then the poem reveals the girl to be deluded by a racist ideology. She has, in bell hooks' terms, "internalized with supremacist values and aesthetics, a way of looking and seeing the world that negates her value" (1992, 3). From this perspective the poem might be read as a critique of the false image sought by Pacific peoples who fall into the Eurocentric trap of believing that beforehand they were not civilized.

What is also implied by the objective voice (read as that of traditional society) is that there is no other way to see this woman—and the rapidly Westernizing nation of the Solomons—than as a transgressor in the process of violating the indigenous body. Being civilized means to embody the foreign and the different; to be singular ("girl") and separate from the community; to become part of a capitalist society where indigenous identity is part of a system of economic exchange; and/or to undergo an identity crisis. The implied frame of reference is the traditional, true Solomon Islands woman, who, by contrast, is modestly clothed, desexualized (except for the purpose of procreation), invisible, and constant. Seen as crossing the boundaries set by traditional society, this girl is labeled as civilized (she does not call herself this). She is set apart from traditional society, from the land and history, and from a "true" indigenous identity, and as expressed in the last stanza, viewed as fake, an "imitation." She is a transgressing girl and, more dangerously, a would-be transgressive woman.

The image of transgression, however, always casts a shadow of subversion. A small but important detail in the poem renders this romanticized past (and the reading explored previously) problematical. The description of the girl's hair as once "Steel-wool hair / Fuzzy and stiff / Now soft as coconut husk / Held by a dozen clips" poses an oppositional before-and-after scenario in which the indigenous self, initially represented as pure and unadulterated, is corrupted, controlled, reinforced, and weakened. The use of the post-contact adjective "steel-wool" to describe her hair connects with the steel of the clips used to tie it back. At the same time, the now Western-styled hair is described with distinctly indigenous imagery ("soft as coconut husk"). The language problematizes a before/traditional–after/Western binary commonly found in early Pacific literature, particularly poetry. It suggests that

foreign influences have been actively and strategically negotiated in island societies throughout its history in varying degrees.

Furthermore (as suggested earlier), another voice is apparent in the poem, or at least emerges in its second half—that of the girl herself. She may not necessarily be the sellout that she first appears, or is framed as being. An alternative reading of the poem views this girl as vitally transitional, rather than transgressive. This civilized girl is someone who validates a new stage of growth in the Solomon Islands: the emergence of educated, opinionated, strong indigenous women in a postcolonial context—much like Makini herself.

If the entire poem is in the voice of the girl, a complex psychological reading is possible. Perhaps the girl is critically assessing herself in the mirror, glorying in her refusal of a name, provocatively straddling her multiple selves, and negotiating her image and identity. From this perspective, line 16 could be read as an insolent challenge to society to define her, as she impatiently demands, "Make up your mind." The last stanza may illustrate the anxiety inherent in the schizophrenic nature of postcolonialism, as the civilized girl endeavors to come to terms with two very different, often conflicting cultures.

The change in tone, technique, and meter halfway through the poem suggests the presence of two voices. Unlike the first voice, that of traditional society (closed, authoritative, judgmental, male, and static), the second voice, in the second half of the poem, is open, explorative, overtly female, and transitional. The poem thus provides a balance between outside/inside and societal/individual views, most apparent in the change of voice from the third to the first person. As previously noted, in the first half of the poem, the girl is paralyzed by outside, superficial, societal judgments. But even in the second stanza, the structured meter of the first stanza (the 3-3-3-4 syllabic pattern with its domineering trochaic beat) begins to break down and deviates into less predictable syllabic patterns (3-4-7-6). The last two lines loosen the metrical rigidity and control in the previous lines. The unpredictability continues in the third stanza, with its downbeat feminine line endings, "eye-brows" and "penciled." The imagery of plucking and penciling evokes notions of control, manipulation, and pain, a filling in and a drawing over. This technical loss of control foreshadows the impending confusion and open-endedness of the second half of the poem, when the mixed meanings of the girl's body are explored as the civilized girl speaks.

Although we hear the girl's voice in the second half of the poem, the judgmental voice resurfaces in the fourth and sixth stanzas, again

differentiated by meter, rhythm, and tone. The voice demands an immediate answer ("Make up your mind") to the girl's question "Who am I?" and her uncertain articulation of options: "Melanesian Caucasian or / Half-caste?" The girl, from this perspective, might be read as negotiating her identity and exploring her options. The final stanza is similarly ambiguous. Whether the girl actually believes the proffered answers to her questions (whether they are her own or society's) is debatable. Perhaps the uncertainty is deliberate. What is important is the critical challenge—the two voices of society and individual must negotiate not only their own identities, but also their very relationship.

Notably, the voice of the girl at the center of the poem never actually claims the label "civilized" for herself. It is a label used by others to describe a modern Solomon Islands woman who, by daring to incorporate difference, is implicitly compared and judged against a traditional girl. However, what society describes in derogatory terms as "civilized" may also be interpreted as an active embracing of the new, the foreign, and the different. Educated Pacific women are particularly prone to such societal judgments, including the demeaning sexual labeling apparent in the poem. The double jeopardy faced by indigenous women may well be at the core of the poem. Not only do indigenous women have to work their way through a colonial education that is both Eurocentric and androcentric, but they must also return to a society that is generally patriarchal in nature and often sexist in behavior.

Several other literary examples starkly convey this notion. An anonymous poem published in the *Kakamora Reporter* in 1972, "Cover Up Your Tits," bluntly conflates any form of Westernization adopted by Melanesian women with overt sexuality, promiscuity, and loss of indigenous identity:

> Tell those girls to cover up their tits.
> Not the real ones,
> Not the true girls.
> Tell those girls to cover up their tits—
> the girls who dream of maiden forms.
> Tell them whiter than white
> means not really, not quite.
> Tell them women's lib
> Melanesian style
> Means
> Cover up those tits.

Sex
Western Style
Means "to tease,"
So tell those girls to cover up their tits.
And remember what they used to be.
 ("Cover Up Your Tits"
 1972, 7–8)

Less direct, although still conflating national corruption with fe-
male debauchery, the following year Ni-Vanuatu poet Albert Leomala's
"Woman" (25) appeared in *Some Modern Poetry from the New Hebrides*.
"Woman" comes after the poem "How Is It Brothers" (23), which pro-
tests the presence of land-grabbing white men, and before "Culture, My
Culture" (26, 27), which laments the loss of culture with Westerniza-
tion. "Woman" is reproduced here in part:

during the day
she wears a
multicoloured mini
paints her lips
red
and her eyelids
black
combs her hair properly
and wears a
yellow hibiscus flower

at night
she throws away
her dress
and lies down naked

her body
becoming slippery with sweat
and she wrinkles
like an earthworm.

In 1980, John Saunana's *The Alternative,* the first Solomon Islands
novel, captured this discriminatory voyeurism, condescension, and
power play at work in much the same way as "Civilized Girl." The pupils

at Maduru's secondary school share stories of mythic proportions about how education culturally and morally corrupts girls:

> When the girls returned, it was said, they would snub their traditional way of life and bring shame on their people. Indeed, some girls had returned to their villages after a few years in New Zealand and, according to the stories, had even forgotten what bananas or yams were! There were actual cases, so it was said, where girls had even forgotten their language. One of Maduru's friends told the story of a particular girl who had ridiculed her father . . . She was all in her best. Complete with the usual fancy stuff—lipstick, hairdo, and high heels—the kind of thing you'd expect to see in Wellington or expensive restaurants in the heart of Kings Cross . . . swaying her hips all the while. (53)

Only girls are susceptible to this type of cultural amnesia when exposed to Western education. Only girls are obliged not to let education change them. The Western accoutrements of "lipstick, hairdo, and high heels" are associated with the foreign and the debauched. Mention of the infamous red-light district of King's Cross, along with the sexually provocative behavior of the woman, again casts the educated woman as prostitute. In this context, education for girls is seen as a foreign and dangerous difference.

That same year, the landmark Pacific anthology *Lali* was published. Papua New Guinean poet Das Mapun's *"O Meri Wantok"* ("Oh Woman of My People") appeared in both pidgin and English and continued in the steps of his fellow Melanesian poets by sexualizing the Westernized indigenous female body (206). The fifth stanza laments:

> Oh woman of my people
> Before your lips were brown
> Now your lips are red
> Before your hair grew high and free
> Now it's all crimped down
> Before your breasts hung soft and loose
> Now they stand out tight and hard.
> You look into the mirror and you say
> "The price is twenty dollars a go!"
> Oh woman of my people I am sad for you. (206–208)

Difference as threat can be seen in "Civilized Girl." The girl is shown reformulating her identity in a new social context. She is viewed as an individual and separate from any community. The questions in the latter half of the poem might be read not simply as anxious confusion but as a self-led exploration and a demonstration of the freedom she has to choose her own identity. She is not accountable to anyone and is free to image and imagine herself, deciding what she will expose or conceal (her legs and hips in skin-tight pants), and what she will shape (her eye-brows) and accentuate (her lips).

Both social and individual concepts of civilization are apparent in the poem, for the girl is both an object of derision and an object of desire. As such, the use of the word "civilized" is deliberately ambiguous, reflecting its interpretation in the island's context. Like the term "development," "civilization" is both spurned and desired. In Makini's poem "Development" (Sipolo 1986, 3), the speaker berates the culturally eroding effects of Western development on indigenous people for almost the entire poem, yet in the final line, anxious about being left behind, she cries out, "I want to develop too!" On one hand, Pacific peoples are anxious to embrace and indigenize certain introductions from the West; on the other hand, they are faced with the erosion of older cultural values. While Makini's poem warns against an unquestioning, uncritical acceptance of things foreign, it does not argue for a total rejection of difference. The answer to the poem's last question ("What's wrong with it? / Civilization!") can be read both as a celebration of the adoption of foreign difference and as a condemnation of it. The girl's body—and the Solomon Islands nation—incorporates both possibilities: it must cope with the inevitable changes while her identity must reflect the changing nature of her society in order for her to move forward.

Makini's "Other" Woman: "Roviana Girl"

Unlike "Civilized Girl," "Roviana Girl" poses no questions. The poem reads as present-continuous statements conveying a certainty lacking in "Civilized Girl." As in the former poem, the first three lines begin with an impersonal rhythmic description of the female body. However, the description in this poem is positive, reaffirming, and specifically Melanesian. This "Roviana Girl" knows her identity and embraces both Melanesian ("black as midnight") and European ("blue-eyed and blonde") mixed blood. This mix is reflected briefly in the language of line 5, which merges English with Roviana dialect: "Tio—we are the

same / Roviana all over." Just like that moment of heteroglossia in the poem's language, identity differences are incorporated into a sameness that is rooted in the land.

Roviana is clan land. It is steeped in historical reference to ancestors and their early contact with Europeans. Here, identity is defined by relationship to the land and to the clan. In contrast, the civilized girl is part of an urban drift, landless, and, consequently, must forge her own identity. The apparent cultural schizophrenia experienced by the civilized girl may also be a consequence of her rootlessness. Her search for identity may seem hollow and, like the voyeuristic description of her in the first three stanzas, superficial. The earlier poem is silent on the issue of land, whereas the girl in "Roviana Girl" is overtly identified by land, as it is the primary frame of reference given for her in the title. Unlike her more glamorous sister, Roviana girl is "black and poor," but her strength, integrity, and raised consciousness are as deep-rooted as her identity: "Don't look down on me / My roots are bedded deep / on Roviana soil." Her humble appearance contrasts with that of the civilized girl. The material poverty of the Roviana girl is compensated by the source of her personal security established in the first two stanzas. Unlike the dislocated, urbanized civilized girl, this girl is a part of a grounded rural mass in which identity is informed by land and its history.

The consciousness of the Roviana girl is more developed than that of her urban sister, who is still at the point of questioning. With a nod to colonial contact that began in 1568 with Spanish explorers, escalating by the mid-nineteenth century with more frequent contact from explorers, adventurers, whalers, traders, missionaries, and colonists (Alaisa and Laracy 1989; Maenu'u 1984), the reference to "flotsam and jetsam" is a telling metaphor. This is followed by a line noting foreign impact on her people with mention of racial categories commonly applied to locate and identify the "Other": "brown-skinned," "mulatto" off-spring, and "imported blood." Again, Makini subverts the norm of the binary indigenous/colonial oppression. The reference to "slaves from headhunting days" is an important acknowledgment of the presence of pre-contact "war, disease and confusion" so strongly denied by the speaker in another poem, "Spinning" (Sipolo 1981). Makini's acknowledgment of pre-contact, intercultural conflict points to the dynamism of a culture that was continually subject to change and transition, and the third stanza reads like an exposé of clan-based infiltration that occurred, not just because of foreign contact, but because of intercultural, land-based, clan-affiliated rivalries and allegiances (Alaisa 1989, 138; Wasuka et al. 1989, 99;).

The last stanza foreshadows the identity crisis in "Civilized Girl," emphasizing the importance of land- and clan-based identity. The exploitative economic exchange of land for "tobacco / and cheap trinkets" in the past is reproduced in the present—except that this time, the product being bought is a people's identity: "Now you buy me." The terms of exchange are food items, seemingly innocent trade-offs when compared to the previously mentioned inequity of trading land for trinkets. However, food is fundamental to human sustenance and with increasing dependence on imported goods, genuine independence is threatened. As the economic term "buy" suggests, dependency on foreign goods is merely another form of slavery.

There is no happy ending in this poem. In a present-continuous voice the final stanza soberly states what is currently occurring. The future remains uncertain. What is certain, and perhaps germinates our kernel of hope, is that the Roviana girl is articulate about the present and past, proudly maintaining her indigeneity. This poem offers a response to the implicit demands made in "Civilized Girl": that we name, locate, and question ourselves. The Roviana girl is identified as "black and poor," but her blackness incorporates regional, clan-based, and foreign differences and influences, primarily because she is located in the land, thus able to name herself as "Roviana all over," a description that connotes her completeness. The Roviana girl names and locates herself in order to guard herself and her culture against the erosion of a dynamic cultural identity.

Makini presents two unruly girls who refuse to submit to disempowering stereotypes. I have placed them in conversation: with themselves, with each other, and with their nation. Makini's feminism is specifically a Pacific feminism. Her message of emancipation is aimed not only at women, but also at the wider Pacific Islands community (Griffen 1985). The gendered body in her poetry serves as a trope for the postcolonial Pacific Islands nation—specifically that of the Solomon Islands. Makini's poetry posits that the personal and political body must be seen as transitional and embraced, rather than as transgressive and judged; it must negotiate difference rather than be uncritically rejected from some purist cultural basis. Like these bodies, the "nation" is a contested site of meaning that must indigenously negotiate Westernization, development, the cash economy, politics, an increasing urban drift, and involvement in the global community. Makini's sense of cultural heterogeneity and specificity emphasizes that nationhood is an imposed ideology, a product of colonialism. This partly accounts for

the difficulty involved in moving a nation toward independence and into a supposedly postcolonial era. The convergence of the female and the national postcolonial body is indicated by the anonymity of the girl. In this sense, Makini critiques the unquestioning adoption, not just of the Western trope of femininity, but of all things Western that have the potential to corrupt, confine, and plunge the nation of the Solomon Islands into an identity crisis. The answer to how this new nation might move forward lies in the critical questioning at the heart of "Civilized Girl." The poem artfully represents a postcolonial Solomon Islands girl in the act of reclaiming her body and negotiating her identity. That act is also required of the national body, which, even after three decades of independence, must keep asking itself "Who am I?" "Where am I going?" and "Why do I do this?" And all citizens must answer. Both "Civilized Girl" and "Roviana Girl" point to the need for women to adapt and change in order to maintain power in a contemporary, continually changing Solomon Islands society, and implicitly, for men to pay heed. These unruly civilized and traditional girls, urban and rural based, must talk to each other in order to realize meaningful personal and political independence.

Works Cited

Alaisa, Sam. 1989. "Politics." In *Ples Blong Iumi: Solomon Islands, The Past Four Thousand Years,* ed. Sam Alaisa and Hugh Laracy, 137–151. Suva, Fiji: Institute of Pacific Studies, University of the South Pacific.

Alaisa, Sam, and Hugh Laracy, eds. 1989. *Ples Blong Iumi: Solomon Islands, The Past Four Thousand Years.* Suva, Fiji: Institute of Pacific Studies, University of the South Pacific.

Allen, R. E., ed. 1990. *Concise Oxford Dictionary of Current English.* Oxford: Clarendon Press.

Bhabha, Homi. 1994. *The Location of Culture.* London: Routledge.

Care, J. Corrin. 2000. "Customary Law and Women's Rights in Solomon Islands." *Development Bulletin* 51:20–22.

"Cover Up Your Tits." 1972. *Kakamora Reporter,* August, 7–8.

Davis, Angela. 1981. *Women, Race and Class.* New York: Random House.

Edmund, Rod. 1997. *Representing the South Pacific: Colonial Discourse from Cook to Gauguin.* Cambridge: Cambridge University Press.

Griffen, Arlene. 1985. "The Different Drum: A Feminist Critique of Selected Works from the New Literature in English from the South Pacific." MA thesis, University of London.

Hawkins, Joyce M., comp. 1988. *Oxford Paperback Dictionary.* 3rd ed. Oxford: Oxford University Press.

hooks, bell. 1992. *Black Looks: Race and Representation.* Boston: South End Press.

Irwin, Kathie. 1992. "Towards Theories of Maori Feminism." In *Feminist Voices: Women's Studies Texts for Aotearoa/New Zealand,* ed. Rosemary Du Plessis, Phillida Bunkle, Kathie Irwin, et al., 1–21. Auckland, New Zealand: Oxford University Press.

Jolly, Margaret. 1987. "The Chimera of Equality in Melanesia." *Mankind* 17, no. 2:168–183.

———. 1994. "Introduction: Gender Relations Project. The Australian National University." *Taja* 5, nos. 1–2:1–10.

Jolly, Margaret, and Martha Macintyre. 1989. *Family and Gender in the Pacific: Domestic Contradictions and the Colonial Impact,* 7–9. Cambridge; New York: Cambridge University Press.

Kii, Hilda. 1992. "Women and Education." In *Independence, Dependence, Interdependence: The First 10 Years of Solomon Islands Independence,* ed. Ron Crocombe and Esau Tuza, 150–151. Honiara: IPS, USP, SICHE (Solomon Islands College of Higher Education).

Langmore, Diane. 1989. "The Object Lesson of a Civilized, Christian Home." In *Family and Gender in the Pacific: Domestic Contradictions and the Colonial Impact,* ed. Margaret Jolly and Martha Macintyre 84–94. Cambridge: Cambridge University Press.

Leomala, Albert. 1975. "Woman." In *Some Modern Poetry from the New Hebrides,* ed. Albert Wendt. Suva, Fiji: Mana Publications.

Liki, Asenati. 2010. "Women Leaders and Solomon Islands Public Service: A Personal and Scholarly Reflection." Discussion paper. *State, Society and Governance in Melanesia,* January. http://ips.cap.anu.edu.au/sites/default/files/2010_01_liki.pdf. Accessed September 4, 2011.

Maenu'u, Leonard, ed. 1984. *Self Rule in Melanesia.* Honiara, Solomon Islands: Government Printery.

Maka'a, Julian, and Stephen Oxenham. 1985. "The Voice in the Shadow: A Survey of Writing in Solomon Islands." In *Pacific Quarterly Moana: An International Review of Arts and Ideas,* ed. Julian Maka'a, 5–13. Hamilton, New Zealand: Outrigger Publishers.

Mapun, Das. 1980. *"O Meri Wantok"* ("Oh Woman of My People"). In *Lali: A Pacific Anthology,* ed. Albert Wendt, 206–208. Auckland, New Zealand: Longman Paul.

Molisa, Grace Mera. 1983. *Black Stone.* Port Vila, Vanuatu: Blackstone Publications.

———. 1987. *Colonized People.* Port Vila, Vanuatu: Black Stone Publications.

———. 1989. *Black Stone II: Poems.* Port Vila, Vanuatu: Black Stone Publications and Vanuatu USP Centre.

Saunana, John. 1980. *The Alternative.* Honiara, Solomon Islands: USP in association with SPCAS and IPS.

Scheyvens, Regina. 1995. "A Quiet Revolution: Strategies for the Empowerment and Development of Rural Women in the Solomon Islands." MA thesis, University of Massey.

———. 2003. "Church Women's Groups and the Empowerment of Women in Solomon Islands." *Oceania* 74:44–60.

Sipolo, Jully. 1981. *Civilized Girl*. Honiara: USP, Solomon Islands Centre in association with SPCAS.

———. 1986. *Praying Parents: A Second Collection of Poems*. Honiara, Solomon Islands: Aruligo Book Centre.

Slatter, Clair. 1980. "Women in Development: Some Preliminary Findings." *'O'O: A Journal of Solomon Islands Studies* 1, nos. 1–2:119–128.

Tongamoa, Taiamoni, ed. 1988. *Pacific Women: Roles of Status of Women in Pacific Societies*. Fiji: IPS, USP.

Waleanisia, Joseph. 1989. "Writing I." In *Ples Blong Iumi: Solomon Islands, The Past Four Thousand Years*, ed. Sam Alaisa and Hugh Laracy, 31–46. Suva, Fiji: Institute of Pacific Studies, University of the South Pacific.

Wasuka, Moffat, with Toswell LAua and Simeon Butu. 1989. "Education." In *Ples Blong Iumi: Solomon Islands, The Past Four Thousand Years*, ed. Sam Alaisa and Hugh Laracy, 94–111. Suva, Fiji: Institute of Pacific Studies, University of the South Pacific.

Wulff, Stuart. 1994. "Solomons Group Promotes Employment and Cultural Pride." *Tok Blong Pasifik: A Quarterly of News and Views on the Pacific Islands* 48.

The Fisherman

MICHAEL PULELOA

THERE'S A COMMUNITY MEETING at the Kulana ʻŌiwi hālau in Kalamaʻula. It's a big one. There's going to be a presentation on the vacant property makai of Kaunakakai Town, on a development project, and many people from across the island show up because they don't like the word. Development. There's a popular bumper sticker on the island, in fact, that reads, "Don't change Molokaʻi. Let Molokaʻi change you." And local people take this to heart.

When Auntie Girlie, a longtime community leader and the facilitator of this meeting, begins her PowerPoint slideshow, she says the plans are to extend the cultural park near the shoreline so that it runs right up to the highway, to improve access roads, and to repopulate the area with native trees and undergrowth. New hālau will be built for public gatherings, for storing canoes and paddleboards. There'll be a pā hula and field for the annual Makahiki.

Some of the attendees stand up and quietly file out of the hālau. They've heard enough, and the fact that they're leaving means: (1) they support the project without having to hear any more; or (2) they've just realized they're in the wrong place—wrong community meeting.

In the remaining crowd, there are still people from all over Molokaʻi: east enders and west enders, south siders and north siders. It's a community meeting, so it's a diverse bunch. Homegrowns and transplants. Hawaiians and haoles. Everything in between. Old-timers. Teenagers. Mommas and poppas and infants. After the first wave of them leaves, there are still some forced to stand at the outer edges of the hālau. There just isn't enough room for everyone.

Auntie Girlie has some remarkable digitized black-and-white photos of Kaunakakai. Most are from state libraries and archives, but some, she says, are hers. There are photos of stoic kings and queens. Photos of children playing in the empty street. Young men and women leaning on cars. She has aerial photos, too. But the one I like the most—the one that stays with me long after I've left the hālau—is of a man standing on the Kaunakakai shoreline with his back to the camera, facing the ocean and a white sky.

It's an action photo. He's throwing net. His arms are out and his net is a faint web suspended like a gray cloud in the air. There's something about the photo that's incredibly striking, but as I sit there and listen to Auntie Girlie's rendition of Kaunakakai's past, I don't know what it is. Auntie Girlie says she took the picture with her first camera. An Argus, she says, in 1939.

———

The meeting lasts for nearly two hours and finally ends after most of the people have left for home. I'm the youngest one left. Twenty-two. And trying to find my place on the island now that I'm home from school. The last four months have been tough. Restless. My friends have moved away—to O'ahu or Maui or the continental United States—for work. And none of them seem to have come back yet. I'm an only child. And without my friends here, it's easy to see how much the island's changed since I left for O'ahu.

I have a bachelor's degree in urban planning from the University of Hawai'i at Mānoa, but no practical experience yet. I work for the county now, Parks and Recreation, a good job, but not something I want to do forever.

I'm not a blood relative of Auntie Girlie's, but she's like an auntie to me. She's like an auntie to many of my generation. We remember her from elementary school and the Kūpuna in the Schools Project. Back then, she was only a little more than forty, but she was already a grandmother of two. She used to joke about that. The fact that her daughter having keiki at such a young age turned out to be a blessing in disguise. "Now they pay me to tell stories," she'd say. And we all laughed with her.

After elementary school, Auntie Girlie followed us up to intermediate and high school, where we went by the busload on field trips to special sites across the island. Heiau. Fishponds. Sacred stones. She

knew everything about them, enough to teach me more about Moloka'i than anyone else.

Auntie Girlie is a great storyteller. When we were kids, she captivated us when she told us about Moloka'i things. We sat still for nearly an hour on Kūpuna Day. And short of a fire drill, there was nothing—absolutely nothing—that distracted us when she spoke at the front of the class. I know this is hard to believe. I was a TA in college, so I've seen what it's like when students—adults, even—have to sit for extended periods.

But it's true. Auntie Girlie can tell a great story.

I wait for her as the remaining attendees circle around her in the hālau to thank her. It's a quiet, calm night, and I hear them say how excited they are about the cultural park, how grateful they are to have seen her photos. There are cars and trucks pulling out of the parking lot. It's much later than we anticipated being here, but no one that's still at the hālau wants to let her go. And it seems, from where I'm standing and watching them, that Auntie Girlie is perfectly fine. She doesn't mind listening or sharing, even if it's clearly time for us to stack up the folding chairs and shut the lights in the hālau.

The time alone gives me the opportunity to think about the photograph. The man and his net. His 'upena kiloi. I've seen the picture before. I'm sure of it. It's a searing image, perfectly framed. He's standing just left of center and the net takes up the right side. Just thinking about it brings sweat to my palms. It's a moment of possibility. There's something important about to happen. And I begin to wish I was there, right beside him, when all of a sudden I know what it is.

I've stood in Auntie Girlie's place. I've taken this picture. Not in Kaunakakai, not a black-and-white, but everything else is exactly the same.

I need to get home and find it. I need to show it to Auntie Girlie.

All the chairs have been stacked and there are two people left, so I walk up behind them shuffling my slippers on the concrete floor. I look down at my watch before they turn their attention from Auntie Girlie, and when they do, like clockwork, they turn back and say thanks again, but it's getting late, they should let her get home.

When they leave, Auntie Girlie gives me a smile. "Nice one, boy," she says. "Not very subtle, but nice." Then she points to the box full of AV equipment and the laptop backpack. "Try grab Auntie's stuffs."

"'Kay," I tell her. "The truck's by the preschool."

I follow her to the back of the hālau, where she turns off the lights. "Maikaʻi," she says.

I've got the backpack on. I'm carrying the box. But I manage to reach into my pocket and grab my keys. There's a little flashlight on the key chain, and although there's enough light to see the truck, I shine the flashlight on the ground in front of Auntie Girlie's feet.

"Whoa," she says. "*Some* service. How old you said you was?"

I'm a little embarrassed. I know that last part is just a joke—the flirty kupuna—but I don't have a comeback. Shucks, I don't even want to try. I've been pressed like this by kupuna in Nānākuli. I'm comfortable with it. Those Nānākuli kūpuna, they taught me. And now I think those urban planning field trips we took on weekends for extra credit have led me here.

Auntie Girlie wants to see me laugh. It's important. And I do. I want to laugh, too.

When we get to the truck, I place the box in the bed, right up against the back of the cab. "I get towel," I say. "I'll cover the box." And then I open her door, look at her again. "Bonus points," I say.

I got my first camera five years ago to photograph large buildings and freeways on Oʻahu. Public infrastructure. But I wound up taking pictures of people at home, on Molokaʻi. As I shut her door and begin to walk around the bed, I wonder about Auntie Girlie's picture. And then I wonder about my own.

When I get into the truck I tell her about what's happened. I'm looking for an answer.

"If you can't remember the photos," she says, "what about all the other moments in your life?"

In the true spirit of a wise woman, she's responded with a question. And it's enough to keep me silent as I roll down my window, flip on the ignition, and turn to look through the rear window of the cab.

I'm concentrating on trying to back up and get out of the parking lot when Auntie Girlie says, "You make them up. As best you can."

It's something I haven't anticipated. Something that, against my will, suddenly makes me question everything she's ever told me. All the great stories. All the moʻolelo about people and places on the island. About the history of Kaunakakai. Even the gods. "What?" I ask. I know full well what she's said, but I don't want any silence now that she's said it.

"Auntie not being mean," she says. "The stories are true. Family stories. Our version. My grandmother started telling them to me when I was very young. I remember plenty. But get some I tell, I not so sure."

She must see the wheels spinning in my head when she says, "But I remember *all* the pictures that I take."

Out the truck window, toward the mountains, I see cornfields and then the entrance to Manila Camp. And before I know it, we're in Kaunakakai Town, almost at the planned site for the cultural park. "Pull in," says Auntie Girlie. "You not in a rush, ah. Hiki nō."

I slow down and make the turn toward the ocean. I can't help but think that the last time I was here—in this truck, with a woman at this time of night—it was because we'd been pulled over by a cop. I slow it down to below five miles per hour. I want to ask Auntie which of the stories she told tonight about Kaunakakai are true stories, but I know where my question will lead.

On our right is the vacant lot. It's covered in tall weeds and empty storage containers. There's a cinder pile and a dump truck. "Those things been there forever," I say. "Waste."

But Auntie Girlie doesn't respond. She looks out her window at the lot. She's thinking, and I know they're all good thoughts. The look on her face would make a wonderful picture, even though it's night. The vacant lot behind her would fill the frame. There'd be a little wind in her hair.

She's lost in the moment, completely exposed.

When we reach the stone platform remains of Mālama, a vacation home of King Kamehameha V, she suddenly snaps out of it. "Not for long," she says. "You'll see." And then she says she always gets 'ono for deer whenever she passes this spot.

The truck pulls up to the beginning of the pier and she asks to pull over. She sees something on the shoreline. And as soon as the truck stops, she's out and walking after it.

I rush out of the truck and run over to help her. She's got her hands on the two-foot stone wall that borders the edge of the road. She's getting ready to climb right over it. She wants to get down to the beach. I step to the side and jump right over. "You should've told me," I say. "I would've pulled in at the platform. We could've driven right up."

"That's no fun," she says. "Be careful, ah." Then she laughs.

From the shoreline, I offer up my arms and guide her toward me. There's a nice breeze, but it's still a calm night, so the smell of limu wafts in the air around us. At the end of the wharf, there are boats

docked in stalls, *The Princess,* and a Matson barge. It looks like there's been a full day of action.

When Auntie Girlie reaches the sand, she dusts herself off. She steps over some 'ākulikuli, then begins heading west, down the beach. There's a half-moon above her that looks like a bowl. Later, on our way into Kapa'akea to drop her off, she'll tell me the phase is called Kāloapau. She'll say it's a good night for torching because of the tide.

I watch her walk down the beach, between stones and coral. Over shadowy roots reaching toward the ocean. I walk behind her, but I give her space. She hasn't told me what she's doing, and I don't want to interfere in it. A wave slides up the shoreline, right to us. And when it wraps around our feet, she finally stops. She turns to the ocean. To the pier. To the boats and the barge. Then up at the moon.

"Come, boy," she says. "Right here." Then she reaches out with her hand.

I step forward until we're close, side by side. I look at the moon and then the moonlight on the surface of the ocean. It's trailing right toward us. She holds my hand as we stand there on the sand, looking out at the shimmering ocean, right at the spot where her picture was taken.

Pasin/Ways

STEVEN WINDUO

Insait long wanwan ples bilong yumi
I gat gutpela save i stap olgeta taim
Sapos yumi go bek bai yumi lainim
Olsem save tumbuna i stap yet
Pasin bilong lukautim graun i stap
Pasin bilong kamapim wok i stap
Pasin bilong singautim abus i stap
Pasin bilong wokim gaden i stap
Pasin bilong singsing i stap
Na pasin bilong stretim sik na sua i stap
Yumi gen lainim ol save bilong wait man
Tasol yumi mas luksave tu
Long olpasin bilong mipela
Em ol i stap na makim mipela hamamas
Long wanem mipela save long ol.
Tingim, sapos yu stap long narapela hap
Bai yu filim olsem yu no wankain
Olsem ol lain yu stap wantaim
Yu bilong Papua New Guinea.

Ways
STEVEN WINDUO

In our villages
There are good ways
If we return we will learn

Our traditions are still alive
Ways to look after our land are there
Ways to develop our lives are there
Ways to hunt are there
Ways to make gardens are there
Ways to sing and dance are there
And ways to heal our illnesses are there
We can learn the white man's ways
But we must recognize
Our traditional ways
They are there to make us happy
Because we know them all
Imagine if you are in another country
You will see that you are not the same
Like the people you live with
You are from Papua New Guinea.

Nau mai, hoki mai

Approaching the Ancestral House

Alice Te Punga Somerville

> I will know I am home
> when I see the meeting house
> *Vernice Wineera, "Tangi"*

PERHAPS ONE OF THE MOST WELL-KNOWN POEMS by a Māori writer is Apirana Taylor's "Sad Joke on a Marae" (1979, 15). In the poem, a man named Tu stands and addresses his ancestors, who are "carved on the meeting house wall." Since its publication in Taylor's 1979 collection *Eyes of the Ruru,* "Sad Joke" has circulated variously as an articulation of cultural loss, cultural continuity, cultural resilience, and cultural change. While Tu is most often read as a Māori man who has spent too long in non-Māori space, he is also a Māori man going through the normal relational process of returning home to his own marae. In this chapter, "Sad Joke on a Marae" does not stand alone but—like Tu in the poem—is accompanied by others: Vernice Wineera's (2009) "Toa Rangatira" and "Tangi,"[1] and Kāterina Mataira's "Restoring the Ancestral House" (1995, 369–370).[2] In all of these poems, an individual approaches a carved wharenui, and in each text a range of Māori aesthetic forms—carved, oral, woven, chanted—are not mere signs of Maoriness, but are active participants in a complex intergenerational negotiation of homecoming and connection. When visitors arrive at a marae, the repeated phrase nau mai, haere mai welcomes the manuhiri, encouraging them to move closer in physical but also spiritual proximity. When

someone returns home to their own marae, however, the welcome affirms that this is an act of return: nau mai, hoki mai.

Approaches: To Houses, to Literature

In 1971, a gathering of scholars and writers at the University of Nairobi explored the range and concept of Black aesthetics. David Dorsey (1973) reflected on the complex relationship between texts and readerships in the production or identification of distinctive Black aesthetics:

> In referring to any particular aesthetic, I mean the syndrome of factors within a work of art which govern the audience's perception of and appreciation of the work, that is, the sum of factors with disparate, inter-related importances which are noted, consciously or unconsciously, by the audience and prized or disparaged. A black aesthetic would be the syndrome of internal factors governing a black audience's perception and appreciation of a work of art. (7)

Dorsey's term "perception" does not necessarily privilege reader response over other kinds of analyses but locates the variability of a text's meaning in the diversity of its audience. This is echoed and extended in Chadwick Allen's 2007 essay "Rere Kē / Moving Differently," in which Allen notes that "only slight attention has been devoted ... to the specific issue of [Indigenous texts'] reception (how particular audiences produce meaning through their encounters with specific texts or how these audiences assign to specific texts literary, cultural, or personal value)" (2). In line with the significant revolutions of literary criticism in the almost four decades between these essays, there is a shift in the attribution of agency between 1971 and 2007. According to Dorsey, factors in the text have the power to "govern" the audience's "perception and appreciation" of a work, whereas Allen ascribes the "audiences" with the power to "produce meaning" and "assign ... value." And yet, these are not necessarily oppositional claims. The important thing for Dorsey and Allen is that aesthetics are inextricable from the multiple and situated ways in which meaning is produced and, furthermore, that specific readerships of a text can produce particular meaning according to the relationship between "factors within a work" and the cultural (or other) perspectives readers themselves bring to a text.

A rich and prominent example of this kind of particularity can be found in the various approaches to Taylor's "Sad Joke on a Marae." For many readers, "Sad Joke" has become an archetypal poem that articulates and confirms narratives about Māori dislocation and cultural crisis. Tu is described as "a casualty of colonialism and Maori urban drift" (New Zealand Book Council, n.d.); "a member of the urban tribe of 'voiceless' Maori" (Knudsen 2004, 69) "who seems to have lost his connection to his tribal traditions" (Pfelier 2003, 37); "a Maori who is unable to cope in the pakeha [sic] world and is in jail" (Hunt 2002); who "feels 'out of place' at the marae" (Edmunds 2009). A chapter of Eva Rask Knudsen's *The Circle and the Spiral* reproduces a long section of the poem but truncates (unmarked) the part where Tu names the carvings, thus obscuring the central and productive contradiction between Tu's demonstration of naming and speaking with his tūpuna and his overt claim, "I said nothing but / Tihei Mauriora / for that's all I knew" (2004, 69). Taylor's motives and Tu's predicament are presumed singular and knowable: "Taylor also presents people who are torn between two cultures" (jedge, n.d.). A passage about Taylor (and Wendt) is offered online as an exemplar for the New Zealand English curriculum: "Maori and Polynesians in my texts felt alienated . . . the theme of lost culture and heritage is featured in Sad Joke On A Marae [sic] by Apirana Taylor" (New Zealand Ministry of Education, n.d.).

Certainly other readings of Taylor's poem are available. In his 1995 introduction to *Indigenous Literature of Oceania,* Goetzfridt identifies the productive contradiction at the heart of the poem that resists any easy attribution of loss or blame:

> The self-reliant expression of Maori writers who do not make overt attempts to identify themselves with black writing is indicative of their focus on mediating between opposites and a reliance upon the 'residual power of a Maori spirit' that is apparent in a poem such as Apirana Taylor's "Sad Joke on a Marae" in which Maoritanga remains a force despite the apparent cultural isolation of many urban Maoris. (3)

Goetzfridt describes the "cultural isolation" represented in the poem as "apparent," foregrounding the seductive but also incomplete reading of "Sad Joke" as a melancholic text and recognizing a deeper, if more subtle, undercurrent of "Maoritanga." In his 2007 essay "Rere Kē / Moving Differently," Chadwick Allen holds "Sad Joke" alongside

Kiowa writer N. Scott Momaday's "Carnegie, Oklahoma, 1919," claiming that "each [poem] performs a moment of spiritual contact between a contemporary speaker and his ancestors. Each poem operates, in part, by situating its speaker on ceremonial grounds and evoking a paradox of space and time" (5).

Although Tu "is explicitly alienated from his Indigenous culture and unable to speak his indigenous language fluently" (5), reading the poem with an appreciation of Māori aesthetics—linguistic, representative, allusory, and material—Allen poses a rather different reading than those that focus on loss: "Taylor's poem emphasizes the role of language and public oratory in this representation of an enabling contact with indigenous ancestors" (7). Allen teases out the various meanings of Tu's name, "which can be translated into English as 'to stand,' 'to fight,' or 'to be wounded.' The name can be read as an allusion to the concept of turangawaewae (standing place) and/or as an allusion to the war god Tumatauenga" (7), and the significance of the repeated oratorical phrase "Tihei Mauriora." More recently, Ngāti Porou scholar Ocean Mercier (2007) gestures toward "Sad Joke" in the context of a discussion about how one might stage a Māori reading of Māori film:

> Using Māori norms of identification with a tribe and a marae, Tu introduces himself to the carved ancestors in the wharenui. Tu's separation from a traditional Māori worldview is painfully self-evident, however. His identification of the pub as his marae, in a sort of confession to the "tekoteko and the ghosts" (Taylor 1979:15), is an admission of his removal from the world of his ancestors. Perhaps not implied in the poem or this film, but certainly understood, is that feeling closer to the pub than to the marae is one of the flow-on impacts of colonisation and subsequent urbanisation of Māori. (44)

Mercier neither disavows nor ignores evidence of "separation" in the poem but takes for granted that Tu's genealogical proximity to his tūpuna overrides any experiential or spatial distance. Mercier understands Tu's first utterance, ultimately, as a "recit[ation]" of "whakapapa." Furthermore, Mercier's use of "separation" to describe Tu's proximity to "worldview" echoes the origin narrative of Ranginui and Papatūānuku that she engages elsewhere in her article, a narrative that pivots on a painful separation in order to produce room for life.

Such readings of "Sad Joke" by Goetzfridt, Allen, and Mercier (and myself, here) are not simply oppositional attempts to rescue the poem from bad, incomplete, imprecise, uncomfortable, or uncritical readings simply by reversing the terms and reframing the poem as a singularly celebratory poem of cultural strength. Rather than being obvious, Tu's situation is productively ambiguous. Indeed, these readings acknowledge that while Tu's tricky and history-soaked negotiation of his relationship to the marae and to his tūpuna is significant, our role is not merely to describe or diagnose loss but to recognize the myriad complex structures of connection, disconnection, and reconnection inherent to this moment of return. Susan Feagin, arguing that plural interpretations do not necessarily produce incompatible right and wrong readings of a text, suggests we evaluate divergent readings not in terms of relative proximity to truth, but "in terms of how the readings they engender enrich our experience both of the work and of the world" (Davies 2007, 94).

What do these divergent readings tell us about "the world"? Is it a coincidence that so many readers assume an individual Indigenous man tragically stands in cultural space that has become alien to him? Sara Ahmed (2000) suggests that encounters are "meetings," which "are not simply in the present: each encounter reopens past encounters . . . encounters between embodied subjects always hesitate between the domain of the particular—the face to face of this encounter—and the general—the framing of the encounter by broader relationships of power and antagonism" (8). Although Ahmed's project is about encounters between "embodied subjects," specific textual encounters—reader with text, or reading of text with reading of text—are not neutral either, and are also deeply inflected by "broader relationships of power and antagonism." Accordingly, in the context of settler colonialism, narratives about cultural loss are rendered self-evident: "it is obvious that he is disconnected from his Maori culture." These readings of the poem draw on conventional narratives in which Māori are tragic victims of cultural loss and, further, in which the retention and practice of Māori culture is foreclosed by living in the city, not speaking Māori, being exposed to non-Māori elements (culture, workplace, violence, jail). Narratives of Māori disconnection and nihilism have become habitus to the extent that such a wide range of readers—scholarly and nonscholarly—produce strikingly similar conjectural readings of the poem. Certainly the poetic is political, too.

The Ancestral House: A House of Ancestors

Why give additional airplay to a poem that has already enjoyed plenty of attention when there are so many other Māori texts that beg for and deserve their time in the sun? Because when I first read "Toa Rangatira," a poem by Vernice Wineera published in Hawai'i the year before *Eyes of the Ruru* was published, my instinct was to pair it with "Sad Joke." Any reading creates the conditions for interpretations of the specific text, but it also—and these processes may well be mutually constitutive— produces links with other texts with which it is (at least in the mind of the reader) in conversation. Sure, all texts are constantly in conversation with all other texts, through their mutual medium of language, but it is worth reflecting on the logic behind pairings or clusters of texts that feel intertwined. (Those of us who teach literature are perhaps even more inclined to see texts in teachable clusters.) "Sad Joke" is often paired with or compared to Alan Duff's fiction because of a perceived thematic concern of urban dysfunction and violence that apparently overrides any other aesthetic or formal considerations. However, when we read Taylor alongside Wineera and Mataira, we notice other synergies at play.

In Taylor's "Sad Joke on a Marae," Mataira's "Restoring the Ancestral House," and Wineera's "Toa Rangatira," the speaker of the poem approaches a wharenui alone. As with "Sad Joke," the single individual could be emblematic of dislocation, loneliness, and separation, and the empty wharenui is a melancholic sign of cultural loss. In each poem, the carvings are damaged: in Mataira's wharenui "sun splinters / ricochet from / the one good eye / of the tekoteko / supine upon the floor," the ancestors in Taylor's wharenui are "grim death and wooden ghosts," and the carvings in Wineera's whare are of "peeling paint, / weathered wood, / blind-eyed." Furthermore, in each poem the carvings are, at least in the beginning, unmoving and immovable. Mataira's tekoteko is "supine upon the floor," Taylor's are "wooden ghosts / carved on the meeting house wall," and Wineera's tekoteko "gave no sign / save that carved out / of defiance." Accordingly, the poems affirm the irrelevance and loss of Māori cultural forms and practices, gesturing toward a vibrant yesteryear and mourning that the vitality of the past merely haunts the present. Or do they?

The built environment of the wharenui is derelict only if one assumes that the carvings and other material cultural forms are inanimate. There is another way of reading these three poems, wherein the

wharenui is a specifically charged space in which ancestors are inevitably present. In his thorough treatment of Māori carving, Roger Neich (2001) reflects at length on Māori aesthetics, including the representation of time, space, and ancestors in carving.[3] Noting that "in Maori thought, time is a continuous stream or sequence of events and processes, ordered simply by their relative positions," Neich writes, "Representation of ancestors in Maori carving continually recreated the timeless, ever-present world of the ancestors" (136–137). While the three poems place certain emphasis on ancestors carved from wood, which are part of many wharenui, the house itself is the embodiment of an ancestor and also functions as a place in which time and space are differently configured and charged by the memory and ongoing presence of ancestors. In Patricia Grace's novel *Cousins* (1992), this cross-temporal and ongoing ancestral presence is described by Mata when she physically returns to her own marae: "Something was happening, because suddenly the place became more and more crowded. Suddenly there were people sitting by where the mats had been lain, where at first there had been nobody. There were men and women with marked chins and faces who belonged to an older time. They had my own face some of them, Makareta's and mine" (254). Ancestors continue to be "ever-present" in and through the structure of the wharenui, and this raises the question of whether these individuals approach the house alone after all.

"Sad Joke on a Marae" is about Tu, then, but it is also about the others at the marae. Focusing on Tu as the speaker of the poem invites an assessment of his familiarity with the entities present in the wharenui, but readings with emphasis on the collective will notice that he is in a familial place. Canada-based scholar Arun Mukherjee (1988) argues:

> The western critic, his sensibility trained by the forms of western literature in which the individual has long held the centre of the stage, is unable to do justice to those works from the new Commonwealth in which community life and larger socio-political issues are of central importance . . . if one choose to read these [Indian texts] as explorations of community life and its historic transformations, everything seems to fall into place. (14–15)

Any marae—including the literal space between the wharenui and manuhiri—is a charged and inhabited space rather than a chasm

or gap. "Sad Joke" does indeed "fall into place" when one notices it is full of people: they're named, directly addressed, and active. The protocol of the pōwhiri produces (temporal and physical) space for the reciting and recollection of shared whakapapa and histories, and this reconnection extends beyond those who physically stand on either side of the marae ātea. Tu's speech to his tūpuna ("In the only Maori I knew / I called / Tihei Mauriora") receives a reply:

> Above me the tekoteko raged
> He ripped his tongue from his mouth
> And threw it at my feet

The tekoteko's "tongue" is the formal response to Tu's already-uttered speech ("Tihei Mauriora"), and this act of mutual speechmaking establishes the connection. Later, Tu realizes that "They understood / The tekoteko and the ghosts." Just as Tu depends on "the tekoteko and the ghosts" for a "tongue," they depend on him to recognize and name them. In this way, "Sad Joke" is a poem about a group of Māori—Tu, the tekoteko, ancestors, and "ghosts"—who interact on Māori space. This does not change Tu's experience, but reframes it.

In Wineera's "Toa Rangatira," the whare is mnemonic for lived experiences and relationships ("return to the time and place / of yesteryear"; "cherished reminiscence"). Like Tu, the speaker in "Toa Rangatira" directly addresses the ancestors—the wind (environment; ngā atua) and the tekoteko (marae; ngā tūpuna)—who are present at the marae. Just as Ahmed describes encounters as "meetings which are not simply in the present: each encounter reopens past encounters," the marae is a multitemporal space in which the speaker simultaneously inhabits the present and memory. These memories are nostalgic and cannot translate into actual return ("one cannot . . . return"), and changes over time affirm this impossibility ("I had grown a giant"); however, another kind of "return" is possible: "one cannot, / save for long, quiet nights, / return." These "long, quiet nights" resonate with the beginning of creation preceded and prefigured by Te Pō, a period recalled in Māori rhetoric as a "long" and very dark night. Te Pō is the period between Te Kore, the realm of nothingness, which is also a realm of potential, and Te Ao Mārama, the realm of daylight in which we live. Indeed, if childhood is a realm of potential and adulthood is the present time, we might imagine that the poem is multitemporal: set in Te Ao Mārama but with a view to Te Kore (childhood, the "yesteryear," before

the speaker "had grown a giant") and Te Pō. The title of the poem, "Toa Rangatira," places these memories of "yesteryear" in a longer context: this is a "return" to a wharenui; Toa Rangatira is the name of the carved wharenui at Takapūwāhia, Wineera's marae, but also of an iwi, Ngāti Toa Rangatira. The poem is thus populated both ways: Toa Rangatira are present as the home people and are also present with and through the speaker.[4]

The ongoing presence of relatives forms an entire stanza in Mataira's "Restoring the Ancestral House." The wharenui is inhabited despite the speaker of the poem being the only person there:

> Old walls creak
> amid mason-bee hum
> sun splinters ricochet . . .

The ancestral house is a space of activity in which the whare itself, animals, and the wider environment interact and engage in a continued process of the creation of meaning: "spiders . . . and the marauding mason-bee / are the spinners of tales." Time has been humming along too, though, and the speaker of the poem approaches the wharenui in order to "restor[e] the ancestral house." Along with the "supine" tekoteko with "one good eye," the kōwhaiwhai "scrolls" are "aged," the tukutuku are "loosened," the photographs are "faded," and the back of the tekoteko is affected by "dry rot." Restoration is different from renovation, though, and the speaker of the poem is careful to acknowledge not only the former glory of the wharenui but also the knowledge connected to its past. Rather than producing a progress narrative in which the present imposes improvement upon the past, or a rescue narrative in which the past is dependent on the present for validation, the speaker seeks to learn through the process of humble, gentle restoration: "hand poised tentatively / to trace aged scrolls"; "let the master craftsman return . . . to guide the untutored hand." In this way, the wharenui is the teacher, the "master craftsman," and so performs the pedagogic role of an ancestor.

As in Wineera's and Taylor's poems, the wharenui is overlaid with memory as well as a longer history of human presence. The speaker of the poem describes a momentary shift in which, like Grace's Mata, she observes a repeopling of the whare:

> The shadows move
> and the house is full

grey mounds humped upon the whariki
sleeping
a child slurps upon his mother's nipple
in the corner
muffled lover shuffling
and the old men snoring

The "house is full" of people from the past, and so the speaker of the poem is surrounded by ancestors layered in generations, from a baby to lovers to "old men." When the moment passes in time ("But only spiders people the house"), these ancestors remain "ever-present": in the wharenui itself ("the ancestral house"), in the creative production ("scrolls," "adornments," "tukutuku") of tūpuna who were "master craftsmen," in photographs, and in the physical presence of the speaker who is their descendant.

The stanza describing this moment is the third of five stanzas, and at the very center of the stanza is the image of "a child slurp[ing] upon his mother's nipple." This "child" could be an ancestor or, perhaps, the speaker who is being nourished in this ancestral space. In a poem focused on the age and deterioration of things, it seems significant that a symbol of birth and futures is at the center. Indeed, given the physical position of the speaker of the poem when this moment occurs—she is up a ladder, a fact confirmed both before ("ladder perched") and after ("ladder shaking") this central stanza—this moment of maternal suckling—could also allude to the relationship between mother and child writ large in the connection between Papatūānuku and her children. Within the wharenui, the origins of the world are mnemonically and literally recalled as the floor/ground (Papatūānuku) and the roof/sky (Ranginui) are held apart by atua and tūpuna who find their shape in the carved panels and supporting beams between them. The speaker of the poem is thus, when on the ladder, suspended between Ranginui and Papatūānuku in an intermediary realm. Perhaps being in this liminal space enables her to see the "ever-present" tūpuna by which "the house" is made "full." Although the presence of tūpuna is marked by a visual change ("the shadows move") and the speaker of the poem is engaged in restoring visual culture—the emphasis on color throughout the poem seems key—the tūpuna are described by the noises they make ("slurps," "muffled lover shuffling," "snoring"), contributing to the soundscape introduced at the beginning of the poem when the speaker's entrance adds to the busy sounds already there ("creak,"

"hum"). Not only visual signs but also aural and linguistic signs are inherited from the tūpuna; our tūpuna are present in and through language. Indeed, the context of restoration recalls Mataira's own impressive and long-standing commitment to the Māori language. Just as the speaker of the poem "trace[s]" and repairs the patterns from before in order to "restor[e]" them for the future, so too Mataira's work in the area of language revitalization was deliberate and urgent in the face of a potential loss of memory about who we are in order to prevent "the old men snoring" from becoming "the old men [who] stare" from "faded photographs."

"All the Old Houses of Home": A Final Approach

The complex and blurred line between approaching the ancestral house alone and with company is central to another poem by Wineera, "Tangi." The poem is narrated by a speaker ("I") who directly addresses the reader while describing a return to a specific wharenui. Although the poem focuses on a specific individual, it is densely populated with people. Over the course of the poem the individual is brought into a matrix of genealogical and lived connections until the first word of the poem—"I"—becomes an inextricable part of the last word of the poem: "home." The opening line, "I will know I am home," is repeated precisely in the beginning of the second stanza and echoed throughout the poem in varying forms: "calling me home"; "the protocol / of my coming home"; "And I will be home"; "I will know I am home"; "when I come home"; "I will know I am home"; and, finally, in the last line of the poem, "I will be home." These phrases become a kind of chant, both confirming the return of the speaker and echoing the layered, repetitive, cycling structure of karanga with which the poem commences ("I will know I am home / when I see the old women. / The old women in shawls / calling the lament / . . . The old women with their long cries"); the karanga is the first action and first utterance of marae ceremonies. In this way, the poem is a kind of karanga, written by an "old wom[a]n," as Wineera is a kuia, and producing, through its repeated keening and somber rhythm, the return home for the speaker, who moves from an active state in which she claims "I will know I am home" to a fixed state: "I will be home." "Tangi" is about physical and spiritual return: the speaker of the poem imagines the process of her own tangihanga at her home marae. While her return follows the structure of any approach to an ancestral house, the reader eventually

realizes the speaker of the poem is not accompanying the tūpāpaku but is herself the one being mourned. For me, this realization happened during stanza 3, when the custom of staying by the tūpāpaku for three days before burial is mentioned: "I will hear the breathing / of those who watch by me / through the long night, / through the three-day night." The elders welcome the speaker—"the old women . . . calling me forward, calling me home," "the old men discussing . . . the protocol / of my coming home"—back to the physical space of the marae, the physical/spiritual space of the earth in which she will be buried, and the spiritual space of home among her people with whom she is genealogically connected. The process of tangihanga is an opportunity to connect with the tūpāpaku and to recall and reassert the connections between the living, both formally ("the old men . . . untangling the genealogies") and informally ("the murmur / of living voices," "the children at play"), and to recall and connect with the bounty of the land and sea during the feasting that includes hāngī, mutton bird, eel, and kina.

The speaker clearly returns to a specific marae, given descriptions of the marae ātea and the wharenui including "the rafters of kowhai-whai" and the kitchen, but she focuses on returning to people: "the old women," "the old men," "those who watch by me," "the children," "the cooks," "the girls setting the long tables." Befitting Māori understandings, the speaker of the poem continues to interact with the living over the three days she is mourned: "I will hear the breathing," "I will hear the murmur / of living voices about me," "I will dream with the children," "when I smell the cooking fires," "I will taste again the hangi meat." After the speaker "eat[s] with all of them," signaling the end of the process of being welcomed to a marae, the line between ancestral house and ancestors gently collapses. The speaker anticipates meeting women engaged in performing arts and displays of welcome ("I will see the pukana of the women, / and the gestures of grace"), echoing the first people encountered in the poem ("I will know I am home / when I see the old women") and yet notably the "women" are not "old women"; they are "timeless." Whereas the "old women" in the first stanza wore "ferns in their hair," a customary expression of mourning, in this final stanza the speaker imagines "fern leaves flowing green / and free beside clean waters." A quiet shift has occurred, in which the signs of mourning are replaced by signs of continued life or, perhaps, life that occurs outside of linear time. At this point, halfway through the last stanza, the speaker has left behind the people at the marae and the conventions of tangihanga in which they are engaged:

> I will hear the nose flute
> across the years,
> and hongi with my tupuna
> and shed tears
> for what was lost along the way.

This time she is called on by a form of Māori instrumentation, "the nose flute," echoing the karanga of the beginning of the poem, a resonance that echoes lines from Wineera's poem "Heritage" ("Trace the call of the karanga across the marae, / the nose flute in the night" [2009, 45]). Rather than calling across space as the karanga had done ("calling me forward") the nose flute calls her across time ("across the years"). She moves generationally rather than geographically, and when she meets her ancestors, they "shed tears," paralleling the stage of the pōwhiri in which manuhiri stop to grieve for those who have passed away. This time, however, the "tears" are "for what was lost along the way" in the world of the living rather than for those who have passed to this world.

The ancestral house is neither portal nor representation of ancestors but a space in which ancestors are present, and the speaker is gradually joined by relatives over the course of the poem. The "house" to which the speaker returns is filled with, and stands in for, the living and the ancestors. The tūpuna are present through the actions and words of their descendants: the practices of tangihanga are passed down, a cultural and intellectual legacy that is inherited, deliberated, and taught in each generation ("the old women . . . swaying to the mourning chants," "the old men discussing politics / and the protocol / of my coming home"). The tūpuna are also present when the old men "untangl[e] the genealogies." Similarly, ancestral presence through the act of naming is further elaborated in Wineera's poem "Whakapapa" in which an "old man calls the names / into the sunlit day": "The names roll off his tongue / and stand in formation / before his eyes . . . They fill the marae as the old man intones" (2009, 65). The connection between the people and the whare is made even closer in the last lines of the poem:

> I will know I am home
> when I see the meeting house.
> Toa Rangatira! The proud name.

As in the poem "Toa Rangatira," a play is made on the "name" as wharenui and as iwi. This doubled return—to a specific place and to a

specific people—ultimately confirms the speaker is "home." The English translation often supplied for wharenui, "meeting house," is literalized and the speaker "meet[s]" her tūpuna and, by logical extension, her descendants as well. Having started with the living, the speaker becomes part of an ever-widening ancestral matrix of connection and relationship among land, house, and people:

> When I see the bush again,
> the hills, the beach,
> the old house.
> All the old houses of home.

Because wharenui are ancestors as well as spaces of meeting ancestors, and "Toa Rangatira" is also the name of her iwi, joining that "old house" to "all the old houses of home" becomes an act of whakapapa; the recognition of multiple houses rhetorically confirms the genealogical links beyond a singular identification or line of descent. The wharenui is in specific space, and the speaker will "know [she is] home" because of her connection to ancestors, iwi, and place.

This ancestral proliferation allows the speaker to engage with her experiential and ancestral past, and the transition from spatial movement to temporal movement is further extended until she occupies a space that is both place and time:

> When I walk around the pa
> knowing again all the houses
> and all my family living and loving
> in all the old houses,
> I will be home.

"All the houses" and "all my family"—ancestral as well as contemporary—are "home" for the speaker. The realm of the ancestral is not separate from place or time, but encompasses them nonlinearly and expansively. This final moment confirms "the old house" (with "house" here as meeting place, ancestor, and iwi) as the realm of the ancestral even when one is still in the realm of the living.

Nau Mai, Hoki Mai: Writing the Ancestral House

Any approach to a wharenui is deeply underwritten by historical, ancestral, and cultural presence, and in each of these texts the return is

both memorialized and poignant. For all of the speakers in these po-
ems, the approach to the wharenui is tinged—even shaped—by the
complex structures of proximity to and distance from the ancestral
space and, ultimately, the ancestral. Although carvings are not the only
Māori aesthetic forms in these or indeed other Māori texts, I have fo-
cused here on the possibilities of reading Māori texts from a starting
point that holds specific Māori configurations of the material creative
production at the center. In this case, I emphasize wharenui as ances-
tors, carvings as ancestors, and ancestors as ever-present. While we are
perfectly capable of producing adequate readings of these poems with-
out self-consciously reminding ourselves to move beyond (or perhaps
through) the "I" of the individual speaker, recognizing the multiple pres-
ences of ancestors and other relatives enables a more complex engage-
ment with each text. While this chapter has focused on specific texts in
which individuals come home onto their own marae, another kind of
approach and interaction is taking place. Ancestors are here, but so are
artists: the Mataira, Wineera, and Taylor poems all foreground the act of
creative production through the materiality of the carvings. The paint of
Wineera's whare is "peeling" and the wood is "weathered"; Taylor's carv-
ings are "carved on the meeting house wall" and his tekoteko "rip[s] his
tongue from his mouth." Kāterina Mataira's "Restoring the Ancestral
House" acknowledges emptiness and disrepair, but the speaker's ap-
proach to the wharenui is deliberate, prepared, and intent on restoration.
Dorsey writes about the changeability of aesthetics over time:

> The black aesthetic will change with time as well as geography.
> It will "develop," transmuting itself as the audience changes.
> Different generations will seek different syndromes. The means
> for fashioning a thing of beauty (a sewing machine, a trumpet,
> a typewriter) the materials (coloured plastic cord, books, ele-
> phant hides) grow more or less available. The occasions for prac-
> tice and performance change with social change. So tastes adapt.
> (1973, 11)

Mataira's poem holds the wharenui as a metaphor for rejuvenation
of the Māori world in which she herself was passionately and deeply
engaged, and the poem is itself an enactment of such rejuvenation. Re-
calling Mataira's restoration project, and gesturing toward but also lit-
erally enacting the continuity of tradition, even where that tradition
feels compromised or empty at first glance, we might also think about
writing. Just as the speaker in her poem fixes "the dry rot / in the

tekoteko's back" with new materials ("shiny acrylic / and cement"), Mataira—and Wineera and Taylor—continue Māori cultural production and aesthetic traditions by writing in Māori and English. If wharenui are ancestors and the speakers of the poems are engaged in restoring wharenui, then the act of restoration and, indeed, the poems restore our ancestors and, thereby, us. Just as carvings are not merely representative of tūpuna, these texts about approaching the ancestral house do not merely describe homecoming but produce it. Writing the ancestral house; writing, the ancestral house. Nau mai, hoki mai.

Notes

This essay is dedicated to Kāterina Te Heikōkō Mataira.

1. "Toa Rangatira" previously appeared in Wineera's *Mahanga* (Lāʻie: Brigham Young University–Hawaii / Polynesian Cultural Center, 1978), the first collection of poetry in English published by a Māori woman.
2. Although this poem is published directly alongside Mataira's "Waiata mo te whare tipuna," a Māori-language version of the same poem, in this chapter I focus only on the English version.
3. The major scholarly contributions to this area of Māori aesthetics in literary and cultural studies are Allen's own work (2007), Ocean Mercier's work on Māori film (2007), Jon Battista's doctoral work (2004), Hirini Melbourne's essay "Whare Whakairo: Maori 'Literary' Traditions" (1991), and Nicholas Thomas's essay "Kissing the Baby Goodbye: *Kowhaiwhai* and Aesthetics in Aotearoa New Zealand" (1995). Teresia Teaiwa (2010) wrote recently about Pacific writing being rooted in material aesthetics and cultures, and while I agree with her suggestion that we trace these alongside oral genealogies of written literature, her essay does not pay attention to the critical (and teaching) work in which these material roots have in fact been made visible.
4. I treat this poem more fully in my monograph, *Once Were Pacific* (Te Punga Somerville 2012).

Works Cited

Ahmed, Sarah. 2000. *Strange Encounters: Embodied Others in Post-Coloniality.* London: Routledge.

Allen, Chadwick. 2007. "Rere Kē / Moving Differently." *SAIL* 19, no. 4 (Winter): 1–26.

Battista, Jon. 2004. "Me He Korokoro Komako: With the Throat of a Bellbird." PhD diss., University of Auckland.

Davies, David. 2007. *Aesthetics and Literature.* London: Continuum.

Dorsey, David. 1973. "Prolegomena for Black Aesthetics." *Black Aesthetics: Papers from a Colloquium held at the University of Nairobi, June 1971,* ed. Pio Zirimu and Andrew Gurr, 7–19. Nairobi: East African Literature Bureau.

Edmunds, Ms. 2009. "Y12 Essay Due End/Wk 5 Beginning Wk 6." Ms Edmunds' English Classes. February 25. http://msedmundsenglish classes.blogspot.com/2009/02/y12-essays-due-endwk-5-beginning-wk -6.html. Accessed September 15, 2012.

Goetzfridt, Nicholas. 1995. *Indigenous Literature of Oceania: A Survey of Criticism and Interpretation.* Westport, CT: Greenwood Press.

Grace, Patricia. 1992. *Cousins.* Auckland, New Zealand: Penguin.

Hunt, Dorothy. 2002. "An Interview with Apirana Taylor." *NZine.* May 24. http://www.nzine.co.nz/features/apirana_taylor.html. Accessed September 15, 2012.

jedge. n.d. "Poetry Comparison Task." Slideshare. http://www.slideshare .net/jedge/poetry-comparison-task. Accessed September 15, 2012.

Knudsen, Eva Rask. 2004. *The Circle and the Spiral: A Study of Australian Aboriginal and New Zealand Maori Literature.* Amsterdam: Rodopi.

Mataira, Kāterina Te Heikōkō. 1995. "Restoring the Ancestral House." In *The Penguin Book of New Zealand Verse,* ed. Ian Wedde and Harvey McQueen, 369–370. Auckland, New Zealand: Penguin.

Melbourne, Hirini. 1991. "Whare Whakairo: Maori 'Literary' Traditions." In *Dirty Silence: Aspects of Language and Literature in New Zealand,* ed. Graham McGregor, Mark Williams, and Ray Harlow, 129–141. Auckland, New Zealand: Oxford University Press.

Mercier, Ocean. 2007. "Close Encounters of the Māori Kind." *New Zealand Journal of Media Studies* 10, no. 2 (December): 32–52.

Mukherjee, Arun. 1988. *Towards an Aesthetic of Opposition: Essays on Literature Criticism and Cultural Imperialism.* Stratford, Ontario, Canada: Williams-Wallace Publishers.

Neich, Roger. 2001. *Carved Histories: Rotorua Ngati Tarawhai Woodcarving.* Auckland, New Zealand: Auckland University Press.

New Zealand Book Council. n.d. "Apirana Taylor." Wellington: New Zealand Book Council. http://www.bookcouncil.org.nz/Writers/Profiles /Taylor,%20Apirana. Accessed September 15, 2012.

New Zealand Ministry of Education. n.d. "Uses an Increasing Understanding of the Connections between Oral, Written, and Visual Language when Creating Texts." English Online / Te Kete Ipurangi. New Zealand Ministry of Education, n.d. http://englishonline.tki.org.nz/layout/set /lightbox/English-Online/Student-needs/English-in-the-NZC/En hancing-the-English-Curriculum/Level-8-Speaking-writing-present ing/Uses-an-increasing. Accessed September 15, 2012.

Pfelier, Martina. 2003. *Sounds of Poetry: Contemporary American Performance Poets.* Tubingen: Gunter Narr Verlag Tupingen.

Taylor, Apirana. 1979. "Sad Joke on a Marae." In *Eyes of the Ruru*, 15. Wellington: Voice.

Te Punga Somerville, Alice. 2012. *Once Were Pacific: Māori Connections with Oceania*. Minneapolis: University of Minnesota Press.

Teaiwa, Teresia. 2010. "What Remains to Be Seen: Reclaiming the Visual Roots of Pacific Literature." *PMLA* 125, no. 3 (May): 730–736.

Thomas, Nicholas. 1995. "Kissing the Baby Goodbye: Kowhaiwhai and Aesthetics in Aotearoa New Zealand." *Critical Inquiry* 22 (Autumn): 90–121.

Wineera, Vernice. 2009. *Into the Luminous Tide: Pacific Poems*. Salt Lake City: Center for the Study of Christian Values in Literature, Brigham Young University.

Tiki Manifesto

Dan Taulapapa McMullin

Tiki mug, tiki mug
My face, my mother's face, my father's face, my sister's face
Tiki mug, tiki mug

White beachcombers in tiki bars drinking zombie cocktails from
 tiki mugs
The undead, the Tiki people, my mother's face, my father's face
The black brown and ugly that make customers feel white and
 beautiful

Tiki mugs, tiki ashtrays, tiki trashcans, tiki kitsch cultures
Tiki bars in Los Angeles, a tiki porn theatre, tiki stores
Tiki conventions, a white guy named Pupulele singing in ooga-
 booga fake Hawaiian
 makes me yearn to hear a true Kanaka Maoli like Kaumakaiwa
 Kanaka'ole
 sing chant move his hands the antidote to tiki bar people
 who don't listen because tiki don't speak any language
 do they

Tiki bars in L.A., in Tokyo, in the lands of Tiki, Honolulu, Pape'ete
Wherever tourists need a background of black skin brown skin ugly
 faces
 to feel land of the free expensive rich on vacation hard
 working

with a background of wallpaper tiki lazy people wallpaper
made from our skins our faces our ancestors our blood

Yes it's all wrong but looks like my great grandmother's fale sort of
except she isn't here and it doesn't really, her fale
didn't have a neon sign blinking for one thing

And yes it looks like Polynesian sculpture sort of not really but what
is the difference, the difference is this, we didn't make it
or if we did it was someone desperate but probably not any of us
just someone making a buck carving shit for drunks

The difference is this, our sculpture is beautiful, tiki kitsch
sculpture is ugly
not because they look so very different but because their shit
is supposed to be ugly
because we are supposed to be ugly
and if we are ugly then they are beautiful
American or European or Australian or Asian or
a lot of us too and anyone can be beautiful and expensive
as long as tiki kitsch is on the walls looking ugly and cheap

I like going to tiki bars sometimes and hearing island music or
doing island karaoke and there are tiki bars in the islands sort
of but
there they're just bars and I'm here in Los Angeles or any
where here
in the so-called West which is everywhere
and here, we are tiki mug people, my mother's face, my
father's face
my face, my sister's face

Our Tiki sculptures are based on our classic carvings, which are
abstractions, idealizations
of beauty, our beauty, though in these bars they are . . .
Well, you get it

Can I remind us that Tiki
Whom we call Ti'eti'e and Ti'iti'i
Some call Ki'i, some call Ti'i

That Tiki was beautiful, jutting eyebrow, thick lips, wide nose
 brown skin in some islands
 black skin in some islands
 brown black deep, thick thighs
 jutting eyebrow, thick lips, wide nostrils, breathing

Lifting the sky over Samoa, lifting the sky over Tonga
 lifting the sky over Viti, lifting the sky over Rapanui
 lifting the sky over Tahiti, lifting the sky over Hawai'i
 lifting the sky over Aotearoa, and looking to, paying
 respects
 to Papua, to the Chamoru, to Vanuatu, to Kiribati
 lifting the ten heavens above Moana, not your Pacific, but
 our Moana

And now in tiki bars Chilean soldiers have drinks from tiki mugs
 after shooting
 down Rapanui protestors in Rapanui, not Easter Island, not
 Isla de Pascua
 but Rapanui, whose entire population was kidnapped and
 sold in slavery
 to Chilean mines in the 19th century, and whose survivors are
 shot on the streets
 of their lands still just a few years ago to today in Rapanui

And American police drink maitais in Honolulu bars from tiki
 mugs while
 native Hawaiian people live homeless on the beaches

And Indonesian settlers drink from tiki mugs in West Papua where
 over 100,000
 Papuans have been killed seeking freedom after being sold
 down the river by
 President Kennedy so he could build some mines for his rich
 cultivated
 humanitarian friends

And French tourists drink from tiki mugs in Nouvelle-Calédonie
 and Polynésie française
 while native people are . . .

Where? Where are we?
In the wallpaper, on the mugs?

Note

Previously published in *Coconut Milk* (Tucson, University of Arizona Press, 2013).

Peleiake: Institutions

let's pull in our nets

Chantal Spitz
Translated by Jean Anderson

It's like fishing with nets. Those endless nets that fishermen billow out from their canoes in a semi-circle to catch ature that don't realize what's coming until they're choking. We are writers jotters scribblers

fishermen who set out the billowing nets we are also the encircled ature. The net is in position it will close around us if we don't watch out if we sink our minds into dominant western ideas if we cut off our originalities in a dominant universal monoculture.

We are the ones who clear the way for futures for memories the path is thickly-grown sometimes dark often disturbing navigators of the "journey of Polynesian literature" (F. Devatine)—with no landmarks to ease our uncertainties no wake to even out our inconsistencies no star to balance our contradictions. We are afraid that the journey may ramble into an endless wandering through unfamiliar spaces and we let ourselves be lulled by the song of the educated scholarly specialist sirens forgetful of the reefs where they like to wreck sailors. Let us tie ourselves to the masts of our pahi but not block our ears—oh such a far-traveled reference . . . on the contrary let us listen let us read the new discourses let us learn to dissect them to track down and hunt out behind these studies these analyses these articles the new terms the new words the new concepts of a new domination.

Let us be careful not to allow ourselves to be totally reduced by the Other—"emergent literature" (M. Aït-Aarab); "francophone or postcolonial literature" (D. Margueron); to be circumscribed cloistered among ourselves "colonized literature" (J. M. T. Pambrun); as if our literature were not a literature as if some adjective were needed to describe it some defining term for it to take shape at last as literature. Literature reaches its heights as French it is not complete as Polynesian it needs to be attributed in order to exist. Let us dare our creativities not let ourselves be muted by the norms let us write as we are and together let us show that Flora is right

And there definitely is a Polynesian literature today

It exists,
It exists the way it is,
It is the way Polynesian writers have imagined that
it is and say that it is today,
that is, different, varied, Polynesian,
multilingual.

Let us dare our literature let us write without worrying about academic ideas about correct usage about those who judge let us not abandon our "questions . . . too swiftly muffled by the narrow-minded certainties of all those who express themselves from the shelter of their more or less legitimate status" (B. Rigo); let us beware of giving in to/for the recognition of those who proclaim themselves censors controllers dispensers of honors and distinctions who are trying to undo our brutishness plane us smooth sand us down and format us into obedient respecters of conformity they are bound up in their veneration for the honorable superiority of academics. Let us beware of giving in to attempts to disqualify writers who stand apart from western favor to unbalance writers who expand their multi-languages from fear of accepting yet another correction added to our sad litany
socially correct politically correct religiously correct intellectually correct
and from now on

literarily correct. Let us beware of accepting the divisions they try
to force on us as if literary talent poetic creation artistic feeling
were the sole preserve of those who possess learning let us be
indomitable before the diktats of the few who claim to equate
literature with academic success. "These writers mark the
beginning of a new era. All are mature writers, who have worked
for a long time in universities" (D. Morvan)—downgrading
other writing. The writing that comes from the belly from
suffering from the deepest wounds.
Let us beware of thinking of ourselves as thinkers in the place of
the thinkers
powerful in the place of the powerful
thinkers with the thinkers
powerful with the powerful
new conquerors writing the words
the word of power
the word through power
power of the word
power through the word
safe passage for the Other whose "pathway . . . toward Polynesian
culture is strewn with pitfalls and false starts" (D. Morvan)
these inevitable midwives at the birth of all the other "Us" of this
land
deciphering them translating them
these unavoidable interpreters of unfathomable specificities since
"the Westerner's access to the Māʻohi nucleus comes, most of
the time, through the 'Demis,' who straddle two cultures,
'cultural border guides'" (D. Morvan)
sometimes often on the surface of inner life
on the outside of the depths
strangers among us all the other "Us" of this land.

Let us be careful not to paint ourselves up into new masters
guardians of bookish knowledge a new imperialism legitimated by
bachelor's master's doctoral degrees authorized to exalt those
"who straddle two cultures"—stuck between two stools—as the
primary fundamental group suited to the ideas words writing
of this land. "In all likelihood when he or she looks straight
at History, and begins to formulate a story, the story-teller

inevitably experiences divided loyalties for his or her origins"
(S. Grand)—taking keeping speaking writing all the words in the
place of all the other Us in this country who have no degrees not
speaking not writing French
guardians of our memories
who tell History as seen from the side of the natives the defeated.
Let us beware of mistaking prestige and allegiance
of collaborating in our turn in the "political and moral native
surrender" and excluding ourselves forever from "reconciliation
with the generations of men and women down through history
from the dawn of time and successive eras right up to today"
(S. Grand).

Our story is serious our literature is serious our commitment is
serious. Let us take them seriously let us be careful not to take
ourselves seriously.
Let's pull in the nets before we choke.

Note

Previously published in French as "Remontons les filets," *Littérama'ohi* 2
(December 2002).

Speeches from the Centennial of the Overthrow

'Iolani Palace, January 17, 1993

HAUNANI-KAY TRASK AND MILILANI TRASK
TRANSCRIBED BY JOAN LANDER OF NĀ MAKA O KA ʻĀINA

HAUNANI-KAY TRASK: Aloha kākou.

CROWD: Aloha.

HAUNANI-KAY TRASK: Aloha, Ka Lāhui Hawaiʻi.

CROWD: Aloha.

HAUNANI-KAY TRASK: Aloha, the indigenous people of these islands, aloha to you, my love to you because you are still here. The intention was to kill every one of us. And we are still here, one hundred years to the day that the racist American country took our sovereignty.

APPLAUSE, CHEERS

I am not an American. I am not an American. I am not an American. I am not an American. I am not an American. I am not an American. Do you think they can hear us now? Do you think John Waiheʻe is listening? Do you think Dan Inouye is listening? How about the Office of Hawaiian Affairs? We are not American. We are not American. We are not American. We are not American. Say it in your heart. Say it when you sleep. We are not American. We will die as Hawaiians. We will never be Americans.

APPLAUSE, CHEERS

I am here to explain what sovereignty is. Sovereignty, as many people say, is a feeling. The other day in the paper, I read sovereignty is aloha,

it's love. Later on someone said it's pride. No. Sovereignty is government. Sovereignty is government. It is an attribute of nationhood. We already have aloha. We already have pride. We already know who we are. Are we sovereign? No, because we don't have a government, because we don't control a land base. Sovereignty is not a feeling; it is a power of government. It is political power. It is politics.

Hawaiians are always being told, especially at the university, join the Democratic Party. I am here to tell you that my grandfather helped to found the Democratic Party. And I repudiate it in front of everyone. I repudiate the Democratic Party just like I repudiate the Republicans. If the Republican Party gave us sugar, the Democrats gave us Waikīkī. If the Republican Party gave us racism, the Democrats gave us another form of racism. We are not fifty percent Hawaiian. We are Hawaiian. Period.

APPLAUSE, CHEERS

Many years ago the Soviet Union, now called Russia, invaded Europe and divided it up. Recently Saddam Hussein invaded Kuwait. The Soviet Union is no longer in Europe. Saddam Hussein has been pushed out of Kuwait. But the United States has not been pushed out of Hawai'i. They invaded this place. They put the marines here. They took our queen. They put her in prison. Maha'oi haole, racist haole.

APPLAUSE, CHEERS

We will never forget, any more than the people in Latvia and Lithuania and Estonia forgot, any more than the Maori of Aotearoa forgot, any more than the Tahitians forgot against the French. We will never forget what the Americans have done to us, never.

VOICE IN CROWD: Never.

HAUNANI-KAY TRASK: Never, never, never.

APPLAUSE, CHEERS

HAUNANI-KAY TRASK: The Americans, my people, are our enemies and you must understand that. They are our enemies. They took our land, they imprisoned our queen, they banned our language, they forcibly made us a colony of the United States. America always says they are democratic. Lies. That is a lie. They have never been democratic with native people; they have never been democratic with Indians; they have never been democratic with Hawaiians.

APPLAUSE, CHEERS

The United States of America is the most powerful imperialist
country in the world, in the world. They control the United Nations;
they control the Pacific Ocean, all these nuclear submarines
circulating throughout the Pacific. The United States of America is a
death country. It gives death to native people. And the only way to
fight the United States of America is to be political. Hawaiians
must learn to be political. They must learn to analyze. We cannot say
any longer, oh, we are Hawaiian, make nice. 'A'ole, 'a'ole. Hawaiians
were fierce. And people tell me, Haunani, you are so un-Hawaiian.
I tell them how would you know? How would you know what a
Hawaiian is? We have been so brainwashed with missionary bullshit.
Be nice.

APPLAUSE, CHEERS

Kamehameha was a warrior; he made war. His father Kahekili was a
warrior; he made war. When did Hawaiians lose their land? When they
stopped making war. That's the truth. That is the truth.

 Give up Christianity; I say that to you right now. Give it up, be-
cause it tells our people, ho'oponopono, make nice. I say kū'ē, kū'ē,
kū'ē, kū'ē, kū'ē, kū'ē. Fight, fight, fight. Don't make nice. Never make
nice.

 When people say to me, Haunani, you should speak softly. Hau-
nani, you should bear in your heart aloha for the governor. Let me tell
you about the governor, the first elected Hawaiian governor. For five
years, Mililani and I worked in the legislature to get a right-to-sue bill.
That's all, a little civil right, that's all. Not sovereignty, just a little civil
right so we could go into court like everybody else in the state of
Hawai'i and bring claims against the Department of Hawaiian Home
Lands and the state of Hawai'i for mismanaging our lands, for giving it
to the military, as Lilikalā has told you.

 We were resisted by George Ariyoshi. We were resisted by Governor
John Waihe'e, the first Hawaiian governor of this state who doesn't even
pronounce his name correctly.

LAUGHTER, APPLAUSE

For five years we asked for a right to sue, but we didn't get a right to
sue. We got a commission to which we can bring claims so that they,
the appointees of the governor, will decide if our Hawaiians should get
their land. Bullshit. That's what that is. Bullshit.

CHEERS, APPLAUSE

When I first came here to speak about sovereignty, there were maybe twenty people. People said we were crazy to fight for sovereignty. We were off the wall. We went to the legislature for a right-to-sue bill. We got nothing, nothing. Does the Democratic Party support a right-to-sue bill? No. The state of Hawai'i is an agent of the United States of America. They are twinsies. The state is here; America is in D.C.

It doesn't matter who is in state office. I have come to learn that painfully. It doesn't matter whether it's a Kepanī, whether it's a Kanaka, whether it's a Filipino. It doesn't matter because they represent the state of Hawai'i. Ka Lāhui Hawai'i represents Hawaiians, Hawaiians.

CHEERS, APPLAUSE

I am not interested; I am not interested in feelings. I have my own feelings. They break my heart. That's what I share with my 'ohana. But to you, my people, what I say is: politics, politics, politics. This march today took years of organizing. Ka Lāhui Hawai'i has worked years to enroll Hawaiians. There are many sovereignty organizations, but there is only one Ka Lāhui Hawai'i. There is only one group that has taken all that time to do a constitution, to enroll citizens.

That's what nationhood is: it's government. It's not a feeling. Please don't let people mislead you. People keep saying I was born sovereign. I was not born sovereign. I was born a colonized woman of color, oppressed in this colony by the United States of Hawai'i.

CHEERS, APPLAUSE

I was not born sovereign. I'm trying to be sovereign. I'm trying to make a government. We need to understand what is at stake, Hawaiians, what is at stake. It doesn't matter that John Waihe'e lowered the flag. It should be burned to the ground.

CHEERS, APPLAUSE

It doesn't matter; it doesn't matter that there's a four-day break. It doesn't matter. What matters is who controls the land, the water, the resources. Who has a government? Who speaks nation to nation?

Mililani and I have gone to the Congress to see if we could get around Dan Inouye. Impossible in the Senate. Maybe in the House. Maybe, maybe. It's very difficult; it's very difficult to do politics in the state of Hawai'i. All the sovereignty people here who have worked for years know what they do to you when you support sovereignty. They

take away your job; they send people to slash your tires. I'm telling you this so you understand what is at stake.

George Helm and Kimo Mitchell, who are part of the In Memoriam for this gathering, were murdered. Never believe that they were lost at sea. They were not lost at sea. They were murdered.

CHEERS, APPLAUSE

We just don't know. We can't put the finger on who killed them.

You know why Ka Lāhui had so much security today during the march? Because we know we can be killed too. Ten years ago when there were twenty of us, it didn't matter. They weren't afraid. Why do you think Waihe'e says he supports sovereignty now? Because he's afraid.

CHEERS, APPLAUSE

Why do you think the Office of Hawaiian Affairs is saying they believe in a nation within a nation? I had to laugh. I had to laugh. *We* told them about that idea first, we did, Mililani and I. A nation within a nation. They can't even pronounce the word sovereignty. They don't know how to spell it.

The state of Hawai'i is an agent of the United States of America. The Office of Hawaiian Affairs is an agent of the state of Hawai'i. It's very simple. A . . . B . . . C. There's no way we can be sovereign with Office of Hawaiian Affairs. They didn't even support it until all of this outpouring, all of you came forward to say you support it.

APPLAUSE

We need legislation through the Congress of the United States to recognize that we are a native people. They don't even recognize that. We have to go around Dan Inouye. We have to beat him; we have to beat Dan Inouye in office. He needs to get out of office.

CHEERS, APPLAUSE

We need to beat Danny Akaka. Everybody says he's such a nice guy. We don't need nice guys in Congress. He should come home, pau already. What we need is a fighter. We need somebody who is fierce.

APPLAUSE

The age has passed for Hawaiians to be nice. The age has passed for Hawaiians to ho'oponopono. I don't believe in ho'oponopono. I've never practiced it. I don't want to. I believe in fighting to the death. And if we lose, we go down and die and we lose. But I am not making any

deals. I am not going to say maybe this, maybe that. OHA, you take the ceded lands. No. I don't recognize that one-hundred-and-twelve-million-dollar settlement. And too bad for Clayton Hee, neither does John Waiheʻe. He's not paying a penny.

LAUGHTER

Ā hoka, that's what the Hawaiians say. Ā hoka to you, the hewa you did, OHA. Now you have no money. No. I don't recognize the Office of Hawaiian Affairs. I campaigned against them; I worked against them. When we went for the right-to-sue bill, did they support us? No. The Office of Hawaiian Affairs did not support us. The only reason they talk nation to nation now is because they're afraid. They're afraid. The Democratic Party is afraid, which is actually the same thing as OHA. The state is afraid.

This kind of gathering sends a message. The message is many, many people in Hawaiʻi are beginning to be aware of sovereignty. They are beginning to hear Ka Lāhui's voice. They are beginning to think that maybe, maybe Hawaiians should get their land back. And it should not go to the Hawaiian Homes Commission, appointed by the governor. Hello? That is not democracy.

Did you ever notice that the United States goes around the world bombing other people, telling them that they're not democratic? They should come bomb Waiheʻe's house. He's not democratic either.

LAUGHTER

Why don't they send the U.S. Marines to arrest him? He's not democratic. If you believe in democracy, you practice what you believe in. The Hawaiians deserve the right-to-sue bill. Period. We deserve a nation. We deserve land, water, resources. That's the truth. Period. That's the truth. None of this negotiation.

When John Waiheʻe ran for office the first time against Patsy Mink and Cec Heftel and even the Libertarian candidate, they asked him—because we had done such a good job in organizing and bringing to the attention of the press the right-to-sue bill—they asked him on television, do you support litigation rights for Hawaiians? You know what he said? No. He said no, I support negotiation. Every other person supported litigation rights, the right-to-sue bill. Patsy Mink, Cec Heftel, believe it or not, two non-Hawaiians. Waiheʻe was elected because he didn't support the right-to-sue bill. That's the way politics works in the state of Hawaiʻi.

I am so proud to be here. I am so proud to be angry. I am so proud to be a Hawaiian. I am so proud to talk to you because it took my whole life to get here, and I'll be damned if I'm ever going to lie in front of my people.

CHEERS, APPLAUSE

I want to introduce to you a person that I most admire. I am always asked that when I'm interviewed. Who do you most admire? Who I admire is who I love, the person who has led Ka Lāhui, fought to form Ka Lāhui, who worked with the kūpuna, who worked with the community, who gives up everything, who doesn't have a house, who has no job, who has no income. I have a job, sort of. I have to fight for it, but I have it. I have a house although the bank owns it. But my sister has neither because she gave up everything for her people. She has more aloha for the Hawaiian people than anyone that I know.

APPLAUSE

Where is she? I present to you, ladies and gentlemen, the Kia'āina of Ka Lāhui Hawai'i.

STANDING OVATION

MILILANI TRASK: Aloha, everyone.

CROWD: Aloha.

MILILANI TRASK: It is a great day for all po'e Hawai'i, for all Kānaka Maoli. This morning, as the sun lifted up, we saw the dawning of a new time. We have not come here to celebrate, nor have we come to mourn. But we have come to mark the turning of a page in the history of our people and to close a chapter of betrayal and treachery and of oppression, a chapter that was opened a hundred years ago on this day when American businessmen and the forces of the United States military marched here and, in open treason, overthrew the lawful and peaceful government of the Kingdom of Hawai'i and imprisoned our beloved queen. Today we remember the dignity with which she stood against great odds. And we strive, each and every one of us in Ka Lāhui and those who are not, to emulate that dignity and integrity, because we are called upon now to begin writing a new chapter in the history of Kānaka Maoli.

CHEERS AND APPLAUSE

I want to acknowledge and welcome all of you who have come from all of the islands. You heard earlier from our po'o. I want to thank and

honor our kūpuna who came in many days ago and who, for three nights from eight to midnight, have come here to pray on the palace grounds. They lead us in this struggle. They lead us in prayer.

I want to acknowledge all of the branches of the government of Ka Lāhui Hawaʻi, our Aliʻi Council, and especially acknowledge the Nā Koa who have provided security here. Mahalo.

APPLAUSE

I want also to thank the members of the Ka Lāhui planning and steering committee for the work that they have done. And I want to acknowledge the many, many days of hard work done by Keahi Allen, the ʻOnipaʻa committee, and Senator Eloise Tangpalan for working with us. In this way, they demonstrate hoʻolōkahi, hoʻolōkahi, many people working in unison: Ka Lāhuiʻs planning committee and the ʻOnipaʻa committee. We celebrate here today because we have hoʻolōkahi.

There are three things that I wanted to go over on this momentous occasion. [The first is] ʻike pono, ʻike pono, the name of the march and the demonstration that brought us back to this ʻāina hānau, this place of the birth of ea, of sovereignty.

I want also to present for your critical review the platform of Ka Lāhui Hawaiʻi in all of the four arenas of sovereignty. And lastly, it is my responsibility and obligation to present for your consideration the counterproposal that is currently being moved by the Democratic Party, state agents, and certain private individuals to stop the resurrection of the sovereign nation. These three things are critical because we are at a turning point in our history. And in a hundred years when they look back and reflect upon this day, they will mark this gathering as the turning point.

CHEERS AND APPLAUSE

ʻIke pono is the Hawaiian term for righteous understanding. When we march to the palace, we chant ʻike pono so that we can fix our mind and focus our mind on the goal at hand: ʻike pono on the issue of sovereignty. The time has come for everyone to understand what sovereignty is. There is great debate. There is great dialogue. And this is appropriate. This is the Hawaiian way.

Sovereignty is an attribute of nationhood, and it is incumbent upon all of us, it is the responsibility of the native people to define that word. [You] can go all over the world, look at models of sovereignty, bring home their definitions. But the issue is what is appropriate for poʻe Hawaiʻi, Kānaka Maoli, and what is culturally acceptable.

In Ka Lāhui Hawai'i, we have no more disagreement or pilikia about the word "sovereignty" because we have 'ike pono, one understanding. The Hawaiian definition of "sovereignty" that we acknowledge is this. There are five elements to sovereignty, and the first is of strong and abiding faith in the Akua, as our brother, Kawai, mentioned earlier. We begin with the Akua. We end with the Akua. With God and with the spiritual basis, this is the true foundation for any sovereign nation. Number one in sovereignty: a strong and abiding spiritual practice. Let all of us make clear our spiritual path, whether you are traditional or Christian. And there are many of the Christian churches who have come to stand with us today, the Protestant and the Catholic alike, that passed resolutions in support of Hawaiian sovereignty.

APPLAUSE

The Akua is number one. And Kānaka Maoli: the second element of sovereignty. We are here, we are resilient, we have not gone away. We are one 'ohana with a common culture and language, with a common land base. The second element of sovereignty, ourselves.

The third element of sovereignty is a land base. In Ka Lāhui Hawai'i we have identified the native lands that are rightfully the property of po'e Hawai'i. Some of these lands are controlled by the state. The Hawaiian Home Lands trust: two hundred and three thousand acres controlled by the state. The ceded land trust: 1.4 million acres of land set aside for the Native Hawaiian people, controlled by the state. The private trusts of Queen's Hospital and Kapi'olani Hospital, the legacy of the monarchy for the indigent and the sick of our people, assets withheld from a native people who suffer the worst health statistics in the United States of America. Queen's Hospital and Kapi'olani Hospital trust assets belong to the native of this land.

APPLAUSE

The Kamehameha Schools Bishop Estate trust—the legacy of the monarchy to educate our children. Lili'uokalani and Lunalilo trusts also—the legacy of our people. We have vast and broad trust assets controlled by the state and private sector corporations. The time has come to ho'ohuli, turn this over, return the land to the native people.

APPLAUSE, CHEERS

The fourth element of sovereignty in Ka Lāhui's collective mind, we have 'ike pono, the fourth element is a structure of government. We can no longer remain separate 'ohana, different organizations. We are

called upon to come together, to speak with one voice. Many, many others within our sovereign movement come forward. They say, geez, you know, why you folks want everybody to come to one? And I tell them that I, in learning the history of my people, in researching, talking with my kūpuna, and I want to thank Pua Kanaka'ole Kanahele for teaching me this, the prophecy, the prophecy that was given by our kāula, our seer—many years before Kamehameha mō'ī ascended, it was seen in the prophecies of our people. And that kāula uttered these words:

> E iho ana o luna,
> Those which are below will be lifted up.
>
> E pi'i ana o lalo,
> Those at the pinnacle are to be cast down.
>
> E hui ana nā moku,
> The islands come together as one hui.
>
> E kū ana ka paia,
> The walls of the nation are lifted up.

CHEERS AND APPLAUSE

E hui ana nā moku. The islands are called to come to one hui. We have named this Ka Lāhui Hawai'i.

. . .

We do this in Kā Lāhui Hawai'i because there are four arenas of sovereignty. The first arena of sovereignty is native to native, what we as Kānaka Maoli say to each other, what we define to be sovereignty, how we will structure our nation, what lands we claim. This is the first arena of sovereignty. And Ka Lāhui presents a program of education to inform our people about their trusts and their entitlements, and also to inform them of the breach of trust on the part of the state and the federal government. Ka Lāhui two days ago had twelve thousand citizens. In the last two days, you have made us be fourteen thousand strong.

CHEERS AND APPLAUSE

The second arena of sovereignty relates to the native people and the country that has stolen their land. In the case of Hawai'i nei, Guam,

Puerto Rico, American Sāmoa, and many others who are native people who must relate to the United States, the United States does not recognize independence, but instead has created a policy by which it purports to give Native Americans the right to control their lands. That policy is a lie because it has never been applied to Native Hawaiians.

Today, a hundred years after the treachery and infamy of American fighting forces, we continue to live as wards of the state. In our hearts we wish to be free. But we know the history of Amelika. We have read in the schools: those who have stood for justice and have tried to secede have been killed. And in the American Civil War, one million murdered because they dare to suggest that they could pull away from the United States. This is the history of America. And this is a nation committed to peace and disarmament, Ka Lāhui Hawai'i. We will not give America any opportunity or any excuse to kill any more Hawaiians. We are going to call forth to America and suggest to them that perhaps it is time that they live with the integrity of their own words.

In the third arena of sovereignty, the international arena, Ka Lāhui Hawai'i has been very active for several years. We have been there at the United Nations to educate them about our condition. Last year, with the help of our brothers and sisters from Aotearoa, who honor us by coming, we were able to take to the United Nations the Civil Rights Report. Ka Lāhui did not have money. Our brother, Kawaipuna, had passed away. And so it was the Maori people who sent an emissary here to take our palapala to Geneva. Thank you, our brothers and sisters from Aotearoa. They move the sovereignty struggle when we cannot.

APPLAUSE AND CHEERS

Our work in the international arena will take many years. Guam, Puerto Rico, continue to fight for complete independence. Over fifty years they have fought, but they continue. We must move an agenda in the international arena at the same time that we move an agenda with America to regain our lands.

And the last arena of sovereignty is nation to nation, how we as a native nation relate to other native nations. I want to honor and welcome the representatives of the Tlingit nations who have come to join us today. They have been here for a week. If you did not hear, last week Thursday, Ka Lāhui Hawai'i signed its fourteenth treaty with native nations in Amelika, Native American Indians and Alaskan

Natives joining together with Ka Lāhui Hawai'i. Fourteen treaties we have.

APPLAUSE AND CHEERS

Ho'opāpā, let those with proposals come to the foreground, and let them reveal to their people what their strategy and program is. Let us cease the empty talk about sovereignty and let us test the mettle of our own people.

APPLAUSE

Sovereignty is not waha. Sovereignty is not wala'au. Sovereignty is what you do with the gesture of your life. I am proud. I am proud to be the elected Kia'āina of Ka Lāhui, the many thousands of our people who have worked to accomplish and to make progress in the four arenas of sovereignty.

APPLAUSE

And now in the tradition of ho'opāpā, I want to share with you my criticisms of the current proposal, the countermovement that is being very well organized and now financed by the Democratic Party, their underlings and syndicate connections. Let us now talk the business of this challenge.

Many years ago, natives for many years have been saying, give to us our lands, the Hawaiian Home Lands, the ceded lands. We could not protect the trust assets that were being distributed to non-Hawaiians. And we know who they are because the names were printed in the front page of the *Wall Street Journal,* all of the Democratic connections stealing the Hawaiian Home Lands while the Hawaiian people lived and died in poverty and desperation. We know their names.

Now they have worked out two settlements, the ceded lands settlement, negotiated by John Waihe'e, Clayton Hee, and others who violate the state sunshine law. Do they believe for a minute that the people will surrender 1.4 million acres of land so that Clayton Hee can get a hundred and eleven million dollars? We are keiki hānau o ka 'āina. We are born from this land. This land is our mother. You don't sell your mother for a hundred and eleven million dollars.

APPLAUSE, CHEERS

The cost for putting homes and infrastructure on Hawaiian Home Lands is two billion dollars U.S., but the Democrats and the governor

say that all claims are resolved now. They got twelve million dollars. What about the twenty-two thousand [people]? We will not keep our people homeless on the beach for eleven-million-, twelve-million-dollar settlement. This proposal is rejected by Ka Lāhui Hawai'i.

APPLAUSE

The political powers in this state have this program that they are moving very subtly. Number one: prevent Hawaiians from accessing the federal court system to sue them. And while you are delaying Hawaiians, rush through settlements of their trust lands. When you hear John Waihe'e and Mr. Inouye talking, they are saying the one who is wrong, the one who is guilty, is the United States of America. Then they are silent.

Surely they must know the history of our people. America overthrew our queen and stole our lands. And in 1959, America gave [away] our people, our children, our kūpuna, we were given in a status of perpetual wardship to the state. And our lands were also given to the state to be held in trust. The stolen lands that were taken by Amelika are now under the control of the Democratic Boys Club, John Waihe'e and the alleged rapist Dan Inouye.

CHEERS AND APPLAUSE

We know our history. Amelika, you are responsible, and your agents and underlings as well. We have business to do with our own people. Ho'opāpā, let the great debates begin so that we can 'ike pono, develop righteous understanding.

APPLAUSE

I want to acknowledge that there is a great political debate going on with our people and the Office of Hawaiian Affairs, which was created in 1978 to be a straw dog for sovereignty. There is nowhere in the United States a native nation that also happens to be a state agency. But John Waihe'e wanted to create one. You know, he went into the executive from the 1978 Constitutional Convention. He was able to garner all the political party support of the Democrats because they're rewarding him for pulling the plug on native initiatives for sovereignty coming from Wai'anae on the island of O'ahu. Ho'āla Kānāwai. [They thought] Let us eradicate this movement. Let us create the Office of Hawaiian Affairs patterned after the Bureau of Indian Affairs. And for many years, all the positions in that office were held by those who

betrayed their people. But now, hoʻohuli. We have some independent voices in the form of trustee Rowena Akana and hope in the form of Sam Kealoha and Moanikeala Akaka.

APPLAUSE, CHEERS

So as we engage in the debate of hoʻopāpā, let us not speak in generalities. Let us see that there are criminals like Clayton Hee. And then there are those who are forthright, like Rowena Akana. This is part of hoʻopāpā, that the truth be told, that the one's name who is responsible be spoken. Hoʻopāpā.

In closing, I want to say that sovereignty is not for sale.

APPLAUSE

There is an undercurrent moving now in the Hawaiian movement. Perhaps we should go back to the identified leaders of the Hawaiian people. Perhaps we should grovel, perhaps we should beg, perhaps we should ask them to give us the kālā.

VOICE: ʻAʻole.

MILILANI TRASK: In recent days, I have been approached by leadership from other sovereign organizations suggesting that perhaps it might be lucrative if I would see Mr. Larry Mehau, Mr. David Trask. As I said earlier, we have turned a page in our history and closed a dark chapter. Sovereignty is for everyone. In the time past there were a handful of power brokers and you had to grovel and curry their favor to achieve anything. I have never traded on my family name, nor have I accomplished anything by accessing the political influence of others with the name of Trask. My grandfather was the first Hawaiian sheriff of Honolulu and later a territorial senator who fought for the rights of his people. That is the reputation of my family, and not sitting up in some tower, in some political bastion, giving out favors. I cannot go to Uncle Larry Mehau or David Trask, because I am accountable to the people.

APPLAUSE

And to them, my own ʻohana and Mr. Mehau, I send this piece of advice: perhaps the time has come when you should come down from the big mountain and stand shoulder to shoulder with your people.

APPLAUSE, CHEERS

Sovereignty is not for sale.

We are not going to pander to the media. We are not going to sell the rights of our people for a fifty-thousand-dollar telethon. We are not going to do it. And in the tradition of hoʻopāpā, let me respond now because I will be gone from the microphone when this latest ploy to move sovereignty to the rear is disclosed later this afternoon. Before I ascended to the mic, I was given a royal proclamation from one of the ʻohanas here. They are saying that this proclamation will acknowledge and honor Senator Daniel Inouye because he recognizes our sovereignty and inherent rights. Senator Daniel Inouye, who for thirty years has been in the U.S. Senate.

CRIES OF DISSENT FROM CROWD

MILILANI TRASK: Did you read the U.S. Commission on Civil Rights Report that documented seventy years of our people's human and civil rights being violated? Read that document. It verifies what we have been saying for many years. Seventy years of human and civil rights violations. And for thirty years, Dan Inouye has ensured that those civil rights would be violated. Hoʻopāpā. We will not proclaim this.

And the next paragraph, commending the governor of the corporate state of Hawaiʻi for supporting Hawaiian sovereignty. Is he not the chief executive who, for ten years, has kept his people impoverished on waiting lists while he negotiated settlements of their homelands and transferred hundreds of acres to private sector non-natives and people with political connections? We will not support this statement. We will not.

CHEERS, APPLAUSE

In closing, there are two points that I would like to make. The first is that we need to look in each other's eyes and recognize our great capacity. We are impoverished. We are denied the right to access our lands. We have serious health and medical needs. But we are resilient. After a hundred years, we are here to stand for justice.

We make this state run. We are the ones who serve the tourists, carry their bags, open their doors. It is our brothers and fathers who drive the big trucks who deliver their food, who allow them to do business.

All Hawaiians, ʻike pono. Focus your mind. Together, when we harness our energy, when we count our vote, we can make a change. I want to encourage you all to look at the proposals that are being enunciated in the Hawaiian community and to consider that there is a

nation here that welcomes you in, each and every one of you, no matter where you are, even as we welcome the islands of Lāna'i, Ni'ihau, Kaho'olawe, and our people from Kalaupapa. There is a place for you in this Hawaiian nation of Ka Lāhui Hawai'i.

Note

Transcribed from *Scenes from the Centennial* (Nā'ālehu, Hawai'i: Nā Maka o ka 'Āina: Hawaiian Documentary and Educational Videos, 1993). www .HawaiianVoice.com/.

Something in the Wind

MICHAEL PULELOA

LYDIA KAMELEMELE IS a beautiful French-Hawaiian woman and has lived all her life on Moloka'i. She has long dark hair she pulls back and wraps tightly in a bun held together with a hair pick that looks like a miniature kāhili. She has little star tattoos on her hands. And a mo'o tattoo at the back of her neck.

She's on the stage in Mitchell Pauole Hall in Kaunakakai Town, sitting among a panel of four others: her younger sister, Lynette Kamelemele; two employees of a national renewable energy company, Likolani Johnson and Syd Kamahana; and one representative of the Hawaii State Department of Business, Economic Development, and Tourism, Rich Rhoady.

Lydia is excited by the large turnout. She can't help but be, so it's reflected in her smile. She's been to community meetings on Moloka'i all of her adult life, and she can't remember one with so many new faces. She sees the usual suspects, a handful of those who always attend these meetings. And she also sees faces she has not seen in a very long time. Kūpuna from many of the moku on the island. Young parents and their children. All these teenagers. Family members. Old friends.

There are handmade protest signs taped to the walls inside the hall—the work of children, students from schools across the island of Moloka'i. They read, *'Aha Moku—Hawaiian Leadership* and *Honor Our Kūpuna* and *Boycott State Process*.

The cafeteria tables in the hall are full with Moloka'i people— older ones in aloha-print clothing, mothers and fathers, their keiki. There are people of all ethnicities, including recent transplants here for

the talk of the town. At the back of the hall, men in jeans and T-shirts sit on park benches that have been brought in before night.

It's near sunset, and golden afternoon sunrays enter through the large sliding doors on the west end of the hall.

Outside, there are families and groups of children, too. Some huddle at the edges of doorways; others are sitting at park tables in the evening shade of the building. Lydia sees them greeting one another—shaking hands, hugging, talking story, and laughing—until from the stage inside the hall a low, reverberating sound, a man's breath, emanates from a pū.

Then there is near silence. And faces turn toward the stage.

Soon, there are oli kāhea and oli komo. And the near silence turns into a boisterous exchange of chanting that carries through the hall and spills out its doorways and into the streets of town.

The hall is filled with mana, Lydia thinks, and she lifts her pen off the table and begins to note names of the meeting's attendees.

———

The man facilitating the community meeting is standing on the stage beside the panel. He is short, but sturdy, muscular. The sound of his voice reminds Lydia why she is there, sitting beside her sister, the two young Hawaiian panelists, and Mr. Rhoady. "One's culture," the facilitator says, "cannot survive without the resources of its land and sea."

The people in the hall applaud in agreement. Some raise an arm in the air. They even whistle. The man turns to look at the panel and then he begins to introduce them to the crowd.

Minutes later, Mr. Rhoady, a representative for the state, leans into the microphone on the lectern and says, "I am passionate about Hawaii's future. And I believe we can work together to help insure the health and prosperity of its people." He looks around, trying to make eye contact with those nearest the stage. The crowd is attentive, almost eager to hear what he has to say. "It's clear our dependency on oil has gone on for much too long. If we care about our environment, we must start looking at other means for generating our energy. We must look to the wind."

Lydia puts down her pen when she sees—at the edge of her vision—a kupuna stand up and raise his hand. The old man is from Hoʻolehua, just outside Hawaiian Homestead land. He had been her father's friend. He is her best friend's father. So seeing the old man

makes Lydia wonder what her own dad might be thinking of all that's spiraling around her and throughout the hall. After a few seconds, she smiles at the old man and then points him out to Mr. Rhoady.

When the hall is quiet, the old man says, "I've lived Moloka'i for over sixty years, moved here when I was a boy. My father, he was a farmer, good one, and he brought us here because he knew we'd always have 'nough. I don't need your windmills to be healthy."

Mr. Rhoady looks down at his notes. He's prepared for a comment like this, but he fidgets with his papers for a few seconds before returning to the old man. He needs to be thoughtful. Sensitive, he reminds himself. He is glad to be on Moloka'i again. The first and only other time he was here, he was told at a meeting very similar to this one, never to return unless he was invited back. "Yes," he says. "Moloka'i is a wonderful place. A beautiful island. In fact, it is one of the most abundant wind resources in the world." He pauses. He wants that last part to resonate in the hall.

Likolani Johnson, the employee from the national energy company, reminds Lydia of what she might've been like when she was the young woman's age. They'd met once before, when Likolani's company flew Lydia, Lynette, and a few other Moloka'i residents to O'ahu for an informational meeting regarding the company and their plan to run energy from Maui, Lāna'i, and Moloka'i to O'ahu. Likolani's from a rural community in Hawai'i, just like Lydia. She grew up wanting to help other Hawaiians, just like Lydia. She is headstrong, passionate, and apparently willing to face vehement opposition in pursuit of her beliefs. Just like Lydia.

It's too bad, then, Lydia thinks, that Likolani seems to know so little about Moloka'i. So it's out of respect for those other things that Lydia remains seated and tries to quiet the crowd with her hands when they have risen from their own seats in the middle of Likolani's self-proclaimed informal presentation. It seems the crowd is still worked up over Mr. Rhoady's final remarks.

It's getting dark outside. And everyone in the hall, Lydia understands, has had a long day. They've driven in from all across the island. They don't want to hear about O'ahu's energy crisis. They don't want someone, anyone, telling them that it's their kuleana to kōkua another island, especially when all they see and hear on television is an endless list of O'ahu's planned development projects. Lydia takes a deep breath

when she realizes it may be her responsibility to teach Likolani to understand this, too.

There are other signs taped to the wall behind the stage in the hall. They read, *Wind Is Our Culture!* and *Honor Our Kuleana* and *KA MAKANI = OUR KULEANA.* Syd Kamahana, the second young Hawaiian employee from the natural energy company, knows what these signs mean. From behind the lectern, he takes a moment to point out the signs before he turns to the crowd. "Mahalo for the invitation to attend tonight's meeting," he says. "I'm not sure how, but I know I'm related to some of you here. I'm a Kamahana, and our 'ohana on O'ahu will be here this summer for a family reunion. I work with Likolani; she's a good person. A very good person. And, like me, she wants what is best for all."

There's an air of cautious interest rising from the crowd. A desire by the people for some kind of connection with this visitor on the panel, but also some hesitancy. There are murmurs regarding the young man's eloquent display of Hawaiian language when he first entered the hall. There are whispers about why he doesn't know how he's related to a few of the elders in the room.

"This is a tough thing," Syd says. "But we need to have these talks. We need to make the right decisions for our future here in Hawai'i. Mahalo. Mahalo again for having me here."

Lydia wonders just how much this new strategy by the national energy company—to bring in a handsome young Hawaiian man to defend industrial wind development on the island—will affect the community's opinion on the project.

Night has arrived and the people in the hall are growing restless. It's a school night, so some of the parents begin to look for their children, who by now have left the hall and are playing outside. The parents, the people, everyone in the hall, they all understand that oil is not the final answer. But they're concerned that the panelists, all but the Kamelemele sisters, have not been candid. There's been no mention of the scope of this proposed alternative energy project. No mention that the size of each windmill will be more than four hundred feet or that there may be more than one hundred of them planted on the island's west end. Nothing to address their serious concerns. Only that when the project is

completed, residents on Moloka'i will qualify for the same electricity rates as those on O'ahu. And even here, things are blurry.

Finally, it's time for questions from the crowd. Those who've been listening outside begin to filter in. Men, women, and teenagers at the tables stand and raise their hands to secure a mic. There's plenty of movement. Things are stirring in the hall.

———

Lydia feels a wind enter through the east doors even before it reaches the stage and the panelists sitting beside her. She imagines the long route the wind has taken to get here, from beyond the highest points on Kamakou, to reach sea level and Kaunakakai. Then she imagines another wind that began alongside this one, a wind still outside, and now moving beyond the town hall and west toward the proposed project site—across Ho'olehua toward Kaluako'i—swirling over the many valleys and gulches toward Maunaloa, or sliding over the plains to reach 'Īlio Point. This wind builds in strength as it moves, cutting over the island's dark landscape, splitting itself whenever it meets a hill. She feels its energy as she imagines it spreading across the west end of the island. And suddenly she is lost in thought.

She is not able to hear the crowd anymore. She doesn't hear the young man who stands to ask what studies have revealed about long-term detriments to people and the environment near or around large-scale wind turbines. She doesn't hear the elderly woman who insists that an argument for renewable energy based on the dangers of oil is nothing more than capitalist scare tactics. She doesn't hear the old Hawaiian man who says he petitioned to keep the windmills off Hawaiian Homes Lands and that he'd sooner die than see them anywhere on Moloka'i. She doesn't hear the high school girl who asks the panel about research the company has done on O'ahu's energy consumption.

———

The men at the back of the hall are pacing back and forth against the wall. Some do all they can to control themselves. They yell in agreement at anti-windmill comments and when questions seem to confound the panelists. It's all they can do to keep from walking right up to the stage and ripping everything apart. They've seen development projects before. They've seen these projects cover religious and historic sites. Projects that have fallen by the wayside, leaving only crumbling concrete and rusting metal infrastructures. There's no more buying in

for the lure of benefits. Finally, one of the men finds a mic and addresses the panel of visitors. "I've listened to what you have to say. I listened because I was told it's protocol. You came and you asked to enter." Then he points to one of the students still in the hall, a girl who suddenly finds herself looking down, eyes to the floor. "That's my daughter. Her and her friends, they oli komo so I can listen. Now I've heard enough. I can make this simple." He turns to the crowd, asks, "Who in here wants to hear more about windmills?"

The hall goes silent.

"Who is *against* windmills on Moloka'i?"

Every single person in the crowd raises a hand.

"That's your answer," he says. "Simple."

And the rest of the men in the hall yell in agreement.

––––––––

Lydia sees the wind moving in the darkness. It is a big wind now. Kumuma'oma'o. The easterly wind of Kaluako'i. It spreads like electricity under the nighttime sky until it covers the western half of the island. She imagines her daughter, Awali'i, her grandfather's favorite, as a speck somewhere on the Ho'olehua Plains, playing in the wind. She imagines her daughter racing over homestead lands with a little flashlight and hiding in the tall, soft grass. And all at once, Lydia's attention returns to the hall, then to the crowd, and finally to the panel and the facilitator still on the stage.

She stands up and asks for the microphone. "The 'Aha Moku," she says, "that's why I've come. Not for the windmills. But these things are connected—the 'Aha will help in times like these, allow us the opportunity to take legal, organized action. I am here tonight on behalf of those who've spent their own money and volunteered their time to tell you this."

The crowd begins to take their seats again. It's late, but Lydia is someone the people have come to trust. She's worked in the community, with the community. She's fought when they've needed her. A few of them have even found themselves at the front door of her Ho'olehua home when it seemed there was nowhere else to go. Most of all, however, the people in the hall want to hear about the 'Aha, their means, they've been told, to self-governance.

Lydia holds stories of Moloka'i close to her heart. Over the years, she's sat beside elders in their homes as they've shared their knowledge

of the island's history. She's spent countless hours over books in the library cross-referencing information. And she's walked the land.

When she was a girl, she was her father's child, always at his side, taking note of what he did and how he did it. She followed him into the eastern valleys of the island when he hunted pig. She camped with him in the forest on nights when even her father's friends stayed home. She jumped fences with him on the west end to hunt deer. She was good with a gun and a knife, even then.

Lydia's daughter, Awali'i, is the one who followed Lydia when she was a child. Awali'i will become the repository of all Lydia has learned in the course of her life. But Awali'i isn't here tonight. She's not at home, either. She's not running through the grass under the nighttime sky of the Ho'olehua Plains. She's on O'ahu, probably doing homework, calculus or physics, alone in a dormitory room, studying.

———

Likolani Johnson remains seated when the facilitator hands her the microphone to address the questions and concerns posed by the crowd. She is an intelligent young woman, and surprisingly poised in light of the recent turmoil generated in the hall. She's a country girl, college educated, and she believes, no matter what others in the room might think, that the Moloka'i community cannot simply denounce the idea of windmills on their island for the sake of keeping its rural community feel. The wind, she believes, like any other resource, cannot be disregarded.

———

As the crowd continues to stump the visiting panelists with questions regarding the development of industrial wind energy on the island, Syd Kamahana begins thinking about the life his path has taken so that he's found himself here, tonight, in the meeting hall of Mitchell Pauole Center. He remembers more than anything these moments from his college education: the economics lecture on sustainability; the introductory music class where he was taught he could never sell out, only buy in; and the Hawaiian studies discussion on the Hawaiian god of wind, La'amaomao. He understands his mere attendance carries just as many contradictions as the lessons he took from those classes, and suddenly he finds himself leaning over, looking at a little girl approaching the stage.

It's his turn now to be carried off by the wind, to think of his own daughter in their home on Oʻahu, and to wonder whether when she gets older she'll have a comfortable life in the place of her birth.

———

Rich Rhoady has mixed feelings about the way things are turning out. He's glad to be sitting here in the hall, listening to the concerns of the Molokaʻi community. He does want to help them. But he's also worried that he hasn't come close to convincing anyone of the necessity of wind power on the island. The men at the back of the hall are angry, and he really can't blame them. He understands what it's like to feel threatened. He understands that people aren't just going to let the project happen if they don't embrace its complexity.

There's something unique about this community, and he sees it now. He sees it in the way the people get charged up, the way their energy moves throughout the room. He takes a moment to consider this, and then he pulls a pen from his pocket and begins noting some of their comments.

———

In this small island community, there are warriors and peacemakers, and Lynette Kamelemele, Lydia's younger sister, would qualify herself as the former. She wouldn't think twice right now to stand up and smack a panelist for being disrespectful to her sister or to an elder in the crowd. She's come close to that before.

She'll sit beside her sister because her sister needs her there. They make a good pair. The older one, the wise one. The younger, the fighter. She's here to help explain the ʻAha concept to the community, but she's perfectly fine just sitting there. A presence. Helping take it all in. Her sister is good at what she does, anyway, so the meeting now is really about these windmills. She's been here before, just like her sister, so it's easy to see where this is going. The last time Rich Rhoady came to Molokaʻi, Lynette was in the crowd that told him not to come back until he was invited. And she didn't invite him back this time. Now he's come with two young Hawaiians, good kids, no less, and she thinks he's up to something.

There are more than fifty recorded wind names for the island of Molokaʻi, and many years ago, Lynette memorized each of them— where they travel, their unique characteristics, when to find them dur-

ing the year. As far as she's concerned, the wind is like the land. You just can't own it.

————

Rich Rhoady stands up and takes the mic again. He's feeling better now. Now that the two young Hawaiian panelists have spoken, the crowd's energy seems to be bouncing off the wall behind him. It's almost chaotic, a good time to step in. "On the way here," he says. "I was thinking about an analogy I could use to help us in this process. And when we reached Kaunakakai, I was reminded that there are some great mango trees on the island." He points out the doorway, into town. "Let's imagine you have a tree that's produced an abundance of mango, and it just so happens that I'd like some. I'm coming here to ask you what it is that I can give you. I want to make a fair trade."

Suddenly, all the energy in the room seems to refocus itself around the stage, around Rich Rhoady, and onto the very words that have just come out of his mouth. A young Hawaiian man in the crowd at the back of the room stands up and begins to approach the stage, cutting between the tables at the center of the hall until he's met on his way there by the facilitator, who steps in front of him and hands the young man a mic. "You're all off!" says the young man. He's fired up, but somehow he maintains his composure. "That's not it. We don't expect anything in return. If you've come for something and you're pono about it, we let you take 'em. For nothing. But if your intentions are wrong, if all you want is to sell the damn mangos, then there's nothing you can give us." He drops the mic to his chest. "Can you understand that?"

There is a silence again. Some of the people in the crowd are standing up, and Mr. Rhoady doesn't know if he should answer the young man or just accept what's been said. Some parents and children begin to file out of the hall, and when the young man sees this, he places the microphone on one of the cafeteria tables and walks out too.

————

Lynette Kamelemele knows translations can be complicated. It's a lesson her grandmother taught her when she became the punahele. Her own name, Kamelemele, for example, which she had been taught in grade school meant "yellow," really refers to "a time of burden or sadness." A name given to her family in commemoration of an event before the arrival of aliʻi to the island of Molokaʻi.

As she watches Mr. Rhoady return to his seat beside her, she thinks about the Kaunakakai wind, Haualialia, a wind that whips, smiting fear. She thinks it's perfect, and she wonders if it could be translated in any other way.

Lydia Kamelemele places her hand on Lynette's. It's a sign that she feels it's time to step off the stage. Time to take their place among the people in the crowd. They've done their job tonight. It's not about windmills. It's about the 'Aha. She collects the papers and posters on the table in front of her, and then she pushes back her chair.

The people of Moloka'i have always come together in times like these. They find ways to put aside their own differences for the greater cause. But it's been a while since she's seen such a definitive stance against an outside agency like this, and she's glad she's been a part of it. There's something about a night like this, she thinks. And she feels a sudden burst of energy when she takes one last overview of the hall and finds a group of teenagers holding hands in a circle near one of the doorways.

In a while, after she has walked out into the parking lot and said good night to her sister, Lydia will be the only person in the car when it makes its way out of town and up the dark, two-lane highway toward her Ho'olehua home. She'll pass Kalama'ula and Nā'iwa, where the winds there will funnel in through the windows of the car before they release her and send her on her way. When she pulls into her driveway, she'll hear gravel crumbling under the tires and see a little porch light behind ironwood trees. She'll step out of the car and into the wind, and it's then she will decide that the first thing she'll do when she gets inside is pick up the phone and call her daughter.

Sovereignty out from under Glass?

Native Hawaiian Rhetorics at the Bishop Museum

Lisa King

Introduction

The long relationship between Euro-American museums and Indigenous peoples bears a legacy of problems and abuses, as museums have interpreted Indigenous peoples' histories and cultures through an exclusively Euro-American worldview. The Bernice Pauahi Bishop Museum of Honolulu is no exception. It is this chapter's purpose to explore the ways in which the Bishop Museum has recognized this colonial rhetorical framework through which it has maintained and displayed its collections. In particular, the chapter analyzes how the 2006–2009 renovation of the Hawaiian Hall facilities at the Bishop Museum was an active, if ultimately ambiguous, attempt to decolonize the rhetorical habits of the institution regarding its relationship with the Native Hawaiian[1] community. By tracing the museum's history and ending with a close reading of the Hawaiian Hall exhibit, this chapter explores how the participation of the Native Hawaiian community in the renovation has created opportunities for ongoing "rhetorical sovereignty" in specifically Native Hawaiian terms while simultaneously revealing the problems and ambiguities of trying to do so within a traditionally colonial framework. In what ways can that which has been locked under glass be made to speak again?

Museums, Rhetorics, and Representations

Museums are rhetorical spaces. If rhetoric can be broadly understood as looking at the construction of narratives or arguments, their purposes

and consequences, the context, the speakers, and the intended audiences, then museums are highly rhetorical in nature. Though more than alphabetic text, museums carry persuasive and communicative force in the narratives of history and culture they create and present to particular audiences. Scholars of contemporary museum studies acknowledge that museums are sites designed most frequently for education and that museum visitors mostly understand museums to be purveyors of truth and authenticity. Curators and exhibit designers choose objects from collections, write labels, gather research, and assemble multimodal, multimedia presentations in exhibits that are rhetorical in terms of the purposes and goals of the presentation, the content choices, how those choices are presented, and for whom the presentation is made.

Museum studies scholars[2] such as Eilean Hooper-Greenhill argue explicitly that exhibits can be read like texts—"pedagogic functions of museums can be analysed by reviewing both *what* is said, and *how* it is said," she asserts—and also, as can be done with texts, multiple meanings may be drawn from them depending upon the audience (Hooper-Greenhill 2000, 3–4). The audiences are a key component in the meaning-making process since not only do audiences draw multiple understandings from museum exhibits, but, as mentioned previously, they also imbue what they understand to be true with a special authority because they make that meaning in a museum. Audience-exhibit relationships are further complicated by the emergence of constituencies (the communities who are represented in the museum's exhibits and to whom the museum has a responsibility in representation) and audiences (those people who come to see the museum), and how exhibitions must reflect both groups' needs—especially when constituencies and audiences overlap.[3] In sum, museums, and especially exhibits, are rhetorical in that they are communicative sites assembled with particular purposes, constituencies, audiences, and audience reactions in mind.

Within recent decades, many museum studies professionals have observed a global trend toward a new museology that acknowledges such complexity. The 1970s saw the beginnings of conversations about the ethics and responsibilities of museums to a wider community (Simpson 1996, 71–72). On a worldwide scale, the new museology movement emerged from discussions, conferences, and the committee work of the International Council of Museums under the auspices of the United Nations Educational, Scientific and Cultural Organization, and was and is primarily concerned with "giving people control over their cultural heritage and its preservation as part of how they main-

tain, reinforce, or construct their identity" (Kreps 2003, 10). Meanwhile, Indigenous peoples have begun building their own museums and cultural centers (Simpson 1996, 73), especially since the enactment of the Native American Graves Protection and Repatriation Act; Brenda J. Child (2009) asserts that tribal museums in North America "[exist] to contest and critique colonial notions of American and Canadian history that have been so disempowering to tribal nations" (251). Worldwide, Indigenous museums are rhetorical sites that may provide counternarratives to colonial representations or even to postcolonial representations. The question, then, is one of rhetorical sovereignty.

Specifically concerning representation, communication, and rhetoric, Scott R. Lyons coined the term "rhetorical sovereignty" to address "the inherent right of [Native and Indigenous] *peoples* to determine their own communicative needs and desires in this pursuit, to decide for themselves the goals, modes, styles, and languages of public discourse" (Lyons 2000, 449; Lyons' italics). Though Lyons was aiming at written discourses in his formulation of the term, it is a useful springboard for thinking about other forms of communication and rhetoric, including public narratives such as museums—especially in the face of the colonizing narratives of both the past and present.

The Bishop Museum, Past and Present

The Bishop Museum was founded in 1889 by American-born Charles Bishop,[4] in honor of his late wife, the last descendant of the royal Kamehameha line, Princess Bernice Pauahi Bishop. Originally intended to preserve and protect her royal heirlooms and the collections of two other chiefesses—a priceless heritage collection—for the Hawaiian people, the museum quickly also became a center for research in "Polynesian Ethnology and Natural History" (Brigham 1903). This meant that, in addition to housing the royal heirloom collection and cultural items from Hawai'i and around the Pacific, the Bishop Museum also became home to large specimen collections of Hawaiian and Polynesian flora and fauna. William T. Brigham, the museum's first director, understood the mission of the museum thusly: "This museum is no longer merely an exhibition to amuse an idle hour, but it is . . . a means of collecting, preserving, and studying the history of the life of the Pacific. . . . The amusement of the people, or even their instruction, is not the chief object of a museum such as this" (quoted in Kelly 1996, 128). Although the Bishop Museum's purpose was to house and protect

Hawaiian treasures, Brigham's rhetorical choices indicate how the museum still placed the emphasis on research and its natural history collections.

To an extent this emphasis has been maintained through the twentieth century and into the twenty-first. As of March 2014, the "About Us" statement on the Bishop Museum website reads:

> Today, Bishop Museum is the largest museum in the state and the premier natural and cultural history institution in the Pacific, recognized throughout the world for its cultural collections, research projects, consulting services and public educational programs. It also has one of the largest natural history specimen collections in the world. Serving and representing the interests of Native Hawaiians is a primary purpose of the Museum. ("About Us" 2011)

The sequencing of "natural and cultural history" is still in place, and the final statement—almost an afterthought—notes that "serving" and "representing the interests" of the Bishop Museum's original constituency is now a "primary purpose," although it is listed last. Such a mission statement reflects not only an unsettled relationship with the Native Hawaiian community, but also an uncertain sense of identity at the Bishop Museum's core. This uneasy relationship with its Native Hawaiian collections and with the Native Hawaiian communities it claims to serve has been documented, for example, in a number of scandals in the late twentieth century over the keeping of and access to sacred objects and *iwi*; the contract archaeology[5] it has engaged in for the sake of funding, often to the detriment of Native Hawaiian sacred and cultural sites; and a lawsuit concerning the keeping and study of the Mokapu ancestral Hawaiian remains (Kelly 1995, 231–239). These are shadows that present enduring rhetorical problems and have created significant Native Hawaiian distrust of the Bishop Museum as an institution.

At the same time, a further rhetorical shift has already happened, as the revised statement from the museum's administration indicates. Published in the fall 2011 edition of the museum's journal, *Ka ʻElele*, and now posted online, this mission statement reads: "As ʻThe Museum of Hawaiʻi,ʼ Bernice Pauahi Bishop Museum's mission is to be a gathering place and educational center that actively engages people in the presentation, exploration, and preservation of Hawaiʻi's [*sic*] cultural heri-

tage and natural history, as well as its ancestral cultures throughout the Pacific" ("Bishop Museum's New Strategic Plan" 2011, 5; also "Our Mission" 2012). In this new mission statement, active engagement with Hawai'i's cultures and heritage, instead of the natural history collections, is foregrounded, and thus the museum makes an attempt to rearticulate its relationship with the Native Hawaiian community and reorient the museum's purpose to Native Hawaiians. On the other hand, the "people" who are to be engaged are not specified, nor is the Native Hawaiian community named specifically—only "Hawaiian cultural heritage" is foregrounded, which could mean any of the many cultures that have settled in the Hawaiian islands. This suggests democratic inclusion of all cultures. Further into the "Strategic Plan," the clarifying "Guiding Statements" do recognize Native Hawaiians as a unique community, at least to a point. Bullet points two, three, and four read as follows:

- We treasure the Museum's connection to Hawai'i's Royal past.
- We recognize Hawai'i and its host culture as our priority.
- We also recognize that to understand the cultural heritage and natural history of Hawai'i one must understand the cultural heritage and natural history of the Pacific. ("Bishop Museum's New Strategic Plan," 2011, 5)

Implicit in these bullet points is an acknowledgment of the responsibility the museum bears to the Native Hawaiian people given the nature of its founding collections, and those bullet points nod to Native Hawaiians not only as the original community, but as still present. By examining the mission statements we can see how the Bishop Museum finds itself situated in the larger shift in museology from sites that record, store, and preserve heritages beyond Indigenous communities' deaths to sites that actively engage (or at least attempt to engage) still-living Indigenous communities. At the same time, the shift here is limited, the heritage promoted here is nearly disembodied (simply there for "people" to engage with), and the acknowledgment of colonizing history is vague at best.

This contemporary ambiguity in framing the museum's purpose—however far it has come—can be explained in part by the diverse constituencies and audiences the Bishop Museum now serves. As noted earlier, its founding was a direct tribute to the life and royal legacy of

Princess Bernice Pauahi Bishop. Thus it bears a direct connection, even an imperative, to serve Native Hawaiians in the unique capacity of protecting the material cultural heritage she left behind; however, as also already noted, the museum's Euro-American directors and administration ultimately had other ideas about what the priorities of the museum should be, and for much of the museum's history, scholars and researchers were the primary audience. Its public outreach programs of the mid-twentieth century shifted the research emphasis to educating and engaging the broader public, and in this movement both local populations—now a mixture of Native Hawaiian, Euro-American, Japanese, Chinese, Korean, Samoan, and others—and tourist populations became the intended audiences. As of 1997, 67 percent of museumgoers throughout Hawai'i were tourists (Liu 1997), and while more recent detailed studies like this have not been done, one may assume that the increase in tourism since 1997 suggests that at least 70 percent of museum traffic in Hawai'i comes from tourists, if not more. Bluntly put, so much tourism means that museums create worldwide exposure and a public face for Hawai'i. Simultaneously, the educational mission and the nature of the Bishop Museum also make it a popular destination for local schoolchildren; as a result, exhibits tend to be brought in or constructed with the tourist and local schoolchildren audiences in mind (Brown 2011).

In sum, the Bishop Museum has an obligation to care for Native Hawaiian cultural collections (as well as cultural collections from broader Pacific) and represent Native Hawaiian constituencies, but, in addition, it tries to represent and serve all other local populations, as they have also built collections at the Bishop Museum. These constituencies are also the potential audiences; other audiences include a sizable proportion of tourists and local schoolchildren. Overall, the Bishop Museum has the closest historical and material cultural ties to the Native Hawaiian community out of all other communities, but it is not a tribal or an Indigenous museum. Yet because of those historical and cultural ties, it is no ordinary public museum that happens to have a collection of Indigenous objects. Understanding and working out what those ties should represent presents a particular puzzle for the Bishop Museum, Native Hawaiian organizations, and the broader public, and in many respects, Hawaiian Hall attempts to solve that puzzle.

A Microcosm of Narrative History: Hawaiian Hall

The construction of Hawaiian Hall was not part of the original plan for the Bishop Museum; the hall was added on as a new wing a few years after the original facility was finished. Construction began on it in 1899, and it officially opened in 1903. As was state-of-the-art architecture for its era, Hawaiian Hall is a large three-story open hall with a main bottom floor ringed by three floors of side galleries with multiple built-in exhibit cases. There was no electricity installed, and light came from the numerous windows in the walls and the large skylight. The exhibit cases were made with indigenous Hawaiian koa wood, and the center floor space of the hall originally had a raised platform with a scale model of the Waha'ula heiau (temple) from the island of Hawai'i under a large glass case, a scale model of Kīlauea under an identical glass case in the center, and a life-size hale pili (grass house) at the far end of the hall. One of the hallmarks of Hawaiian Hall, a fifty-five-foot sperm whale, was also an original installation. The surrounding galleries of glass cases on the first and second floors contained objects from the Bishop collections, and the third-floor gallery initially served as a library. Anthropologist and museum scholar Marjorie Kelly observes that the exhibits broadly reflected the museum attitudes of the time: the Boasian anthropological model of grouping objects together without much reference to the people who produced them or the activities in which they were used, the classic collections under glass (Kelly 1996, 127–128). Additionally, natural history elements—displays of birds, animals, and vegetation—were interspersed with the artifact exhibits. Thus the original Hawaiian Hall exhibit represented the historical presence of Native Hawaiians, in the sense that their pre-contact material culture was represented and displayed; juxtaposed against this was the isolation of these collections and the clear absence of Native Hawaiian people or communities who produced the objects and carried the knowledge of their making, past or present. The only visible representations of Native Hawaiian people were in four diorama cases that depicted the processes of pounding poi, making kapa cloth, scraping olonā bark for its fibers, and "praying a victim to death" (Kelly 1996, 128). Photographs from the time show mannequins with unkempt wigs and pre-contact dress. Overall, these representations (or conspicuous lack of them) relegate Native Hawai'i to the past, disconnected from the present.

While the previous exhibits had been a mixture of natural and cultural history, the renovated exhibit of the 1960s removed the natural

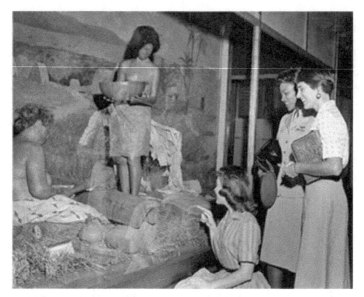

Colonial Vision: Kapa Cloth Diorama, circa 1960. Photographer unknown. Bishop Museum Archives

history elements from the cases and the model of Kīlauea from the center of the floor exhibits (Brown 2011). The four dioramas were removed, and the poi-pounding figure was set inside the hale pili—misplaced, given that poi is not actually pounded inside a hale pili—for the sake of providing a human figure in proportion to the grass house. The first floor retained some anthropological displays, the second floor became dedicated to narrating the history of Hawai'i and Western contact, and the third floor was reserved for exhibits on Hawai'i's immigrant communities (Brown 2011). The shift to include other ethnic communities of Hawai'i was, in part, a matter of ethos-building for fund-raising (for why would a community contribute to a museum that does not serve them?), but also an effort to better represent the more recent history of Hawai'i, which was now so strongly multiethnic. At the same time, the narrative concerning Native Hawai'i did not change much; the narrative of civilization from a Euro-American/colonist view was still firmly in place.

By 1995—at the writing of Kelly's study—Hawaiian Hall had been altered only by some piecemeal additions to the Native Hawaiian exhibits on the first floor that were originally parts of another exhibit, *Hawaii: The Royal Isles* (Kelly 1996, 129–131). Though a renovation of the

hall was begun in 1984, funding constraints halted the process, and continued problems with funding prevented any further renovation of the space until the early 2000s (Brown 2011).

Thus the hall stood in a state of physical, narrative, and rhetorical neglect: preserving a history that centered on contact and that narrated a Euro-American/colonist point of view; telling that history piecemeal, without coherent narration or rhetorical design; and ultimately, articulating a rhetorical disregard of the people it ostensibly represented, no matter how lovingly the objects themselves were preserved. Though preserving the past was important, and in some respects the Bishop Museum and Hawaiian Hall performed that function, Hawaiian Hall had ever been silent concerning Indigenous "host" perspectives except to frame them as informants for Euro-American ethnographic study. The narratives followed the line of progress: Native Hawai'i was gone with the end of the nineteenth century; the overthrow of the Hawaiian Kingdom and eventual annexation were never overtly addressed; and contemporary perspectives were completely missing. In terms of the community involvement that the new museology of the 1990s advocated, the Bishop Museum was in desperate need of change. Rhetorical sovereignty, or an acknowledgment of any sovereignty, was not a consideration.

Hawaiian Hall: The Renovation and Revision

In 2005, work began to plan a reimagining of the space that would preserve and modernize what was best about the architecture and those features that had become iconic for the museum (the sperm whale, the heiau model, and the hale pili), and to "update the way the Museum presented its collections by introducing multiple voices and a Native Hawaiian perspective, as well as displaying the artifacts along with high-tech, exciting, and interactive exhibit components" ("Hawaiian Hall Retrospective" 2009, 7). The original architectural elements of the hall were restored, electrical wiring was updated, and climate control was installed. But just as important, if not more so, all of the exhibits were stripped out, and new conceptual schema based in Native Hawaiian cultural perspectives were used as the foundation for selecting and displaying collections, which were arranged by floor. These particular schema, with the titles "Kai Ākea—Ocean Realm," "Wao Kānaka—Realm of Man," and "Wao Lani—Realm of Gods," already existed on the Hawai'i Alive (2011) educational website, a teachers' resource developed

Revised: Renovated Hawaiian Hall, 2010. Photo by Charley Myers

in consultation with selected representatives from the Native Hawaiian community[6] with the Bishop Museum in 2005. Given the three-floor architecture of the hall, this approach was a natural fit (Brown 2011). Furthermore, planners intended that the interpretation and narration of objects and the arrangement would be "informed by the concept of *kaona* or layers of meaning; the subtleties and multiplicities of meaning will increase from the first to the third floors, so that visitors will find deeper insights into Hawaiian culture as they move up through the building" ("Hawaiian Hall Restoration Project" 2006, 6).

The overall rhetorical impact of this presentation is layered: it grounds the visitor in the origin stories of Hawai'i rather than the official Euro-American history that begins more or less with contact; it creates a taxonomy of objects and ideas organized from those stories, rather than based on Euro-American scientific endeavors; it blends contemporary artists' works with artifacts, chants, and mo'olelo (stories/histories); and it addresses the Hawaiian Kingdom's overthrow and annexation in order to extend Native Hawaiian history into the present. The conceptual groundwork upends the traditional museum's approach and the Bishop's long-standing approach of forwarding Euro-American renderings of history over a silenced Native Hawaiian populace. If visitors (Native or non-Native) arrive with the expectation of finding canonized Euro-American history, the new Hawaiian Hall instead immerses them in a worldview firmly grounded in Hawai'i, from a perspective of connected cosmology, land, and history.

The first floor, "Kai Ākea—Ocean Realm," centers the visitor in Native Hawaiian knowledge of origins and history. Here, a visitor encounters artistic renderings of ancient events and creation stories (the Kumulipo, in particular), as well as the sights and sounds of land and water from which all life comes. These connections are reinforced in the taxonomies of the exhibit cases, with each case organized not by like objects (as in the previous arrangements in Hawaiian Hall), but by the god addressed, his or her responsibilities, and the life forms and activities associated with him or her. For example, the case explaining the god Lono contains objects associated with him: carved representations of him in human form, a gourd calabash, a wild pig, and humuhumunukunukuapuaʻa (depicted via video), all of which are embodied forms of Lono. Above hangs a net full of fruits and vegetables, a reference to the Makahiki season of harvest, over which Lono presides. A text panel introduces the topic of the case and a short explanation of the god and his or her responsibilities. Literally layered—etched on the glass of the case—is a short excerpt of a mele about Lono in both Hawaiian and English; a small kapa cloth-like display within the case adds an excerpt from a moʻolelo (story/history) about him. The rest of the cases around the first floor follow in like fashion. The effect is to create a grouping of objects, explanations, and stories that again center the visitor in the organization, complexity, and interconnectedness of a traditional Native Hawaiian context.

The inclusion of newly made objects as part of the displays also provides a counterpoint to visitors' potential expectations of an exhibit about Indigenous peoples. Rather than focusing only on objects made in the distant past by unknown hands, many of the cases include objects and artwork made by contemporary Native Hawaiian artists. As the creator of the piece *Kumulipo*, Carl Pao, puts it, "Imagine kids now coming through and seeing today's work alongside objects from hundreds of years ago . . . We're still vibrant and growing. And these students will be able to form their own identities and have the confidence to move forward . . . it's right here in front of them" ("New Acquisitions" 2009, 11). Adding contemporary visions of living stories reinforces the life of those stories and Native Hawaiian culture in the present, and in the presence of visitors. Even the now-restored hale pili and the model of the heiau—two of the oldest installations in the hall—are placed within new contexts, not as anthropological models, but as embodied evidence of these lives and these stories.

The second floor of Hawaiian Hall continues this work, only now drawing visitors' attention to "Wao Kānaka—Realm of Man": the realm

of daily, cyclical, and place-based work and activity that encompasses planting, fishing, harvesting, and special events. The rhetorical effects of "Wao Kānaka—Realm of Man" are nuanced; though there is plenty of ethnographic information to satisfy the visitor who wants a more traditional museum journey through Indigenous culture, the arrangement of the information and objects continues to reinforce a Native Hawaiian worldview and contemporary presence, layered over the work of the first floor. Whether the visitor recognizes it immediately or not, she is guided through regional activity according to the ahupua'a structure of traditional land division and management, and thus (unless she skips ahead) absorbs information according to a Native Hawaiian structural sequencing. The cases themselves continue a similar pattern from the first floor, in that each case links objects thematically (on the activity in question, or in the rail cases, the portion of the lunar cycle), includes explanations of use based on archival records from Native Hawaiians, and for the upright cases, contextualizes the activities with more mele etched on the glass through which a visitor must look to see the objects. Additionally, at least in theory, given that the visitor has also gone through the conceptual framework of the first floor already, there is the potential for visitors to link the description of day-to-day fishing with the stories of fish and fishing downstairs, or link the pounding of poi with the origin story of the kalo (taro plant) on the first floor. Thus, a visitor can receive additional reinforcement from a Native Hawaiian perspective and set these daily, monthly, and yearly activities into cultural context.

Also like the objects on the first floor, the objects mounted in the cases on the second floor are a mixture of old and new works, and the video footage from the computer kiosks helps to reinforce the sense of living practice. Among the wooden calabashes is an 'umeke (traditional wooden bowl) made by contemporary woodworker Solomon Apio, and with the old gourd vessels sits a new ipu pāwehe (decorated gourd) by artist Elroy Juan. Apio observes, "Before, the museum only just had the old things. And now, you're putting us with them. . . . We want to carry on and show people that we are still doing this" ("New Acquisitions" 2009, 10). The computer kiosks reinforce this continuity; for example, next to the case describing the use of olonā fiber to make cordage and netting, the nearby computer kiosk offers video of Sam Ka'ai explaining how the olonā cordage is as symbolically significant as it is physically useful, and of ethnobotanist Cathy Davenport showing what the olonā plant looks like and how the fiber is harvested. The total effect,

should a curious visitor avail himself, is one of cultural continuity into the present.

Ascending the final set of stairs to the third floor, a visitor will move into "Wao Lani—Realm of Gods,"[7] and in some respects this is the most complex section of the hall. Given the narrative chronology established, and the sacred connection of the ali'i to the gods, the highest floor is devoted to the ali'i and nineteenth- and twentieth-century history. This floor includes exhibit cases devoted to the three chiefesses whose heirlooms are the foundation of the museum, and a case for each monarch that mirrors the organization of the deity cases on the first floor. Queen Lili'uokalani, the last monarch of Hawai'i, has her case at the end of the far wall, and the back case and corner space cover the illegal overthrow of the Hawaiian government by Americans, the annexation, and Native Hawaiian insurrection and protests. The one computer kiosk features a digitalized version of the petition, signed by almost the entire Native Hawaiian population at the time, protesting annexation. The final corner of the third floor highlights the proud carriers of culture in the first half of the twentieth century and the Native Hawaiian Renaissance of the 1970s. Meanwhile, the rail cases all around the third floor are a historical timeline that traces the Hawaiian nation and its governance from pre-contact to contact with Europeans, into the present.

The rhetorical impact of this part of the hall is tremendous if visitors are paying attention: here they may witness, encapsulated in a series of glass cases, the establishment of the Hawaiian Kingdom and its royal line in a new age; its struggle to maintain cultural and political sovereignty while enmeshed in European and American business and religious influences; and the injustice of its overthrow. For the first time, annexation is explicitly addressed—that was not part of the original Hawaiian Hall, nor had it ever been—and the historical misperception of Hawaiians as docile and welcoming of annexation is countered by the digital presence of the petition. Here, the losses of a culture and a people are embodied in the feathered pā'ū of Nāhi'ena'ena, which should have been worn as a symbol of hope and fertility and ultimately became a royal funeral pall. And here, perhaps an unintentional irony, annexation receives coverage while contemporary Native Hawaiian sovereignty movements and nation reclamation do not.

The final display of the third floor is the forty-panel work called *Ho'oulu Hou* ("to cause to grow, again"), a community mural project connected to "The Ho'ohuli: To Cause an Overturning, a Change," the prophecy of Kapihe. This community work of art is a particularly

noteworthy way to end the exhibition as a present manifestation of the prophecy, and also points to that potential split in interpretation between advocating for cultural revival and sovereignty and political revival and sovereignty. The prophecy reads as follows from the exhibit panel: "E iho ana o luna (that which is above would come down) / E pii ana o lalo (that which was below would rise up) / E hui ana na moku (the islands shall unite) / E ku ana ka paia (the walls shall stand firm)." The prophecy of Kapihe, a figure from the era of Kamehameha I, predicted "an overturning, a change to the Hawaiian world order" that came to pass with the overthrow of the kapu system in 1819, and the meaning of the prophecy has been extended in the panel text to include the overthrow of the Hawaiian Kingdom and the Hawaiian Renaissance. Further on, the panel reads, "This chant acknowledges difficulty and sorrow, heartache and turmoil, warfare and destruction. It is a prophecy that we will stand together in the face of adversity and that we are a stronger and united community, not in spite of our past, but because of it." Through this interpretation, the prophecy is a powerful reminder of survival and a testament to the strength of a community that is still here. Beneath the mural and the explanatory text panel, however, is an interactive video kiosk with interviews from Native Hawaiian political and cultural activists who assert a more pointed interpretation of the prophecy; in the words of Hinaleimoana Falemei (who, not incidentally, speaks Hawaiian throughout the interview and therefore requires English subtitles), "That which is in power now, will be brought down tomorrow . . . we, the native people of these lands, shall prevail."

Rhetorical Sovereignty and the Bishop Museum

If it is an Indigenous people's right to "determine their own communicative needs and desires . . . to decide for themselves the goals, modes, styles, and languages of public discourse" (Lyons 2000, 449), then Hawaiian Hall has begun to reflect that: in the incorporation of contemporary interpretations and works of art, in the inclusion of contemporary artisans' work alongside older artifacts, in the emphatic and consistent use of the Hawaiian language as part of exhibit text, and in the visual and content orientation toward a distinctly Hawaiian worldview. All of these move toward a statement of rhetorical sovereignty in that the goals, styles, and languages of public discourse are strongly shaped by Native Hawaiians and Native Hawaiian culture. Even in the absence of a Native Hawaiian unity or a body politic, the work of Native

Hawaiian curators, contributors, artists, and language experts cannot be disregarded. Given the history of Hawaiian Hall, perhaps the strongest element of rhetorical sovereignty here is the reclamation of the space for Native Hawaiian culture with the participation of a network of people from Native Hawaiian communities.

At the same time, Hawaiian Hall does not and perhaps cannot ever make a full statement of rhetorical sovereignty. The third floor of the exhibit tackles the difficult work of the overthrow and annexation, but it does so little with Native Hawaiian communities in the twentieth century that the narrative seems to hang, suspended, even though it picks up again with the 1970s and makes a small acknowledgment of activism in the 1990s. One might explain this sudden narrative withdrawal into generalities as an implicit acknowledgment of the cultural loss that Native Hawaiians experienced into the twentieth century— that somehow, there are few stories to tell, or the stories are as yet too painful to articulate—and/or a lack of space (and therefore inability) to work fully through the complicated rebirth of Native Hawaiian culture and fights for cultural and political sovereignty.

Brown (2011) expressly notes the hesitation of the renovation team to address sovereignty and the difficulties of defining it, saying that they didn't want to define it, because "it's not our place." Rhetorical sovereignty has its limits, both in the content displayed and in who maintains control over the exhibit space in Hawaiian Hall. It declares a general rhetorical sovereignty in cultural realms, but in the name of serving the broadest Native Hawaiian constituency and as many audiences possible, it is currently incapable of picking up the narrative thread of history into the present. One can read it as abdicating responsibility to address sovereignty or as appropriate respect to avoid defining what the Bishop Museum has no right to define. Put another way, it is able to support rhetorical sovereignty through discussions and presentation of Native Hawaiian culture, and thus provides a foundation for presenting Native Hawaiian claims for political sovereignty—all without articulating anything substantial about political sovereignty itself. Thus, what may be spoken is limited, as is what rhetorical sovereignty can be enacted there.

Conclusion

Ultimately, Bishop Museum staff member Noelle Kahanu's assessment of the renovation is perhaps most accurate. In her own retrospective

piece on the renovation of the Hall, she acknowledges the problems the Bishop Museum has had in its relationship to Native Hawai'i: "As with any institution with such a long history, Bishop Museum has had lessons to learn, relationships to mend, and wounds to heal. . . . When we closed Hawaiian Hall in 2006, we closed the door on speaking about Hawaiians in the past tense with that anonymous omnipotent all knowing Western voice . . . on speaking *about* Hawaiians, not *with* them" (2009, 3). Though Hawaiian Hall may not be capable of providing the strongest statement of rhetorical sovereignty—and perhaps cannot ever be the place to, given its context at the Bishop Museum—it can at least be a site to begin the multilayered dialogue about Hawai'i's future, and an educational site that can begin reorienting the rest of the world to the first peoples of these islands. It is not a perfect statement, and it cannot represent all things to all Native Hawaiian communities, and the Bishop Museum's circumstances limit what it can say. That said, given the history of the Bishop Museum and Hawaiian Hall itself, the renovation is to an extent a statement of rhetorical and cultural sovereignty that reorients visitors to a Native Hawaiian worldview and acknowledges some of the historical injustices that have made Hawai'i what it is today. Making Native Hawaiian culture and history accessible in the renovated Hawaiian Hall can begin to bring these objects, histories, and relationships out of the archives and affirm the life that was in them all along, no longer reduced to mere objects under glass.

Notes

I want to thank my relatives and those who helped me undertake this work: Jeff Carroll, Brandy Nālani McDougall, and Georganne Nordstrom, my patient editors, for their feedback and encouragement; Thorsten Huth, for doing the unofficial (but essential) reading and editing; DeSoto Brown, for his expertise and knowledge at the Bishop Museum; and Charles Myers, for his help in the archives and with the photography. Any mistakes here are my own.

1. A note on terminology and positioning: I use the term "Native" in reference to American Indian nations and communities, partly out of a sense of discomfort with the term "Indian" and its rhetorical connotations, and partly to reflect that shorthand of "Native" often used in Indigenous studies. Here, I use "Native Hawaiian" to identify the Kānaka Maoli of the Hawaiian Islands, a term that readers outside of Hawai'i might find more familiar, and an identifier that links the experiences of Native Hawaiian people, at least regarding museums and coloniza-

tion, with those of Native Americans. I use "Indigenous," capitalized, to refer globally to first peoples.

Furthermore, I have not drawn great attention to my position as a researcher; as someone trained in academia, I assume that angle is already visible, and as someone trained in U.S. Native studies, one may also assume that my general knowledge of Native and Indigenous histories and issues is more extensive than the average museum visitor's. However, though I am of Native descent—Munsee (Delaware)—I am not a member of the Native Hawaiian community, nor have I ever been on the staff of the Bishop Museum. In that way, I come to the Bishop Museum as a visitor too, and I hope that my position as a Native and an academic, but outside Native Hawaiian communities and the Bishop Museum, provides a useful vantage point from which to do this analysis.

2. See also "Living in a Learning Society: Museums and Free-Choice Learning," by John H. Falk et al.; "Museum Education," by George E. Hein; "Interactivity: Thinking Beyond," by Andrea Witcomb; and "Studying Visitors," by Eilean Hooper-Greenhill, for a recent grouping of articles in Sharon Macdonald, ed., *A Companion to Museum Studies* (Hoboken, NJ: Wiley-Blackwell, 2011).

3. See "The Construction of Native Voice at the National Museum of the American Indian," by Jennifer Shannon, for a discussion of defining what is "authentically" representative of Native constituencies, and for balancing viewpoints between curatorial staff, who work most closely with Native communities, and exhibit design staff, whose job requires looking toward museum visitor needs. Shannon's essay appears in *Contesting Knowledge: Museums and Indigenous Perspectives*, ed. Susan Sleeper-Smith, 218–247 (Lincoln: University of Nebraska Press, 2009).

4. As noted by historian Lilikalā Kameʻelihiwa, Charles Bishop was an American businessman, a sugar planter, and a figure in the Hawaiian government who benefited in significant and arguably questionable ways from his position. As such, he bears mention in this analysis not so much as a founder-hero, but as the historically problematic figure that he is. See *Native Land and Foreign Desires: Pehea Lā E Pono Ai?* by Lilikalā Kameʻelihiwa (Honolulu: Bishop Museum Press, 1992).

5. "Contract archaeology" refers to the practice of identifying and evaluating potential sites of archaeological interest, especially when they are threatened by development. In its best uses, it serves to help protect these sites; at its worst, contract archaeology can be a potentially predatory business practice.

6. When I cite "representatives from the Native Hawaiian community," I do not intend to imply that the Native Hawaiian community is united on all fronts or that these representatives speak for all. In many Indigenous

communities, there is a diversity of opinions concerning cultural practice, language, and story, and the same is true here.

7. Brown (2011) observes that it at first seems as though all the material about Hawai'i's gods should have gone in the physically highest space, and that would have been the preference except that the cases on the top floor could not accommodate some of the carved figures, and the first floor cases could.

Works Cited

"About Us." 2011. Bishop Museum. http://www.bishopmuseum.org/about us/. Accessed March 19, 2014.

"Bishop Museum's New Strategic Plan." 2011. *Ka 'Elele/The Messenger: The Journal of Bishop Museum* (Fall): 4–5.

Brigham, William T. 1903. *A Handbook for Visitors to the Bernice Pauahi Bishop Museum of Polynesian Ethnology and Natural History.* Honolulu.

Brown, DeSoto. 2011. Interview with the author. November 30.

Child, Brenda J. 2009. "Creation of the Tribal Museum." In *Contesting Knowledge: Museums and Indigenous Perspectives,* ed. Susan Sleeper-Smith, 251–256. Lincoln: University of Nebraska Press.

Hawai'i Alive: Bringing Hawaiian Culture to Life. 2011. Bishop Museum. http://www.hawaiialive.org/. Accessed December 10, 2011.

"The Hawaiian Hall Restoration Project." 2006. Honolulu: Bishop Museum. Accessed March 30, 2012.

"Hawaiian Hall Retrospective." 2009. *Ka 'Elele/The Messenger: The Journal of Bishop Museum* (Fall): 7–8.

Hooper-Greenhill, Eilean. 2000. *Museums and the Interpretation of Visual Culture.* New York: Routledge.

Kahanu, Noelle M. K. Y. 2009. "E Kū Ana Ka Paia: Finding Contemporary Relevance in an Ancient Prophecy." In *Restoring Bishop Museum's Hawaiian Hall: Ho'i Hou Ka Wena I Kaiwi'ula,* 1–5. Honolulu: Bishop Museum Press.

Kelly, Marjorie. 1995. "Native Hawaiians and the Bishop Museum: Negotiating Ownership of the Island Past." *Curator* 38, no. 4 (December): 228–245.

———. 1996. "The Museum Visitor Experience in Bishop Museum's Hawaiian Hall." In *Multiculturalism and Representation: Selected Essays,* ed. John Rieder and Larry E. Smith, 123–141. Honolulu: College of Languages, Linguistics, and Literature, University of Hawai'i.

Kreps, Christina F. 2003. *Liberating Culture: Cross-Cultural Perspectives on Museums, Curation, and Heritage Preservation.* New York: Routledge.

Liu, Juanita C. 1997. "Economic Impact of Hawai'i Museums and Their Role in Tourism." Honolulu: Hawai'i Museums Association.

Lyons, Scott Richard. 2000. "Rhetorical Sovereignty: What Do American Indians Want from Writing?" *College Composition and Communication* 51, no. 3 (February): 447–468.

"New Acquisitions—A New Dawn." 2009. *Ka 'Elele/The Messenger: The Journal of Bishop Museum* (Fall): 10–11.

"Our Mission." 2012. Bishop Museum. http://www.bishopmuseum.org /images/pdf/StratPlan.pdf. Accessed April 1, 2012.

Simpson, Moira G. 1996. *Making Representations: Museums in the Post-Colonial Era*. New York: Routledge.

The Many Different Faces of the Dusky Maiden

A Context for Understanding Maiden Aotearoa

JO SMITH

IN MAY 2011, the Wellington City Gallery (based in New Zealand's capital city) hosted an exhibit of photographic works by four Māori women artists—the first photographic exhibit of its kind in Aotearoa/New Zealand.[1] The exhibit was titled *Maiden Aotearoa* (May 21–June 26, 2011) and featured the work of Vicky Thomas (Ngāti Kahu, Pākehā, Irish/Welsh), Suzanne Tamaki (Ngāti Maniapoto, Tūhoe, Te Arawa), Aimee Ratana (Ngai Tūhoe), and Sarah Hudson (Ngāti Awa, Tūhoe).[2] The collection demonstrated a range of approaches to representing Indigenous worlds and women. Some of the artists focused on the ways colonial photographers depicted women from te ao Māori and how one can rework these depictions. Others demonstrated the ways imaging technologies, when harnessed by Indigenous practitioners, continue the work of whakapapa, advance a politicized agenda, and function as aids in securing and strengthening Indigenous links to lands and communities. The exhibition also included more global connections between imaging technologies and raced and gendered stereotypes. As such, *Maiden Aotearoa* is a significant exhibition in that it revisits tired tropes of Indigenous stereotypes and gestures to the paradoxical forces of colonial history that help shape contemporary art practices. This chapter provides a broader context for understanding the photographic works in *Maiden Aotearoa*.

The exhibition's title has at least two readings: one refers to campaigns promoting products "made in" New Zealand and the other ref-

erences an earlier term for femininity, "maiden," with a more implicit gesture toward the Dusky Maiden stereotype of Pacific societies. These two reference points have some significant connections. The first reference point gestures to the underlying political economies that inform articulations of New Zealand national identity, and the second highlights the ways representations of Pacific femininities have added an aestheticized dimension that has helped advance these more socioeconomic concerns.

An imperative to showcase locally made products in an increasingly globalized economy is one shared by many nation-states, including Aotearoa/New Zealand. The branding of New Zealand resources, labor, and intellectual property has been a key driver of contemporary national culture (Lawn and Beatty 2005). Both Labour (center-left) and National (center-right) governments have pursued consistent and enduring strategies to attract global finance, to secure international audiences, and to convince international workers and tourists that New Zealand is the place to be. Indeed, New Zealand is the poster child of what Ghassan Hage (2003) calls a rising managerial form of governance, in which "national governments all over the world are transformed from being primarily the managers of a national society to being the managers of an aesthetics of investment space" (19). Hage argues that under current conditions, capitalism "simply hovers over the Earth looking for a suitable place to land and invest . . . until it is time to fly again" (19). As such, nation-states are no longer the anchors for global capital but rather function as transient and nonpermanent landing pads. The question then becomes "how do we make ourselves attractive enough to entice this transcendental capital hovering above us to land in our nation?" (19). Hage suggests that this process of aestheticization is an extremely anxious one that must be constantly negotiated and that strikes at the heart of a form of paranoid nationalism that, in Hage's context, is endemic in Australia; however, the notion of an anxious form of nationalism particular to a settler nation chimes with some of the experiences of the New Zealand nation too.[3] In the context of New Zealand, images of easily consumable cultural differences help ease these anxieties.

Dusky Maiden Dynamics

Key characteristics of New Zealand's "aesthetics of investment space" have often involved the visual and cultural distinctiveness of the world

of Māori. As is the case in early cinema across the world, exotic land-scapes and Indigenous peoples are the hallmark of early New Zealand film (Blythe 1994; Hillyer 1997; Mita 1992). Domesticated versions of Māori cultural differences for the sake of a settler nation have a long history; they range from the colonial postcards used to promote the colony to British subjects to the insignia used to demarcate state bodies such as the armed forces and the police to the much-loved feature film *Whale Rider* (2002). As such, the contemporary and historical impera-tive to signal the distinctiveness of the New Zealand nation in an era of intense globalization involves representations of te ao Māori that offer an inviting point of difference for a global audience and a reassuring myth of cultural harmony for a more local audience.

The second meaning of *Maiden Aotearoa* refers to the Dusky Maiden stereotype and the ways Polynesian women have been framed as objects of desire and as access points to the appropriation of land and re-sources. Much literature exists on the ways colonial portraiture photogra-phy and postcards perpetuated the project of imperialism in the Pacific (Jolly 1997; Mathews 2001; Pearson 2005; Smith 2008; Vercoe 2004). As the 2000 anthology *Bitter Sweet: Indigenous Women in the Pacific* (Jones, Herda, and Suaalii 2000) demonstrates, Māori and other Polynesian cul-tural groups are generally positioned in a passive relationship to an all-knowing Western subject: a form of passive/active aestheticization that helps normalize more socioeconomic impositions. Similarly, Lisa Taou-ma's (1998) research into the Dusky Maiden stereotype highlights the role played by images in the subordination of Polynesian cultural and sexual difference. What these critiques have in common is their atten-tion to the dynamics of colonial hegemony and the kinds of aesthetic and epistemological discourses that continue to regulate and discipline repre-sentations of Polynesian cultural difference. Accordingly, the Dusky Maiden dynamic has a long history of cloaking ongoing forms of social regulation and of contributing to an "aesthetics of investment space" in ways that foster a multitude of non-Indigenous interests. In what follows, I examine how the prevailing anxieties underpinning an aestheticization of investment space might reveal different manifestations of Dusky Maiden imagery that express alternate forms of Indigenous female agency (what we might call mana wahine Māori in the context of Aote-aroa/New Zealand) and more Indigenous-directed investments.[4] These differences include Dusky Maiden imagery as a form of countermem-ory and as potentially disruptive repetitions and reworkings that refute orthodox understandings of colonial and neocolonial power relations.

The Dusky Maiden as Countermemory

Hage's notion of an "aesthetics of investment space" suggests that the work of making a nation amenable to transcendental capital requires a kind of emptying out of those entrenched local differences that might threaten the "landing pad" that a nation might seek to devise. Offering up reified, commodified, and "flat" images of New Zealand bicultural harmony is one way of sealing off more recalcitrant and unattractive articulations of national belonging. We could think here of media depictions of Tūhoe member Tame Iti as a folk devil in this context (more on this later). However, as postcolonial theorist Homi K. Bhabha (1994) has shown, seemingly flat, emptied out, and stereotypical depictions of cultural difference often have a flipside that reveals the ambivalence at the heart of any stereotype. Given that Hage's critique of contemporary globalization is rooted in the recognition of the deeper histories of colonization, his notion of paranoid nationalism chimes in many ways with Bhabha's work on the colonial stereotype.

Bhabha's critique of the colonial stereotype offers a useful framework for thinking through the multiple effects of Dusky Maiden dynamics. Arguing that stereotypical depictions of the racialized other are colonialism's major discursive strategy, Bhabha contends that the constant repetition of these stereotypes reveals, not a self-assured and authoritative exercise of power, but a discursive formation that is anxious and phobic. As such, colonial discourse produces ambivalent effects that flow in at least two directions.[5] Colonialism's drive to fix racial difference within a rigid, unchanging order reveals a necessary flipside of "disorder, degeneracy and daemonic repetition" (Bhabha 1994, 66). Colonial discourse, then, is "a form of knowledge and identification that vacillates between what is always 'in place,' already known, and something that must be anxiously repeated" (66). Accordingly, the very colonial modes of knowledge production (film, photography, the novel, or news media) that disseminate and distribute raced (and gendered) stereotypes in ways that seem authoritative actually provide the conditions necessary for unsettling this authority. These interruptive, unsettling vacillations form the basis of Bhabha's deconstructive-inflected cultural politics.

A very clear example of how a stereotype of racial and gendered difference might contain an interruptive force is captured in Geoff Steven's 1985 documentary *Adventures in Māoriland: Alexander Markey and the Making of Hei Tiki*. This documentary tells the story of the

residual effects of an American filmmaker who made a film in New Zealand in the 1930s. Markey struck a deal with Ngāti Tūwharetoa (an iwi located in the scenic central plateau of the North Island) to gain their assistance in producing his feature film. According to film scholar Minette Hillyer (1997), the film "uses New Zealand as a site for a prelapsarian fantasy of inter-tribal romance" (27). Hillyer goes on to state that "everyone who worked on the production suffered some loss, including the loss of many tāonga lent to Markey for the duration of the shoot" (41). The residual effects of Markey's visit live on in *Adventures in Māoriland*. Scholarship surrounding early New Zealand cinema often focuses on the exploitative dimensions of foreign (or government-funded) filmmakers depicting Indigenous communities (Blythe 1994; Wells 2008). While Markey's *Hei Tiki* is certainly an exemplar of this approach, Geoff Steven's later documentary reveals the more ambivalent effects of the colonial visual archive.

The opening scene of *Adventures in Māoriland* begins with the scratched and faded intertitle from Markey's 1935 film *Hei Tiki: A Saga of the Māoris [sic]*. The opening then cuts to scenes from a school hall in the South Island town of Bluff, where the Bradshaw family and their friends are to see this film for the first time. A voice-over tells us that eight members of the audience are particularly interested in this film, as the female lead is their mother, who died when two of the children were still babies. The scene then changes to the content of Markey's film, and we watch as a young woman in a piupiu emerges from the bushes and wades in the water. As this Dusky Maiden appears on-screen, the narrator tells us that the Bradshaw family are "watching a woman that they never had a chance to know." The documentary then cuts to interview footage of one of the Bradshaw daughters, who, clearly moved, describes how it is to watch this footage:

> Seeing her walk, reach out and touch. You know, this meant a lot to me. I couldn't believe that we'd all come from that woman. . . . It was lovely seeing Mum in that role and thinking, you know, we are mothers of children now and that's our mother. She had all of us and, you know . . . well, it's just Mother on the screen.

This scene describes a deeply affective moment when an audience links a filmic representation of a family member on-screen to the present-day realities of being mothers with children. This school-hall event provided the Bradshaw whanau with a filmic conduit between

past and present that reignited the whakapapa links between their generations. Generative, moving, and deeply embedded in a sense of connection, this moment in *Adventures in Māoriland* is a filmic articulation of the multiple effects of colonial discourse. While the documentary goes on to discuss Markey's more negative impact on Tūwharetoa (particularly the theft of tāonga and poor treatment of actors), his stereotypical depiction of a "noble race" also helps reignite a sense of identity and connection for those audience members with a relationship to the people and place on-screen. Rather than a stereotype of Māori femininity that empties out the specificities of local identity, *Hei Tiki* in its re-screening in Bluff becomes the mechanism that recharges links with the North Island–based Tūwharetoa for a family located at other ends of the country.

More than this recognition and reignition of whakapapa, the Bradshaw family example suggests that ostensibly stereotypical representations of Māori women involve a range of memories, repertoires, and citational structures that can be deployed to assert another way of knowing and understanding colonial and neocolonial encounters. In this instance, the Bradshaw whanau's response underscores the idea of film as an art of encounter, where new meaning is made with every singular screening. So, too, other artworks inaugurate a singular experience that invites the possibility of thinking and feeling otherwise. This is the unruly dimension of aesthetic discourse that Bhabha gestures to in his analyses. If we apply this emphasis on ambivalence to Hage's notion of "an aesthetics of investment space," then we can see how a repeat screening of a Dusky Maiden in a film such as *Hei Tiki* provides a form of reinvestment in Indigenous cultural identity. What the Bradshaw family experience illustrates is the idea that the Dusky Maiden is both flat and full and that the affective charge surrounding repetitions of the Dusky Maiden enriches, fills, and fuels a form of counterinvestment space: a space where countermemories of place and people can persist. As such, one cannot help but want to inhabit this stereotype as a woman with whakapapa links to this history. There is a force to these images that cannot be refuted; contemporary Māori and Pacific women artists offer a glimpse of the increasingly diverse ways of drawing on the detritus of colonial discourse that have the potential to unsettle any kind of claim to authority by asserting other modes of knowing.

As many Indigenous women artists know, the very tools, images, and archives that one responds to as a woman native to the Pacific are the very materials that already frame one. The double-edged nature of

framing, then, is a key element in contemporary responses to the Dusky Maiden stereotype, and there are many Indigenous artists who strategically deploy a repetition of stereotyping to call these very images and frames into question. In the context of Aotearoa/New Zealand, these artists include, among others, Ani O'Neill, Lonnie Hutchinson, Sofia Tekela-Smith, Shigeyuki Kihara, Rosanna Raymond, Sue Pearson, Sima Urale, and Lisa Reihana.[6] The artists in *Maiden Aotearoa* are also part of this intellectual and artistic whakapapa.

The Dusky Maiden and Contemporary Aotearoa/New Zealand

To summarize the key characteristics of the Dusky Maiden dynamic, one could say that this stereotype helps cloak ongoing forms of social regulation and contributes to an "aesthetics of investment space" in ways that foster a multitude of interests, both Indigenous and non-Indigenous. The ambivalent aesthetic powers of the Dusky Maiden include a range of repertoires and citational structures that can be deployed in diverse directions. The City Gallery's 2011 *Maiden Aotearoa* photography exhibition offers a glimpse of the increasingly assorted ways of negotiating and harnessing the Dusky Maiden legacy. How might *Maiden Aotearoa* be approached as a snapshot of contemporary cultural politics? How might we see this quite minor exhibition as expressive of a larger cultural condition and at the same time pay heed to the singularities of each artwork and artist?

The promotional image used for the exhibition tells us something about the broad appeal the Deane Gallery curator, Reuben Friend (Ngāti Maniapoto), sought to inspire for the exhibit. Vicky Thomas' *Self Portrait #3* (2009) is the public face of *Maiden Aotearoa* and is featured in the poster campaign and website accompanying the exhibition. Wanganui-based artist and critic Peter Ireland (2011) describes Thomas' artwork as "a dauntingly powerful self-portrait" whose double-life-size dimensions, upraised chin (in the style of a police mug shot), and silver bangle earrings deliver a "Don't fuck with me, mister" attitude. The self-portrait gestures to the 1970s blaxploitation period of American cinema and, in particular, it invokes the spirit of Pam Grier, the African American femme fatale who rose to fame with films such as *Coffy* (1973) and *Foxy Brown* (1974). The blaxploitation genre was made specifically for an urban American black audience but has since gained a wider audience. For example, Quentin Tarantino reworked *Foxy Brown* via the Pam Grier vehicle *Jackie Brown* (1997) as an homage to the

genre. Initially, the genre received criticism from within black communities for its repetition of negative imagery. The subsequent reappropriation of this genre by the likes of Quentin Tarantino and others speaks of a complex cultural formation readily available to a variety of audiences for different purposes and effects. The vexed nature of the cultural politics surrounding this genre is something that chimes with the content of *Maiden Aotearoa* more generally.

With her Afro, bruised-blue eye shadow, and black handheld revolver, Thomas' self-portrait suggests that *Maiden Aotearoa* might involve a street-smart, savvy embrace of more global popular cultural formations in relation to images of Māori women in this time and place; however, this is a false promise, as other artworks in the exhibit focus on more local issues. Indeed, one could argue that, if anything, Thomas' reference to blaxploitation cinema conjures up a vexed set of desires and impulses that are subsequently mobilized in relation to these more local and regional Indigenous concerns. This is the strength of *Maiden Aotearoa* as a contemporary expression of Indigenous photography made by women. The artists do not deny the sociopolitical dimensions of photography that disseminate images throughout a range of varying contexts and situations. Indeed, these artists use these powers of dissemination to express other ways of knowing and doing. These artistic labors require nuanced and renewed conceptual frameworks with which to understand their multiple effects as artworks.

For example, while Thomas' reference to Pam Grier's 1970s-style *Foxy Brown* conjures up a more globalized circulation of eroticized exotic women, Thomas' second work (*Poi III*) invokes the beauty and grace of a more culturally embedded representation of femininity. One in a five-part sequence taken from the 2004 series entitled *Miss Appropriate,* this photograph depicts the cropped figure of a woman, framed from the waist down, and appears to draw upon fashion magazine–style photography with its high-contrast lighting and neutral background. The figure is clad in a traditional piupiu that sits on top of a bright-red underskirt. The figure is in motion, performing a kapa haka movement. The significant feature of this photograph is the fact that this Māori maiden wears black patent-leather stiletto heels. The staged contrast between high heels, red skirt, and piupiu gestures to the dynamic nature of cultural practices that change and adapt to prevailing conditions; however, the grace and beauty of the kapa haka performer that Thomas captures on camera also speak of the long-standing and expressive power of Māori femininities. When this image from *Miss*

Appropriate is read in relation to *Self Portrait #3*, one could argue that Thomas' art highlights the generative dimensions of popular cultural imagery that traffic across local and global circuits of exchange.

The populist appeal of Thomas' artworks (her reference to the blaxploitation genre and to fashion magazine photography) fits with her artistic and political strategies, which repeat and recirculate stereotypes to offer a critique of these images and ideas. Thomas read and engaged with the work of Coco Fusco when she was in art school. In 1993, Fusco and Guillermo Gómez-Peña exhibited themselves as caged Amerindians from an imaginary island. While the artists' intent was to create a satirical commentary on the notion of anthropological discovery, they soon realized that many of their viewers believed the fiction and thought the artists were real "savages." It is this kind of framing and de-framing that Thomas' work draws attention to.

Suzanne Tamaki's work also asks her audience to think in different directions. Tamaki describes herself as a fiber artist. She works under the label Native Sista and was a founding member of the Pacific Sisters fashion collective. Her reworking of the New Zealand flag as a garment for her contribution to *Maiden Aotearoa* is a continuation of a long-standing interest in colonial-styled mise-en-scène. This series is titled *Treaty of Why Tangi*, a play on the 1840 te Tiriti o Waitangi/Treaty of Waitangi, which forms the basis of New Zealand's vexed cultural politics. Tamaki worked with photographer Norman Heke to produce two very large photographic images (1.5 meters by 1 meter) that confront the viewer as they enter the small exhibition space. These works reference colonial studio photography practices and contain the figure of a woman with tā moko on her chin and arms. The same woman appears in both artworks. The photograph to the left is titled *For God, For Queen, For Country* and depicts the woman wearing a pearl necklace and dressed in a garment made of the Union Jack, with a scarf made up of the New Zealand flag. She stares directly at the camera in a formal pose, with gloves and top hat completing the composition. The photograph to the right is titled *For Māori, For Sure* and shows the woman now hatless, without pearls, but instead wearing a pounamu toki. The flag is now held in her left hand, and in her right she clasps a pair of scissors.

This most recent artwork from Tamaki continues her long-standing interest in politics, an interest perhaps encapsulated in titles such as *DNA: Diluted Native Aotearoa* and *AOTEAROA: Land of the Wrong White Crowd* (a play on the more conventional translation of Aotearoa as "Land of the Long White Cloud"). Tamaki's long-standing

interest in flags bears some relationship to her links with Tūhoe and her uncle Tame Iti, a significant member of Tūhoe who is often framed as something of a folk devil by major media outlets (Abel 2008; Devadas 2008). In 2005, during a pōwhiri, which formed part of a Waitangi Tribunal hearing (a process designed to address the hurts of colonization), Iti fired a shotgun into a New Zealand flag. Television crews filmed this event and news media outlets often recycle footage of Iti when any mention of unrest among Māori communities becomes a television news item. Tamaki's reworking of the New Zealand flag for *Maiden Aotearoa* acts as an intertextual reference to Iti's flag-shooting event and to a prevailing government authority that still seeks to expunge aspects of Indigenous agency. That is to say, the title of the second artwork, *For Māori, For Sure,* contains an intertextual reference to the 2004 Foreshore and Seabed Act, which ensured state ownership of land below the high-tide mark. This act was a response to the New Zealand Court of Appeal's ruling that the Māori Land Court could investigate claims of Māori customary rights to this area. By declaring this land New Zealand Crown–owned, the government prevented Māori from exercising their rights as guaranteed under the 1840 Treaty of Waitangi.[7] Accordingly, Tamaki's reworking of the New Zealand flag in the second photograph, and the stance and scissors wielded by her subject, expresses the perpetual threat that Māori might overturn the status quo and that the nation-state might one day be iwi-focused rather than settler-centric. A feminine take on the more usual folk-devil treatment of Tame Iti, Tamaki's artworks navigate a fine line between effective aesthetic intervention and bold, didactic sloganeering. Each tactic has its place; however, the former aesthetic tactic can often use the expressive forces of art to offer effective countermemories of the nation. This aesthetic technique can be found in the work of Aimee Ratana.

Deeply invested in current politics and the ways Tūhoe occupy a particular space in New Zealand mediascapes, Tamaki's work shares something with the contribution made by Tūhoe artist Aimee Ratana. Based in the Bay of Plenty, Ratana's photographic series *Tōku Tūhoetanga* draws from the Whakatāne Museum archive as well as more contemporary images, processed in black and white to underscore the continuity between both archival and contemporary photographic images. This conduit between past and present is crucial to Ratana's notion of photographic whakapapa. A descendant of Te Arani, a wife of Tūhoe prophet and leader Rua Kēnana, Ratana inserts her own self-portraits into this series (albeit framed a little separately on a wall facing the more

historical images). In many ways Ratana's self-portraits do the work of renewing intergenerational links in ways that echo the Bradshaw whanau experience of watching *Hei Tiki*. Through the archive left by earlier photographers, Ratana can cite five generations of photographic whakapapa; these photographic works sit alongside those other practices that continue the work of cultural continuity (oral narratives, carvings, and landscapes).

While the past is an integral element of *Tōku Tūhoetanga*, Ratana's photographic series also bears witness to the persistent pressure placed on Tūhoe by the New Zealand Crown. *Tōku Tūhoetanga* references the 1916 Crown invasion of the Tūhoe community based at Maungapōhatu, the arrest of Rua Kēnana, and the establishment of Te Whitu Tekau Council in 1872, a Tūhoe governing body designed to keep out government authorities. Yet, the underlying irony of this artwork lies in the fact that Ratana developed this series at the same time that media outlets were focused on the so-called Tūhoe Terror raids. On October 15, 2007, a large-scale paramilitary police operation saw seventeen putative "terrorists" arrested under the 2002 Terrorism Suppression Act in Auckland, Wellington, Christchurch, and Te Urewera, the interior forested domain of the Tūhoe people. Those arrested were mostly but not all Māori and consisted of Indigenous rights activists, environmentalists, and anarchists. Police, in particular, closed off the small rural town of Ruatoki, and locals were stopped, searched, photographed, and at times detained for lengthy periods. Ratana's artwork insists upon the conduit between past and present and the enabling powers of photography to ignite and sustain these links even as television news media and print media functioned to posit Tūhoe as terrorists within their own lands.

Tōku Tūhoetanga is a haunting homage to this irony, voiced from the perspective of a Tūhoe woman. By foregrounding this deeper history between iwi and state, Ratana sidesteps the tyranny of the colonial stereotype that would have te ao Māori framed as a negative differential in relation to the norms of settler society. Ratana's self-portraits assert mana wahine Tūhoe rather than a Dusky Maiden stereotype. This work is all about whakapapa and the potency of imaging technologies to secure a sense of place, belonging, and whanau under conditions that seek to destroy these connections. Ratana's work acknowledges the resistant and resilient dimensions of Tūhoe culture that, in part, have been facilitated by photographic technologies.

Finally, the youngest artist in the exhibition, Sarah Hudson, offers up two works that demarcate a deconstructive approach to representa-

tions of the Dusky Maiden. In the Deane Gallery, Hudson's largest work sits between Tamaki's didactic political imagery and Ratana's photographic whakapapa. This positioning is intriguing. Where Tamaki boldly inhabits a stereotypical depiction of native identity in relation to state authority (invoking images of those "troublesome Māori activists"), and where Ratana's series affirms the specificities of place and identity by invoking her Tūhoetanga, Hudson's *Dark but Comely* (2010) imbues a colonial photograph of a "native woman" with a haunting effect of absence.

Hudson's artworks emerge from the unnerving experience of coming across a photograph in her grandmother's collection of close whanau members re-creating a scene for a professional photographer. Hudson's subsequent artworks ask her audience: How can one imagine the shock of being connected to those subjects of colonial postcard imagery whose presence and authority has been erased by mass production? Both *Dark but Comely* and Hudson's second piece in the exhibit, *Māori Beauty*, attempt to reenact this shock by digitally manipulating archival postcard images. Based on a George Iles photograph made into a postcard in the early twentieth century, *Dark but Comely* is larger than life-size and depicts the blacked-out face of a woman wearing feathers in her hair and a woven cloak. Hudson has joined the outline of the sitter's hair with a vast expanse of blackness that fills the space that once held the sitter's features. At once monstrous and chilling, the artwork is also ambiguous. While we expect a portrait to have the sitter confront the camera, *Dark but Comely* offers up the possibility that the sitter is in fact turning away from the photographer, an act of refusal that could be construed as "speaking back" to the will to visualize that so dominates the colonial project. Indeed, Hudson has said of this work that it conjures up such a sense of a woman's presence that the postcard is elevated from being understood as a "widespread commodity to an image that deserves respect" (Hudson 2010, 27).

Māori Beauty offers a similar absent sitter and a similar technique of digital erasure. Framed atop a light box that makes the surface of the image gleam, this artwork depicts an empty picture frame with ornate edging that draws attention to the looming darkness at its center. The small printed title, "Māori Beauty," sits below the frame and references the anonymous nature of mass-produced postcards that used generic titles to describe their subjects. Small in scale (approx. 105 by 175 millimeters), in keeping with the actual dimensions of a colonial postcard, *Māori Beauty* is nonetheless a luminous presence in the exhibition.

Both works invoke the negative effects of colonial photography that rendered their sitters anonymous, and through her use of digital manipulation, Hudson reenacts these symbolic violences at the same time that she enables a once-repressed presence to ring through. Some have responded negatively to her digital erasures; however, perhaps it is productive to feel this affront and to work through the implications of a contemporary Māori woman artist engaging with the legacy of colonization. Might this performative reenactment not have pedagogical effects? Might it not tell us something about the importance of images, history, and connection in a world where images are increasingly ephemeral, transient, and open to manipulation? Hudson's empty frames (empty but full) perhaps pose a reminder of all those stories, images, and connections lost to so many due to ongoing processes of colonization.

Conclusion

As I stated at the outset, the title *Maiden Aotearoa* references the Dusky Maiden stereotype, but also the many ways images of Māori cultural differences have helped the New Zealand nation make itself attractive to a global audience; however, the wordplay involved in the title can be traced in yet a third way. That is to say, the phrase "made in" also gestures to the ways Indigenous cultures are inextricably linked to land, place, whanau, and community as embedded in the term tangata whenua (people of the land). The ways this sense of belonging is affirmed, refreshed, restated, and asserted change over time and in relation to prevailing conditions. The photographers in this exhibition express the persistent negotiation of Indigenous belonging in ways that reflect a tie not only to the nation-state (Tamaki's *For Māori, For Sure*) but also to a photographic history that has many different faces. Thomas' *Self Portrait #3* reaffirms a sisterly connection to an African American diva that is then returned to a local referent of identity in her portrait of kapa haka beauty. This juxtaposition reminds us that raced and gendered representations have global resonances that can be tapped to assert more localized expressions of feminine beauty and power. Ratana's harnessing of the persistent link between past and present Tūhoe imagery functions as a form of photographic whakapapa that reminds its audience of the ongoing injustices experienced by iwi. Where major media outlets frame Tūhoe using Tama Iti as a folk devil, Ratana's counterhistory of Tūhoe media brings contexts and presences from the past into the present. Hudson's hauntingly empty frames remind us

that although colonial depictions of Dusky Maidens often attempted to empty out and eradicate any sense of autonomy, agency, and human presence, these images nonetheless "speak." All four artists in *Maiden Aotearoa* remind us that art is an exchange, an invitation, an affront, and an insistence. It is a force that invites reciprocity, and it is that which gives us the capacity to imagine something different. As art critic Lucy Lippard (1992) has argued, the best photographic works provide "the illusion of seeing for ourselves, the way we never *would* see for ourselves, which is what communication is about" (43). While ostensibly an exhibit dedicated to a tired and outmoded trope of gendered and cultural difference, *Maiden Aotearoa* also invites its audience to reflect upon contemporary cultural politics, the prior histories of cross-cultural encounter that condition this place, and the ongoing work of asserting Indigenous female presences under such conditions.

Notes

1. This chapter vacillates between the name Aotearoa/New Zealand and the name New Zealand to make an implicit distinction between the idea of this nation-state from the perspective of te ao Māori (Aotearoa/New Zealand) and the more settler-centric term New Zealand, the latter of which dominates discussions of national identity.
2. *Maiden Aotearoa*, May 21–June 26, 2011, City Gallery Wellington, New Zealand, http://citygallery.org.nz/exhibitions/maiden-aotearoa.
3. Elsewhere I have argued that settler colonialism is an ongoing project that must continually code, decode, and recode social norms and social spaces so as to secure a meaningful (read proprietary) relationship to the territories and resources at stake. Somewhat akin to an obsessive-compulsive disorder, settler colonialism is deeply vexed by its own precarious identity, a precariousness that at the same time extends its powers throughout the social matrix that is the nation (see Smith 2011, 111–131).
4. Ngahuia Te Awekotuku defines mana wahine Māori as "reclaiming and celebrating what we have been, and what we will become" as Māori women (see Te Awekotuku 1991, 10).
5. Margaret Jolly notes the ambivalent effect of Dusky Maiden imagery when she argues that such stereotypes express a form of sexual vulnerability at the same time they express a potent danger (see Jolly 1997, 99–122).
6. See Taouma 1998, 35–46; Tamaira 2010, 1–35.
7. Lawyer Tom Bennion suggests that the Foreshore and Seabed Act has been as significant to New Zealand as the Mabo decision of 1992 was

to Australia. Whereas the Australian case demonstrated the political recognition of customary rights, the New Zealand case witnessed the extinction of native title. By restricting the notion of Indigenous customary law, the FSA demonstrated the limits of state-sanctioned bicultural politics, which promises the official recognition of two separate peoples. The most significant Indigenous response to these restrictive practices was Labour MP Tariana Turia's break with the party and the establishment of New Zealand's first Indigenous political party, the Māori Party.

Works Cited

Abel, Sue. 2008. "Tūhoe, Terror and Television." In *Terror in Our Midst?*, ed. Danny Keenan, 113–128. Wellington, New Zealand: Huia Publishing.

Bhabha, Homi K. 1994. *The Location of Politics*. London: Routledge.

Blythe, Martin. 1994. *Naming the Other: Images of the Māori in New Zealand Film and Television*. Metuchen, NJ: Scarecrow Press.

Devadas, Vijay. 2008. "15 October 2007, Aotearoa: Race, Terror and Sovereignty." *Sites: A Journal of Social Anthropology and Cultural Studies* 5, no. 1:124–151.

Hage, Ghassan. 2003. *Against Paranoid Nationalism: Searching for Hope in a Shrinking Society*. Melbourne: Pluto Press Australia; Merlin Press.

Hillyer, Minette. 1997. "We Calmly and Adventurously Go Travelling: New Zealand Film 1925–35." MA thesis, University of Auckland.

Hudson, Sarah. 2010. "Other Identities: Portrayals from the Past and What Remains in the Present." MFA thesis, Massey University.

Ireland, Peter. 2011. "Guerrilla Girls." Review of *Maiden Aotearoa*. EyeContact. June. http://eyecontactsite.com/2011/06/guerilla-girls. Accessed October 8, 2011.

Jolly, Margaret. 1997. "From Point Venus to Bali Ha'i: Eroticism and Exoticism in Representations of the Pacific." In *Sites of Desire, Economics of Pleasure: Sexualities in Asia and the Pacific*, ed. Lenore Manderson and Margaret Jolly, 99–122. Chicago: University of Chicago Press.

Jones, Alison, Phyllis Herda, and Tamasailau M. Suaalii, eds. 2000. *Bitter Sweet: Indigenous Women in the Pacific*. Dunedin: University of Otago Press.

Lawn, Jenny, and Bronwyn Beatty. 2005. "Getting to Wellywood: National Branding and the Globalisation of the New Zealand Film Industry." *Post Script* 24, nos. 2–3:125–143.

Lippard, Lucy, ed. 1992. *Partial Recall: With Essays on Native North Americans*. New York: New Press.

Mathews, Nancy Mowll. 2001. *Paul Gauguin: An Erotic Life*. New Haven, CT: Yale University Press.

Mita, Merata. 1992. "The Soul and the Image." In *Film in Aotearoa New Zealand*, ed. Jonathan Dennis and Jan Bieringa, 36–54. Wellington: Victoria University Press.

Pearson, Sarina. 2005. "Darkness and Light: Dusky Maidens and Velvet Dreams." *Camera Obscura* 58, no. 20 1:84–206.

Smith, Bernard. 1960. *European Vision and the South Pacific 1768–1850: A Study in the History of Art and Ideas*. London: Oxford University Press.

Smith, Jo. 2008. "Postcolonial Affirmations: The Return of the Dusky Maiden in Sima Urale's *Velvet Dreams*." *Continuum: Journal of Media and Cultural Studies* 22, no. 1:79–88.

————. 2010. "Native Reenactments/Living Iterability: Lisa Reihana's *Native Portraits n.19897*." In *Settler and Creole Re-enactment*, ed. Jonathan Lamb and Vanessa Agnew, 273–293. Houndmills, Basingstoke, Hampshire, UK: Palgrave Macmillan.

————. 2011. "Aotearoa/New Zealand: An Unsettled State in a Sea of Islands." *Settler Colonial Studies* 1:111–131. http://www.tandfonline.com /doi/pdf/10.1080/2201473X.2011.10648803. Accessed September 18, 2012.

Tamaira, A. Marata. 2010. "From Full Dusk to Full Tusk: Reimagining the 'Dusky Maiden' through the Visual Arts." *Contemporary Pacific* 22, no. 1:1–35.

Taouma, Lisa. 1998. "Re-picturing Paradise: Myths of the Dusky Maiden." MA thesis, University of Auckland.

Te Awekotuku, Ngahuia. 1991. *Mana Wahine Māori Selected Writings on Māori Women's Art, Culture and Politics*. Auckland, New Zealand: New Women's Press.

Vercoe, Caroline. 2004. "The Many Faces of Paradise." In *Paradise Now?*, ed. Caroline Vercoe and Melissa Chiu, 34–47. New York: Asia Society Museum.

Wells, Lee Rona. 2008. "*The Seekers:* Unmasking Localised Identities in Media Representations." Intern Research Report 5. *MAI Review* 1. www .review.mai.ac.nz/index.php/MR/article/viewFile/108/119. Accessed September 18, 2012.

Stealing the Piko

(Re)placing Kānaka Maoli at Disney's Aulani Resort

BRANDY NĀLANI MCDOUGALL AND GEORGANNE NORDSTROM

'A'ohe mālama pau i ka 'iole.
No one who takes care of his possessions has ever found them
eaten by rats.

'Ai no ka 'iole a ha'alele i kona kūkae.
A rat eats, then leaves its droppings.

He piko pau 'iole.
An umbilical cord taken by a rat.

AS THESE 'ŌLELO NO'EAU SUGGEST, the Hawaiian proverbs featuring
the 'iole depict the rodent as, at best, a rude, disrespectful, and unwel-
come guest and, at worst, a thief. Even though the mouse is a more "re-
cent introduction" to Hawai'i, probably from California (Bryan 1915, 293),
it is likely that these 'ōlelo no'eau refer inclusively to the rat and mouse, as
in 'ōlelo Hawai'i, 'iole may be translated as either. While the rat and the
mouse are both common pets, in Hawai'i both are also invasive species
that potentially transmit diseases, contaminate food, and destroy prop-
erty. Thus, the caution conveyed by these 'ōlelo no'eau can arguably be
applied to both rodents. The last 'ōlelo no'eau gives the strongest warn-
ing: protect the piko, or umbilical cord, of a child from being taken by
rats. The piko holds the mana[1] of the infant and, as such, it is placed or
planted according to the traditions of various 'ohana (families), to con-
nect the child to a particular 'āina, or land. If a rat took a piko from
where it had been placed or planted, it is believed that the child might

become a thief. Having a piko stolen by a rat represents a severing of the ʻāina connection. Without an ʻāina to which one may anchor and draw strength, a child may always feel that lack and turn to thievery, therein becoming a rat him- or herself. Conversely, when a child's piko is safe in the ʻāina of its ʻohana, the child will be strongly connected and will mālama ʻāina (care for the land) and aloha ʻāina (love the land) throughout his or her life.

As the story of the piko shows, ʻāina is not only sacred to Hawaiians; it is familial, and just as people have relationships and (hi) stories—moʻokūʻauhau and moʻolelo—so does the ʻāina. ʻĀina is, after all, an ancestor of Kānaka Maoli. Papahānaumoku, as the Hawaiian Earth Mother, Wākea, as the Hawaiian Sky Father, and Hāloanaka or Hāloanakalaukapalili, the kalo, are ancestors common to all Kānaka Maoli. Papahānaumoku, or "Papa who Gives Birth to Islands," embodies the ʻāina, or land, even as she is able to create more. The recognition of Papa, Wākea, and Hāloanaka as ancestors is also the recognition that Kānaka Maoli are descended from and are continually nourished by the earth and sky of Hawaiʻi. This genealogical relationship has great cultural and political importance for Hawaiians: it underscores Indigenous identity and belonging to Hawaiʻi, the responsibility to mālama ʻāina and aloha ʻāina, and political and cultural claims to lands and sovereignty.

Despite this intimate genealogical and familial relationship between Kānaka Maoli and Hawaiian lands and the volume of moʻolelo and moʻokūʻauhau that call attention to these connections, American settler colonialism has created its own narratives about Hawaiʻi for the very specific purpose of reinforcing a colonial capitalist agenda that often includes occupying and claiming Native Hawaiian land. In "Dole, Hawaiʻi, and the Question of Land under Globalization," Laura Lyons (2010) elaborates on the conflict between Native Hawaiian and Western perspectives of and relationships with the land, asserting that Native Hawaiians' "concept of being and of the land . . . is incommensurate not only with capitalism's relegation of land to 'real estate' but also with western categorizations of land as such" (71). Lyons further notes that "one material effect of [capitalist] thinking can be to disable and render suspect the real-world politics of Indigenous groups who too often are forced to argue for their connections to particular lands" (71). In Hawaiʻi, colonial corporate structures have consistently created and appropriated stories in efforts to make believable the notion that their claims to lands are equal to or supersede Hawaiians' claims, so as to

justify American colonial occupation and its corporate interests. These interests inevitably include the commodification of Hawaiian culture.

A common element in such narratives is the simulated erasure of Indigenous peoples, which allows colonial settlers to fashion roles for themselves as protectors of and spokespeople for the Indigenous groups they are displacing, in this case, Native Hawaiians. In *Legendary Hawai'i and the Politics of Place: Tradition, Translation, and Tourism,* Cristina Bacchilega (2007) examines how mo'olelo, or "connected (hi)stories," have been rewritten and deemed "legends" for the purpose of creating a touristic space "constructed for non-Hawaiians (and especially Americans) to experience . . . a Hawai'i that is exotic and primitive while beautiful and welcoming" (5). Though not widely criticized for its imperialist insidiousness, Disney and its Imagineers have been successful in constructing similar narratives that promote consumerism at the expense of Kanaka Maoli[2] culture and sovereignty.

As the ensuing examination of Disney's Aulani Resort on O'ahu's 'Ewa coast demonstrates, it is precisely because Disney is associated with childlike innocence, and not colonial and corporate greed, that the corporation has been able to create stories that indigenize and facilitate its corporate colonial presence in Hawai'i. Arguing that Disney's indigenization narratives coincide with themes of simulated native presence and implied native absence, we highlight how Mickey Mouse is yet another 'iole who consumes, displaces, and dispossesses.

The strategy of appropriating and distorting the stories of a particular place and/or creating new stories so as to naturalize an agenda of corporate capitalism is certainly not new for Disney. In fact, it has built its multibillion-dollar corporate empire on such stories. Telling of its now widespread usage, Merriam-Webster has added the term "Disneyfication" to its dictionary, defining it as "the transformation (as of something real or unsettling) into carefully controlled and safe entertainment or an environment with similar qualities" ("Disneyfication" n.d.). Indeed, Disneyfication is at the foundation of the company's homogenous claiming and branding of stories and places. For Indigenous peoples, the problem with Disneyfication is compounded in that it parallels and often incorporates settler colonial constructions of Indigenous peoples as noble savages—whether sexualized and natural (as in *Pocahontas*); clownish, mischievous, and alienated (as in *Lilo & Stitch*); untamed and childlike (as in *The Jungle Book*'s Mowgli); or wild and inarticulate (as in Big Chief, Squaw, and Tiger Lily in *Peter Pan*). These films are the first step in a marketing agenda that then turns these

caricatures into merchandise, feeding the insatiable Disney 'iole even further. Disneyfied portrayals reinforce settler colonial hegemony by erasing and replacing native peoples (and their (hi)stories and experiences) and by ignoring or negating their claims to lands and Indigenous identity. In *Fugitive Poses: Native American Scenes of Absence and Presence,* Gerald Vizenor (2000) asserts that colonial constructions/inventions of natives intended to replace native presence inevitably denote native absence. Though applied to examine how Native Americans have been represented, Vizenor's concept of the colonially constructed "indian" as being "cultural narratives of an absence, the absolute misnomer of a native presence and the originary," may be readily applied to examine how Kānaka Maoli are portrayed as well. Disney's simulations of Hawaiianness in its films, television shows, and Aulani Resort are similarly "mimetic representation[s] of that [native] presence" (28), fabricated caricatures aligned with a dominant narrative of native absence.

In terms of Hawai'i, Disney has honed and refined its colonial stories for nearly eighty years, moving from narratives promoting a more overt or literal form of native absence to its simulations of Hawaiianness veiling native absence. "Hawaiian Holiday," a 1937 cartoon, is the earliest example of Disney's imposition of its own stories onto Hawai'i. It features Mickey, Minnie, Donald, Goofy, and Pluto on an empty beach in Waikīkī with the iconic Lē'ahi (Diamond Head) in the background. Technicolor enlivens the scene of a dense jungle with ferns, coconut trees, and abandoned canoes on the secluded beach. The cartoon begins with Pluto playing alone along the shore. He runs to meet up with Donald and Mickey, who are playing 'ukulele in front of their grass shack as Minnie, garbed in a grass skirt, a lei, and high heels, dances a hula to a song without words. Meanwhile, Goofy is taking his stone longboard out on the water, trying to surf a wave that seems to have a mind of its own. Like many of these early cartoons that Walt Disney drew himself, there is very little dialogue as the characters' slapstick actions and interactions speak for themselves amid a cheerful symphonic tune. At just over eight minutes, and without words, the cartoon speaks volumes about absences—gone are the hotels of Waikīkī, which even in 1937 were present and growing with the tourism industry; gone are any signs of the "civilization" and "progress" that were a strong part of the Americanization process in territorial Hawai'i; and perhaps most significantly, gone are any people, Indigenous or otherwise. It becomes apparent that a good holiday—a Hawaiian Holiday—entails enjoying 'ukulele, hula, lei, surfing, and

beach, all elements intricately associated with Hawai'i; however, it does not include being hindered by any actual people. "Hawaiian Holiday" is a harbinger of Disney's corporate imperialist approach to creating a space that is both absent of Indigenous people and, at the same time, occupied by Disney. The absence of Indigenous people, moreover, also leaves abandoned cultural symbols free to be claimed and consumed, and because Disney has so successfully built an ethos around what Henry Giroux (1998) calls a "discourse of innocence" (256), Disney becomes a safe and trusted proxy on Hawaiian land simulated to be a terra nullius.

For the remainder of the twentieth century, Disney, the master corporate storyteller, whose "strategic association with childhood [has created] a world cleansed of contradictions and free of politics" (Giroux 1998, 258), would continually return to Hawai'i and the rest of the Pacific for exotic narrative material that could be used to feed the company's library of "multicultural" and "ethnically responsible" projects. The 1963 debut of its "Enchanted Tiki Room" at Disneyland featured a seventeen-minute show of mechanized singing/speaking birds and caricatured tiki. Polynesian gods including Rongo, or Lono as he is known in Hawai'i, in the forms of Disneyfied tiki, or ki'i, continue to be posted just outside the Enchanted Tiki Room to entertain those waiting in line. Toward the end of the century, the company's focus on Hawai'i intensified: in 1990, Disney opened its first retail store in Hawai'i; in 2002 it released *Lilo & Stitch*, an animated feature film; *Stitch! The Movie*, a direct-to-video animated spin-off film, and *Lilo & Stitch*, an animated spin-off television series, were both released in 2003; in 2007, it announced plans to build an eight-hundred-unit resort in Hawai'i; and in 2011, Disney opened its heralded Aulani Resort in the 'Ewa moku (district).

In its conception and building of Aulani, Disney has represented itself as engaging with the Hawaiian culture in ways that other Hawai'i-based tourist commodity projects have not. They hired Hawaiian consulting firms and amassed a collection of Hawaiian artwork created by Hawaiian artists[3]—indeed, the Aulani website boasts, "Aulani features one of the largest collections of contemporary Hawaiian art in the country" ("Aulani Daily Calendar" n.d.). John McClintock, a spokesman for Disney, explains the role Disney assumed in their approach to this endeavor: "We're a storytelling company . . . and when we came to Hawaii [sic], we didn't come to tell our own stories. We

came to tell the stories that already exist here" (quoted in Lovitt 2011). In this way, Disney grants itself the authority to tell the (hi)stories of Hawai'i through a sense of entitlement to native cultural productions, while simultaneously representing itself as culturally responsible:

> Walt Disney Imagineers worked hand in hand with locals to cre-ate Aulani, A Disney Resort & Spa in Ko Olina—a Hawai'i Re-sort that celebrates Hawaiian culture, history and traditions. From contemporary Hawaiian art and design to myriad recre-ational activities, entertainment, excursions and more, Aulani immerses Guests in the legends of the islands so you can experi-ence the true enchantment of Hawai'i. ("The Aulani Story" n.d.)[4]

With Aulani, Disney arguably has progressed in terms of includ-ing Indigenous cultural perspectives in its representations, particularly when compared to other tourist attractions and corporations/colonial endeavors in Hawai'i. We are not going to suggest that the hotel is not beautiful—to the contrary, the accommodations and the setting are quite amazing, if not a bit overwhelming (but when is Disney not?). The constructed ethos of Disney coupled with its self-deployed narra-tives that Aulani Resort is a culturally responsible project, however, al-lows Disney to tell a particular brand of stories about Hawai'i that work to legitimize and indigenize the company's presence.

A cursory glance at the numerous free activities and teaching events offered at the resort points particularly to Disney's assumed authoritative and pedagogical role in terms of Hawaiian culture: "Eruption Disruption Volcanic Island Science"; "'Ukulele for Tweens and Teens"; "'Ohana Hula"; a "Hawaiian Craft Series"; an "Interactive Stingray Experience"; "Kilo Hōkū" (Navigation and Stargazing); and "Discover Aulani Tours," events tailored to cover a variety of topics that include Hawaiian culture, language, navigation, and art. Given that Disney's imbricated colonial and corporate allegiances are veiled by its discourse of innocence, this assumed pedagogical role is especially problematic. This is not, however, the first time that Disney's associa-tion with education has come under scrutiny. In "Public Pedagogy and Rodent Politics: Cultural Studies and the Challenge of Disney," Giroux (1998) discusses Disney's increasing presence in schools and how this works to promote a culture of consumerism that ultimately works to sustain the company's economic growth:

Disney Corporation increasingly presents itself not only as a purveyor of entertainment and fun, but also as a political force in developing models of education that influence how young people are educated in public schools, spheres traditionally understood to offer children the space for critical and intellectual development uninhibited by the relentless fascinations of consumer culture. (257–258)

The corporation's strategically created ethos complicates the pedagogical role Disney assumes, further enabling Disney to simulate apolitical realities through its narratives while reproducing ideologies of power and dominance that benefit its corporate well-being. Giroux argues that Disney's association with "innocence . . . serves as a rhetorical device that cleanses the Disney image of the messy influence of commerce, ideology, and power" (1998, 258). This well-established ethos positively associated with children facilitates an aura of truth allowing Disney and its Imagineers to recast fantasy as reality and vice versa, a particularly insidious act when the fantasy obfuscates Indigenous dispossession and marginalization.

As demonstrated in numerous news clips about the resort, there is a suggestion that Hawai'i's "real" stories will, at the very least, be made accessible. Maile Meyer, a Hawaiian consultant to Aulani, subtly hints at this illusion of authenticity: "Is it 100-percent authentic Hawaiian? Of course not . . . But it's as real as you can get in a visitor experience" (quoted in Lovitt 2011). When the comments in Disney's press releases are read collectively, it becomes apparent that the carefully crafted statements clearly avoid language that claims authenticity but rather subtly implies it. Indeed, the resort incorporates and simulates so many elements of Hawaiian culture, authenticity seems almost plausible. Arguably, releasing statements that imply authenticity does some work in establishing a culturally responsible ethos for Disney, but that work is furthered through material representations. To demonstrate what we mean here, we turn now to describing the resort as we experienced it.

When we arrived at the resort, we were greeted first by Aulani's concrete-terraced lo'i, whose auwai flow alongside the resort, then by the hotel "Cast Members," who gave tuberose lei to the women and kukui lei to the men and offered us all cups of ice water. Called the "McDougall and Nordstrom 'ohana," we were invited into the main lobby, which is decorated from floor to ceiling. A three-faced stylized wood ki'i of

Māui and his brothers,[5] left unidentified and unexplained, greets entering guests and represents traditional Hawaiian religion in a secular space; printed kapa,[6] once used to clothe people, decorates the walls; kahili, representing Hawaiian royalty and customarily carried by kahili bearers, stand unattended in the corners; kākau designs, signifying Hawaiian genealogies, are superimposed on transparent glass windows that reach all the way up to the ceiling; 'ipu and 'umeke, once used for carrying food and water from the 'āina, function as light fixtures; and a floor medallion depicts kalo (Hāloanaka) encircling an 'iwa, a bird celebrated for its beauty and regal stature in Hawaiian mo'olelo. Notably, many of the cultural items and symbols on display are reimagined and recast to fulfill the vision for the resort's Hawaiian-themed aesthetic; however, their (mis)placement and (mis)use emphasize their lack of functionality and belonging in the modern space. None of these objects or representations are needed or wanted for their original purposes in Aulani's lobby, and their histories and symbolism are left unexplained; indeed, they are displayed as obsolete relics, artifacts reduced to décor as they are left unused and unpeopled. As replacements for and representations of Kānaka Maoli, the resort's rhetorical and aesthetic (mis)placement and (mis)use of these cultural objects and symbols suggest that Hawaiian people and culture are terminal and ancient, outside of modernity, while elevating dominant American culture as progressive, innovative, and contemporary.

The main attraction of the lobby, a mural that completely encircles the large foyer, relates a similar story. It is intended, according to a Cast Member, to capture how life has changed, or rather progressed, in Hawai'i. The mural moves from a time of native governance (though any recognizable ali'i are not included),[7] steeped in isolation and tradition, to the present moment, wherein ali'i are also absent, but Native Hawaiians, now dressed in Western clothing, continue to fish and enjoy the 'āina. It was explained to us that the mural is meant to depict the evolution of activities and practices Hawaiians engaged in from ancient to present time. The "present" of the mural culminates in front of an open lanai that overlooks the rest of the resort, what Disney calls Waikolohe[8] Valley, with its resort buildings stylized to resemble traditional hale and hale wa'a. Framing traditional Hawaiian culture as needing Western evolution is a part of the colonial rhetoric and aesthetic of the space immediately. Even as Aulani appears to be honoring Hawaiian cultural heritage through the mural, the interpretation Cast Members, some of whom are Kanaka Maoli, give is entrenched in what

Renato Rosaldo (1989) calls "imperialist nostalgia," wherein "people mourn the passing of what they themselves have transformed" or destroyed. Furthermore, imperialist nostalgia's "innocent yearning" obscures colonizing aims to conquer and justifies conquest:

> Imperialist nostalgia occurs alongside a peculiar sense of mission, the white man's burden, where civilized nations stand duty-bound to uplift so-called savage ones. In this ideologically constructed world of ongoing progressive change, putatively static savage societies become a stable reference point for defining (the felicitous progress of) civilized identity. (Rosaldo 1989, 107–108)

Thus, what appears or is asserted to be an innocent celebration of Hawaiian culture is enmeshed within systems of colonial power and domination maintained and reinforced by visual and orally rendered narratives of progress and civilization. These marketable narratives emphasize Hawai'i and Hawaiian culture as offering an exotic and primitive escape from civilized and modern identity, which at the same time attributes modernity solely to the colonizer. That a Kanaka Maoli Cast Member may be reiterating these colonial narratives as part of his or her job disturbingly highlights how Indigenous peoples may be exploited to simulate consent and credibility.

Within Aulani, constructed narratives also serve to simulate the deep roots of Disney in Hawai'i. These narratives of Disney's indigenization are embedded within and expressed through Aulani's artificial land formations: the creation of an 'ahupua'a, a Hawaiian land division running from the mountain to the ocean, Waikolohe Valley, Waikolohe Pool and Stream, Rainbow Reef and Pu'u Kilo. Waikolohe is the name given to Aulani's network of pools, man-made rivers, and slides; however, it is also the name given to the "valley" formed within and by the resort's buildings. Waikolohe Valley's design mimics an 'ahupua'a, with the hotels forming the mountains and Waikolohe Stream flowing from these "mountains" to the ocean. Guests may float on the stream, which forms a loop, in large inner tubes, passing by or under waterfalls. While they travel along the "lazy river," they are sure to see wooden menehune hidden in the surrounding landscaped jungle of native plants; artificial rock formations that expose the deep simulated roots of trees; holoholona (animals) fossilized within the rocks; and fabricated kukui lamps lighting the dark tunnels. Another artificial site, Rainbow Reef, invites guests to snorkel "amongst tropical fish

found around Hawai'i, including Angel Fish, Butterfly Fish and Tangs" in "the only private snorkeling lagoon on O'ahu" (Disney 2012). Finally, guests may also go down two different slides, the tunnel slide, Volcanic Vertical, and the tube slide, Tubestone Curl, after hiking atop Pu'u Kilo (Hill of the Seer), a man-made lava rock formation/volcano (spouting water instead of lava) with various 'aumākua, or animal guardians specific to certain Hawaiian genealogies, hidden in its slopes. Pu'u Kilo mimics how Kanaka Maoli mo'olelo relate histories of various land formations in Hawai'i,[9] while doubling as an I-spy game wherein children must find the hidden animals. Imagineer Joe Rohde confirms that this was indeed Disney's intention:

> What you can see right along this very stretch of coastline on Oahu [*sic*] is that, as the lava flowed hundreds of thousands of years ago, it cooled rapidly as it hit the sea, piling up on itself and creating fantastic shapes. . . . That's the inspiration behind the rock formations. . . . We wanted the rock you come across here to appear to be the very rock that would be coming up out of the ground, as if it was real, only ours will be ever-so-slightly magical. (quoted in "Inspired" n.d.)

Disney's creation of artificial land enables the process of Disneyfication; in this way, Disney builds over, alters, and destroys the actual 'āina on which the resort is built so Waikolohe Valley may "appear as if it has been here for many, many years" ("Inspired" n.d.).

Disney further indigenizes itself in Hawai'i through narratives that are both appropriated from mo'olelo and newly composed. For example, Aulani's Menehune Bridge references various mo'olelo of menehune, an ancient race of people known to be industrious builders who built bridges, ditches, fishponds, and other engineering feats and are described as being both helpful and mischievous. According to Aulani's storyline, their Menehune Bridge, "an interactive water play area," was built by menehune, and they continue to inhabit the bridge and the resort (McClintock 2011). The resort's menehune, which are reimagined to resemble wooden monkeys (Ka'apana et al. 2012), are hidden throughout the resort, and children are encouraged to go on a menehune scavenger hunt to find them all. The depictions of menehune as monkey-like or unhuman may seem fanciful and cute, but these images misappropriate Hawaiian mo'olelo in which menehune are described as humans, though shorter and stockier than Kānaka Maoli

(Pukui et al. 1985). To 'ohana who observe menehune as ancestral spirits, Aulani's depictions are irreverent and disrespectful, even offensive; to peoples who have histories of being racialized with dehumanizing and animalistic caricatures, Disney's menehune reassert hierarchies of power. All of these constructions, in narrative and physical forms, appropriate Hawaiian culture and mo'olelo to simulate the indigeneity of Aulani—and of Disney—to Hawai'i: just as menehune accomplished great feats that benefited Native Hawaiians, they have expended the same energy for Disney through the building of Menehune Bridge, therein suggesting that these revered people somehow now view Disney as being of equal status to Kānaka Maoli in Hawai'i.

As we continued our walk around Waikolohe Valley, we passed a display of Hawaiian instruments without players and dancers—pahu drums, ipu, 'ulī'ulī—and we heard the pahu as we approached as if there was magic at work, creating an authentic Hawaiian sound in absentia of authentic Hawaiians. Right next to that, there was a display of kapa-making materials and tools, arranged as if someone were right in the middle of pounding the cloth. The only element of the kapa-making process missing was the person to do the pounding and dying. What we got instead was Tinker Bell's famed twinkling sound as the kapa cloth lit up as if it had been sprinkled with fairy dust. As in various other examples of native absence, there were no Hawaiians in any of these representations. References to people and Hawaiians and their role as the essential element of the culture (there is no culture without a people) are glaringly absent not only in the physical space, but in the comments made about the resort on the website and in press releases— except when there is mention of enlisting Hawaiian consultants in the design of the resort, and, of course, workers (labeled Cast Members). Hawaiians do not play the drums; Disney does. The long and laborious effort required to make kapa is erased as the material magically appears with the help of fairy dust. On the artwork throughout the hotel, we were unable to find any descriptors that offered the names of any of the artists, nor the names of their artworks, though certainly we were able to recognize the individual styles of Hawaiian artists such as Carl F. K. Pao, Doug Tolentino, Brooke Kapukuniahi Parker, and Harinani Orme. Their works are subsumed through the magic of Disney as well. Like the menehune, Kānaka Maoli are valued for their disembodied culture, but they themselves are invisible except as Cast Members, which reinforces a narrative that obscures the ways in which colonial dominance and power are perpetuated by and through the hotel.

It is through this use of Hawaiian objects and symbols that Disney "cites" the Hawaiian culture in the way Michel de Certeau (1984) uses the term in "Believing and Making People Believe." Disney has created a scenario in which the company and its Cast Members emerge as authorized spokespeople for Hawaiʻi, trained and deemed responsible to represent Hawaiʻi in a culturally sensitive and responsible way. The explanation of the resort's name clearly positions Disney as an authority in relation to Hawaiʻi and its people:

> Aulani traditionally means "a messenger of a chief—one who delivers a message from a higher authority," Joe Rohde, senior vice president, Creative for Walt Disney Imagineering, said in a press release. "The name Aulani was chosen to position the resort as a messenger of the 'higher authority' that is Hawaii [*sic*], its spirit and its culture. (Dolan 2011)

Disney uses the definition of the resort's name to carve out a privileged position as a messenger for Hawaiʻi, a position seemingly sanctioned by the Hawaiian community. The multitude of messages being sent has the convoluted effect of situating Disney as an authority on everything Hawaiian, which problematically adds credence to the distorted Disneyfied narrative it weaves about this place, its people, and Disney's role. Asserting that this kind of self-effacing strategy promotes believability, de Certeau (1984) writes that "to cite the other on their behalf is hence to make credible the simulacra produced in a particular place" (188–189). Disney is unquestionably one of the masters of simulacra, and at Aulani, Disney has become the main actor in its representations of Hawaiian culture and the possessor of the artworks.

It becomes increasingly apparent what is accomplished when Disney claims to be the messenger of "Hawaii, its spirit and culture." By erasing the people, Disney does not disrupt but rather continues the colonizing agenda by suggesting that the ʻāina and culture of Hawaiʻi can be claimed by foreigners. Disney creates a simulacra wherein Hawaiʻi is a place of magic and enchantment, and, most important, available for occupation. The ugliness of dispossession, displacement, and disenfranchisement of the Hawaiian people is obscured. Moreover, the imperialist nostalgia facilitated through the discourse reproduced in representations both visual and oral masks any culpability in colonizing practices, as "nostalgia is a particularly appropriate emotion to invoke in attempting to establish one's innocence and at the same

time talk about what one has destroyed" (Rosaldo 1989, 108). The inclusion of so many elements of Hawaiian culture allows Disney to create a very particular image of Hawai'i, one of which Disney is intricately a part. Certeau's assertion that "to cite is thus to give reality to the simulacrum produced by a power, by making people believe that others believe in it, but without providing any believable object" (1984, 189) is quite applicable here in that it explains the effect Disney's selective representation and manipulation have on people in terms of selling a story. At Disney's Aulani, elements and symbols of the culture are divorced from their function and place in Hawaiian culture precisely because it is impossible to capture the actual purpose and functions without incorporation of the people who use and understand them. Inclusion of Hawaiians as agents in these activities would force different (hi)stories to emerge, ones of colonization and displacement that Disney does not want to tell simply because these (hi)stories do not further Disney's corporate goals. Looking closer at one of the stories told at the resort and the work it does to naturalize Disney presence, then juxtaposing it with stories of the particular wahi pana the resort occupies, can further illustrate this point.

While at the resort, we were told by a Cast Member the "mo'olelo" of Aunty's Beach House, a house-like structure where families can leave their children for child care during their stay. The beach house is larger than many homes in Hawai'i and features a TV room, a game room, a kitchen, and an outside play area, among other activity areas. We were told that the beach house is the site of a home where Aunty and Uncle (both characters played at any given time by one of three Cast Members) once lived. Uncle spent his days fishing and providing for his family, and Aunty kept a welcoming house where many of the children in the community would come to play. Their house was famous among families because of Aunty and Uncle's aloha—they always welcomed everyone into their home. In the 1930s the house was rebuilt and stood, apparently until Disney rebuilt it again with the same intent of aloha for the families and children of the resort. Indeed, Aunty is always on site to look over and welcome the children, and in the evenings, Uncle hosts *The Starlit Hui*, a Hawaiian music and hula show, and offers "Mo'olelo Firepit Story Telling."

This constructed narrative uses the Hawaiian identities of Aunty and Uncle to simulate a welcoming, generous, and nonthreatening native presence, one open to sharing land and stories alike. Read in this way, the story of Aunty and Uncle, further substantiated by its other

Kanaka Maoli Cast Members, facilitates Aulani's presence as welcome, authenticated, and endorsed by Hawaiians. This narrative obscures how the 'āina continues to be devastated by development touted as progress and how colonial circumstances have forced many Kānaka Maoli off of their 'āina to work low-paying, service-level jobs within the tourism industry. Thus, nowhere in the story of Aunty and Uncle is there recognition of the land upon which Aulani is erected, nor is there any recognition of how the resort's beach is largely man-made with relocated sand covering a reef destroyed by dynamite. In fact, according to Cast Members, the Beach House is built in the same spot it has stood on for at least a hundred years. And, even as Disney reaps the benefits of settler colonialism in Hawai'i, it may still present itself as an economic savior, providing those low-paying, service-level jobs so residents, Hawaiians and non-Hawaiians alike, may actually have jobs. Perhaps this rescue narrative is the most difficult to counter, as in 2011, Disney "pumped some $800 million into the local economy to build the Aulani, hired about 800 employees to run the property and is doing business with a variety of local vendors" (Bumgarner); the number of Aulani employees has grown since then and will more than likely continue to grow, as Disney is currently expanding the Aulani resort. Considering Aulani sits on the edge of one of the most economically devastated areas of O'ahu, Wai'anae, employment opportunities are not to be undervalued. The question, then, is how much should those jobs cost in terms of land devastation and cultural exploitation? Perhaps Disney considers it a reciprocal benefit that it brings attention to Wai'anae's plight by naming one of its resort buildings after the area that suffers from some of the highest statistics of unemployment and homelessness in the state (Hill 2012).

In Hawai'i, colonial narrativizing has included exoticizing and primitivizing Kanaka Maoli culture to further entrench American colonial occupation and its corporate interests. All too frequently these narratives facilitate the dispossession and simulated erasure of Indigenous peoples and allow colonial settlers to fashion roles for themselves as protectors and spokespeople who may even appropriate and distort Indigenous narratives as commodities and vehicles for settler indigenization. Unfortunately, Disney's Aulani continues this colonial storytelling tradition and draws from its well-established ethos of innocence and self-appointed Hawaiian cultural authority to do so. Despite the voracity with which Disney appropriates and strategically creates its own narratives and its own Disneyfied land, Aulani can only mimic

native stories and simulate its indigeneity. Under interrogation, however, these instances of simulation only serve to underscore Disney's tenuous belonging and to demonstrate how Kanaka Maoli Indigenous identity supersedes settler identity.

Gerald Vizenor (2000) asserts that a "real sense of presence, memories, and coincidence is borne in native stories. The trick is to create a new theater of native names and antecedence that uncovers nativism and false memories; at the same time, native stories must tease out of the truisms of cultural exclusions and the trumperies of simulations" (69–70). Fortunately, Hawai'i has never lacked for native stories, and native stories continue to be told. 'Ewa, where Aulani sits amid its simulations, is no different. One mo'olelo of 'Ewa goes like this: before the 'iole tried to steal the piko of the people, before the resort complex of Ko Olina, before Horita dynamited the reef and imported sand to create four lagoons, before Kalaeloa became Barbers Point, before Campbell stole the waters of Waiahole and Waikāne for his plantations—Kekauonohi retained 43,250 acres at the Māhele, Ka'ahumanu, Kamehameha, and earlier, Kakuhihewa replenished themselves in the sacred saltwater pool, just as Hi'iaka replenished and healed her grief-stricken spirit to prepare for the inevitable battle with Pele ahead of her. And there were others before them and in between, too, making and inspiring more mo'olelo of 'Ewa. But the first ones were Honokawailani, who spurted freshwater, Pu'uokapolei, Nāwahineokama'oma'o, Pu'ukua, Kānehoa, and Halehau of 'Ewa, all of O'ahu and the rest of the islands now known as Hawai'i, who arose from the ocean, waiting for their names to be spoken and their mo'olelo to be told by their children.

Notes

1. We have chosen to leave certain Hawaiian terms untranslated. See Mary Kawena Pukui and Samuel H. Elbert, *Hawaiian Dictionary,* revised and enlarged edition (Honolulu: University of Hawai'i Press, 1986), for English translations.

2. Throughout this chapter, we use the terms "Kanaka Maoli," "Native Hawaiian," and "Hawaiian" interchangeably to refer to the Indigenous people of Hawai'i. Kānaka Maoli (with the kahakō, or macron) indicates the plural version of the term.

3. Aulani's art collection has several notable absences and by no means represents all contemporary Kanaka Maoli artists, and these absences tell a different narrative that focuses on Disney's exploitation and

appropriation of both the artwork and the artists that are represented at the resort. Since we wrote this chapter, artists Kapulani Landgraf and April Drexel curated an exhibit entitled *a mini retort,* which opened at Mark's Garage in Honolulu, Hawai'i, on May 5, 2013, to critique Aulani's Hawaiian art collection and the participation of certain artists. This exhibit underscores the cultural and political divisions within the Kanaka Maoli arts community that have been created by Disney's purchase and controlled treatment of their art collection at Aulani.

4. This excerpt from the Aulani website has been revised several times. The one we use here is the most recent before printing, April 4, 2014.

5. While no explanation of the ki'i is given in the lobby, nor names for the artists who carved it, MagicalKingdoms.com, a website dedicated to the Disney Vacation Club, shares that the ki'i are of Māui and his two brothers and were created by master carvers Rocky Jensen, Pat Pine, and Jordan Souza ("Hawaiian Art at Aulani Resort" n.d.).

6. MagicalKingdoms.com credits Dalani Tanahy, a famed kapa artist and practitioner, for the kapa ("Hawaiian Art at Aulani Resort" n.d.).

7. MagicalKingdoms.com identifies Martin Charlot as the muralist ("Hawaiian Art at Aulani Resort" n.d.). The two figures may be recognized as ali'i because of their royal regalia, the mahi'ole and 'ahu'ula the man wears and the lei niho palaoa the woman wears. These figures, however, are not of any readily recognizable ali'i; rather they were more than likely modeled after sketches by John Webber, a young artist who accompanied James Cook on his voyages. Both subjects of Webber's original sketches were not identified by name, only as "Man of the Sandwich Islands" and "Woman of the Sandwich Islands." It is unclear whether or not the mural artist intended to have his work be interpreted as an "evolutionary" narrative by the Aulani Cast Members.

8. Waikolohe may be translated as Mischievous Water.

9. There are numerous examples of wahi pana (storied places) throughout Hawai'i that feature natural land formations resembling deities, people, and/or animals. The mo'olelo associated with such land formations are generally etiological and render (hi)stories specific to the particular 'āina on which they are found. See "Na Wahi Pana o Ewa" in the Hawaiian-language newspaper *Ka Loea Kalaiaina* (August 26, 1899) for mo'olelo such as these specific to 'Ewa, O'ahu.

Works Cited

"Aulani Daily Calendar." n.d. Aulani, A Disney Resort and Spa. Disney Corporation. http://resorts.disney.go.com/aulani-hawaii-resort/activities-amenities/iwa-vacation-daily-planner/. Accessed June 5, 2012.

"The Aulani Story." n.d. Aulani, A Disney Resort and Spa. Disney Corporation. http://resorts.disney.go.com/aulani-hawaii-resort/about-aulani/story/. Accessed June 5, 2012.

Bacchilega, Cristina. 2007. *Legendary Hawai'i and the Politics of Place: Tradition, Translation, and Tourism.* Philadelphia: University of Pennsylvania Press.

Bryan, William Alanson. 1915. *Natural History of Hawaii: Being an Account of the Hawaiian People, The Geography and Geology of the Islands, and the Native and Introduced Plants and Animals of the Group.* Honolulu: Hawaii Gazette Co.

Bumgarner, Kevin. 2011. "My List of the Year's Biggest Business Stories." *Pacific Business News* (Honolulu, HI), December 30. http://www.bizjournals.com/pacific/print-edition/2011/12/30/my-list-of-the-years-biggest-business.html?page=all. Accessed August 1, 2012.

Certeau, Michel de. 1984. *The Practice of Everyday Life.* Berkeley: University of California Press.

Disney. 2012. "The Daily 'Iwa." Honolulu: Disney, June 21.

"Disneyfication." n.d. Merriam-Webster.com. *Merriam-Webster.* http://www.merriam-webster.com/dictionary/Disneyfication. Accessed July 17, 2012.

Dolan, Rebecca. 2011. "Disney's New Aulani Resort Welcomes Its First Guests." *Huffington Post,* Destinations, October 30. http://www.huffingtonpost.com/2011/08/30/disneys-aulani-resort-wel_n_941683.html. Accessed July 28, 2012.

Giroux, Henry A. 1998. "Public Pedagogy and Rodent Politics: Cultural Studies and the Challenge of Disney." *Arizona Journal of Hispanic Cultural Studies* 2:253–266.

"Hawaiian Art at Aulani Resort." n.d. MagicalKingdoms.com. http://www.magicalkingdoms.com/dvc/aulani_hawaiian_art.html. Accessed July 11, 2012.

Hill, Tiffany. 2012. "Kamehameha Schools Focuses on Public Schools along the Waianae Coast: Educating Hawaiians beyond the Walls of Its Campuses, KSBE Provides Targeted Support to One of Oahu's Low-Income Communities." *Honolulu* magazine, May. http://www.honolulumagazine.com/Honolulu-Magazine/May-2012/Kamehameha-Schools-Focuses-on-Public-Schools-Along-the-Waianae-Coast/. Accessed August 2, 2012.

"Inspired by Magical Legends and Natural Beauty of Hawaii, Imagineers Built a Valley of Wonder at Aulani." n.d. *Disneyland Resort News.* Disneyland Resort Public Relations. http://disneylandnews.com/2011/09/20/inspired-by-magical-legends-and-natural-beauty-of-hawaii-imagineers-built-a-valley-of-wonder-at-aulani/. Accessed August 1, 2012.

Kaʻapana, Damian Kamuela, Brandie Leong, Christina Fear, and Lindsay Pualei Hanohano-Tripp. 2012. "Hawaiʻi Tourism and Aulani: Desecration or Revitalization of a Native's Culture?" PowerPoint presentation for American Studies 220, University of Hawaiʻi, Spring.

Lovitt, Rob. 2011. "Disney Breaks the Mold with Aulani Resort." Today Travel. Msnbc.msn, August 29. http://www.today.com/id/44293251 /ns/today-today_travel/t/disney-breaks-mold-aulani-resort/# .UysxzF7Q-Ho. Accessed July 9, 2012.

Lyons, Laura. 2010. "Dole, Hawaiʻi, and the Question of Land under Globalization." In *Cultural Critique and the Global Corporation,* ed. Purnima Bose and Laura E. Lyons, 64–101. Bloomington: Indiana University Press.

McClintock, John. 2011. "Kids at Aulani Will Discover Fun in a Play Area Left by the Menehune." Disney Parks Blog. Disney Public Relations. June 1. http://disneyparks.disney.go.com/blog/2011/06/kids-at-aulani -will-discover-fun-in-a-play-area-left-by-the-menehune/. Accessed July 15, 2012.

Pukui, Mary Kawena, Caroline Curtis, and Robin Yoko Burningham, eds. 1985. *Tales of the Menehune.* Honolulu: Kamehameha Schools Press.

Rosaldo, Renato. 1989. "Imperialist Nostalgia." *Representations* 26 (Spring): 107–122.

Vizenor, Gerald. 2000. *Fugitive Poses: Native American Scenes of Absence and Presence.* Lincoln: University of Nebraska Press.

Kūpuku: Community

"I Lina'la' Tataotao Ta'lo"

The Rhetoric and Aesthetics of Militarism, Religiosity, and Commemoration

CRAIG SANTOS PEREZ

> *"hu hongge*
> *i lina'la' tataotao*
> *ta'lo åmen"*

~

MY FAMILY MIGRATED from Guåhan (Guam) to California in 1995, when I was a sophomore in high school. One of the reasons my parents decided to move was so that I could be better prepared to succeed in a "mainland" university. While I was excited about continuing my education, I had no idea how my family could afford college. After expressing this concern to my new high school counselor, he suggested I attend the Army recruiter's presentation during the time when college recruiters visited our campus.

The recruiter wore his uniform with pride, and he reminded me of my relatives who were in the military. When he spoke about how the Army would pay for college after we served, he had answered my prayers. Even though I did not tell my parents, I also visited the Army recruiting center in Fremont, California, for more information.

About a month later, the recruiter unexpectedly visited the house my family was renting. My mom's memory of his visit is vague. She has told me: "I don't even think we let him in the house. I don't remember us letting anybody in. I just think we talked to him through the screen

door. I didn't want you joining the service because I don't believe in fighting wars or having to go off to fight wars when you were so young. You didn't even have a chance to live yet. I don't think it's fair that they recruit kids at such a young age. I don't even think they should be allowed on the high school campus. I want to see those young kids have a chance to grow and live. I know a lot of kids were joining the service because a lot of people can't afford to go to college. But I wanted us to find a different way. We listened to the guy and we took the information. But that wasn't my plan for you. Craig, Thank god you never joined."

My father remembers it differently: "I don't like that he came to our house to recruit. He even came in his uniform. And when he found out I was a veteran and I was in the Army, he thought that was good. But I don't want anyone else in the family going to the military." My father was drafted, like many other Chamorro men of Guåhan, to fight in the Vietnam War. Nearly thirty years later, he was speaking to a recruiter who wanted to recruit his son: "He was trying to tell me that when you graduate you can get money to go to college. It just felt to me it wasn't a way to get college money—I always thought, what if you don't live? You went and you die and you don't get any college then. I could see a guy like that is just trying to make his quota as a recruiter. They think parents will be naïve, and they say that you don't have to worry about college and that you can travel all around the world, get free clothes, free food and housing. But you have to look beyond. You don't have to go to the military."

~

On September 11, 2001, I was 21 years old and studying Italian Renaissance art and literature at the Studio Arts Center International (SACI) in Florence, Italy. This was my semester "abroad"; in the spring, I would return to the University of Redlands in California to graduate.

We were learning how to say where we were from in Beginning Italian Language when the Dean interrupted our class and told us the news. Classes were cancelled, so many of us went to an English pub across the street because they were showing the BBC news. That night, a candlelight vigil near the Duomo was held for the victims.

I remember that the BBC newscaster compared the attack to Pearl Harbor. What many people do not know is that on December 8, 1941, Japan bombed Guåhan, which had been a territorial possession of the

United States since the Spanish-American war of 1898. That day, most residents were attending mass to commemorate the Feast of the Immaculate Conception, honoring our patron saint, Santa Marian Kamalen. Two days later, around 3,000 Japanese soldiers invaded, and U.S. Naval Captain George J. McMillin signed a letter of surrender shortly after. To signal that Guåhan had fallen, Japanese soldiers placed an American flag on the ground and shined flashlights on it. The first American territory to fall into enemy hands. Bodies falling, towers falling.

~

"i believe
i lina'la' tataotao
ta'lo, åmen"

~

The U.S. invaded Afghanistan on October 7, 2001. Young Italians began protesting American imperialism. After that tense semester ended, I bought a Eurail pass and planned to backpack through Western Europe for two weeks before returning to California. In every country I traveled to (Switzerland, Germany, Austria, France, Amsterdam, England, and Spain), there were protests against America and security was tight at the train stations. I hated showing my passport on trains because it always provoked comments. I explained over and over: *I am not American,* even though I speak English like an American, even though I am a U.S. citizen. I explained, over and over, where and what "Guam" is.

The U.S. invaded Iraq on March 20, 2003: Operation Iraqi Freedom. The first Chamorro soldier died in Iraq on December 8, 2003. Christopher Rivera Wesley. He was 26 years old.

Despite the status of Guåhan as a colonial possession of the U.S., Chamorros enlist in the U.S. armed forces at some of the highest rates in the nation. During the Vietnam War, Guåhan had one of the highest killed-in-action rates per capita. In 1980, the Department of Defense estimated that 5 percent of Guåhan was in the military, which was twelve times the national average. During the Iraq war, most recruitment officers struggled to meet their quotas. However, Guåhan's recruiters excelled; four of the Army's twelve most successful recruiters are based in Guåhan (Bevacqua 2010, 35).

Headline: "US Territories: A Recruiter's Paradise: Army Goes Where Fish Are Biting" (*Salt Lake Tribune*, 8/05/07).

A young Chamorro named Jonathan Pangelinan Santos joined the Army after high school as a way to pay for college. He was deployed to Iraq in 2004. They nicknamed him "The Librarian" because he collected many books while in Iraq. He also kept a video diary using a handheld camera and a written diary in a government-issued green notebook. He wrote: "I will read 'The Principles of Writing,' and then I will write the Great American novel and get hired as a professor at a prestigious university." Jonathan's mother, Doris Kent, discovered the diary and tapes when the Army delivered his "Tuff Box" to her—his most valuable belongings, his relics. She donated her son's boots to "Eyes Wide Open," a traveling exhibition of the American Friends Service Committee. The exhibit, begun in 2004, features a pair of empty boots for each U.S. military casualty in Iraq and Afghanistan, and a pair of shoes for each Iraqi and Afghan civilian death. Jonathan was 22 years old when he was killed in Iraq.

~

[2004]

[U.S. Army 1st Lt. Michael Aguon Vega, 42, a Guam native, died after he sustained injuries from a roadside blast in Iraq]

[U.S. Army Sgt. Yihjyh "Eddie" Lang Chen, 31, of Saipan was killed in Iraq when his unit was attacked]

[U.S. Marine Cpl. JayGee Meluat, 24, a native of Palau, was killed by enemy fire in Iraq]

[U.S. Army Sgt. Skipper Soram, 23, from Kolonia, in the FSM state of Pohnpei, died after an explosion occurred near his security post in Iraq]

[Ferdinand Ibabao, an employee of DynCorp security company, was killed in an explosion in Iraq. Ibabao had been a Guam police officer. He was 36]

[U.S. Army Spc. Jonathan Pangelinan Santos, a former Santa Rita resident, was killed in Iraq, when his vehicle hit a land mine. He was 22]

~

"hu hongge
the life tataotao
ta'lo åmen"

~

In 2005, I sit across from my grandfather at a small kitchen table in his apartment in Fairfield, California. He talks story of growing up in Guåhan and remembers how he was taught to weave a talaya, or throw net. Threads hung from hooks in the ceiling, lead weights at the end of each thread. "You hold the nicho like this," he says. "And the nasa around your fingers like this." He points to the empty ceiling: "You have to imagine." Ghost, weave, weight. He explains how the size of the mesh is determined by the fish you are hunting. Smaller mesh for the manahak and a larger mesh for the ti'ao. He refers to the mesh of the net as "eyes."

He stands, cradling an imaginary net in his hands, and bends his body into proper form. It's been years, he says. But his body remembers. He uncoils and throws the talaya directly over me. He picks up the imaginary net and stalks through the kitchen. He explains how you can identify a fish by reading the surface movement of currents and shadows. How to minimize your shadow depending on the angle of the sun.

After a few casts, he stares at his hands, surprised they are empty. He remembers holding his niece's hands as they walk down San Roman hill toward the Dulce Nombre de Maria Cathedral-Basilica in Hagåtña to celebrate the Feast of the Immaculate Conception. December 8, 1941. He is 15 years old. "During mass we heard a bunch of planes. Usually only one Pan-American would fly over Agana to the airport in Sumay. But we could hear the bombing and the priest announced that mass is ended."

A few days later, they were ordered to report to the military checkpoint in Plaza de España in Hagåtña. He walks with everyone from his village to be "processed." Procession. "I remember seeing for the first time the Japanese flag," he says. "Sentries were posted

and beat those who didn't bow to them. We waited in line and they gave us a white piece of cloth with Japanese writing on it and we had to keep it pinned there"—he points to my chest—"by our heart and they pointed to the sky where we had to bow." He stands and straightens his body with his fingers glued straight and his arms straight against his sides and looks straight past me. He bows. Till his head almost touches the table.

For the duration of the war, soldiers would come in their trucks to his village for the morning roll call. He and others were taken to build the airstrip in Barrigada. "It took us six months to cut out the hill to fill in the airship. Their bayonets in our backs." He was then stationed in Asan to construct machine gun encampments. First, they made the forms, mixing salt water from the beach with cement and sand. After they made the foundation and retaining wall, they set the concrete. "I never carved my initials into the concrete. I even tried to avoid leaving fingerprints."

~

[2005]

[U.S. Army Staff Sgt. Steven Bayow, 42, a Yap native, was killed in Iraq when a bomb hit their vehicle]

[U.S. Army Spc. Derence Jack, 31, of Saipan was killed in a roadside bomb attack in Iraq]

[U.S. Army Sgt. Wilgene Lieto, 28, of Saipan was killed in a roadside bomb attack in Iraq]

[U.S. Army Spc. Richard DeGracia Naputi Jr., 24, of Talofofo was killed in Iraq when a homemade bomb detonated during combat operations]

~

"hu hongge
i lina'la' body
ta'lo åmen"

~

On July 21, 1944, the U.S. military invaded Guåhan and a three-week battle for the island ensued, which would ultimately end Japanese rule. "Liberation Day" was created a year later. This annual commemoration was seen as a time of rebirth and forgiveness, emphasizing "notions of spiritual salvation, national sacrifice, and cultural obligation" (Camacho 2011, 86). Indeed, the first liberation celebrations resembled Catholic rituals, as opposed to civic or military ceremonies. For example, the first Liberation Day in 1945 included a religious procession at the Plaza de España, which is near the Dulce Nombre de Maria Cathedral-Basilica, that centered around Santa Marian Kamalen. The themes of salvation and liberation became intertwined, reflecting the "interconnected nature of spirituality, identity, and nationality in postwar Guam" (Camacho 2011, 89). Liberation Day underwent a shift in the 1950s–1960s when the key commemorative theme became Chamorro loyalty to America, and the actual event became more civic and secular with parades, marching bands, and floats. Young women even competed to become "Liberation Day Queen" by selling fund-raising tickets. Over the years, Liberation Day has "mediated the memories and histories of the war"; as such, narratives of American salvation and liberation, coupled with Chamorro loyalty, have dominated the "collective memory" of Chamorros (Camacho 2011, 109). This rhetoric of salvation and religiosity inscribed by Liberation Day ignited Chamorro "codes of indigenous indebtedness" (Diaz 2001, 162). Scholars suggest that the rhetoric of liberation and indebtedness explains "the high levels of public and phatic patriotism, military and civilian loyalty and devotion" (Bevacqua 2010, 36), in addition to the high rates of Chamorro enlistment in the U.S. military. Thus, the Chamorro soldier "willingly and loyally shoulders the indigenous sacrifice" (Bevacqua 2010, 48) as military service becomes payment toward the Chamorro debt for being liberated.

~

[2006]

[U.S. Army Pfc. Kasper Allen Camacho Dudkiewicz, 23, of Chalan Pago was killed in Iraq, when the Humvee in which he was the gunner was involved in a vehicle collision]

[U.S. Army Pfc. Henry Paul, 24, of Kolonia, in the FSM state of Pohnpei died in Baghdad of injuries sustained when their M2A3 Bradley Fighting Vehicle rolled over]

[U.S. Army Sgt. Jesse Castro, 22, a Guam native, was killed when a roadside explosion destroyed their Humvee in Iraq]

~

"hu hongge
i lina'la' tataotao
return åmen"

~

In 2006, the U.S. announced a major realignment of U.S. military forces and operations in the Asia-Pacific region—a " mega-buildup" within a long history of militarization on Guåhan (Kirk and Natividad, 2010, n.p.). This buildup would include the construction of facilities to house and support the transfer of 8,600 marines, their 9,000 dependents, 7,000 transient Navy personnel, 600–1,000 Army personnel, and 20,000 foreign workers; the establishment of an Air and Missile Defense Task Force; a firing range complex; and the creation of a deep-draft wharf in Apra Harbor for nuclear-powered aircraft carriers.

According to their plan, the military will take at least 2,300 more acres of land (the U.S. military already occupies one-third of the 212-square-mile island). The sacred lands that stretch from Marbo Caves to Pagat Caves (an area rich with ancient Chamorro artifacts and remains) might be used as a firing and bombing range. In addition, the construction of permanent military facilities and infrastructure will desecrate ancient burial sites, eliminate hundreds of acres of jungle and medicinal plants, and deny access to sacred sites and fishing grounds. A camp for tens of thousands of laborers will replace another hundred acres of jungle. More will be razed to make way for the luxury military homes. The dredging and construction of a deep-draft wharf in Apra harbor for the passage of nuclear-powered aircraft carriers will rip 2.3 million square feet of living coral reef from the ocean floor. Green and hawksbill sea turtles, the damselfish, clownfish, and butterfly fish—all attached to their territory in Apra harbor—will be killed. So will the 6-foot blue elephant ear sponges that brighten the coral. Scalloped hammerhead sharks give birth directly in the carriers' path into the wharf. The total amount of hazardous waste produced will equal 8 tons per year—added to the eighty contaminated military dump sites that still exist on Guåhan. The abnormally high cancer rates

among Chamorros will continue as will our exposure to radiation and other toxins.

~

[2007]

[U.S. Marine Cpl. Adam Quitugua Emul, 20, from Saipan, was killed while conducting combat operations in Iraq]

[U.S. Army Cpl. Lee Roy Apatang Camacho, 27, from Saipan died of wounds he sustained from an explosion in Iraq]

[Guam Army National Guard Sgt. Gregory D. Fejeran was killed in Ethiopia when the vehicle he was in rolled over. He was 28]

[Guam Army National Guard Sgt. Christopher Fernandez was killed in Ethiopia when the vehicle he was in rolled over. He was 28]

[U.S. Army Spc. John D. Flores, 21, of Barrigada, was killed when his unit came under attack by enemy fire in Iraq]

[U.S. Army Pfc. Victor Michael Fontanilla, 23, was killed in a bomb blast in Iraq]

[U.S. Army Sgt. Iosiwo Uruo died in Iraq of wounds suffered when his unit came under attack by enemy forces. He was 27]

[U.S. Army Cpl. Meresebang Ngiraked, 21, of Koror, Palau, died from injuries he sustained from a vehicle-based improvised explosive device in Iraq]

[Army Pfc. Jose Charfauros Jr., 33, of Rota was one of 14 soldiers killed in a single day in Iraq]

[Army Maj. Henry Ofeciar died when enemy forces using small arms fire and rocket-propelled grenades attacked his unit in Afghanistan. He was 37]

[Navy Master-at-arms Anamarie San Nicolas Camacho, 20, of Tinian and Guam, was killed in Bahrain]

~

"hu hongge
i lina'la' tataotao
ta'lo åmen"

~

My grandfather struggles to tell his story. His voice breaks. His eyes become salt water. He looks at his empty hands. "Many of us, to this day, have not received reparations."

In 1945, the U.S. passed The Guam Meritorious Claims Act for residents whose property had been destroyed as a result of the war or was taken to be used by the military. In the Act's one-year filing period, only 6,646 claims were filed among a surviving Chamorro population of about 22,000. In the 1951 Peace Treaty with Japan, the U.S. waived all wartime claims made by U.S. citizens and nationals against Japan. Since that time, Congress passed the Micronesian Claims Act of 1971, the Philippines Rehabilitation Act of 1946, the Wake Island Amendment to the War Claims Act of 1962, the Aleutian and Pribilof Islands Restitution Act of 1988, and the Civil Liberties Act of 1988, which provided redress of $20,000 for every surviving Japanese American detained in an internment camp (a redress totaling more than a billion dollars).

Politicians and activists on Guåhan sought to address what they saw as a disparity between the Guam Claims Act of 1945 and other war claims legislation. So in 1983, Guåhan's first Congressman to the United States, Antonio Won Pat, introduced a new Guåhan war claims bill. Guåhan's second delegate, Ben Blaz, introduced four war claims bills, one of which would grant $20,000 for a death claim, $5,000 for personal injury, and $3000 for forced labor—estimating the total cost of reparations to be between $20 million and $80 million. Guåhan's next delegate, Robert Underwood, introduced five pieces of war claims legislation in his five terms. His first three bills sought reparations in addition to the establishment of a trust fund for the descendants of survivors who had died since the war. This fund would provide scholarships, first-time homeownership loans, and grants for research and educational activities about Japanese occupation. Spanning nearly twenty years, the U.S. Congress did not pass any of these bills.

Underwood, then, decided to take a different route; he sought to create a War Claims Review Commission. In his last term, the bill

passed and became law in 2002. The Commission aimed to determine whether the people of Guåhan were adequately informed about and compensated by the Guam Meritorious War Claims Act of 1945, in addition to determining whether there was parity between those war claims and claims awarded to other U.S. citizens and nationals.

On December 8 and 9, 2003, the Review Commission held public hearings, in which around 100 Chamorro war survivors—or relatives of those no longer living—testified. Throughout, Chamorros spoke to the brutality they were subjected to or witnessed, not to mention the destruction of homes and ancestral lands. The Review Commission concluded what most people already knew: the Chamorro people were not adequately informed or compensated. Armed with the War Review Commission's report, Guåhan's next representative, Congresswoman Madeleine Bordallo, introduced the Guam World War II Loyalty Recognition Act in 2005. The bill sought war claims in the amounts of $25,000 for death, $15,000 for victims who were raped or suffered personal injury, $12,000 to $10,000 to those who suffered forced labor, and $7,000 for descendants of deceased survivors. Despite Bordallo's rhetorical appeal to Chamorro loyalty, Congress did not pass the bill.

~

"i lahi-hu gaige giya Iraq"
"i haga-hu gaige giya Afghanistan"

~

My grandfather insists that if I ever write his story as a poem, he wants me to send it to the president at the time, George W. Bush. Then he laughs and says he isn't sure if Bush actually knows how to read. But his smile quickly fades: "People in the United States at least need to know what we suffered. At this point in my life, it's not about money—there is no amount. I've lived without the money for more than sixty years. I want to be heard. I want to be recognized."

Poetry is one way of being heard. I imagine each word is the weight at the end of a thread. Each thread connects us to i hale-ta, our root. Each word opens the mouth of the net. I imagine the blank page as an excerpt of the ocean, i tasi. Its tides, currents, and depths. The poem is the cast net suspended in the moment that the net touches the water of the page.

A suspended net resembles the typographical symbol known as the tilde (~). It also resembles a wave. In languages, the tilde indicates a change or shift of pronunciation. In mathematics, the tilde shows equivalence (e.g., x~y). In my poems, I cast the tilde to indicate a discursive or thematic shift and equivalence between personal/familial stories and historical, political, and cultural narratives.

~

In 2008, documentary filmmaker Patricia Boiko produced and co-directed "The Corporal's Diary: 38 Days in Iraq," which features Jonathan Santos' words and video footage from his diaries. My first book of poems, *from unincorporated territory [hacha]*, was published in 2008. Its main poem is titled "from ta(la)ya."

~

[2008]

[U.S. Army Staff Sgt. Joseph Gamboa of the 1st Squadron, 2nd Stryker Cavalry Regiment, from Merizo died in Iraq from injuries sustained when he came under indirect fire. He was 34]

[U.S. Army Spc. Philton Ueki was killed in Iraq. He was buried in California]

[Christopher Albert Quitugua died in Iraq after the vehicle he was riding in flipped after a tire blowout. He was 28]

[Guam Army National Guard Sgt. Brian S. Leon Guerrero was killed in Afghanistan when the vehicle he was in hit an improvised explosive device. He was 34]

[Guam Army National Guard Spc. Samson A. Mora was killed in Afghanistan when his vehicle was hit by an improvised explosive device. He was 28]

[U.S. Navy Petty Officer 2nd Class Anthony M. "Tony" Carbullido died from injuries he suffered when his convoy vehicle hit an improvised explosive device in Afghanistan]

~

"i believe
in the resurrection
of the body, amen"

~

On Sunday, March 8, 2009, The Dulce Nombre de Maria Cathedral-Basilica in Hagåtña hosted "Operation: Special Intentions." The exhibit presented relics of St. Anthony of Padua (Patron Saint of Sailors), St. Therese of Lisieux (Patron Saint of Pilots and Aircrews), and St. Ignatius of Loyola (Patron of Soldiers). This national tour was coordinated with the Los Angeles–based Apostolate for Holy Relics, the Archdiocese for Military Service in Washington, D.C., and the Sacred Military Constantinian Order of St. George. The relics arrived on Guåhan after a tour in Manila and they continued to Pearl Harbor.

According to Monsignor James L. G. Benavente from Guåhan: "This is an opportunity for the people to express their solidarity with loved ones in the armed forces. I invite our faithful, family, and friends to pray to and visit with these patron saints so that they may intercede for all of us, especially those abroad . . . Let this be a time to recall the ultimate sacrifice given by our military men and women—past and present."

The Cathedral also invited those with loved ones serving in the military to "enlist" their names in the prayer book and to post tribute photos at the church. *St. Anthony of Padua, tayuyuti ham.* "My son gaige giya Iraq." *St. Therese of Lisieux, tayuyuti ham.* "My daughter gaige giya Afghanistan." *St. Ignatius of Loyola, tayuyuti ham.*

~

In 2009, Congresswoman Bordallo introduced H.R. 44, mirroring her previous Loyalty bill. It passed in the House of Representatives, but was never voted on in the Senate. Later that year, the House passed H.R. 2647, the National Defense Authorization Act for Fiscal year 2010, which included, as an amendment, H.R. 44. The amendment did not make it to the final Senate bill because Senators Carl Levin and John McCain would only keep H.R. 44 if claims were awarded solely to descendants of those killed during the war and to living survivors, but not

to the heirs of survivors who have died since the war. Bordallo rejected their counterproposal.

~

[2009]

[Hawaii Army National Guard Spc. Cwislyn K. Walter, 19, died as a result of injuries sustained in a single-vehicle accident in Kuwait]

[U.S. Army Sgt. Jasper Obakrairur, 26, of Palau, was killed by a roadside bomb in Afghanistan]

[U.S. Army 1st Sgt. Jose San Nicolas Crisostomo, formerly of Inarajan, died after an improvised explosive device detonated near his convoy in Afghanistan]

[U.S. Army Sgt. Youvert Loney, 28, from Pohnpei, died in Afghanistan, when enemy forces attacked his vehicle]

~

> *"do you believe?*
> *i lina'la' tataotao*
> *ta'lo åmen"*

~

In 2010, the Konsehilon Tinaotao Guam (Guam Humanities Council) invited me to participate in their project: "'8,000, How Will It Change Our Lives?' Community Conversations on the US Military Buildup in Guam." This project created space for residents to discuss the military buildup through "humanities-based conversations." I was set to travel home to Guåhan a few weeks after my thirtieth birthday. I lived the first fifteen years of my life in Guåhan, and the last fifteen years of my life in California. After all this time, my body was returning home.

The publication of my second book of poems, *from unincorporated territory [saina]*, coincided with my return. Boxes of my book were shipped from California (where my publisher is based) to Guåhan.

During the trip, I engaged in community conversations at many of Guåhan's public high schools, the Guam Community College, and the University of Guam. I remember walking down the halls of one public school before meeting with students in the library. As I turned down one hall, I was startled to see a young man dressed in fatigues carrying a machine gun, standing perfectly still. My eyes deceived me: it was not a real person, but a life-sized cardboard cutout. This figure, as opposed to a figure of one of our chiefs or cultural leaders, greeted these students every day. I imagined military recruiters stalking through the tides for their daily catch of new recruits. Quite a few of the students I met were enrolled in JROTC. They said they were enlisting after high school because the military promised to pay for college.

Will we survive them?

~

[2010]

[U.S. Army Spc. Eric M. Finniginam, 26, of Yap, died of wounds sustained when insurgents attacked his unit in Afghanistan]

[U.S. Army Sgt. Joshua Akoni Sablan Lukeala, 23, formerly of Yigo, died while in combat in Afghanistan]

[U.S. Marine Cpl. Dave Michael Santos, 21, was killed in Afghanistan]

[Army Pfc. Jaysine "Jen" Petree, 19, was killed by an improvised explosive device in Afghanistan]

~

do you believe
in the resurrection
of the body?

~

As I walked toward the departure gate of the Guam International Airport, I was confronted with the sight of a proud soldier. Then another and another and another: "The Fallen Brave of Micronesia."

Twenty-three banners. Each banner featured a photo of a soldier from Micronesia who died in Iraq and Afghanistan. Name, rank, flag of their home island. Above them and behind them all: an American flag waving in the wind. This pictorial memorial was installed and unveiled in the East Ticket Lobby of the airport to honor the twenty-three sons of the Commonwealth of the Northern Marianas, the Federated States of Micronesia, Guåhan, and the Republic of Palau. A dedication ceremony occurred on July 20, 2007, as an official event of the 63rd Liberation Day festivities.

I look at Jonathan Santos' picture. If I ever write a novel, I say to him, I will name a character after you. There's a picture on the Internet of Jonathan's mother holding a pair of boots. The laces are threaded with a rosary.

~

My grandfather, like many others of his generation, joined the U.S. military after the war. After being stationed far from home for many years, he returned to Guåhan and worked as the Superintendent of the National Park Service War Memorial. My poem, " from ta(la)ya" ends with his words: "My job was to preserve things that I wasn't willing to build in the first place."

The U.S. National Park System curates "an archipelago of government-run, on-site 'museums'[,] geographical sites of territorial and rhetorical nation-building" (Herman 2008, 632). The archipelagic metaphor is apt when we consider the vision of The War in the Pacific National Historical Park on Guåhan in the 1950s, and its establishment by Congress in 1978. The commemorative park consists of seven parcels of land throughout the island, each representing an aspect of the three-week battle between the U.S. and Japan. The creation of the park caused controversy because of the amount of land it acquired, the location of the land, and the narrative it memorialized. The signage of the park was originally in English and Japanese (catering to the relatively new tourism industry servicing Japan), and related tales of American heroism, Japanese stoicism, and Chamorro victimhood. The practice of transforming battlefields into historical parks marks "the rhetorical transformation of violent expansionism into a nationalist commemorative site for American soldier-heroes" (Herman 2008, 642). Like "Liberation Day," The War in the Pacific National Historical Park thus in-

scribes the land of Guåhan and the memory of Chamorros with the rhetoric of liberation and loyalty.

~

I think about this fact often: I was 17 years old when the recruiter visited, 21 years old when the U.S. invaded Afghanistan, and 23 years old when the U.S. invaded Iraq. I almost made the same sacrifice that many Chamorros made before me. The recruiter cast his net toward my body so that I could be devoured by the endless debt to our liberator. I barely escaped. *Hasso. Enlisted Chamorro bodies. Uniformed Chamorro bodies. Fallen Chamorro bodies. Tough boxes. Chamorro bodies returning home in boxes. Their relics in Tough Boxes. Tayayuti ham.*

Around 1,000 Chamorros died during World War II. Of the 22,000 Chamorros who survived, less than 1,000 are alive today. *Hasso. Invaded Chamorro bodies. Bombed Chamorro bodies. Breathing Chamorro bodies in caves hiding under dead Chamorro bodies. Gutted Chamorro bodies. To this day, their hands remain empty. Tayayuti ham.*

And many have begun asking: Hafa na liberasion? What is liberation?—If we continue to be colonized? What is liberation if our political sovereignty continues to be denied? If our "savior" doesn't recognize our loyalty, why should we remain loyal? Within the next decade, Guåhan's greatest generation—the war survivors—will all be dead. Will we continue to inherit their perceived debt? *Hasso. Memories of fallen Chamorro bodies in our rising Chamorro bodies. Silenced Chamorro bodies. Memorize our faces, memorialize our names. Chamorro bodies we can never hold again.*

What are Chamorro bodies worth? According to the Navy's Land and Claims Commission (which oversaw the 1945 Guam Claims Act), the average paid in the limited amount of 1945 death claims was about $1,900. Under the Micronesian Claims Act of 1971, the Micronesian Claims Commission adopted a sliding scale of $500 to $5,000 for death claims: $500 if the deceased was 12 years old or younger, with an increase of $500 for each additional year of age up to age 21, and a decrease of $100 per year for each additional year up to age 61, at which age the amount awardable remained at $1,000. The Micronesian Claims Commission devised this scale after studying the Navy's Land and Claims Commission's treatment of death claims on Guam. *Hasso. Chamorro bodies leaving home. Chamorro bodies returning home. Chamorro*

bodies heave under the weight of our sacrifice. Chamorro bodies surviving the fallen. Chamorro bodies surviving. Tayayuti ham.

We must escape their nets. We must tear through their nets. We must cast our own nets of words. We must re-inscribe our memories of the war. Because of the efforts of Chamorro activists and politicians, a commemorative monument was constructed in the War in the Pacific Historical Park on the eve of the 50th anniversary of Liberation Day in 1993, to remember those Chamorros, *by individual names,* who suffered during the war. The signage of the park also became tri-lingual around this time, adding Chamorro. *Hasso. Remember our names. In the name of the fallen. In the name of our ancestors. I lina'la gi na'an. There is life in our names. Chant the names of the fallen. Tayayuti ham.*

Chamorro writers must continue to deconstruct and decolonize the colonial narratives of salvation, liberation, and loyalty. We must re-inscribe the land and our memories with narratives of survival, resistance, and sovereignty. We must cast our stories upon the intertidal zone (where water and land weave); upon the intertidal zone of our individual, familial, and collective memories; upon the intertidal zone of the past and the present—so that we can stand in the tide and imagine a new horizon. Every word we cast toward a new Guåhan is a commemoration, a memorial, a living memory of the continuing strength of our people. Future generations will gather our nets of words into their hands. Harvest. *Hasso.*

When I first see my grandfather after my first book was published, he places his hand on my shoulder and says, "Remember, no one can take our story away from us." I do not remember if he ever let go of my shoulders.

Manhonnge yu gi Taotao Tano yan i taihinekkok na sinangan'ta åmen

Notes

Previously published in *from unincorporated territory [Guma]* (Richmond, CA: Omnidawn, 2014).

The names of the fallen soldiers retrieved from a feature in the *Pacific Daily News* titled "Remembering Our Fallen," posted on May 2, 2011, http://www.guampdn.com/article/20110503/NEWS01/105030301/Remembering-our-fallen (accessed May 5, 2011).

Background information on Jonathan Pangelinan Santos and quote from his diary are from "'The Corporal's Diary': Fallen Soldier's Journal and Videotapes Inspire Documentary," by Donald Allen, in *Stars and Stripes,*

January 4, 2009. Also, the note about his nickname can be found at the Combat Veterans International memorials online, http://www.combatvet erans.com/memorials/santos.htm (accessed April 31, 2011).

Information on *Operation: Special Intentions* and the quote from Monsignor James L. G. Benavente was retrieved from "Relics of Military Patron Saints Tour Guam," a press release of the Dulce Nombre de Maria Cathedral-Basilica (Hagåtña, Guam), March 4, 2009.

Background information on Guam's quest for war reparations was retrieved from various sources, including "The War Reparations Sage: Why Guam's Survivors Still Await Justice," by Victoria-Lola Leon Guerrero, on the Guam War Survivors website, http://guamwarsurvivorstory .com (accessed March 11, 2011); Report on the Implementation of the Guam Meritorious Claims Act of 1945, Including Findings and Recommendations," by M. J. Tamargo, A. R. Unpingco, B. J. Cruz, R. J. Lagomarsino, and R. G. Van Cleve. Guam War Claims Review Commission, 2004; and Bernard Punzalan, "Guam World War II War Claims: A Legislative History" (2009), Guampedia, http://guampedia. com/guam-world-war-ii-war -claims-legislative-history/ (accessed March 13, 2011).

Works Cited

Bevacqua, Michael Lujan. 2010. "The Exceptional Life and Death of a Chamorro Soldier: Tracing the Militarization of Desire in Guam, USA." In *Militarized Currents: Toward a Decolonized Future in Asia and the Pacific,* ed. Setsu Shigematsu and Keith L. Camacho, 33–62. Minneapolis: University of Minnesota Press.

Camacho, Keith L. 2011. *Cultures of Commemoration: The Politics of War, Memory, and History in the Mariana Islands.* Honolulu: University of Hawai'i Press.

Diaz, Vicente. 2001. "Deliberating 'Liberation Day': Identity, History, Memory, and War in Guam." In *Perilous Memories: The Asia-Pacific War(s),* ed. T. Fujitani, Geoffrey M. White, and Lisa Yoneyama, 155–180. Durham: Duke University Press.

Herman, R. D. K. 2008. "Inscribing Empire: Guam and the War in the Pacific National Historical Park." *Political Geography* 27:630–651.

Kirk, Gwen, and Lisa Natividad. 2010. "Fortress Guam: Resistance to U.S. Military Mega-Buildup." *Asia-Pacific* 19, nos. 1–10 (May 10). http://japan focus.org/-Gwyn-Kirk/3356. Accessed September 19, 2012.

Perez, Craig Santos. 2008. *from unincorporated territory [hacha].* Kāne'ohe: Tinfish Press.

The Words to Speak Our Woes

Chantal Spitz
Translated by Jean Anderson

"E tū, e a tau, e a hiti noa atu
resistance and resignation"
Assembly of French Polynesia
June 25–26, 2008

The colonizer makes history, and knows he is making it[1]
how could we express any better what we have been living through
 for the last 150 years and more
all those texts, documented argued informed
explaining rationalizing concluding the history of this country
our country
avatar of the French colonial empire

all those authorities validated authenticated legitimized
with their hypothesizing antithesizing synthesizing facts dates
 documents
forgetting the thousands of dead
our ancestors
blown apart by cannon balls
torn apart by musket shot
fallen in the fratricidal wars of christianization of colonization
erasing the unplumbed depths of our pain children women men
christianized poxified alcoholized
disqualified dehumanized dispossessed

voiceless people

we are here to speak the words
the words that will create a historic occasion
the words that will let us take back our memories
the words to tell the deeply-felt lived history

a history
ours
different from the facts, historic academic stamped referenced
 labeled
told for the last 150 years and more in a litany by brilliant special-
 ists trained up in the universities of the French Republic

we are here to
resist the History always told through the filter of French criteria
the filter of an arrogant way of thinking that burdens itself with a
 civilizing mission
the secular continuation of the missionary impulse

two examples

Jules Ferry speaking in parliament in 1885
*"We must state openly that the higher races have rights over the
 lower races. I say again, higher races have rights, because it is their
 duty. It is their duty to civilize the lower races."*

Henri Fontanier, socialist spokesman in parliament in 1925
*"Colonization can only be justified if it brings the natives a higher
 form of civilization and if the nations which possess colonies exercise
 within them the role of civilization's representatives on behalf of the
 whole of humanity."*

the filter of a clear conscience inoculated with republican schooling
 and through free and compulsory education
not just for the children of French citizens but for those of colo-
 nized natives as well

two extracts from school textbooks used until the mid-twentieth
 century to *"instill a certain number of patriotic duties and moral
 obligations"*

" 'France' and 'humanity' are not contradictory terms: they are united and indivisible. Our nation is the most humane of nations. Vive la France." (Lavisse 1920)

"Everywhere, France has brought order and peace. Brutal exploitation, slavery and massacres have ceased. Everywhere, France has opened schools where the inhabitants are taught and learn our language. They are cared for by our doctors. And everywhere, France has built roads, railways and ports." (Gauthier and Deschamps, 1923)

oh the benefits of the Republic's schools
anchoring deep in our minds the greatness that is France

and now we ourselves repeat this idea over and over again
we are the creators of our own decline
in mortal self-denigration
an idea now completely adopted by our straitjacketed memories
the better to conform to the noxious intellectual conformism that
 is shrinking our society
repeated practically word for word as the stock in trade of those
 who support the French presence in our country

we are here to
consider the more than two hundred years of unimaginable
 violence that reached its heights with colonization
the colonization that exiled us from our own temporality
excluded us from our territoriality
cast us out from the history of humanity
in opposition to France's credo of its *"civilizing mission"* still in
 vogue today
supposedly opening up the colonized to a place in history

Albert Memmi writes: *"The greatest lack suffered by the colonized is
 to be positioned outside history and outside the city"*[2]

while Nicolas Sarkozy maintains[3] *"Muslim civilization, Christianity, colonization, if we set aside the crimes and errors committed in their names, which are unforgivable, opened African hearts and*

minds to the universal and to history," underlining the recognition
of *"the positive role of the French presence overseas"* embodied in
the law of 23 February 2005

we are here to
speak the words of our history
take back our stolen voices
soothe the distress of our amnesia
revisit history so we may at last act it not suffer it
collapse the one-sided way of thinking
still colonial colonizing colonized
that shuts us away in an absence of memory
that encloses us in a historical void

*"The past, our subjugated past, which is not yet history for us, is
 nonetheless there (here) and tormenting us"*[4]

and it is precisely this torment that we must lessen
this subjugated past with all its violent acts
missionary colonial nuclear
the multitude of losses of dignity identity sovereignty
history distorted disfigured disembodied
memories depopulated desiccated deserted
trajectories countered confounded congealed
historic dispossession
traumatic subjection
pathological alienation

we are here to
speak the words
unmask our woes
go back to the beginning of all our pathologies
air the deepest wound disabling haunting crippling
strip colonization bare
its frantic memories its putrid scars its stagnating rags

there can be no closure yet
colonization is a debt that remains to be paid[5]

to cleanse away the trauma of colonization[6]
"the very kernel" of continued suffering
that makes us who we are
for today
have we not inherited more from colonization than from our own
 heritage
numbed by depersonalization that is intimate internal interiorized
silently slyly consciously passed on
from memory to memory
generation to generation
ever since the original offence

and yet
to blame all our pathologies on colonialism's violence would be to
 repeat in our turn
the denial of our history the neglect of our memories the forget-
 ting of our futures
for although modern colonization used all and extreme forms of
 violence
we must not forget that the original trauma was inflicted by
 christianity

how many of us see ourselves call ourselves christians before we
 see ourselves feel ourselves call ourselves māʻohi
the most striking examples need no context
the cross and the slogan of tāvini huiraʻatira[7]
the placing of a cross on the wall of the Assembly of French
 Polynesia as a totem of identity[8]
the even-handedness of 5 March 29 June 14 July each one a public
 holiday[9]
with preference given to 5 March which has its own street

while the trauma of conversion to christianity was the root of it all
our history is written in the blood of colonization's wars

we are here for ourselves
because we have the right to take stock because we must make
 demands
combine our shaky memories to inhabit our dignity

join our internal exiles to achieve our wholeness
accept all our unfinished mourning to achieve our bond

strike down our *intimate enemy*[10] who has internalized the stereo-
 types of colonial ideology
throw off the denials the falsifications the outrageous misrepresen-
 tations of the facts
suspend the refusal of reality the rewriting of history the spreading
 of an infectious resentment
and detoxify ourselves from our self-disparagement

cast out from our minds the myths from elsewhere that are the
 basis of our new identity
noble savages made human by conversion to christianity
languidly languorous vahines leaping into bed with stinking sailors
eternally childlike people who spontaneously asked for annexation
joyfully gave away our territory
cheerfully handed over the administration of our affairs
inept irresponsible even incapable of having a language that could
 express ideas
stereotypes that deny us our place as historical agents

banish from our discourse the self-stereotypes that mutilate our
 reality sell out our futures
the treaty of 29 June 1880 that turned all Polynesians into French
 citizens
day of celebration for some of mourning for others
when in fact it took sixty years of warfare and more than a dozen
 treaties to annex all the territories that would become the French
 Settlements in Oceania because that was the will of the coloniz-
 ing state
when in fact people in territories not under Pomare rule remained
 subjects until 1945
Teraupo'o called a rebel when he was fighting to stay free
French presence bringing a standard of living unequaled in the
 Pacific
in a country where welfare poverty marginalization keep growing
French the only language for getting ahead for academic and social
 success for modern times

in a society wallowing in academic failure social failure
independence to take back our dignity
when sadly the collapse is the greater the more persistent for being
 internal
and the ill-effects of colonial alienation are not ended by political
 decolonization

to sweep from our minds
the risk of turning contempt for ourselves into fratricidal conflicts
the risk of falling for the mythification of our origins the celebration
 of imaginary roots the sectarian exaltation of traditional culture
the risk of exchanging the mythology forced on us by the colonizer
 for a *counter-mythology a positive myth of ourselves*[11]
setting out in our turn along the path of a new disidentity

we are here for hope a history a memory
we are here for two words
that sum up our historicity state our temporality give us voice

resistance
resignation

neither the one nor the other
and yet the one and the other

wars are a turmoil of chaos of ideals
humans are molded of greediness of loyalties
our history because it is humanity's
is laced through with greatness with fetidness
with pestilence with hopefulness
we have nothing to be ashamed of

we are here for ourselves
in the desire to reclaim ourselves
in all humility in all humanity
free from authoritarianism dogmatism prejudice
let us not mistake our enemy
we must follow together the slow path of a people freed from the
 denial of our history

without seeking triumphal revenge for some and intense guilt for
 others
without wanting to denigrate accuse judge

about the second world war Sardou sings[12]

it's not a question
of what your mother or your father did in those dark days
what I'm concerned about is
what I would have done

but if I'd been in the war
lord what would I have done

for those who are born today
choosing the right side is clear
a lot of them wanted to save their lives
a lot were by nature submissive
what sort of man would I have been
to avoid seeing ourselves in a lax and complacent way
plan exit routes imagine ways out open up an elsewhere
challenge history in spite of its irreversible passing
confront it resist it by thinking about the past and reimagining
 memories

we are here because we must remember
summon all our memories
stony scrubby slimy mucky
luminous audacious gracious sumptuous
not one of them not even the most stunted must be denied
they are all our inheritance
they are all our history

we have no need to wait for some outside validation of our ideas
it is down to us to take responsibility heirs to the christianizing
 trauma the colonial trauma the nuclear trauma
not in a spirit of victimhood but in a liberating leap
we must work through all the festering rot that eats away at our
 understanding

clean out all the cesspits that clot our consciences
move beyond the dark nights that necrotize our imaginations
to overcome our greatest mourning
our grief for our own identity
and finally decolonize our minds

> *The decolonized are often, if not the only, then at least the chief*
> *agents of their decolonization. And it is always at their initiative*
> *that the decolonization process is begun. . . . The decolonized are*
> *therefore the true decolonizers, and if they are free one day, it is be-*
> *cause they have been their own liberators*[13]
>
> *emancipate yourself from mental slavery*
> *'cause none but ourselves can free our mind*[14]

decolonize our minds
the rest will follow

e tū, a tau e a hiti noa atu

Notes

This speech was originally delivered before the General Assembly of
French Polynesia, June 25–26, 2008, in 'Ara'Ara.

1. Franz Fanon, *Les Damnés de la terre* (The Wretched of the Earth) (Paris: Gallimard, 1991), 82.
2. Albert Memmi, *Portrait du colonisé* (The Colonizer and the Colonized) (Paris: Gallimard, 1985), 112.
3. Speech delivered at the University of Dakar, July 26, 2007.
4. Edouard Glissant, *Discours antillais* (Caribbean Discourse) (Paris: Seuil, 1981), 131.
5. Patrick Sultan, "Littérature comparée et théorie postcoloniale: le cas des écritures postcoloniales" (Comparative literature and postcolonial theory: the case of postcolonial writing) (doctoral thesis, University of Lille 3, 2008), 243.
6. "Freudian psychology . . . describes the traumatized state with precision: the subject, who suffers a violent, terrifying and unexpected shock—which may be repeated—becomes a victim of a 'fixed idea' (Janet), a 'reminiscence' (Freud) that affects him over a long period and interferes with his psychic life. This brutal blow destroys the idea of self, causing the 'loss of one's own form' (Ferenczi). This shock is henceforth part of the person: while it is external, it is also internal.

The patient is changed by it, his temporality is shattered, his bearings disrupted. The subject affected in this way remains as if frozen, fixated on the blow received, which finally incrusts itself within him to such a degree that he cannot move beyond his obsessions, let alone interpret them. . . . Unable to interpret these traumatic memories, to go back to their source and remember them with full awareness, he suffers—as Paul Ricœur put it—from 'blocked memory,' 'wounded, even sick' memory (Paul Ricœur, *La Mémoire, l'histoire, l'oubli* [Paris: Seuil, 2000], p. 83; published in English as *Memory, History, Forgetting* in 2004). "The trauma victim has had an unspeakable experience of 'death's reality' (Lebigot), of a breakdown in meaning that throws him into a void and an endless state of mourning or deep melancholy: a descent into Hell from which only a long and difficult process of remembering can bring him back." Sultan, "Littérature comparée et théorie postcoloniale," 244.

7. Tāvini Huira'atira is the leading separatist party. Its president, Oscar Temaru, was elected president of the French Polynesian government on June 15, 2004, and removed by a no-confidence motion on October 8, 2004. The party emblem is a cross, and its slogan is *Te atua ta'u fatu.*

8. On June 3, 2004, Antony Geros, longtime militant member of Tāvini Huira'atira, and recently elected president of the assembly, decided to have a crucifix placed in the assembly hall. The decision caused some controversy.

9. Translator's note: Gospel Day, Autonomy Day, and National Day (Bastille Day), respectively.

10. See Ashis Nandy, *The Intimate Enemy: Loss and Recovery of Self under Colonialism* (Oxford: Oxford University Press, 1984).

11. Memmi, *Portrait du colonisé,* 185.

12. Michel Sardou and Jean-Loup Dabadie, "Qu'est-ce que j'aurais fait moi?" (What would I have done?) from the album *Bercy,* 1998.

13. Guy de Bosschère, *Les Deux Versants de l'Histoire, tome 2: Perspectives de la Colonization* (The Two Sides of History, vol. 2, Perspectives on Colonization) (Paris: Albin Michel, 1967), 16.

14. Marcus Garvey in *Black Man* magazine, vol. 3, no. 10 (July 1938), pp. 7–11; quoted in The Marcus Garvey and Universal Negro Improvement Association Papers, vol. VII: November 1927–August 1940; ISBN 978-0-520-07208-4. Marcus Garvey, author; Robert A. Hill and Barbara Bair, eds.

All Things Depending

Renewing Interdependence in Oceania

JONATHAN KAY KAMAKAWIWOʻOLE OSORIO

AUTHOR'S NOTE: In February 2011, I was honored to give the Distinguished Lecture for the Association for Social Anthropology in Oceania's annual meeting, held in Honolulu. I opened with a mele inoa, a song that I had composed the week before for the infant daughter of a close friend who is himself a musician and descendant of some of the most respected and important Hawaiian composers of the last century. I had several reasons for singing that song for the lecture. In particular, I wanted to stress the importance of relying on our own language for commemorating the truly important occasions of our lives, even though we feel less than adequately fluent. My song also remembers this child in the place where she was born and remembers her ancestors who came from those places on Hawaiʻi Island. It is neither appropriate nor necessary to publish that mele here. In its place I would like to offer this song to you, composed in 1999, and published in *ʻŌiwi: A Native Hawaiian Journal* in 2005.

I Come to the Water

> I come to the water, a child, to gather
> the life and the strength of the sea
> I come to the water to gather, with others
> for the water will not come to me
> Though we both for the moment are free
>
> I come to the water, a young man, a lover
> The pride and the hope of my family

I come to the water to sing and to wonder
And I yearn for a glimpse of my destiny
as I sail in the arms of the sea

I come to the water, an elder, a father
the life and the strength of my family
I come with the others to gather and struggle
And I toil with a tiring urgency
for the children depending on me

I come to the ocean, an old man's devotion
alone with my songs and my memories
I come to the ocean and drift with emotions
for the people who've parted from me
as I nod and dream like the sea

In the closing moments of *Half-Life,* Dennis O'Rourke's film documentary of American nuclear testing in the Marshall Islands, an unnamed woman looks into the camera and delivers a most devastating judgment of Americans and their government. The interview took place decades after the Bravo tests that had torn her and her family from the island of Rongelap after subjecting them all to the nuclear fallout that had killed her young son. After questioning our sanity as a people she asks, "Don't Americans know that all life is precious?"

The question is an important one and reveals the abyss separating Islanders in Oceania and Americans and how we view humanity. I believe that it is this great disparity in our views about human beings that has provoked our historic exploitation and has brought us to the tipping point of our very existence.

I think it is safe to say that for the most part people of Oceania have been unprepared for the voracious appetites that foreigners—Haole, Pakeha, Palagi, Caldoche—have had for our lands and resources. This unwariness is not the result, as many believe, of naiveté, nor merely unfamiliarity with the consumptive power of capitalism. We have not been equipped to deal with foreign adventurism also because we have a fundamentally different way of regarding the world and all of its inhabitants. Frankly, we do not understand a people who think only of themselves.

Even today Kānaka Maoli live within a web of interdependencies that reach out laterally to an extended 'ohana of family members but

also vertically to ancestors and descendants. At one time, every aspect of our lives invoked relationships with gods, akua, and ʻaumākua who were both lineal ancestors and living things surrounding us. The shark, the owl, the volcanic fire are not just beings in nature that we cherished and cared for but the living vessels of remembered human ancestors. Our voyages and settlements of new islands did not only carry us as individuals and families to new destinations, they carried our memories of people and places that were inseparably entwined and were brought with us as perhaps our most precious cargo. Songs, stories, genealogies, and even the technologies of planting, fishing, and voyaging were taught and learned through a pattern of relationships, not all of them sanguine, but each one necessary to the instruction of countless generations about a particular place, a weather pattern, or the habits of a plant, an animal, or a stream of water upon which we depended. And we depended on them all.

It is fascinating to read the narratives of nineteenth- and early twentieth-century Hawaiian authors, including Christian converts who continued to acknowledge the significance of these relationships in their writing. There clearly was, in Hawaiʻi as in the rest of Oceania, a deliberate discouragement of such stories, by churches, yes, and by schools and books that praised the sciences of modernity as they disparaged the traditional lore of islands.

I need not refish this pond except to point out that despite the enormous efforts made to civilize the Hawaiian, the Maori, the Samoan, and Fijian, we have not forgotten all of our stories and in fact many of our societies are in a position to recover much of the knowledge that sustained our very sustainable communities for thousands of years. Pivotal to this effort in Hawaiʻi has been the considerable archive of articles, letters, essays, and histories that were published in the Hawaiian language newspapers, just over one million pages of text in all. Nearly half a century after the last nupepa stopped its presses and Hawaiʻi was, as far as anyone could tell, an English-speaking state, scholars trained in our language and most of them of Hawaiian ancestry are avidly delving into this rich source of nineteenth-century observations and thinking.

It is a fact that most of the twentieth-century Haole historians ignored that archive. Unable to read our language, they also dismissed the knowledge that these stories contained. Modern academics, interested in Hawaiiana, depended on interpreters like Martha Beckwith or Samuel Elbert, or missionaries like Nathaniel Emerson to select the stories of interest, translate them, and provide a rudimentary commen-

tary on their significance. The information may have been interesting but the person who likely provided it was not. As a way of identifying that person, the words "native informant" were perfectly adequate. But when we native scholars learn our language and peer into these pages we hear the voices of our grandparents and great-grandparents, and we feel a tremendous excitement in reconnecting with them. From their words we learn that there was nothing insufficient about their understanding of the world nor even about the terrible things that were happening to them in that cataclysmic century of disease and dispossession.

I cannot tell you how many times I have heard students wonder aloud how intelligent, how perceptive our ancestors were, and that realization has profoundly changed the way we look at the human beings who preceded us. We no longer see them as less innovative, less knowledgeable, less empirical than the foreigners who came here, nor any less observant and capable than anyone alive today. We had our brilliant philosophers, composers, navigators, military strategists, and political leaders and among the things that we lost in the brutal first century of interaction with Europe, America, and Asia were hundreds of thousands of lives, their intellects, and their memories.

Like just about everyone in this room and beyond, Kānaka Maoli have been taught from early childhood to regard the emergence of the world into modernity as the overarching story of human beings, and for most of the last 120 years all of the institutions of learning, whether public or private schools, churches, journals, books, or newspapers, have trumpeted the triumphs of science, technology, and industry along with the equally significant developments of liberalism and law. Reared with this understanding, the modern human being uses terms like inclusion and access when talking about improving the society and making it more just. This kind of vocabulary presumes, I think, that the resources of the world can never be assumed to be shared—that purposeful actions like laws and policies must be devised in order to make certain some kind of sharing takes place. Our universe is the marketplace where things both necessary and desirable are seized, transformed, and traded by individuals and we are interdependent only through those transactions and protected only through the laws that we have devised to regulate those transactions. We need each other in the sense that a product needs a buyer and, increasingly, a marketable product can be just about anything.

But Kānaka use terms like mana and pono and kuleana: mana, a spiritual and emotional power that an individual increases and refines

through leadership and other kinds of relationships with others; pono, a balanced object or person at equilibrium between those things that are male and female, easy and disciplined, sacred and ordinary; and kuleana, one's obligations to the family, to the community, and to the land that are both responsibilities and privileges at the same time. The Hawaiian/Oceanian worldview does not just celebrate harmony, it creates and re-creates it endlessly through webs of obligations and a profound sense of respect for kūpuna, for reverence, for sharing, for limits, and for our duty to family.

I will not exaggerate some kind of pristine Islander identity. Surely, as people we have been as seduced as anyone else by the bright and fascinating toys that modern society produces. But we have not been seduced into the belief that the pursuit of such things obligates us to do everything within our power to secure them. In 1941, the author Joseph Barber, in *Hawaii, Restless Rampart*, wrote this evaluation of Hawaiians: "Their supreme failing as a people has been their constitutional incapacity to develop an acquisitive sense" (237). Barber may have seen that as a failing back in 1941. I wonder what he would think today. I remember a T-shirt from the early 1990s that read "He who dies with the most toys wins." I knew of course that the comment was intended to be ironic, but there was a twist to that irony—that the single-minded pursuit of toys and the means to secure them was just about the only obvious purpose left in a world that had become both cynical and efficiently productive.

As scholars of the Pacific, we know very well that the vast and ever more consumer-driven network of peoples and governments and lands in the Americas and Asia was created during those busy centuries of European forays into this ocean, and that the runaway capitalism that is so sobering to us today is the logical result of missionaries, pork and sandalwood traders, whalers, sugar and cotton plantations—all of these old and oppressive exploitations, now transformed into tourist destinations and military bases guarding the mercantile routes between the richest nations in the world. Sobering? 'Ae. Because we know that all of this consumption produces dire effects on the land, air, and even this great sea. Because we know that the whole world cannot live like Americans, and because we know that it is difficult for any of us to extricate ourselves from our own dependencies on more tourists, more investment, and more cheap fuel. Perhaps we ought to feel helpless.

For what can we do about any of this? To the extent that we willingly participate in this global economy as consumers and workers in

resorts, and as soldiers and sailors in the armed forces of our own colonizers, what can we Kānaka say to any American about the need to change the way we think about ourselves?

For this we must turn, as our people always have, back to our ancestors, back to our 'aumākua and outward to our families and other relationships here in Hawai'i, in Moana Nui, in the world. We must turn to the mountains, and streams and hills, to the shorelines and reefs. We must look to our children and unborn descendants and we must acknowledge that we cannot live our lives disconnected from any of them. We cannot make a future for ourselves that does not provide for all of those relations, and, as difficult a task as it may be, we must reclaim a faith in one another and a determination to change this world and its future together.

I remember my European history courses that taught us how a new humanism was born in the high middle ages that renewed a sense of dignity and optimism and resulted in a transformation of Europe. I argue that there is a need for a new vision that reunites human beings with all of their relations in the world, and that vision is necessary to sustain a very difficult struggle. We must recognize that the world is a limited space but that our imaginations, our mental universe is infinite. We must understand that the ultimate freedom is freedom from want, the ultimate security is sharing, the ultimate power is, simply, aloha.

And certainly vision is not enough. This is why I am made hopeful by what we in the Pasifik have done to reclaim our heritages— finding our voices in our languages, stories, and songs, our perspectives in our arts and literatures, our muscle and will in our own political advocacy, and pursuit of our rights in courts and international arenas. Our gains may seem trivial to some. So a few thousand more Hawaiians can speak our ancestral language; so there are three or four flourishing taro gardens in urban Honolulu. But there is a momentum building on numerous fronts, and you can feel it everywhere. In Hawai'i, in Aotearoa, on Saipan and Guam, in Vanuatu, and Kanaky we have all taken the measure of Western ideas and coercions, of disease and global wars, and of the enticements of the global marketplace. And we are still very much ourselves.

We have work to do. And that is our principal edge over this overwhelming global activity. We actually have a mission, a destination, and some idea of how to get there. We know that voyages cannot be taken alone. We sail with others and with our ancestors again. The distance and the obstacles do not deter us. Our people have been this way before.

Author's Note: As a postscript I offer this second composition with which I closed the lecture in Honolulu. I wrote "From a Dancer" for Keola Kamahele and his family, who left Hawai'i nearly fifteen years ago. A hula master and consummate performer, Keola personalizes for me the tens of thousands of our people who have left Hawai'i since the English navigator arrived, and of the hundreds of thousands of our kin who live out in the world. They will always be welcomed here and always belong.

From a Dancer

When I leave, I will take from this place the lei that we share
When I leave, I will breathe in the grace of this love in the air
And it will live as long as I live and with every song that I hear

I'll believe that my spirit still lives in the wind and the sea
And I'll breathe every memory of you as it wafts out to me
And I'll be here as long as you're here and wherever I go

Ride on the songs you've been given
Fly back to us when you hear them,
Oh hear them

I have seen all the signs of my life as they daily unfold
I am pleased to have joined with you all in the dance of my soul
And I will feel as long as you feel that we're never apart
When I leave

Note

Previously published in *Oceania* 81, no. 3 (November 2011).

Works Cited

Barber, Joseph, Jr. 1941. *Hawaii, Restless Rampart*. Indianapolis: Bobbs-Merrill.
Osorio, Jonathan K. 2005. "I Come to the Water." *'Ōiwi: A Native Hawaiian Journal* 3:86.

Pasin Pasifik/Pasifik Way

STEVEN WINDUO

Tupela maus bilong yumi Pasifik
Yu kam long ailan or maunten
Yu drip man or papa graun
Taim yu harim maus bilong
Taur na garamut yu klia
Olsem igat bikpela toktok
I stap insait long singaut
Bilong tupela maus bilong Pasifik
Na taim ol Polynesia winim Taur
Ol Melanesia i hamarim garamut
Na singautim ol Micronesia
Long kam bung olsem wansolwara
Yumi nogat koros namel long yumi
Yu hamamas long laip bilong mipela
Em ol narapela i mangalim na tok
Pasin Pasifik em trupela pasin.

Pasifik Way
STEVEN WINDUO

Our two voices
Whether you're from the islands or the mountains
You migrant or landowner
When you hear the call of
The conchshell and the drum, you will know
That a meeting will take place

A message within
These voices of the Pasifik
Polynesians will blow the conchshells
The Melanesians will beat the drums
And call the Micronesians
To come meet together as islanders
We don't have any differences
We are happy with our lives
That others are so envious of
Pasifik way the true way.

He Huaka'i ma Hā'ena

Treasured Places and the Rhetorical Art of Identity

GREGORY CLARK AND CHELLE PAHINUI

> *E hui pū ia kākou i ka 'imi 'ana*
> *I ka ho'oilina Hawai'i.*
> *Aia no ia i ka 'ōlelo makuahine,*
> *a me nā mo'olelo o ka 'āina aloha*
> *a me nā oli mai nā kūpuna mai*
>
> *Let us join together in the quest*
> *For knowledge of Hawaiian heritage*
> *That is in the language,*
> *The history of the beloved land and*
> *Of the chants as told us by our ancestors.*
> *—Mikahala Roy*

RHETORIC WORKS TO RESOLVE conflict by forging agreement. Aesthetic works to provide diverse people with a common experience. Both, whether directly or by considerable indirection, help people who find they must share a space move from contention to community. They do that by communicating identity—a sense of self and affiliation for those who are addressed to adopt for themselves. So we might phrase it this way: rhetoric forges the kind of agreement we understand in conceptual terms, while aesthetic offers an opportunity to experience that agreement by inhabiting with others at least for a moment a common identity. When the need for agreement is most pressing, rhetoric and aesthetic become almost the same. An example: after the individuals

who shared the space of the United States had contested the question of common identity to the point of nearly destroying themselves in civil war, the poet Walt Whitman confessed that his "fear of conflicting and irreconcilable interiors, and the lack of a common skeleton, knitting all close, continually haunts me," and intensified his conviction that "nothing is plainer than the need, a long period to come, of a fusion of the States into the only reliable identity, a moral and artistic one" (Whitman [1871] 2010, 10).

Much was working against an encompassing American identity in the years preceding and following that civil war. What identity had developed during the nation's first four-score years was made of materials from decades of arguments that finally collapsed in catastrophic violence. And the rhetoric of national unity that followed showed him no promise. So Whitman looked past politics to the binding power of art to hold his nation together. Put another way, he looked for uniquely American aesthetic experiences upon the assumption that art could lead this fractious people to a shared way of identifying themselves in the world. He looked, but failed to find them.

Hawaiians share a similar need to see themselves in a shared way, and a similar sense that they might meet that need in aesthetic experience. Throughout the eighteenth and nineteenth centuries, increased pressure on their commonality came from foreigners whose ships depended on their islands. Hawaiians who hosted good harbors found themselves pressured into separate alliances, a situation that prompted their efforts to identify themselves anew as a Hawaiian people. But then came successive waves of immigration that changed every element of Hawaiian culture again, from spirituality and language to material ways of daily life. And then, the variegated Hawaiian nationalism they established late in the nineteenth century as the kingdom of Hawai'i was undermined by American interests that effectively annexed the islands into their nation at the turn of the twentieth century. So Hawaiians became Americans, at least in name.

As a minority in their own land, learning the hard way that political rhetoric is insufficient to perpetuate and protect their Hawaiian identity, Native Hawaiians have in the last half century revived traditional arts that had embodied that identity for generations: music, hula, traditional crafts like kapa making and voyaging. Interest in these arts as well as in the Hawaiian language itself has now developed to a point where Hawaiians can again provide each other with experiences that let them find themselves at home. This essay describes one such expe-

rience and reflects on what it has to teach about the rhetoric and aesthetics of identity and place.

Aesthetic Experience at Hā'ena

Hula Loea, George Lanakilakeikiahiali'i Na'ope, known to most as Uncle George, began his hula studies in the traditional manner at the age of three and dedicated his entire life to the hula arts. He was cofounder of the Merrie Monarch Festival in Hilo and provided inspiration and direction for numerous successful hula events and activities throughout the world. Until his recent passing, he was one of the last living links to the spirits of old and was regarded as an island treasure and a great and valuable authority and repository of hula lore. During the last years of his life, he was passionately committed to creating a living cultural museum, Hale Kia'i O Nā Mea Hawai'i and Hōlani Hula Archive, a project that employs the hula arts to preserve and perpetuate Hawai'i's heritage and traditions.

To better understand the importance of traditional practitioners such as Uncle George, it is helpful to understand the Hawaiian perspective of the natural environment. Unlike the Western perspective of the environment as a resource base, for Hawaiians the environment is a living being—a home for other living beings made by living gods. Almost all aspects of Hawaiian culture and life were instilled with ho'omana (religious activity) that required prayer, a relationship with something greater than oneself. As Malcom Naea Chun explains, "A wooden or stone image is just a piece of wood or rock until it is ho'omana, imbued with mana, or in the religious-poetic language 'when the god dwells 'noho' in the object.' Hence, certain trees, stones, rocks, and places could become sacred when mana is invoked and the divine intervenes" (Chun 2011, 170).

The concept of aloha 'āina (love for the land) originates from ancient traditions concerned with the genealogy and birthing (formation) of first the Hawaiian archipelago followed by the Hawaiian people from which all genealogies descend. We learn from oral traditions such as the Kumulipo, a Hawaiian chant of creation, that the history of the land and its people are inseparable.

Thus, each of the Hawaiian Islands has its own unique features and characteristics. Each is special, significant, and sacred for different reasons. Hawaiian landscapes are embedded with traditional histories and stories that document how the ancestors felt about a particular

area, its features or phenomena. They help to transform what might seem like empty geographic spaces into cultural places enriched with meaning and significance. Ancient names reveal the succession of each formation, an account of the history of each island, and the traditional significance of particular sites.

The most noteworthy of these 'āina are recognized as wahi pana—a sacred place that both receives and nourishes. Underlying the concept of wahi pana is the Hawaiian belief that the various forces of nature directed by gods to form the earth also imbued it with a dynamic life force and energy. As direct descendants of the creator gods, these naturalists not only live on active volcanoes but also have the capability of power and influence over them as well as the kuleana (responsibility) to respect and care for these ancestral places.

One of the programs inspired and designed by Uncle George is the series of workshops called He Huaka'i e Pana na i ke Ea—A Journey to Bring Pulse to the Living, a traveling succession of instruction where training focuses on mele wahi pana, the chants, songs, music, and hula of treasured regions or sites. In cultures where traditions are kept and passed orally, chants, songs, and dances are an archive of ideology, connections, memories, and experiences from Hawaiian ancestors. Through the detailed chants and precise movements of nā hula, the mores of society, duty, honor, birth, death, revival, passion, revenge, and place names are meticulously taught and remembered. Thus these arts reveal the very essence of the Hawaiian people, and their practice keeps the history, language, and Hawaiian people alive. The intention of this program is to ground and reconnect students with the life of the land and the traditional knowledge it endows.

Master of Hawaiian music Cyril Pahinui, a lifelong friend of Uncle George, was asked to lead the workshops by selecting musicians and cultural resource people to share their knowledge and experience of the selected local site. Participation is comprised of a variety of community resource people, master musicians, cultural practitioners, music students of all ages, and visitors as cultural tourists.

As a young boy, Uncle George was taken to each site referenced in a chant or mele he was learning to reflect on its environmental nuances and historic significance. As a kumu (master instructor), he insisted that his students take the time to experience for themselves the slope of the pali (cliff) or the sting of the rain at a particular locale to gain a deeper understanding and better execute the intrinsic motions of a

dance. He taught that underlying the traditions of nā hula is the concept of mana, or spiritual power, a world linked to the elements where one can speak directly to the winds or the rain and expect an answer. Also essential is an understanding of the three different levels of the oral language used in a Hawaiian composition: the literal; the kaona, or hidden meanings woven into the obvious, and the noa huna, or spiritual level, where spoken words have the power to cause action including life and death (Young 1998, 12).

In addition to music and dance training, the He Huaka'i program was designed to provide residents and visitors with a unique, enriching, and authentic quality cultural experience; to present insight into the history, customs, art, traditions, and significant context; to offer close-up interaction with the community and its resource people; to increase familiarity with treasured sites; and to encourage aloha 'āina, an ingrained respect for the land, and mālama 'āina, a desire to preserve, protect, and take care of the precious resources of the land.

Students began the He Huaka'i project by mapping hundreds of chants and songs to sites throughout the Hawaiian Islands, and now the training moves through that map, each year locating in another district, where the chants, music, and hula of that region are featured and taught. The series began in Ka'ū, a vast, rural, and remote area on the island of Hawai'i, home to most of the Hawai'i Volcanoes National Park, which includes Kīlauea, home to the Hawaiian volcano goddess Pele and one of the world's most active volcanoes, a place of natural wonders where one can witness the creation of the islands.

The eighth year of the series, 2011, was planned for the district of Puna on the island of Hawai'i, an area steeped in traditional chants and mele. It is also the last large intact native rain forest, at 25,856 acres. The district of Puna is highly valued by Native Hawaiians for its ecological and cultural significance. Two sites were selected for the three-day workshop, Hā'ena Beach and Kalapana. Both are significant to the story of Pele and her sister Hi'iaka. Two other more contemporary mele, "Lei O Hā'ena" and "Hōlei," are also associated with these sites.

Hā'ena Beach is one of the most scenic and least-visited beaches in lower Puna: a small, beautiful, white sand cove sheltered by a reef of pāhoehoe (smooth lava) on a coastline dominated by rugged black lava cliffs and spectacular crashing waves. This area is isolated, with limited access along a rough beach trail that runs through the private property of W. H. Shipman, Ltd. Immediately inland from the cove are the

traditionally styled W. H. Shipman homes built in the nineteenth century and a large freshwater pond that now serves as a refuge for the endangered nene geese. The water is exceptionally clear, and it is possible to see bubbling springs of freshwater coming up through the sand along the shore during low tide. In its natural landscape, the area is covered with native plants used for hula and groves of hala (pandanus) used for weaving.

Because of the inaccessibility of this site and its association with cultural tradition, in the 1990s, beach access was the subject of a series of demonstrations and confrontations between W. H. Shipman Ltd. and community activists over public access via the one access road to the beach, which the company built and claimed as private property. In 1994, the dispute came to a head when, during a Hawaiian "spiritual gathering" of more than 125 people, 28 people were arrested for trespassing. Four years later, in 1998, the state Supreme Court upheld their conviction of this "crime."

Tom English, a Shipman descendant who now manages the property, took participants in the 2011 He Huaka'i to Hā'ena Beach. Included were event director Cyril Pahinui, Dennis Kamakahi, one of the most prolific composers of Hawaiian music, and Kekuhi Kealiikanaka-oleohaililani, a renowned hula practitioner from the Edith Kanaka'ole Foundation. The group gathered in the early morning at the Shipman offices located at Kea'au town and, with guitars and 'ukulele, caravanned down the road that leads to the homesite at Hā'ena. On arrival, the group moved almost instinctually past the houses and toward the beautiful white sand beach. For those who had never been to the site, it was a surprise, and for those who had seen it before, it was as captivating as when first discovered. As the group strolled the beach, Tom and Kekuhi—two who had not met before—were drawn together in a chance moment to connect and exchange thoughts.

The group was called to assemble on a circle of chairs set out for their comfort. In traditional custom, a pule (prayer) was offered in gratitude for the opportunity to experience this cherished site and to ask for inspiration, safety, and blessings for those in attendance. This traditional formality was intended to provide bonding, focus, and unity for the diverse group of participants.

This site is the scene of the story of Pele and Hi'iaka that is one of the defining myths of Hawaiian hula. The oral tradition is filled with themes of creation, love, betrayal, and heroic redemption and illuminates the concept of aloha 'āina, a concept that encompasses the Hawai-

Tom English and Kekuhi Kanahele talking at Nanahuki Bay at Hā'ena, Kea'au, Hawai'i

ian identity and relationship to place. The full story of Pele and Hi'iaka takes place on numerous sites throughout the island chain, but it begins on the island of Hawai'i at Hā'ena Beach in Kea'au. In its entirety, it is an epic myth filled with protocol and cultural values that are at the foundation of Hawai'i's rich indigenous culture and provides a resource to many who seek to understand the culture and its perspective on the eternal cycle of renewal and destruction.

In the cultural tradition of ho'okipa (hospitality), a tradition experienced and described in the story by Hi'iaka in her ventures across the islands, the workshop began with a greeting of welcome followed by a heahea (recitation) of genealogy by Tom English, a descendant of William Herbert Shipman, the son of Reverend William Cornelius Shipman, who was dispatched to Hawai'i by the American Board of Foreign Missions in 1854.

After graduating from college, W. H. Shipman moved to Hawai'i Island to manage family ranch lands in the Puna district. There he met and married part Hawaiian Mary Elizabeth Johnston from Kona. The couple often traveled the Kings Highway, a rough trail that ran from Kapoho to Hilo along the Puna coastline. Each time the couple passed the beautiful beach at Hā'ena, Mary would mention the specialness of the site and her desire to own the property and protect it for future generations.

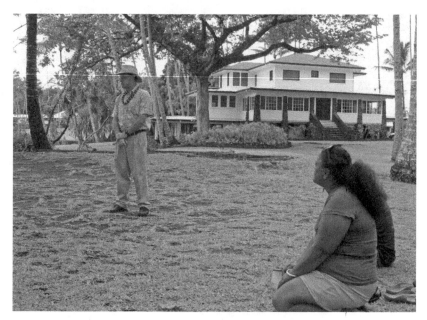

Tom English and Kekuhi Kanahele at Hā'ena

In 1888, the King Lunalilo estate sold the seventy-thousand-acre ahupua'a (traditional mountain-to-the-sea land division) to the Shipmans, and William bought out sole interest in the lands of Kea'au. He built a home at Hā'ena Beach in 1904, where he farmed and raised orchids, dairy cattle, and poultry including nene, the then nearly extinct native Hawaiian goose. A well-known mele, "Lei O Hā'ena" ("Beloved Child of Hā'ena") was composed for the family by Helen Desha Beamer, a highly respected Hawaiian composer, following her visit to the home.

Mary and William's grandson, Roy Shipman, managed the property until turning it over to his great-grandsons Bill Walter and Tom English in 2005. Although much of their lands have been sold or put into development and diversified agriculture, the site at Hā'ena remains in the family, protected by their strong commitment to land and resource preservation and profound aloha for this special place.

Following this welcome, Kekuhi Kealiikanakaoleohaililani was introduced to the group. Kekuhi is the daughter of Pualani Kanaka'ole Kanahele, kumu hula of the Hālau O Kekuhi, who has spent her life in the hālau learning, performing, and teaching the ancient body of chants contained in the Pele and Hi'iaka tradition. When Kekuhi was

asked to be a presenter at the workshop, she requested to bring along some others without offering any disclosure as to why or who they were. As established by Uncle George, the workshops are open to everyone who requests attendance. The workshops are not promoted widely, and it was his sincere feeling that attendance should be left to akua (gods of the land / powers that be), that those who should be there would come and those who should not would not.

As protocol instructs, Kekuhi introduced herself, along with her seven-year-old daughter and her husband, and explained her family's legacy and cultural links to the ancient traditions of the site. She described how throughout her life she had danced to the chants about Hā'ena and yet had only actually come to the site three times: once when she was seven with her grandmother Edith Kanaka'ole, once with her mother, and again on this day when she brought her own daughter to experience for the first time these traditions at the site of their origin, this mele wahi pana (storied place). She discussed the significance of the site to hula, its natural history, the geological formation, what it was like before Hawaiian voyagers arrived, the ecosystem, the meaning of its name, and why the people who settled in the area celebrated it.

In introducing us to this place, Kekuhi explained that Hā'ena means "red-hot" or "burning," and that this is a place where opposites come together—she called it a place of transitions. Here, the two dominant volcanoes, Mauna Loa and Mauna Kea, have both flowed into the sea yet have not crossed paths, salt water and freshwater flow together on the beach, and the primordial mud is formed. Here, the black and white sands make elegant swirls together but do not mix, and here the Shipman and Kanahele Hawaiian histories are not mixing but flowing together. This is what we were to experience at Hā'ena.

Kekuhi next introduced the story of the migration of the Pele family to Hawai'i following expulsion from their distant homeland. Kekuhi offered a chant describing how the family had traveled from island to island before settling at Moku'āweoweo, the active volcanic "land of the burning." She also told of Pele's first meeting with Lohi'au on Kaua'i and the deep love Pele had for this chief. She went on to explain how Pele also carried her youngest sister, Hi'iaka'ikapoli'opele. Hi'iaka had spent her childhood frolicking in the waves in the bay by which we sat, known as Nanahuki. Kekuhi described how Hi'iaka was taught to chant and dance by her friend Hōpoe, imitating the motions of the waves and plants in the breeze and how she became one with nature by creating garlands to adorn herself while she danced.

Ke haʻa lā Puna i ka makani
Haʻa ka ulu hala i Keaʻau

Puna dances in the breeze
The hala groves of Keaʻau join the dance ("Ke Haʻa Lā Puna"
 [the Puna Dance], traditional chant)

While explaining how the story was one of becoming, not one of beginning and ending, Kekuhi described how our being there was part of the continuation of the story, and how we were all now a part of the living story of this place. She encouraged each of us to open ourselves to our own becoming. By immersing ourselves at once in the place and the chant, we would, she said, find something of our timeless identity and individual potential in this convergence of myth and land. That is because places such as this, when encountered in the context of the fundamental events of mythic time, provide space in which to develop and understand the meaning, value, and purpose of the self—a self attached to the godliness that is inherent but almost always inaccessible in us all. She then called upon us to let ourselves be encompassed by an experience of life and time on this sacred land. In this place of becoming for Hiʻiaka, we, too, could each begin to become our greatest self.

As Kekuhi was speaking, a light breeze blew in from the ocean and the trees began to flutter. Sensed by everyone, a feeling known in Hawaiʻi as chicken skin came over us all. Taken by the moment and her deep love for this place, Kekuhi suddenly dropped to an ʻai haʻa (crouching) position and began to chant and dance the story she had been raised to tell:

Ke haʻa lā Puna i ka makani;
Haʻa ka hala i Keaʻau;
Haʻa Hāʻena me Hōpoe;
Haʻa ka wahine,
Ami i kai o Nana-huki, la—
Hula leʻa wale,
I kai o Nana-huki, e-e!

Puna's a dance in the breeze,
The hala groves of Keaʻau shaken;
Hāʻena and Hōpoe are swaying;
The thighs of the dancing nymph

Noho ana i ka uluwehiwehi. I ka nahele i puīa i ke 'ala onaona
Nestling in lush beauty. In a wooded grove over spread with soft sweet fragrance
"Lei O Hā 'ena," Helen Desha Beamer

> Quiver and sway, down at Nana-huki—
> A dance most sightly and pleasing,
> Down by the sea Nana-huki. (Emerson [1915] 2005, 1)

 With the sand of the beach as her stage and the sounds of nature her accompaniment, she took us with her on a path of remembering the legacy that was by kuleana (hereditary responsibility) hers to share at this sacred site of its origin. Joined by a line of nēnē also entranced and swaying now along with the trees to the sounds of the chant, we were transported by the music of her words and the motion of her dance to a mythical antiquity, a time when goddesses first danced and chanted these now ancient verses.

> O Puna kai kuwa i ka hala;
> Pae ka leo o ke kai;

A Haʻa Hāʻena me Hōpoe Haʻa ka wahine
ʻAmi i kai o Nanahuki la

Ke lū, lā, i nā pua lehua.
Nāna i kai o Hōpoe,
Ka wahine ami i kai
O Nana-huki, la;
Hula leʻa wale,
I kai o Nana-huki, e-e

The voice of Puna's sea resounds
Through the echoing hala groves;
The lehua trees cast their bloom.
Look at the dancing girl Hōpoe;
Her graceful hips swing to and fro,
A dance on the beach Nana-huki;
A dance that is full of delight,
Down by the sea Nana-huki.

ʻO Nana-huki la;
Hula leʻa wale,
I kai o Nana-huki, e-e.

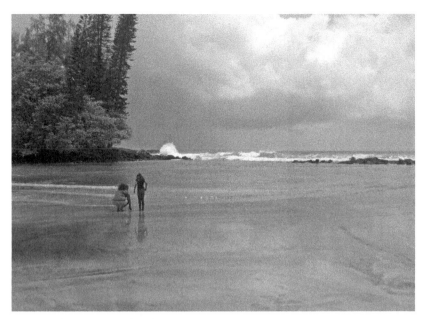

Kea'au, i ke kai nehe i ka 'ili'ili.
Kea'au, where the sea murmurs over the pebbles ('*Ōlelo No'eau*, 180).

A dance on the beach Nana-huki:
A dance that is full of delight,
Down by the sea Nana-huki. (Emerson [1915] 2005, 1)

Suddenly, a light rain came in from the sea, almost breaking our fascination as we gave thought to move inside. But no one could move, and the chant continued, and we fell back under the spell of the experience. For nearly an hour, the sprinkle of rain washed us as the story unfolded of Hi'iaka's difficult task to retrieve Pele's lover Lohi'au from Kaua'i. Then, as the story concluded, so did the rain, and the day was once again filled with sunlight and sparkling reflections on leaves and on the sea.

Following the session, as we reflected on what we had experienced and Kekuhi prepared to leave, Tom remarked that although he had spent most of his life at this place, he had not heard these chants and so had never experienced this place as he had that day. He was visibly moved. He wholeheartedly thanked Kekuhi for coming and welcomed her to come again, at any time, and to bring her family and students.

This itself was a moment of transition. We had witnessed the mana (power) of this place for reconciliation and transformation.

An Aesthetic Rhetoric of Hawaiian Place

Rhetoric works discursively to do the work of influence—the work by which someone shapes the ideas and even the actions of someone else. Aesthetic does that same work of influence, but narratively, experientially. What a poem, painting, or piece of music provides for those who encounter it is an immediate experience of an alternative reality, one that, unlike the mundane reality we inhabit firsthand, is sufficiently complete and coherent to enable us to inhabit its meaning. The chants, the mele, the hula of Hawaiʻi are aesthetic experiences made from the Hawaiian consciousness and sense of place. Such was our experience at Hāʻena Beach. It gave our lives a new sense of meaning as we immersed ourselves in the sensory experience of inhabiting for a time that seemingly perpetual place.

As we came into the property that morning through gates that could be opened only by Shipman keys, some among us perceived Tom and Kekuhi as stewards of contending claims. Simply put, it was easy to frame the place as a site of the conflict between colonial and native stewardship of the land. But through our shared experience and connection to the ancestral legacy we were learning, we understood that Tom and Kekuhi are both Hawaiians with kuleana and belonging at this place. In ways we might not be able to articulate but had just experienced, Tom and Kekuhi and those Hawaiians they each represent are integral elements of that storied place in the land they share. That was the transition we experienced, the mythic moment when we realized that two meanings of this place that might look contradictory were actually quite similar.

What Hāʻena provided was an insight into Hawaiian identity and, indeed, into the nature of identity itself. On the mainland at midcentury, philosopher and cultural critic Kenneth Burke had proposed a fundamental revision to the conventional conception of rhetoric inherited from Aristotle. Burke's proposal: that we understand the effect of influence to reach well beyond persuasion—an effect is primarily cognitive—to encompass identity. That is, the work of influence proceeds not just by marshaling evidence in argument, but also by providing people with what we might call a transformative experience—sometimes we describe it as "life-changing." That makes the reach of the rhetorical expansive. Here is how Burke put it:

The key term for the old rhetoric was "persuasion" and its stress upon deliberate design. The key term for the "new" rhetoric would be "identification," which can include a partially "unconscious" factor in appeal. "Identification" at its simplest is a deliberate device, as when the politician seeks to identify himself with his audience. In this respect, its equivalents are plentiful in Aristotle's *Rhetoric*. But identification can also be an end, as when people earnestly yearn to identify themselves with some group or another. Here they are not necessarily being acted upon by a conscious external agent, but may be acting upon themselves to this end. In such identification there is a partially dreamlike, idealistic motive, somewhat compensatory to real differences or divisions, which the rhetoric of identification would transcend. (Burke 1967, 63)

Our experience at Hāʻena performed this rhetorical work. Its lessons were lessons of identity: about fundamental and timeless elements of human experience, about relationships with a place and a people that are inherent elements of individual identity, and about the possibilities for connection between two contrasting identities that become manifest when people acknowledge that place and myth both represent rich and expansive realities that give human identity durable meaning. On that day, among this group, the rhetorical work that proceeded was also about what it means to be Hawaiian. Tom's story of this Hawaiian place was historical, and Kekuhi's was historical too, but mythological as well. The two recited different histories, but both histories were of Hawaiʻi. What we witnessed in that place was the convergence of those histories in a sense of Hawaiian identity that was transformed. As Kenneth Burke would describe it, what we experienced at Hāʻena was "transcendence": "A rhetorician . . . is like one voice in a dialogue. Put several such voices together, each voicing its own special assertion, let them act upon one another in a co-operative competition, and you get a dialectic that, properly developed, can lead to views transcending the limitations of each" (Burke 1967, 63). These views are elements of a new conception of identity that enacts in perception, attitude, and action what he described as "the unitary principle discovered enroute" (64). As we drove away from Hāʻena, where we had been enthralled first by the beauty and inchoate power in the place and then by stories, dance, and song, we were able to understand what it means to be Hawaiian in a new and encompassing way that at least some of us

had been unable to comprehend before. This is rhetorical work being done, and every bit of it was done aesthetically.

We sat in a circle in a place of origin for many of those gathered there—much as members of a family would gather in a home. And while the problem, the conflict, was never named, it was enacted in the distance that divided the separate stories of Hawaiian identity that Tom and Kekuhi each told. That separation was a space bridged only by Hā'ena, as they each described a very different connection to this same treasured and storied place. Although there was no admission or utterance of forgiveness, those present experienced a moment of transition marked by our chicken skin, as chant and place, words and dance, shower and sun, the sound of breaking waves, and the sight of hala leaves graceful in the breeze all professed essential connection that was manifest in this place. We came away changed: concepts enriched, hearts enlivened, connections forged. It was, as we returned to our cars and caravanned back through the rain forest and then the plantation to Kea'au Town, as if, at least in this place—at least in Hawai'i—we might somehow begin to understand our commonality.

Conclusion

We began this essay with a statement from Mikahala Roy, kahu (spiritual and material caretaker) of Ahu'ena Heiau, the carefully restored heiau, or temple, of the first Kamehameha on the Kona coast that is now part of the grounds of a resort hotel. This Kamehameha was the first Hawaiian leader to unify the people who inhabited these islands. That unity was political, but it was also cultural, as what followed from it was a sense of Hawaiian identity that was shared across the island chain as it had not been shared before. Each island has sacred, storied places like Hā'ena, places spiritual in the sense that they are where events that define a people occurred. In recounting those events, whether mythological or historical, in visiting these places, individuals are reminded that they are each something more than is manifest in their daily lives.

Hawaiian identity has always been a moving target, changing as the people who find themselves rooted in these places have changed. In response, something like the aesthetic sort of lōkahi (unity) we experienced at Hā'ena has occurred before, over and over, in chants and hula, in story and mele. As Taupouri Tangaro suggests in his introduction to a new edition of Nathaniel B. Emerson's version of the myth of Pele and

Hiʻiaka, this ancestral connection provides a view into "the sacred interior of the Hawaiian psyche, of a people dwelling on sacred ground, and of a journey toward the recovery of the sacred inherent in every individual" (Emerson ([1915] 2005, iii). Through discovery of the sacred that is Hawaiʻi, Hawaiians as well as those who visit them can launch their "own mythic expedition toward profound actualization."

Identification—the assigning of identity—is a matter of inclusion and exclusion. It binds some people together as it separates them from others. That's the way it is. There were visitors present at that gathering at Hāʻena, tourists to whom the experience we have recounted communicated the fact that they are not, after all, Hawaiian. Yet they still experienced the transformative power of that place. And inherent in that Hawaiian experience was an encounter with universal human identity that enabled them to understand, in ways that they had not before, the possibilities that aesthetic experiences provide us to, as Burke liked to put it, "make ourselves over in the image of the imagery" (Burke 1973, 117). Indeed, what they learned about Hawaiians at Hāʻena enabled them to remember their own recurring need, as Dennis Kamakahi described it later when the group reconvened inland, to realign themselves both with others and with the lessons of the land that is their common origin. So even the tourists among us that day in that place could answer in their own ways Mikahala Roy's call:

> Let us join together in the quest
> For knowledge of Hawaiian heritage
> That is in the language,
> The history of the beloved land and
> Of the chants as told us by our ancestors.

Works Cited

Beamer, Helen Desha. 1987. "Lei O Hāʻena." © P.C. Beamer Jr.

Burke, Kenneth. 1967. "Rhetoric—Old and New." In *New Rhetorics,* ed. Martin Steinmann, 59–76. New York: Scribner.

———. 1973. *The Philosophy of Literary Form: Studies in Symbolic Action.* 3rd ed. Berkeley: University of California Press.

Chun, Malcolm Naea. 2011. *No Na Mamo Traditional and Contemporary Hawaiian Beliefs and Practices.* Honolulu: University of Hawaiʻi Press and Curriculum Research and Development Group, College of Education, University of Hawaiʻi at Mānoa.

Emerson, Nathaniel B. [1915] 2005. *Pele and Hiʻiaka: A Myth from Hawaii, with an Introduction to the New Edition*. Revised edition. Preface by Taupouri Tangaro. Hilo, Hawaiʻi: Edith Kanakaole Foundation.

ʻŌlelo Noʻeau: Hawaiian Proverbs and Poetical Sayings. 1983. Collected, translated, and annotated by Mary Kawena Pukui. Illustrated by Dietrich Varez. Honolulu, Hawaiʻi: Bishop Museum Press.

Whitman, Walt. [1871] 2010. *Democratic Vistas: The Original Edition in Facsimile*. Ed. Ed Folsom. Iowa City: University of Iowa Press.

Young, Kanalu G. Terry. 1998. *Rethinking the Native Hawaiian Past*. New York: Routledge.

Words & Music

JEFFREY CARROLL

AUTHOR'S NOTE: Quoted speech in what follows is pure Gabby, as reported in two extended interviews with him: Brian Thornton's "Gabby Pahinui: My Life and Hard Times," which appeared in the *Hawaii Observer,* April 7, 1977, and Robert Kamohalu Kasher and Burl Burlingame's "Gabby Pahinui," which appeared in their *Da Kine Sound: Conversations with the People Who Create Hawaiian Music,* published in 1978 by Press Pacifica.

> Gabby was born in Honolulu
> Denies being born in Kailua-Kona or Lahaina
> Gabby was born Charles Kapono Kahahawai Jr
> His family name was Kahahawai
> He was hanaied by Charles Philip and Emily Pahinui
> They did paperwork 50 years later
> He grew up in in Kaka'ako
> Philip was nicknamed Gabby
> Gabby is short for gabardine
> They said his hair was shiny
> It also means very talkative
> Gabby was nicknamed Pops
> Gabby was Hawaiian, Portuguese, German
> He learned how to play the guitar in Kaka'ako from a neighbor
> named Herman
> Herman was never located
> "all I did was listen, listen"

Bass steel guitar ʻukulele guitar
Gabby quit school when he was 13
Shined shoes
"all I did was listen, listen"
Stevedore for Matson
Locomotive water tender at Pearl
"black smoke in the air, anti-aircraft shells everywhere"
Gabby had his first hit when he was 42 in 1955 "Hiʻilawe"
Met his wife Emily Kaua at a volleyball match on Ena Road
He listened to Benny Goodman, Eddie Condon, Count Basie, Duke
 Ellington, and Lionel Hampton
He played along with Django Reinhardt
Django was a gypsy only four fingers on his picking hand
He loved the music of Aunti Genoa Keawe, Johnny Alameida, Paul
 McCartney, Charley Davis, Alvin Isaacs
"I loved all kinds of music"
"I don't read music"
He filled potholes for the City & County of Honolulu until his truck
 was rear-ended
 and he went on disability drove garbage truck
Gabby's voice was thunder
Gabby's voice was honey
Gabby's voice falsetto leo kiʻe kiʻe
Gabby's voice was low and rough
A vibrato from deep down
But the falsetto high in the throat
At age 57: "How can they call me a legend? I'm just a young boy"
"Hiʻilawe Lei Nani Moana Loa Ipo Lei Manu E Nihi Ka Hele Kauai
 Beauty
 Leahi Lihue Pua Tuberose Lei No Kaʻiulani No Ke Ano
 Ahiahi"
His guitar had six strings twelve strings
He played with two fingers three fingers
His thumb is counted as one of his fingers
The thumb plays the bass part
The fingers play the melody
They all play rhythm
On drinking: "Oh, yes"
On dancing a comical hula in California: "What can you do? They
 thought I did it funny. But deep in my heart I wish I had had my
 ticket to come home then"

On the right place to play: "outside with a few grass shacks here
 and there and the feeling of the ocean water and a beautiful luau
 outside"
"if we had a little stew, well, that was a luau"
crackers and water drinking off the money falling down drunk
*King of Slack Key Two Slack Key Guitars Pure Gabby Gabby
Rabbit Island Music Festival Hawaiian Band 1 Hawaiian Band 2*
"All I know is that I tried to make it sound the way I felt"
Collected toy trains 23 locomotives 29 grandchildren
Gabby died at Olomana
Gabby was playing golf with friends
Gabby called musical notes golf clubs
"I don't read music"
grooves rhythm forward motion circular power rolling pulling back
 and rhythm
from several feet under to the tops of trees lifted by waves
 rolled over and over
floats like clouds the ringing of bells hula hymn
"I don't read music"
"I loved all kinds of music"
"if it sounds like Hawaiian music, then that's the way I did it"

PART 4

Ke Aweawe a Makali'i: Word

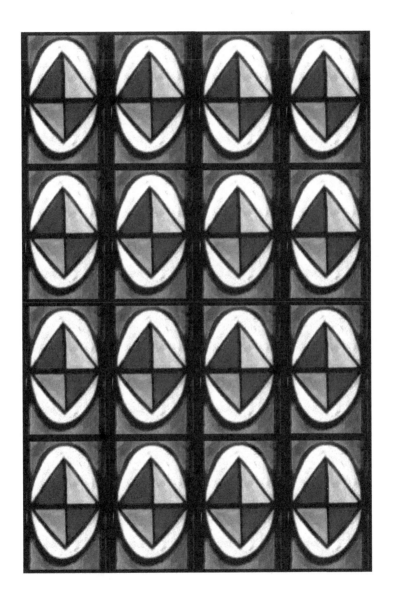

I write (J'écris)

CHANTAL SPITZ
TRANSLATED BY JEAN ANDERSON

"... the fear that it might very quickly overflow and get away from
us, dragging us onto the terrain of protests, of political
issues ..."

thank you Flora for always giving me that little trigger that forces
my laziness to think to try to sort out our issues

in our country as in every colonized country is not the act of
writing in and of itself the supreme act of protest resistance
subversion dissidence does it not carry within itself all the
ferment the protests that will sprout forth blossom open out
multiply

when our memories began to fade with the arrival of christianity
when our civilization continued to fade with the arrival of
colonization
we wrote
writing our memories our history
writing our civilization our foundation
writing our immemoriality for our eternity
writing our absences for our endurance
protesting against the imported the imposed order

when our anxieties began to solidify with the disqualification of our
memories

when our insecurities continued to solidify with the disqualification
 of our civilization
we wrote
writing our searing our tearing wounds
writing our emptiness our bitterness
writing our affirmations for our emancipation
writing our convictions for our insubordination

protesting against the imposed the accepted order

when Henri called on us to write in all our spaces
when you call on us to write with all our daring
we wrote we are writing we will keep writing
writing our fears our naïvety
writing our fervor our rigidity
writing our constancy for our hope
writing our conflicts for our existence

protesting against the accepted the established order

protests—nervous fierce
 unspoken open
 frightened forthright

for so long in so many ways we have been writing protesting

every text is a stone added to our wall of protests

texts—murmured chanted
 prayed recited
 sung declaimed

texts—manuscripts ink-written
 typed printed
 memorized saved to disk

protest is underway cocooned since the first puta tupuna it has
 nestled deep within the souls spirits hearts bellies bodies
we write it we sing it we read it we hear it
it tangles in our gut it overturns our intelligence

and yet
since we are normed to western literary models it escapes us
because
it is like our literature
polyformed polylingual polycolored
so very polynesian

protest has been underway openly since the moment we began to
 admit the existence the quality of our literature since we became
 impatient with our publications still too few since we began to
 dare to comment analyze wish since we overcame our shame
 our fears our doubts since we stood together in support in the
 light of our literature

it is down to us to spread into all the spaces of thought
 into all the spaces of writing
 into all the spaces of society
 into all the spaces of modernity

it is down to us to succor it with our hiccups our smiles
 our anger our love
 our disasters our desires
 our deaths our hopes

it is down to us to offer it the best of clothing
 the most eloquent words
 the most elegant verses
 the most forthright texts

why such fear

on the contrary

let us call for the protests of all our pens all our voices all our texts
let us protest against all the imported imposed accepted estab-
 lished orders
let us protest against all the social economic cultural intellectual
 disorders
let us deviate from all policies that aim to anesthetize our intelli-
 gence into a single non-thinking state

let us desist from all religions that aim to bend our intelligence
 into expiatory submission

let us depart from all conformism that aims to close down our
 intelligence into comatose normality

let us protest gently harshly
 peacefully wildly
 calmly passionately

let us protest through fables through columns
 through novels through pamphlets
 through novellas through comedies

our country our people deserve subversive texts
texts that overturn abolish conventional behavior and thought
texts that dismantle collapse injustice and inequality
texts that compose modulate dignity and pride
texts that found develop confidence and certainty
texts that commit author and reader to a perspective not certified
 as the only reasonable one

it is down to us who write overtly unknowingly
 hesitantly ambiguously
to make this protest audible readable intelligible
for us
for all of us

our country our people deserve these subversive texts

Note

Previously published in *Littérama'ohi* 3, Tarafarero Motu Maeva (December 2002).

Ka Li'u o ka Pa'akai (Well Seasoned with Salt)

Recognizing Literary Devices, Rhetorical Strategies, and Aesthetics in Kanaka Maoli Literature

KU'UALOHA HO'OMANAWANUI

Welina

KANAKA 'Ōiwi (Native Hawaiian[1]) oral tradition, traditional literature, and literary production have long been studied and regarded as highly poetic.[2] Less often examined, however, are the literary devices and rhetorical strategies within Kanaka Maoli verbal and written expression. Meiwi mo'okalaleo, or Kanaka Maoli oral, literary, and rhetorical devices, form the foundation of Kanaka Maoli aesthetics, or what is considered beautiful, pleasing, and desirable in the performance or reading of mo'olelo (story, history). The skillful use of meiwi both creates and enhances the 'ono (flavor) of Hawaiian verbal and literary arts. Thus, the reference to pa'akai (sea salt), a mainstay cultural product that preserves and enhances the flavors of food, seems an appropriate metaphor; li'u refers to being well seasoned or salted, a kaona (metaphorical or veiled) reference to deep and profound skill or knowledge (Pukui and Elbert 1986, 208).

This chapter explores mo'okū'auhau (genealogy) as a key traditional meiwi that was adapted from oral traditions to ka palapala (literature). While mo'okū'auhau is utilized in a variety of traditional and modern genres of Hawaiian writing, this chapter focuses on Kanaka Maoli mo'olelo (more specifically, nonfiction writing) from the nineteenth

century to the present, and discusses how moʻokūʻauhau informs additional literary devices and rhetorical strategies.

Mai ka Pō Mai (From the Ancient Past to the Present): Meiwi Moʻokalalelo and the Transition from Orature to Literature

By many accounts, when ka palapala (reading and writing) was introduced into Hawaiian society by American Calvinist missionaries in the 1820s and 1830s, Kanaka Maoli quickly recognized its value; by the 1880s, the Hawaiian population was widely considered one of the most literate in the world ("Hawaiian Education" 1883, 1; Schutz 1994, 153, 174). Traditional oral devices, such as moʻokūʻauhau, oli (chant), helu (listing), kaona, ʻōlelo noʻeau (proverbs), and ʻēkoʻa (opposite pairing) are identified in Kanaka Maoli writing throughout the nineteenth and early twentieth centuries in a variety of texts, including letters to newspaper editors, articles, stories, legislative speeches, and published books. Hawaiian historian Lilikalā Kameʻeleihiwa (1996) writes: "Once Hawaiians learned the miracle of writing, a literary tradition arose that reflected their traditional love of orature. People from every class and background, and with varying degrees of eloquence, seemed compelled to write down what they knew, and often challenged the opinions of fellow Hawaiians in heated letter-writing debates" (xiv). ʻŌiwi writing flourished for about a century (1830s–1930s), mostly in Hawaiian, although prominent Kānaka Maoli such as Emma Nakuina, Joseph Poepoe, Charles Kahiliaulani Notley, and Queen Liliʻuokalani wrote in eloquent English as well.

Hawaiian literature scholars have long been interested in the poetic devices that inform Kanaka Maoli literary aesthetics. Linguist Samuel H. Elbert read "about nine hundred pages" of what he called "oral literature" printed in Hawaiian between 1870–1890 (Elbert 1951, 345). In this initial study, Elbert identified ten "western" literary devices found in Hawaiian moʻolelo: hyperbole, metaphor, simile, symbolism, humor, names, details, nonsemantic elements (antithesis, repetition, catalogues, or lists), delineation of character, and repetition (345). Elbert does not recognize moʻokūʻauhau as a Hawaiian literary device. In his 2011 dissertation on traditional Hawaiian oratory, however, Hiapo Perreira identifies twenty-four separate meiwi in fifteen categories (some of which overlap Elbert's) specific to Kanaka Maoli oral and literary expression.

In Perreira's work, moʻokūʻauhau is prominently listed. While his list doesn't explicitly name specific (sub)genres, their inclusion is implicit; for example, moʻokūʻauhau also includes koʻihonua (a genealogical chant, or a chanted genealogy), and mele (song) includes oli (chant) and hula (dance). Meiwi are identified by Perreira and others as both oral and literary devices in part because oral traditions have been intertwined with literary compositions since writing was first introduced; what was previously composed, refined, memorized, and passed down orally for centuries was then transcribed, recorded, preserved, and later composed on paper. These written records have become crucial repositories of Hawaiian knowledge and cultural practices used by scholars of Hawaiian studies and cultural practices today.[3] Of course, Kānaka Maoli continue to compose mele, oli, and moʻolelo that are still orally performed as well.

Meiwi such as moʻokūʻauhau are evident in all genres of Hawaiian literature, starting with traditional ones such as moʻolelo, which is not surprising, as it is identified by cultural practitioner and scholar Pualani Kanahele ([1989] 2011) as "the genealogical starting point for all things Hawaiian" (xiv). Moʻokūauhau are a primary meiwi because they are an expression of ʻŌiwi heritage, ancestry, identity, and ethos. Hawaiian nationalist and scholar Haunani Kay Trask explains that "who we are is determined by our connection to our lands and to our families. Therefore, our bloodlines and birthplace tell our identity" (Trask [1993] 1999, front matter). Hawaiian historian Kanalu Young (1998) argues, "Far more than a 'who-begat-whom' structure of linear descent, *moʻokūʻauhau* functioned as an identity cohesive and role determining force which brought different subgroups of aliʻi together in a system that, at its height, operated to the benefit of all in ʻŌiwi Maoli society" (66). In writing about the pig kupua (demigod) Kamapuaʻa, Kameʻeleihiwa (1996) emphasizes that the moʻolelo "begins with the hero's genealogy, for his lineage defines his character" (xii).

In an oral culture that prized moʻokūʻauhau and koʻihonua, genealogies that were chanted were also important. Not only was oli a primary vehicle of expression in oral culture; its structure allowed for delivery and memory. As demonstrated in other contexts of oral composition outside of Hawaiʻi,[4] traditional oral and rhetorical devices were useful in memorizing and passing down oral compositions that contained important historical and cultural information; one example is the Kumulipo, a koʻihonua that connects the birth of

eighteenth-century ali'i Kalananui'īamamao with the very origins of the universe.[5]

The Kumulipo contains eight wā (epochs) set in pō (night, chaos), detailing the creation of various species of plants and animals of the Hawaiian environment, before transitioning to eight wā in ao (light, order), which contain a listing of eight hundred generations of Kānaka 'Ōiwi leading to the birth of the ali'i Kalaninui'īamamao in the late 1700s, making it one of the most comprehensive papa helu (listing) of mo'okū'auhau in Hawaiian tradition. The mo'okū'auhau is structured in such a way that it incorporates other oral devices, such as helu (lists, recounting of knowledge).[6] Hawaiian scholar Rubellite Kawena Johnson (2001) states that ko'ihonua combined "a series of stories told in poetry intended to be chanted or recited" with "a list of names, male and female progenitors and their descendants" (Johnson 2001, 21). Thus, its chanting or performance is another important oral device that aided in memorization and was also a form of entertainment to the listener.

The Kumulipo begins with the initial formation of the universe, with pō giving birth:

Hānau **Kumulipo**[7] i ka pō, he kāne	Born was Kumulipo, **Source of Deep Darkness** in the night, a male
Hānau **Pō'ele** i ka pō, he wahine	Born was Pō'ele, **Black Night** in the night, a female
Hānau ka **'Ukuko'ako'a**, hānau kāna, he **'Āko'ako'a**, puka	Born was the **tiny coral polyp**, born was the **coral head** emerged
Hānau ke **Ko'e 'enuhe** 'eli ho'opu'u honua	Born was the **grub** that digs and heaps up the earth
Hānau kāna, he **Ko'e**, puka	Born was its [child], an **earthworm**, emerged[8]

When a pair gives birth (hānau) to offspring, this excerpt illustrates the helu of the genealogy; for example, from the male and female elements of night are born the first coral, 'Ukuko'ako'a, a tiny coral (perhaps individual coral polyps). From the tiny polyps of coral the coral heads ('āko'ako'a) emerge, from which reefs are built, and so forth.[9] The word for coral head, 'āko'ako'a, is reminiscent of 'ākoakoa, to collect, assemble, gather, adding a layer of kaona that suggests the building of coral reefs, an integral part of the Hawaiian environment.

One of the most prevalent meiwi in the Kumulipo is ʻēkoʻa, which works as an antithetical but complementary pairing. In this excerpt, the male Kumulipo (Source of Deep Darkness) is paired with the female Pōʻele (Black Night); each subsequent pairing is a parent species from which a subsequent species child (keiki) is born: from the ʻukukoʻakoʻa comes the ʻākoʻakoʻa, from the koʻe enuhe comes the koʻe, and so forth. ʻŌlelo pīnaʻi (repetition) is demonstrated in the structure of the segment. The phrase "Hānau ka/ke" (born was the) precedes the name of each element/species and is followed by "hānau kana keiki" (born was its child). The name of the element/species is then stated and followed by "puka" (emerged), with the phrases having very little variation between them.[10]

Pīnaʻi helu (repetition of similar sounds) is also incorporated in later refrains at the end of each wā, as demonstrated in this passage:

O ke kāne huawai, akua kēnā	The male water gourd, he is divine
O kalina a ka wai i hoʻoulu ai	The long vine that flourishes from the water
O ka huli hoʻokawowo honua	The plant cutting develop freely
O paia [ʻa] i ke auau ka manawa	Multiplying in the passing time
O heʻe au loloa ka pō	The long night slips along
O piha, o pihapiha	Filled, completely full
O piha–ū, o piha–ā	Spreading here, spreading there
O piha–ē, o piha–ō	Spreading this way, spreading that way
O ke koʻo honua, paʻa ka lani	The earth is supported, the heavens are fixed
O lewa ke au, ia Kumulipo ka pō Pō–nō.	The current of time passes, this night of Kumulipo Still it is night (only night).

A high level of assonance and other sound repetition is prevalent throughout the passage, particularly with the letters "a," "o," "h," and "k." Moreover, toward the end of the passage, the word piha is repeated in several forms, with what Elbert (1951) calls the nonsemantic, euphonic emphasis (345); the "ū," "ā," "ē," and "ō" are linked to the word piha and underscore the fruitfulness or abundance of nature flourishing in this epoch. The phrase pō-nō is translated as "only night"; however,

this phrase also alludes to the word pono (balance and harmony), a ka-ona reference to the fruitfulness or abundance of nature. The conclud-ing phrase Pō-nō is also an example of ʻōlelo pīnaʻi within the larger structure of the Kumulipo, as it is repeated at the end of each wā.

Koʻihonua is an important genre of moʻokūʻauhau because it high-lights lineage and descendants. In an article on family chants, kumu hula Kahaʻi Topolinski (1976) describes koʻihonua:

> This koihonua chant is one that ties the forefathers of a Hawaiian family together with their descendents [sic], com-posed of both blood and adopted relatives, and honors their significant or colorful deeds by assuring their preservation within the family's consciousness. A comparison of the koi-honua chants of Kualiʻi, Peleiholani, Hikikuiolono, and Umi-kukaailani, as found in the collection of the late Mrs. Victoria Kualiʻi Sumner Ellis Buffandeau, discloses an accuracy in content that is almost unbelievable.

This is an example of how meiwi also functioned as important markers of ʻŌiwi aesthetics, both performative and literary, and were highly valued and appreciated by Kanaka Maoli audiences. It is no sur-prise, then, that these important markers of poetic expression were adapted to writing in the nineteenth century.

Moʻokūʻauhau as a Literary and Rhetorical Device

Traditional orature is a primary source of the rhetorical and aesthetic devices that were quickly adapted to writing. Moʻolelo of illustrious mythic and legendary ancestors such as the Kamapuaʻa, volcano god-dess Pele and her beloved youngest sister Hiʻiaka, the riddling keiki (youth) Kūapakaʻa and Kalapana, and the legendary aliʻi nui (high chief) Kamehameha and his esteemed teacher and paramount warrior, Kekūhaupiʻo, are but a few examples published in the early Hawaiian-language newspapers or as books, written down for the first time in the mid-nineteenth to early twentieth century, after being transmitted orally for generations. In some cases (Pele and Hiʻiaka are noted ex-amples), multiple versions were published by different writers in a number of competing newspapers.

It was very common for traditional moʻolelo to begin with a moʻokūʻauhau of the key figure, although how moʻokūʻauhau were pre-

sented varied. Some, such as the moʻokūʻauhau for the riddling cham-
pion Kalapana, were simply stated: "O Kanepoiki ke kane ao Halepaki
ka wahine. O laua na makua o Kalapana, ke keiki hoopapa" (Nakuina
1994, 1; Kānepōiki was the man and Halepākī was the woman. The two
of them were the parents of Kalapana, the riddling child). It was almost
required that a moʻokūʻauhau be rooted to a particular ʻāina (land) and
poetically described as one's one hānau (birth sands). Such a connec-
tion emphasizes the important cultural philosophy of aloha ʻāina (love
for the land), "a very old concept" representing "typical Hawaiian pride
of the ancestral homeland" (Pukui and Elbert 1986, 21). Implicit in this
concept is the practice of burying the īewe (placenta) and/or piko (um-
bilical cord) on or near the place of one's birth to anchor that child to
the family's ancestral ʻāina (Kimura 1983, 177). Thus, the simple
moʻokūʻauhau Nakuina provides for Kalapana is immediately appended
by the connection of his parents to their specific homelands:

> ʻO Kona, mokupuni ʻo Hawaiʻi, ko Kānepōiki one hānau a he
> keiki papa nō hoʻi ʻo ia no ia ʻāina. "A i Kauaʻi, / A ke ao lewa i
> luna / A ka pua nānā i kai o Wailua," i hānau ʻia ai ʻo Halepākī.
> ʻO Kapalaoa kekahi inoa o Halepākī a ua kapa ʻia ka ʻāina āna i
> noho ai i Kona ʻo Kapalaoa. (Nakuina 1994, 1)

> Kona on the island of Hawaiʻi was Kānepōiki's birthplace, and
> he was a child whose ancestors went back many generations on
> that land. "And on Kauaʻi, land of the clouds floating [in the heav-
> ens] above / And the blossoms floating on the sea of Wailua
> [below]," Halepākī was born. Kapalaoa was one of Halepākī's
> names, and the land where she was living in Kona was [thus]
> called Kapalaoa.

The connection between kanaka (person) and ʻāina is so strong that
specific land areas in Kona and Hilo are named for Kalapana's mother,
Kalaoa, because she lived in both places.

In a Kamapuaʻa moʻolelo published in 1891, Kamapuaʻa's
moʻokūʻauhau begins not with his birth and immediate lineage, but
with that of his grandparents' generation and their ʻāina hānau:

> O Kananananuiaimoku k, noho ae ia Haumealani w, ke kaika-
> mahine no Kuaihelani, mai ke kukulu mai o Kahiki. O Kanan-
> ananuiaimoku k, no ka pali ia o Kapulehu, e pili la i Waihee,

Maui, oia kona one hanau. Ua hanau mai na Kananananui-
aimoku k, me Haumealani w, keia mau keiki; Kamaunuaniho
w, Haunuu w, Haulani k, Haalokuloku k, Kamanokaianui k,
Lono k, Ui k, Uilani w, Kuliaikekaua k, a me Aweaweikealoha k,
pau na kupuna o Kamapua'a. ("He Moolelo Kaao no Kamapuaa,"
June 22, 1891)

Kananananui'aimoku, a man, lived with Haumealani, a woman,
the daughter from Ku'aihelani, from the Pillars of Kahiki.
Kananananui'aimoku, the man, was from the cliffs of Kapulehu,
close to Waihe'e, Māui. Those were the sands of his birth.
Born to Kananananui'aimoku, a man, and to Haumealani, a
woman, were these children: Kamaunuaniho, Haunu'u, Haulani,
Ha'alokoloku, Kamanōkai'anui, Lono, U'i, Uilani, Kūliaikekaua,
and 'Awe'aweikealoha. This concludes the . . . [names of the]
grandparents of Kamapua'a. (Kame'eleihiwa 1996, 2–4)

When the names of Kamapua'a's ancestors are recounted, his mana
(power) is placed within the context of his illustrious lineage. As
Kame'eleihiwa (1996) argues, "All of his wondrous feats are due to the
mana of his grandmother (which in many ancient Polynesian epics is a
natural source of wisdom)" (xiii).

Context, or the web of relationships within the larger lāhui (na-
tion), community, and 'āina, is as important as the bloodline being re-
called. Thus, the mo'okū'auhau of Kūapāka'a, the main character in *Ka
Ipu Makani o Laamaomao (The Wind Gourd of La'amaomao)*, begins
with his kūpunakāne (grandfather) Kūanu'uanu and highlights not
only his connection to 'āina but also his relationship as a kahu (hon-
ored attendant) of the ali'i nui Keawenuia'umi: "O Kuanuuanu ka
makuakane o Pakaa, a he kahu iwikuamoo hoi oia no Keawenuiaumi
ke alii o Hawaii, ke keiki a Umi ke alii, a me kana wahine o Kapukini.
Ua noho aloha o Kuanuuanu me Keawenuiaumi kana hanai" (Nakuina
1900, 1; Kūanu'uanu was the father of Pāka'a; he was the beloved per-
sonal attendant of the chief of Hawai'i [island], Keawenuia'umi, the son
of the chief 'Umi and his woman Kapukini. Kūanu'uanu had a good
relationship with Keawenuia'umi, his provider).[11] Such a connection
between the ali'i and his kahu was an appropriate relationship (and
genealogy) to recount, not only because courtly retainers were often
genealogically related to the ali'i, but also because of the love of the
people for their ali'i. In his introduction, Nakuina reminds his readers

(like Desha (2000) does later in *Kamehameha and His Warrior Kekūhaupi'o*) that Hawaiians were known as having and expressing "deep love for the Ali'i . . . in the past [one that we] still feel today" (Mookini and Nakoa 1990, vii). Thus, presenting the mo'okū'auhau of a subordinate and including his relationship to the ali'i nui would also be appropriate.[12]

In contrast, there are multiple genealogies provided for Pele and Hi'iaka in various traditions; the first published genealogy is in the epic printed in 1893 in the Hawaiian-language newspaper *Ka Leo o ka Lahui* and signed by Simeon Pa'aluhi and John E. Bush. It names Kū[w]ahailo as Pele's father and Haumea as her mother. A list of their eleven daughters, of whom Pele is the oldest, is provided, followed by a list of Pele's six brothers. Of these numerous siblings, the writers specifically mention that Hi'iaka is born "mai ka waha" (from Haumea's mouth) and their sacred shark brother Kamohoali'i is born "ma ke po'o" (from her head) (Bush and Pa'aluhi 1893, 1). Subsequent mo'olelo provide alternative mo'okū'auhau for the Pele 'ohana.[13] In my work on Pele and Hi'iaka literature, I argue that differences between the mo'olelo reflect different island traditions (ho'omanawanui 2014, xxxviii). Kanahele ([1989] 2011) suggests that one reason multiple mo'okū'auhau are provided for Pele is because each emphasizes different philosophies of creation and perhaps time periods of geological events (1–7).

Mo'okū'auhau and Kanaka Maoli Nonfiction Writing

While traditional mo'olelo provided a foundation for the conveying of mo'okū'auhau in Hawaiian literature, they were not the only genres of literature to incorporate mo'okū'auhau. Mo'okū'auahu were also featured in various life-writing narratives, such as memoirs, testimonies, autobiographies, and biographies.

A biography of King David La'amea Kalākaua, attributed to the esteemed writer Joseph Moku'ōhai Poepoe and published in 1891, begins with a beautifully poetic introduction, which is immediately followed by "Kona Hanau ana" (the circumstances of his birth), beginning with where he was born, "ma Hale Uluhe, Manamana, Honolulu, ma kahi kokoke i ke kahua e ku nei ka Halemai Moiwahine" (Poepoe 1891, 4–5; at Hale Uluhe, Manamana, Honolulu [island of O'ahu], at a place close to where Queen's Hospital now stands). The text then offers a brief mo'okū'auahu for Kalākaua, which works to connect him to the ali'i nui Kamehameha:

O kona luaui makuakane oia no ke Aliikiekie Kahanu Kapaakea,
a o kona luaui makuahine oia no ke Kamaʻliiwahine Analea
Keohokalole, he omaka no loko mai o ka niau koi-ula a Keawe-
heulu, he koa, he kakaolelo, a he kuhikuhi puuone na Kame-
hameha I., ka Nai-Aupuni kamahao a kaulana o ka Pakipika.
(Poepoe 1891, 5)

His birth father was the high chief Kahanu Kapaʻakea and his
birth mother was the Princess Analea Keohokalole, the bud
from within the "red-hued rainbow" of Keaweheulu, the war-
rior, orator, and master heiau architect for Kamehameha I, the
wonderful and famous Conqueror of the Pacific.

The biographer then ensures that the reading audience understands
the relationship of the mōʻī (king) to his ʻāina hānau by stating,

Ma ke ewe a ma ka hanau ana, he Oahu ke Alii ka Moi i niau
palanehe aku la i ke ala Poliku [sic]-a-Kane. Ae—he Oahu oia, ka
aina no na ka puana ia ana—"I Oahu au i ka aina makaewaewa"—
aka; iloko ona ua pahuʻa ia mea he makaewaewa, a ua hoewe-
paa ia iloko o kona papa houpo Alii ka ike makamaka, ka hea-
hea, ka olu waipahe, ka ike kanaka—mai ke au iki a ke au
nui—he hale kipa ia na ka malihini, he puuwai hamama, aohe
mea kaupale iloko o kona umauma no kela a me keia e kipa aku
ana imua ona. (Poepoe 1891, 5)

Through his lineage and his birthing, the Chief, the King was
Oʻahu, a swift and silent current on the road to Kāne's invisible
realm beyond. Yes—he is Oʻahu, the land for which it is said, "I
am on Oʻahu, the land of indifference"—however, it was noth-
ing to him, this reference to indifference, because it was firmly
fixed in the hearts of the chiefly class the knowledge of friend-
ship and hospitality, of being polite and courteous, knowledge
of people—from the "big current to the little current."[14]

In this passage, Kalākaua is not just "from" or "born on" the island of
Oʻahu; he is the land itself (he Oʻahu). This rhetorical positioning of his
aliʻi identity is found in the lines of the ancient koʻihonua "Eia Hawaiʻi,
he moku, he kanaka, he kanaka nui Hawaiʻi ē" (Fornander [1878] 2007,
10; Here is Hawaiʻi, an island, a man, a great chief is Hawaiʻi indeed).

As Nakuina does in Kalapana, Poepoe employs a traditional poetic device, in this case, an 'ōlelo no'eau (proverb) describing O'ahu; although the reference to O'ahu as a land of inhospitality (maka 'ewa'ewa) is considered to be extremely negative in Hawaiian culture, Poepoe contrasts Kalākaua's deeply ingrained sense of hospitality and courtesy not only to demonstrate his truly chiefly nature (described as 'ōpū ali'i, or having the stomach of a chief, which figuratively means embodying generosity), but also to make a negative reference to his 'āina hānau, meaningless (pahu'a) to him. Poepoe also employs the common rhetorical strategy of 'ēko'a to compare inhospitality with extreme hospitality. Poepoe emphasizes Kalākaua's chiefly, hospitable nature further by using two synonymous terms to describe each aspect listed: makamaka and heahea (both meaning to be hospitable, thus a kind of double hospitality) as well as 'olu ('olu'olu) and waipahē, descriptors implying politeness and courtesy; the duplication of a term is a rhetorical strategy that reinforces and deepens the meaning conveyed. Moreover, this deeply ingrained hospitality was offered to both the important and the humble man, metaphorically represented by a commonly used phrase, "ke au iki a ke au nui" (the small and large currents). Thus, Poepoe is saying Kalākaua was chiefly in his 'ano (demeanor) and kuleana (responsibilities).

Similarly, Queen Lili'uokalani begins her autobiography, *Hawaii's Story by Hawaii's Queen* ([1898] 1990), with her mo'okū'auhau and attachment to 'āina. Lili'uokalani recounts her illustrious chiefly lineage, beginning, "My father's name was Kapaakea, and my mother was Keohokalole" (1). Just as Nakuina connects Kūanu'uanu's mo'okū'auhau to his chief Keawenuia'umi in La'amaomao, the queen then establishes her own connection to previous generations of chiefs while also highlighting their accomplishments: "[My mother] was one of the fifteen counselors of the king, Kamehameha III, who in 1840 gave the first written constitution to the Hawaiian people. My great-grandfather, Keawe-a-Heulu, the founder of the dynasty of the Kamehamehas, and Keoua, father of Kamehameha I, were own cousins . . . and my great-grandaunt was the celebrated Queen Kapiolani, one of the first converts to Christianity" (1).

The Queen also anchors her mo'olelo to Pūowaina in Honolulu because, she reveals, it is near her birthplace. Pūowaina is the long-extinct volcanic crater now known as Punchbowl, the most prominent hill in Honolulu. Linking her birth to such a well-known geological feature is an assertion through kaona of her connection to Pele, the volcano goddess responsible for the creation of such features.

Brandy Nālani McDougall and Georganne Nordstrom (2011) discuss how the Queen "negotiated a complex rhetorical situation" in writing her autobiography (106). Linking her birth to Pūowaina is one small example of how, through her moʻokūʻauhau, the Queen made an explicit claim not only to her human ancestors, but also to her godly ancestor, Pele, by using a kaona reference to the creation of land. McDougall and Nordstrom discuss the circumstances surrounding the Queen's uses of kaona and their implications on audience reception: "because everything she wrote was being scrutinized and censored, the queen knew that if she wanted to convey any messages to her people she would have to do so using kaona. Kaona allowed the Queen to rely on the collective knowledge of her people and, through allusion to significant cultural traditions, to tell them things she knew her American audience did not know" (2011, 107).

One reason the Queen did this was "to offer hope to her Hawaiian readers by sending messages of resistance and unity as well as to reaffirm her resolve to restore the Hawaiian Kingdom," which was accomplished by embedding kaona into English, a language foreign to Hawaiians, to appeal for support from the colonizers, while simultaneously creating "images and significant passages so that her people would recognize her messages through kaona" (McDougall and Nordstrom 2011, 107). The interweaving of meiwi such as moʻokūʻauhau and kaona were recognized rhetorical devices that allowed the Queen to communicate effectively with her people during a time of extreme political surveillance. It worked because these meiwi were widely used, and establishing one's moʻokūʻauhau and connection to ʻāina was not reserved for the aliʻi alone.

In 1906, newspaper editor John Sheldon (Kahikina Kelekona) published a biography of the beloved educator and statesman Joseph K. Nāwahīokalaniʻōpuʻu. Like Poepoe's biography of Kalākaua, Sheldon's biography of Nāwahī was written and published posthumously. After a brief introduction and prefatory materials, such as mele inoa (name chants) for Nāwahī, the first chapter, "Kona Hānau ʻana" (Regarding his birth), begins with Nāwahī's place of birth,

ma Kaimū, i ka "lau o nā one," ma na kaiāulu o ka ʻāina o ka hikina a ka lā a i kaulana hoʻi i ka paia ʻaʻala i ka hala me ka hīnano, ʻo ia ka lā, ka mahina, a me ka makahiki, a ma ia ʻāina i Puna i ke onaona i ke kūkulu hema o ka Mokupuni o Keawe i hanu mua loa aʻe ai ʻo Hon. Iosepa Kahoʻoluhi Nāwahī i nā

kīpona ea hoʻomōhalapua o kēia nohona olakio ʻuhane ʻana, ma muli o ka hāʻawi makana ʻana mai o Keaweolalo (Keaweleikini), kona lūauʻi makuahine iā ia i pulapula o ka lāhui ʻōiwi a i pua hoʻonani hoʻi no ko lāua kīhāpai home a me kona koʻolua kāne, ʻo Nāwahīokalaniʻōpuʻu, ka lūauʻi makua kāne hoʻi o Iosepa, ka hua hiapo makamae o ko lāua mau pūhaka laʻahia. (Sheldon [1906] 1996, 1)

at Kaimū of the "Patterned Sands" in the districts of the land where the sun first appears and which is famed for its perfumed bowers of hala and hīnano, that was the day, the month, the year, and the land in fragrant Puna at the southern boundary of the island of chief Keawe where the Hon. Joseph Kahoʻoluhi Nāwahī first breathed the sweet invigorating air of spiritual reality, following his presentation by his own mother, Keaweolalo (Keaweleikini), as an offspring of the native race and as a beautifying flower for the garden of her and her husband Nāwahīokalaniʻōpuʻu, the true father of Joseph, this cherished first-born of their blessed loins. (Sheldon 1988, 25)

Within the opening sentence, Sheldon incorporates three poetic references to ʻāina: the specific location where Nāwahī is born, the village of Kaimū, which is ka lau o nā one (land of the patterned sands, perhaps referring to the volcanic black and sometimes green olivine sands mixed with coral-derived white sands), Puna is represented by hala trees and their hīnano flowers, evoking the oft-used poetic saying for Puna, paia ʻala i ka hala (fragrant in the walls of hala trees), and using the common epithet for the island of Hawaiʻi, moku o Keawe (island of Keawe). As Kalākaua is an ʻōmaka (bud, sprout) of his genealogy, so, too, is Nāwahī described in similar nature-derived poetry as a pua hoʻonani (adorning flower) for his parent's kīhāpai (garden).

An Example of Moʻokūʻauhau in Contemporary Scholarship

Haunani Kay Trask's academic and political essays are notable because of the inclusion of references to her own genealogical ties to ʻāina and ancestry. What is so exceptional as well as groundbreaking about Trask's genealogical inclusion in what is considered scholarly writing is that she is one of the first Hawaiian academics to utilize such a foundational device as part of her rhetorical, persuasive strategy. In the front

matter of *From a Native Daughter: Colonialism and Sovereignty in Hawai'i*, Trask begins with a declaration that "Hawaiians are not Americans." Trask drives this point home genealogically—Kānaka Maoli are not Americans because "we are the children of Papa—earth mother, and Wākea, sky father—who created the sacred lands of Hawai'i Nei. From these lands came the taro, and from the taro, came the Hawaiian people." She then expands the genealogical connection and importance of genealogy to the wider Pacific: "As in all of Polynesia, so in Hawai'i: the younger sibling must care for and honor elder sibling who, in return, will protect and provide for younger sibling . . . in Polynesian cultures, genealogy is paramount."

Trask then recounts her personal genealogy and connection to her specific 'āina: "I am descended of two genealogical lines: the Pi'ilani line through my mother who is from Hāna, Maui, and the Kahakumakaliua line through my father's family from Kaua'i. I came of age on the Ko'olau side of the island of O'ahu. This is who I am and who my people are and where we come from." Trask offers her genealogy with the caveat that she gives her genealogy when she "meets other Hawaiians" (Trask [1993] 1999, front matter). This stipulation informs the reader that there is a cultural preference in play, an often unstated mandate; Hawaiians have a penchant for genealogy, and the sharing of genealogy and connections to 'āina can create or reinforce relationships and tell another person knowledgeable about mo'okū'auhau much more in fewer words. It is a cultural way to claim kuleana (rights, responsibility, and authority).

Kimura (1983) describes how Hawaiian-language poetically describes kānaka *belonging to* 'āina, often multiple 'āina, such as where one's ancestors are from, and where one was born, raised, or lives (177). Trask connects her mo'okū'auhau to her family's ancestral lands— Hāna, Maui, and Kaua'i—through her parent's genealogical lines. She was not born in these locations, because settler colonial practices (such as giving birth in hospitals often located away from one's ancestral homelands) often make such a direct connection to one's ancestral lands impossible. Yet the practice of linking mo'okū'auhau to specific 'āina where one's ancestors are from is a culturally acceptable way of identifying with one's 'ohana and 'āina.

This is evident in the title of the book, which alludes to genealogical connections of family and place. Positioning herself as a native daughter, Trask evokes a connection of relationships to others, beginning with parents (the first logical pairing with children or, specifi-

cally here, a female offspring). The word "daughter" is implicitly female, which also suggests a connection to Papahānaumoku, the Earth Mother, and other native goddess-ancestors so prominently featured throughout Trask's poetry. Trask asserts her familial, cultural, and intellectual genealogical connection to the 'āina by tracing her genealogy to these deities, who create land and cause it to flourish. She is also employing the desirable device of ha'aha'a, humility—on one hand, her status as native daughter is one of authority, which allows her to speak; on the other, it positions her within the larger lāhui and recognized social, cultural, and political hierarchy. Identifying herself as a daughter within the larger genealogical framework of relationships between 'āina and kanaka, Trask asserts her position as an indigenous woman whose ancestors are the land and are literally born from the land. Thus, Trask herself is descended from 'āina, and the kuleana (rights, responsibilities) to care for, honor, and respect the 'āina as elder and ancestor is embedded in this lineage and cultural protocol.

Trask's inclusion of mo'okū'auhau in her essays demonstrates the possibility of utilizing Hawaiian thought and cultural practices in new ways. From an indigenous perspective, the incorporation of meiwi asserts an indigenous foundation for academic argument and is not just superfluous.

Ha'ina 'ia Mai Ana ka Puana (Conclusion)

Ha'ina 'ia mai ana ka puana (and thus the story is told) is a common concluding refrain in Hawaiian mele that summarizes its focus. As Māori scholar Linda Tuhiwai Smith (1999) discusses in *Decolonizing Methodologies,* it is essential for modern indigenous scholars to recognize and utilize indigenous tools for our research, because "the survival of peoples, cultures and languages" and the "pursuit of social justice" are imperative (142). The result of implementing indigenous methods of research and scholarship, including the use of meiwi such as mo'okū'auhau to highlight 'Ōiwi aesthetics, for example, opens up indigenized spaces within the academy. It also allows for indigenous and other audiences to learn about, recognize, and appreciate such methods and strategies, thus providing models of how to incorporate such strategies into current writing projects that, in their own right, continue the intellectual and literary history of the lāhui. The Kanaka 'Ōiwi writings discussed in this chapter demonstrate that mo'okū'auhau is an important meiwi mo'okalaleo that continues to be implemented in meaningful ways.

Notes

1. The terms Kanaka Maoli, Kanaka, Kanaka ʻŌiwi, Kanaka Hawaiʻi, Native Hawaiian, and Hawaiian refer to the indigenous people of the Hawaiian Islands and their descendants and are used interchangeably throughout this chapter.
2. See Pukui 1949; Elbert 1951; Luomala 1955; Elbert and Mahoe 1970; Kimura 1983; Nogelmeier 2001.
3. For more information about such sources, both published and unpublished, see works by Nogelmeier 2010 and hoʻomanawanui 2014.
4. See Lord 1960, and Foley 1985, 1995, 2002 as examples of recording, documenting, and studying oral poetry.
5. For more in-depth analysis of the *Kumulipo*, see Beckwith 1951; Johnson 1981, 2001; hoʻomanawanui 2005; McDougall 2011; McDougall and Nordstrom 2011.
6. John Charlot (2005) identifies these as oli helu, or "listing chants," which function as catalogs of knowledge.
7. I use boldface here and elsewhere to distinguish the noun in the line for readers who may be unfamiliar with Hawaiian so they may more easily see what is giving birth, and more easily see the rhyme scheme.
8. The text has been regularized (modern diacritical marks added) by author. Unless specifically stated, all translations of Hawaiian terms and passages throughout the essay are also my own.
9. This may also be a play on ʻākoakoa, "to collect, gather, assemble," as the coral polyps formed reefs.
10. This is demonstrated in many other wā specific to the element or species being listed (hoʻomanawanui 2005).
11. An alternate translation is provided by Mookini and Nakoa, 1990.
12. In his moʻolelo of Kamehameha's kahu Kekūhaupiʻo, however, Desha does not provide a specific moʻokūʻauhau for Kekūhaupiʻo. See Desha (2000) for a fuller explanation of this approach.
13. In alternate versions of the Pele and Hiʻiaka moʻolelo, different people are named as parents; for examples of this, see Manu 1899; Poepoe, "Hiiaka" 1908–1911; and Rice 1908.
14. Meaning "from the most important to the most humble status of society."

Works Cited

Beckwith, Martha Warren. 1951. *The Kumulipo, a Hawaiian Creation Chant.* Honolulu: University of Hawaiʻi Press.

Bush, John E., and S. Paʻaluhi. 1893. "Ka Moolelo o Hiiakaikapoliopele." *Ka Leo o ka Lahui,* January 6, 1.

Charlot, John. 2005. *Classical Hawaiian Education: Generations of Hawaiian Culture*. Lāʻie, HI: Institute for Polynesian Studies, Brigham Young University Hawaiʻi. CD-ROM.

Desha, Stephen Langhern. 2000. *Kamehameha and His Warrior Kekūhaupiʻo*. Trans. Frances Frazier. Honolulu: Kamehameha Schools Press.

Elbert, Samuel H. 1951. "Hawaiian Literary Style and Culture." *American Anthropologist* 53, no. 3 (July–September): 345–354.

Elbert, Samuel H., and Noelani Mahoe. 1970. *Nā Mele o Hawaiʻi Nei, 101 Hawaiian Songs*. Honolulu: University of Hawaiʻi Press.

Foley, John Miles. 1985. *Oral-Formulaic Theory and Research, an Introduction and Annotated Bibliography*. New York: Garland Publishing.

———. 1995. *The Singer of Tales in Performance*. Bloomington, IN: Indiana University Press.

———. 2002. *How to Read an Oral Poem*. Urbana: University of Illinois Press.

Fornander, Abraham. [1878] 2007. *An Account of the Polynesian Race: Its Origin and Migrations, and the Ancient History of the Hawaiian People to the Times of Kamehameha I*. Vol. 1. Whitefish: Kessinger.

"Hawaiian Education." 1883. *Pacific Commercial Daily Advertiser*, February 23, 1.

"He Moolelo Kaao no Kamapuaa." 1891. *Ka Leo o ka Lahui*, June 22–September 28.

hoʻomanawanui, kuʻualoha. 2007. "Pele's Appeal: Moʻokūʻauhau, Kaona, and Hulihia in Pele and Hiʻiaka Literature, 1861–1928." Diss., University of Hawaiʻi at Mānoa.

———. 2014. *Voices of Fire: Reweaving the Literary Lei of Pele and Hiʻiaka*. Minneapolis: University of Minnesota Press.

Johnson, Rubellite Kawena. 1981. *Kumulipo: The Hawaiian Hymn of Creation, volume I*. Honolulu: Topgallant Press.

———. 2001. "Course Reader, HAW 261 Hawaiian Literature." Honolulu: University of Hawaiʻi at Mānoa.

———. 2005. "He Lei Hoʻoheno no nā Kau a Kau: Language, Performance and Form in Hawaiian Poetry." *Contemporary Pacific* (Fall): 29–82.

Kameʻeleihiwa, Lilikalā. 1996. *A Legendary Tradition of Kamapuaʻa, the Hawaiian Pig God*. Honolulu: Bishop Museum Press.

Kanahele, Pualani Kanakaʻole. [1989] 2011. *Ka Honua Ola*. Honolulu: Kamehameha Schools Press.

Kimura, Larry Lindsey. 1983. "Native Hawaiian Culture." In *Native Hawaiian Study Commission Report*, 173–224. Washington, DC: U.S. Government Printing Office.

Liliʻuokalani. [1898] 1990. *Hawaiʻi's Story by Hawaiʻi's Queen*. Honolulu: Mutual Publishing.

Lord, Albert Bates. 1960. *The Singer of Tales.* Cambridge, MA: Harvard University Press.

Luomala, Katherine. 1955. *Voices on the Wind, Polynesian Myths and Chants.* Honolulu: Bishop Museum Press.

Manu, Moses. 1899. "He Moolelo Kaao no ke Kaua nui Weliweli mawaena o Pelekeahi'āloa a me Wakakeakaikawai." *Ka Loea Kalaiaina,* May 13–December 30.

McDougall, Brandy Nālani. 2011. "'O ka Lipo o ka Lā, 'o ka Lipo o ka Pō: Cosmogonic Kaona in Contemporary Kanaka Maoli Literature." Diss., University of Hawai'i.

McDougall, Brandy Nālani, and Georganne Nordstrom. 2011. "Ma ka Hana ka 'Ike (In the Work Is the Knowledge): Kaona as Rhetorical Action." *College Composition and Communication* 63, no. 1 (September): 98–121.

Mookini, Esther, and Sarah Nakoa, trans. 1990. *The Wind Gourd of Laamaomao.* Honolulu: Kalamakū Press.

Nakuina, Moses K. 1900. *Moolelo Hawaii o Pakaa a me Ku-a-Pakaa, na kahu iwikuamoo o Keawenuiami, ke alii o Hawaii, a o na moopuna hoi a Laamaomao! Ke kamaeu nana i hoolakalaka na makani a pau o na mokupuni o Hawaii nei, a uhao iloko o kana ipu kaulana i kapaia o ka ipumakani a Laamaomao!* Honolulu: n.p.

———. 1994. *Moolelo Hawaii o Kalapana he keiki hoopapa o Puna.* Hilo: Hale Kuamo'o.

Nogelmeier, Puakea, ed. 2001. *He Lei no 'Emalani, Chants for Queen Emma Kaleleonālani.* Honolulu, HI: Queen Emma Foundation, Bishop Museum Press.

———. 2010. *Mai Pa'a i ka Leo: Historical Voice in Hawaiian Primary Materials, Looking Forward and Listening Back.* Honolulu: Bishop Museum Press.

Perreira, Hiapo. 2011. "He Ha'i'ōlelo Ku'una: Nā Hi'ohi'ona me nā Ki'ina Ho'āla Hou in ā Kākā'ōlelo [Classical Hawaiian Speechmaking: Aspects and Revitalization of Hawaiian Oratory]." Diss., Ka Haka 'Ula o ka Lani Center for Hawaiian Studies, University of Hawai'i at Hilo.

Poepoe, Joseph Moku'ōhai. 1891. *Ka Moolelo o ka Moi Kalakaua I.* Honolulu: n.p.

———. 1908–1911. "Ka Moolelo Kaao o Hiiakaikapoliopele." *Kuokoa Home Rula,* January 10, 1908–January 20, 1911.

Pukui, Mary Kawena. "Songs (Mele) of Old Ka'ū, Hawai'i." 1949. *Journal of American Folklore,* July–September, vol. 62, no. 245 (247).

Pukui, Mary Kawena, and Samuel H. Elbert. 1986. *The Hawaiian Dictionary.* Revised edition. Honolulu: University of Hawai'i Press.

Rice, William Hyde. 1908. "He Moolelo no Pele a me Kona Kaikaina Hiiakaikapoliopele." *Ka Hoku o Hawaii,* May 21–September 10.

Schutz, Albert. 1994. *Voices of Eden: A History of Hawaiian Language Studies*. Honolulu: University of Hawai'i Press.

Sheldon, J. G. M. [Kahikina Kelekona]. [1906] 1996. *Ka Puke Moolelo o ka Hon. Joseph K. Nawahi*. Hilo: Hale Kuamo'o, Ka Haka 'Ula o Ke'ēlikōlani.

———. 1988. *Biography of Joseph K. Nāwahī*. Trans. M. Puakea Nogelmeier. Honolulu: Hawaiian Historical Society.

Topolinski, Kaha'i. 1976. "Nā Mele 'Ohana." *Ha'ilono Mele,* January. Reprinted in Kaleinamanu Literary Archive, Kamehameha Schools Ka'iwakīloumoku Center for Hawaiian Studies. https://apps.ksbe.edu /kaiwakiloumoku/kaleinamanu/essays/na_mele_ohana. Accessed May 23, 2011.

Trask, Haunani Kay. [1993] 1999. *From a Native Daughter: Colonialism and Sovereignty in Hawai'i*. Honolulu: University of Hawai'i Press.

Tuhiwai Smith, Linda. 1999. *Decolonizing Methodologies: Research and Indigenous Peoples*. New York: Zed Books.

Young, Kanalu G. Terry. 1998. *Rethinking the Native Hawaiian Past*. New York: Garland.

First Class

ALBERT WENDT

IF IT WASN'T RAINING HEAVILY, he walked to and from work. Because of his high cholesterol and blood pressure his doctor had recommended that he exercise regularly—a brisk thirty-minute walk or jog each day would be ideal. He also enjoyed the route down Woodlawn Avenue, then across the sports field of Noelani Elementary School, and round the back streets and through St. Francis High School for girls and the Newman's Centre and into the campus. The route was lushly rich in fruit and flowering trees and plants, such as mangoes, avocadoes, bananas, vi, papaya, ginger, and frangipani and the ever-changing aroma of flowers and the stream and, most fascinating for him, was the inescapable presence of the Ko'olau Range. If he was walking away from it, he would sometimes play games with it, unexpectedly looking back over his shoulder and catching it observing him—yah, gotcha!—and smiling to himself knowing it was always going to be there. Most inviting though was his return, his walking up towards the range, and watching the light and clouds and shadows changing constantly on the mountains. When the range was still blazing with light, he felt it was disappearing into the heavens and he had to look at his arms and re-affirm he wasn't disappearing with it. When swift winds were driving large clouds across it, outracing their immense shadows that swam in and out of the ravines and valleys on its slopes, he raced with it, letting his heart and belly sing with the speed. Once, and the memory of it still awed and frightened him, he'd stopped in the middle of the Noelani school field as evening was happening, his feet deep in the dry grass, and had gazed up at the Ko'olau and, with mounting fear, had watched

the last rays of the setting sun contracting into one quickly-reducing sliver of brilliant light which, as it slid and slipped across the massive contours of the mountains, as if someone was pulling it towards the west, looked as if it was never returning. That night, he'd tried recording that experience in a poem, and had managed only one worthwhile line: *The light is pulling out.*

The back of his aloha shirt and armpits were soaking wet from his brisk walk from his apartment to his office, through the mid-morning sun, and he didn't have the time to let his office air conditioning cool him and dry off the sweat, his first session with his 313 Writing of Poetry class was five minutes away, and he was never late for any class, and, as usual, he was stressed—that tight dry starting-to-churn-up feeling in the dead center of his stomach—anticipating his first session with new students he knew little about. Though he'd taught American students in his first semester and had found most of them—especially the Asians and Hawaiians—welcoming, considerate, and respectful, he still considered himself ignorant of their ways, finding even the ways they spoke difficult to understand. Also, in his eighteen years of teaching he had always dreaded first lectures; sometimes the fear was so demanding he suffered nausea and vomited.

As he hurried down the corridor to his lecture room, he recalled that when, during his first year as a lecturer at Auckland University, he'd first told his mother about his dread, she'd laughed and had repeated her core philosophy, "Daniel, you in the lion's den; get out of it. Just act; be an actor like Marlon Brando. That's what they want, a performance like *On the Waterfront*! All through my schooling, I wanted for to see acting, but my bloody ignorant Hamo teachers were not John Wayne or Bogart." Another time when she caught him spewing in the toilet before his lecture, "Hey, Daniel in the lion's den, why you sick with worry? They only bloody Pālagi. You, beloved, you the brown Brando. Yes, you be like me: act through your life: act, act, act, that's the only way you going to get somewhere."

Just before he turned the handle of the door into the lecture room, the tight ball of stress in his stomach began easing away. His mother had certainly been the most accomplished, unrelenting and devious actor he'd ever known. It wasn't lying, she'd insisted, when his father discovered in her pay slip, from her first job at the hospital laundry, that her name was now Emerald Malaetau; and she had repeated that denial when he'd later accused her of conning her way into a secretarial job in the Social Welfare Department, under the name Janine Elizabeth

Wiley; and then later when he was at university studying Shakespeare and she'd persisted in walking round him, while he was trying to analyze *Macbeth*, reciting Lady Macbeth's lines and claiming that she'd first read Bill's—as she always referred to Shakespeare—work in Samoan in her village, and, ashamed and exasperated, he'd accused her of lying about that; and she'd continued repeating that whenever he or his father or anyone else, including the police, had accused her of lying. Even if you're caught red-handed, never admit that you're guilty, why? Because the so-called "truth" came in many forms and guises. Isn't that what Albert Einstein meant in his theory of relativity? After Albert, her favorite philosopher, everything was relative, depending on your individual perspective and viewpoint. "What about agasala, sin? You know, doing wrong?" his father had insisted. After Albert, there was no such vicious creature, she'd argued, only illness, and lack of certain chemicals in the brain. "Where you learn all that lāpisi from?" he'd countered. Look around you, she'd pointed out, look at all your extremely poko and brainy son's books? Go into his computer and up into the space, into the internet! Listen to his very clever talking, to him and his godless and intellect-whatever-that-word-is friends! And go to the movies, Lemu, then you no longer be slow but become fast in your brain and learn as fast as the computer in 2001 Space Something-or-Other.

Since he'd first looked up his fifteen students' names on the computer registry, two weeks previously, he'd wondered what his students looked like—and, in Hawai'i, how many were going to be Hawaiians/Kānaka Maoli, Pacific Islanders, and Asians, but he now couldn't look at them as he walked self-consciously across the room in front of the black-board, feeling their heavy curiosity enveloping him, placed his folio of lecture notes and a copy of their only class text on the desk, stood with head bowed, hands gripping the front corners of the moveable lectern for a deeply silent moment, and then, letting his shoulders sag as if he was now ready to relax and get into it, gazed up and into the expanse that was filled with their curiosity and expectations of who and what he was like, this Samoan/Polynesian professor from New Zealand, a country they knew little about and cared even less about. With his mother's absolutely winning Joan Crawford smile, he extended his arms in the manner of Miss Baystall when she'd first welcomed them to school, and, in Brando's voice as Mark Anthony in *Julius Caesar*, said, "First of all I'd like to welcome myself to our class, 313 Writing of Poetry!" He felt

them lift instantly: a short high but quickly suppressed exclamation of surprise. Some of them laughed, and he now had the attention of even the professionally bored-looking ones, so he declared, "For me it is wonderful for a change to be in a class in which most of the people look like me!" Nearly all of them laughed, the professionals trying to disguise their pleasure at such a totally unexpected and witty observation. "You are also one of the handsomest classes I've ever taught." Instantly, many squirmed in delight and elated embarrassment and oh Jesus, we're not that good looking but thank you for saying it!

"Yeah, bro!" exclaimed the handsome Samoan with the Dwayne "The Rock" Johnson haircut and the taulima tattoo around his thick biceps. He was ensconced in the middle of the back row between a hefty Samoan woman, who was trying to appear disassociated from the rude and foolish dude who'd just broken the Samoan taboo against being too forward with your elders and teachers and a beanpole thin and angular haole whose grin was telling him he was now expecting an even more unexpected repartee.

So he gave it to them. "Apart from the fact we're all handsome, most of us have one other thing in common." He waited, and they were dying for it. "We are all permanently suntanned!" The Samoan with The Rock haircut raised his fists and pumped them into the handsome air, the beanpole thin haole inflated to twice his size with laughter, the hefty stern Samoan woman slapped at her massive thighs that were threatening to burst through her jeans and crooned, "Right on, uso!" and the rest of the class laughed knowing they were never ever going to forget this charismatic guy and his unique remarks and humor. No, dis professor from Noo-Zeeland/Arrruuteeayroar was cool, man! You are the bomb, bro! he imagined all the Polynesians in his class saying to themselves.

His dread had vanished, gone without him observing it, worrying about it. He had them, in the cool of his acting. Like his mother had always said, it's all acting; give them your best Brando performance. But he'd learned early in his teaching career that he also had to know his subject, in depth, and, in his individual way, show he had a passion for it and infect his students forever with that passion and the desire to learn more. His mother was a massively talented actor who could mesmerize most audiences into believing any role she played, but sometimes she was lazy, overconfident and arrogant and didn't research the roles intimately, and suffered the consequences of an indifferent, uninformed performance.

In triumph, he swept his euphoric, possessive gaze lingeringly over his enraptured audience. Good, wonderful, wonderful. Once more, another sweep, enjoy, enjoy. The left-hand corner of his left eye threatened to snag on someone at the back left-hand corner of the room, but kept sweeping. His students were all satisfied—no, elated—no, absolutely taken with him. It was going to be right on, brother, for the rest of the semester! Then he glanced over at the back left-hand corner. He detested snags, students who weren't convinced of his mana, but there she was, scribbling intently on a yellow pad, the light caught in her long wavy hair that hid most of her face from his view; scribbling, scribbling and paying him no attention whatsoever.

"Please answer when I call your name," he instructed. She continued scribbling. He read out their names carefully and ticked them on his roll. The most difficult names for him were the Hawaiian ones—twice he had to ask the individual students to pronounce their names so he could learn them.

"Are there people here whose names are not on our list?" he asked. This time the snag raised her right hand in a slow calculated upward movement that seemed to establish her permanently and fully in the center of his view, and also made him aware she was older than the other students; at least ten years older, he reckoned when he examined her face. "Please come and see me at the end of this session," he told her. She nodded once and, for the first time, dropped her pencil onto her yellow pad, and focused on him.

Quickly he distributed blank index cards, instructing them to write their names, addresses, and phone numbers on them. "Despite the fact that the confidentiality laws of your very litigious nation don't allow me to compel you to do even that, I want you to also put in some brief information about your private selves." Some laughed, but he was inexplicably uncomfortable "feeling" her observing him, though he sensed she was trying not to.

"Whad sorta information, professor?" the angular haole asked.

"Such things as: if you've survived any writing classes before, especially poetry classes; what you read; do you like films and plays and the other arts we of the bourgeoisie are supposed to love; do you play the uke; you know, anything that'll help me help you improve your writing, or amaze me with your boundless talent and your ability to hide, from me, the real truths about your lives because that's what we and all other autobiographers do." He stopped and glanced at her and

caught her smiling for the first time. That he interpreted as her congratulating him on his performance, but he didn't want that; he wasn't a child.

The rest of the session was him taking them through the course prescription, schedule and reading list, explaining what he was hoping they were going to study and write during the semester. He ended by giving them a potted history of Hawai'i and the other Pacific countries out of which the literature and writers they were studying had emerged. Throughout it they were quite respectful and open about questioning him on aspects of the course they didn't understand.

Most of the class thanked him as they started leaving. As she strolled up to him, he was surprised; she was much taller than he'd thought, even taller than him by a few inches, with extremely wide shoulders, a long powerful torso, long arms and large hands—no nail polish—small breasts and narrow hips, tightly muscled flanks. Her deeply tanned body literally glowed with health. She was obviously into body-building, sports and exercising regularly at the gym. "My name's Lanimua Niuhi," she introduced herself, still avoiding looking into his face as she reached out and he had to shake her hand. "I'm Kanaka Maoli and from Hawai'i, the Big Island." He paused, and he wasn't going to ease her discomfort by talking in turn, so she added, "I rang you about two weeks ago, and then again last week, and left messages about wanting to enroll in this class, professor."

"I'm sorry but I haven't opened my voicemail in weeks." He tried to turn his neglect into a joke.

"I hope my messages are on it because I really want to be in your class."

"Have you done much writing?"

"Not much poetry or fiction but lots of memos and reports and letters." She smiled. "Had to earn a living."

Before he could stop himself, he suggested, "Perhaps you should try and get into a first-year writing class; all the students in this class have done at least two years of creative writing." When he sensed her disappointment, he quickly added, "This class is also limited to fifteen students only."

"I wanted to be in your class because you're only one of three Polynesian instructors in creative writing in this department." She looked into his face for the first time, right through his performance, and then added, with a touch of admiring shyness, "And I've read all your

books—and love them!" Praise always sent him into a painful adolescent squirming and embarrassment that completely disabled him from replying coherently to it.

"It's alright, Miss—Miss . . ."

"Lanimua Niuhi, Professor Malaetau," she saved him.

"I'm—I'm glad you liked the books," he mumbled.

"Everyone calls me Mua," she helped him again.

He couldn't look into her face, realizing he was now cauled firmly in the aura of her imposing height and physical presence. "I think I can allow one more into our class," he heard himself admitting defeat, but he was relieved; in fact, very pleased about it.

"Thank you, professor," she said.

They were all waiting for him when he entered the room for their second session. They'd rearranged the seating into a semi-circle with his desk and chair at the open end of the semi-circle. He liked that. He paused and looked at them: the Samoan athlete sat first to his left, then the angular haole, then the Samoan woman. Lanimua occupied the seat just where the circle curved towards his right, so she was side on to him.

"Is it possible to turn the temperature down, professor?" Lanimua asked. "It's chilly in here."

"I don't think you can," he replied. "Any others finding it chilly?" A few nodded.

"I think if we leave the doors open, that'll lessen the cold," she suggested. He nodded and she hurried to the back door, opened it and wedged a chair against it to stop it from re-closing. The angular haole did the same to the front door.

"Now that we've made our little contribution to our consciences for not pandering to the expensive and eternal chill that enriches the electricity corporates, we shall begin," he pandered to his inner moral discomfort. But the irony was lost on most of them. And Lanimua looked puzzled; slightly skeptical.

Quickly he told them to look at their copies of the course prescription he'd distributed the day before. He knew it. It happened every time, everywhere, with university students. Two of them boldly raised their hands and asked for copies. "Let's get this clear; we are writers, we are professionals and professionals do not forget the stuff they need for class, at home!" They squirmed as he handed them copies. "We must not reinforce the public's stereotype of us writers as being disorga-

nized, irresponsible, impractical, always-late dreamers, who rarely meet their obligations and deadlines." They all drew silent and couldn't look at him. Good. No irony now, no subtle joking. He then re-explained the prescription, and re-emphasized what he expected of them in terms of how much poetry they had to have in their final folios by the end of semester and on which they would be graded. "Now, please hand in the index cards I wanted you to fill in." For an annoyed instant he thought he saw in the body language of a few of them that they'd forgotten the cards. But all the cards came in.

He'd prepared the first poetry exercise he was going to give them, the week before, but another inspiration came unexpectedly and he couldn't deny it. He said, "I'm now going to explain the exercise I want you to do." He paused. He went on to explain, that before Hawai'i, he'd not liked air-conditioning, having grown up in the temperate climate of New Zealand in which you didn't need it. In Samoa and Fiji, where it was just as hot as Hawai'i, and where he'd worked at the universities, his offices had been well ventilated and hadn't needed air condition-ing. You switched on the fans if it got too hot. It was also a matter of principle: in a poor country air conditioning was absolutely wasteful. Did they know that capitalist America wasted at least three-fifths of the world's energy resources? And he was now in tropical America, in which, whenever you went indoors, you were in the air-conditioned nightmare. But, lo and behold, within a matter of weeks—suffering the relentless heat outside and in his apartment—he'd grown accus-tomed to his workplace being in perpetual cold and artificial light. "As you well know, our lecture rooms get chilly, really chilly, because you can't control the temperature and there are no windows we can open out to the outside world of natural heat and light. And I'm behaving like most people and putting my physical comfort ahead of my so-called principles. I need air conditioning. My conscience, as usual, has learned to live with that." When he looked at them, the professionals tried to look as if they understood what he'd said; the angular haole looked pleased with himself; the two Samoans looked lost; and the rest of them, except for Lanimua and a few of the locals, looked offended; yes offended.

"Some of you obviously disagree with some or all of what I've just said," he offered.

"Yes, professor," said the short, muscular blonde with the ex-tremely short Levi's skirt that revealed her solid legs, and who was sit-ting opposite him. Mainland America, he identified her; not a trace of

Hawai'i in her accent. "We *need* air conditioning in the heat of Hawai'i, in this room, too, otherwise we won't be able to think and write." Paused, ran her tongue over her lips. "And your—your attack on America was unfair, professor."

"What attack?"

"Your claim that capitalist America is wasting all that energy," the untidy, flimsily dressed haole next to her, replied.

"Well, isn't it?" the Samoan woman asked.

"We only have the professor's word for it!" the short blonde scoffed.

"So you're saying Professor Malaetau is lying!" the interjection was issued without any trace of anger in the voice but with utter clarity. Everyone looked at Lanimua.

"No, I'm not saying that," the blonde tried regaining the high ground.

"So what are you saying?" Lanimua asked. The blonde and her friend from the Mainland retreated.

"She's saying that some of us are fed up with the misinformation and unwarranted attacks on *our* country!" This time it was a haole man with the chunky physique, the square shoulders, the thick overtrained biceps and a number two haircut. Another Mainlander, this time with the military training. "Our boys are dying in Iraq to protect freedom . . ."

"That's it!" Professor Malaetau cut it off. "Let's not go there." He was surprised, and somewhat shocked, that it took only a quite harmless discussion about air conditioning to bring out the battle formations in his class. Even more upsetting were the arrogance and ignorance of some of the students from the Mainland. He'd seen a little of it the year before in his other classes. He glanced over at Lanimua. She refused to look at him. "Now, for your first exercise. I want you to write a poem, no more than six lines in length, on the topic of cold. I want you to use the present tense and set the poem here in Hawai'i. Any questions?"

"Six lines, in the present tense, in Hawai'i, about the cold, professor?" the angular haole summed it up.

"Yes, and do not use the I perspective," he said. When he noted the puzzled looks on the faces of the two women from the Mainland, he said, writing on the blackboard at the same time, "Not in the I perspective, meaning not in the first person. Okay?" Most of them nodded.

"And can we use it to spread *misinformation* about the great ole' US-of-A?" He was surprised it was the Micronesian woman, who'd

been silent up to then, and not Lanimua. With bold mischief in her eyes, the woman was gazing directly at the Mainlander with the number two haircut.

Suppressed laughter among some of the Hawaiians and locals. "Yeah, ya can' wride ah po-eeem about da killing cold in Hawai'i, man!" One of the men exaggerated his Hawaiian accent.

"Yeah, bro', an' in seex lines . . . ," a friend continue to parody.

". . . An' in da presen' tense. . . . ," another one added.

". . . An' widoud da eye, man!" another one ended it.

"Yeah, does that mean you write it blind, professor?" Lanimua finished it. The whole class, including the chunky number two haircut, erupted with laughter.

That night, with the trades shuffling through the louvers and cooling his apartment, and dressed only in an 'ie lavalava, he studied their index cards, jotting down on the cards the observations he'd made about them in class, and filing the cards in individual folders. He always found it difficult to remember people's names, so, at the start of each course, he tried to memorize his students' names by visualizing them and attaching to them easily remembered features, mannerisms, and history.

For instance, the haole with the number two haircut was Malcolm Lowry Unders, twenty-one years old: he had shifted, most of his life, from military base to military base with his family, his father being an officer in the Marine Corps; this was his first year at UH; he loved jazz and marching bands, and played the trumpet; he had read a wide range of poetry, especially American poetry; his favorite poets were the ones shaped and published by the *New Yorker;* his favorite writer and philosopher was Ayn Rand.

The striking Micronesian woman, who'd challenged Malcolm, was Maria Gomez, from Guam. A brief four lines scribbled at the center of her card read: "I am Chammoro. Third year at UH on scholarship. Have not done much writing but joined your class because I admire your writing, especially *The Final Return Home.* Want to learn from you. I love Māori writing too."

The angular haole was Nigel "The Hammer" Blathmire. He had spent since the late 1990s traveling around Asia and the Pacific, attending some of the universities there. He *loved* Hawai'i and Hawaiian music and culture, and was learning to play the slack guitar. Had published a few poems in various magazines. Considered Robert Lowell

the "awfullest" poet in American poetry. "Fuck the American academy for inflating Lowell's importance. The King of Poetry is Bukowski!"

The Samoan athlete was Nathaniel Matagi: "everyone calls me Nat. Born in Tennessee but am Samoan at heart and muscle and soul." The Rock was his hero because "The Rock can rock any honky out of the ring and is Samoan and proud of it. Want to be a novelist like Albert Wendt whose novel *Sons for the Return Home* changed my life." Hadn't written any poetry at all but he wanted to learn from Daniel Malaetau, "the greatest poet on the planet and Samoan."

Folole Misamalosi, the Samoan woman, was from Pago Pago, American Samoa, and didn't want to live anywhere else "because Pago is the Paradise of the Pacific." She claimed she was living in exile in Honolulu because she wanted the best education so she could help her people. Wanted to be a lawyer. That way she could kick ass, especially those of the "ignorant, arrogant Palagis who dominate my beloved country." Wanted to be a poet so she could be more eloquent when she argued her court cases. Praise God!

Shirley Anne Beems was the name of the short obstreperous blonde. She was originally from Iowa City but had lived and studied in numerous other places on the Mainland. This was her first time overseas. She was attracted to Hawai'i by the "surf, sun, and the movies about Hawai'i." "Haven't read or written much fiction but written lots of poetry. Guess it's what you call 'confessional stuff'." Hated Sylvia Plath though. "I want to write a novel in verse about surfing, sun, the movies about Hawai'i, and getting away from your hopeless parents who are drowning in their expensive middle-class shit."

Her friend was "Just call me 'Michel' with the surname Nargler." Who loved "any kind of poetry written by any kind of woman anywhere." Most male poets were full of macho shit and blather, and Bukowski is the "blatherest." Will spend her semester trying to fish love poems out of "the female universe that is still becoming."

Last but now the most compelling presence—and he was in self-denial that she was attracting the usual fire in his body—was Lanimua, call me Mua. Again he reminded himself that in his whole career as a teacher he had never had an affair with any of his students or colleagues. No. Definitely. Too right he'd suffered huge temptations, which sometimes he had almost given way to, yes. Most difficult were those students who came onto you openly, without shame or false modesty. Almost irresistible moral and jail bait. And now, when some of those lurid episodes threatened to swamp him, he jotted down these

notes about Lanimua: in her late thirties, she had not finished her de-
gree when she'd first attended UH fresh out of high school. "Too many
irresistible distractions." (He wondered what those had been.) Then
worked. (Nothing about what that had been.) Was now back to finish
her BA in English. "Love the writing by Kanaka Maoli and Pacific writ-
ers, especially John Dominis Holt, Haunani-Kay Trask, Joe Balaz, Vic-
toria Kneubuhl and Imaikalani Kalahele." At the bottom of her card
she'd scrawled, as an afterthought, "My aumakua is the niuhi, the
white shark." Yet he concluded—but didn't know why—that was the
most important thing she'd said about herself. The other thing that
struck him was the fact that she'd said little about what she'd done since
her first stint at UH.

 He finished compiling the information on the students by about
ten o'clock, then turned on the TV and watched *Law and Order*. Lan-
imua continued infiltrating his attention and diverting it from the ded-
icated team of detectives as they hunted another devious serial killer.

The following Wednesday when he arrived for their session, they were
all in their seats, trying to appear relaxed and unconcerned about hav-
ing to read out and discuss the individual poems, on cold, they'd writ-
ten during the week; their first exercise and leap into the evaluation
and critical judgment of people and a professor they didn't yet know.
Strangers to the slaughter. You were putting your head and heart and
imagination and everything on the block, in the form of this six-line
poem. It was the same every year, and he needed to reassure them, so
he did what he did every year. He held up the sheaf of copies of the po-
ems they'd emailed him (and one another) and which he'd read and
studied carefully, writing careful and encouraging remarks on them,
and said, with his most genuine smile: "These are good, people. I like
them very much." He could see their bodies relax, whaarr, releasing
the tension and apprehension. (Lanimua looked the most relieved and,
without makeup and in a simple yellow t-shirt and jeans and sandals,
the most attractive.) "Of course, being your first poem for me, there
may be things you need to revise." Malcolm looked startled. Nigel, Nat,
Maria, and Folole nodded in agreement. "Right now, I have to remind
you that you won't be a good writer if you don't revise and revise and
revise your work." Shirley looked superior, above that advice, and Mi-
chel copied her.

 Not long after that, he invited them to read their poems aloud,
and, again anticipated that no one would offer to go first. They all

avoided his scrutiny. His anticipation was dead right. So, he asked again, "Isn't there a courageous poet in this class?"

"I'll read," Lanimua offered, almost inaudibly. Most of the others looked as if they'd been saved from drowning. Her face was now turning pale, as she struggled to swallow back her fear. "Okay, this isn't a good poem—it's the first poem I've ever written," Paused, swallowed again.

> "Our 'aumakua lives in the Moana-nui-a-Kiwa
> It swims, moves, weaves in the cold depths
> It mustn't stop—if it does it will drown
> Our niuhi lives in perpetual motion
> beyond the cold and the edge of stillness."

"Are you sure, Mua, it's the first poem you've ever written?" he asked deliberately, smiling.

She started chortling. "Well, if you call the couple of poems I tried to write in elementary school poems, professor!"

Now he invited them to comment on Lanimua's poem. Most of the others looked away from him. He turned to the hand as it rose. "Name's Jake Nakasone," the slender, black-haired young man with the fine bone fishhook pendant said. "Ah'm jus' puzzled, professor, I thought the poem was to be about the cold." A few others nodded.

"You want to read your poem again, Mua, and talk about it a little bit?" he asked her.

Reluctantly she reread it, and then said, "Some sharks, especially the niuhi, the great white, are built not to feel the cold, so I think the cold is in the poem but the niuhi can't feel it. It lives beyond it. It also can't be stationary, it can't just lie down on the ocean bed and have a sleep." Some laughed. "It has to keep moving."

"Yeah, in perpetual motion," Folole remarked. "That's a very apt way of puttin' it. Imagine, you can't sleep, ya havta keep movin' and movin' and movin' until you die . . ."

". . . Beyond the edge of stillness and the cold," Maria added.

"Yeah, I ged id now," Jake nodded. "Id's a beaudiful way of puttin' it, Mua."

"Frank's my name," another Hawaiian student said. "The poor sharks have had a very bad press since Hollywood turned them into ferocious, man-eating monsters . . ."

"But that's true, man," Malcolm interjected. "I saw a documentary about sharks off the tip of South Africa. They even attacked the scientists who were in steel cages filming them."

"Hollywood made millions from turnin' Mua's 'aumakua into Jaws, a frightening monster," Frank countered.

"Yeah, like haole and the tourist industry continue to make millions by selling everything Hawaiian!" Lanimua continued.

"So yah don't believe in the sayings about sharks?" Malcolm said.

"What?" Lanimua demanded, final and deadly.

"Loan sharks, business sharks etc?" Malcolm was oblivious to the corner he was painting himself into.

"Those metaphors are in the cultures of people who know fuck-all about sharks!" Lanimua attacked. And he didn't want to stop the argument. "People who don't even read the scientific studies done by their own scientists about sharks."

"Ah thought we were writing and talking about poetry," Jake tried rescuing the situation.

"I thought the discussion so far is about that," he said. "Mua's poem is about sharks; a particular shark: the niuhi and its role as 'aumakua."

"Let her tell us what Hawaiians believe sharks are really like!" Maria insisted. "So much bullshit has been fed us about sharks by haole films and TV!"

Lanimua glanced over at him and he nodded. "Okay, if we believe the films, most sharks are large and ferocious. In fact, most sharks are quite small, ranging from a few inches to a few feet in length. Those movies portray sharks as feeding in packs and do so in day-long feeding frenzies. In fact most sharks eat less than ten percent of their body weight each day. That is less than most animals. And they feed individually, not in packs. And they certainly don't attack out of some innate sense of ferocity and violence. They're not crazy feeding and attacking machines. I'll stop there—I'm boring you." Some asked that she continue but she refused.

"And now that I know all that," Jake said, "I can now see some of the complexity in Mua's poem."

"And when we know more about Hawaiian culture and the history out of which the poem has come obviously, that complexity will increase," he added.

"For instance, Mua," Michel said, "what is an 'aumakua?"

Lanimua was trying to be patient. "It is a family akua or god. Other families had other creatures as their 'aumākua. Our niuhi protected us, fed us, provided us with a role model for courage and patience, etc. Even today there is a shark heiau in Kāne'ohe Bay. And sharks still come there to spawn and grow."

"In Fiji, the great white shark is one of the important gods," he added. When he glanced at the class, he noted most of them wanted to move onto the next poem, the next victim. "So, who's going next?" Paused. "Mua, thank you for being the first in our class." She smiled, glad she was no longer the centre of attention.

"Professor, the name's Shannon; may I read my poem?" It was one of the Hawaiians who'd joked about the cold at their last session. Dark, black wavy hair, trace of oriental features. "Okay, here we go."

> "Before the haole came we had no words for snow, ice, sleet,
> and all those other elements produced by the cold
> Those were not in our lives.
> So what did the first bit of ice feel like
> in the amazed hand of a Hawaiian who didn't have the vocabulary
> of the cold?
> That touch would have fired his search for that language."

Paused, eyes lowered. "Ah'm not happy about it; not happy about the las' line especially. And I need to condense it further, eh?"

From past experience, he anticipated that a few—maybe three—would try and cruise their way, with the minimum effort, through the course using smooth articulate talk and bluff, and he was again correct. Jocelyn Kim, a slim young woman who was deliberately trying to be inconspicuous, and whose name he asked her for when he sensed she was not going to offer her poem, read her poem with enormous verve and confidence, but that didn't fool him into believing she'd spent much time on it. After the others discussed it, saying it was a quality poem, he said, curtly, "You need to revise that numerous times and show it to me again next session, okay?" And as he anticipated, she smiled beautifully and said, "Certainly, Professor Malaetau!" That would have conned other men, but he was used to working with such confidence tricksters! The challenge was to turn her confidence into a talent for using her writing to con readers into believing anything she wanted them to believe. That's what art was all about.

He was disappointed that Nathaniel, a fellow Samoan and a straightforward, uncomplicated soul, though not a confidence trickster, was expecting to get through the course with first drafts as final ones. Nathaniel read his poem in the voice and manner of The Rock:

"In winter, bro, it's cold in Tennessee,
so cold your ears and other valuables can freeze and break off."

(A wave of suppressed laughter from the class.)

"Playing football in winter is a shit
You can't feel anything in your hands . . ."

He lost interest in Nathaniel Matagi's poem right there. He didn't even wait for the others to comment. "You need to revise that many times, Nathaniel. It's like practicing a move in football until you get it perfect. How do you do that?"

"Over and over again until it looks and feels easy," Nathaniel admitted.

"Yeah, bro, in football you get killed by the opposition if you don't rehearse and practice, right?"

"Right!" Nathaniel replied.

He was also disappointed in Shirley Beems' effort—or lack of it. He smiled but was blunt. "How many times did you rewrite that?" he asked, immediately after she read it. He refused to set her free from his gaze.

She squirmed, and then admitted, "Twice."

"So, class, I expect you all to revise and revise your work, otherwise drop out of this course now and do something you can con your way through!" He laughed, the others didn't because they knew he wasn't bluffing.

Apart from those three, by the time they'd all read and discussed their poems, he was enveloped in the usual feeling of relief and self-satisfaction and euphoric keenness to write their next poems that was emanating from the rest of the class. It was like that in each course, at the end of the first readings and critiquing. He was especially pleased that no one had been insensitive, arrogant and destructive in their analyses.

"Next week's exercise is this: Write a poem no more than eight lines, again without the I, but in any tense, and using in the poem the

words *she, fire, lava,* and *blue light.*" He wrote it up on the board. "You will also continue to revise the poems you wrote for today and keep them in your folios for me to look at again later on."

"Before we finish, professor, may I ask Mua another question about sharks?" Nigel "the Hammer" Blathmire, who'd said little during the class, asked.

"Go right ahead, Manō Kihikihi," Lanimua replied, with an ironical smile.

"I mean, if sharks were ancestral gods, why did Hawaiians eat them?" The Hammer asked.

"We, Kānaka Maoli, are a spiritual but very practical people," she explained, eyes twinkling mischievously. "Not all manō, or sharks, were ʻaumākua. We ate those who were not our ʻaumākua. And we only caught what we needed, and it wasn't just for the fins to make shark fin soup or to mix some concoction to try and get our limp hopes erect again!" Most of the class, including the Hammer, laughed with her, and for the first time he sensed they were becoming a class, a group held together by mutual respect and trust.

That evening at home, he got out his Hawaiian dictionary and looked up manō kihikihi, and laughed to himself when he saw the meaning: hammerhead shark.

Note

Previously published in *Ancestry* (Wellington, New Zealand: Huia Press, 2012).

Adventures in Chronicling

The Relational Web of Albert Wendt's The Adventures of Vela

STEVEN GIN

TO CALL ALBERT WENDT'S 2009 *The Adventures of Vela* a novel is somewhat inaccurate; it is written entirely in verse and takes on many of the features of an epic. It follows three chronicler-narrators in their intertwined quests to construct and narrate a chronicle of their own and each other's lives: Alapati, who is strikingly similar to the biographical Wendt in many ways; Vela, a queer, immortal chronicler for the Samoan Goddess of War, Nafanua; and Nafanua herself. Even though the adventures begin linearly—with Vela's childhood, his romance with Mulialofa, and then his being seized as a spoil of war by Nafanua—the stories become mixed in with one another when he begins telling Nafanua's stories and Alapati starts putting in his own asides, mixing his own life in with those of the people whose stories he tells. The narrative becomes increasingly multifarious and difficult to adequately characterize within any singular genre.

While it crosses boundaries, *Vela* maintains a Pacific core; it is rooted or anchored in Samoa, but stretches outward, builds relationships, looks toward other shores, "Towards a New Oceania," if you will. Moreover, as Wendt explores the Va—the space between all things—directing flows of intertexts and other "adoptions," the Pacific center is ultimately strengthened because Wendt's living indigenized Pacific novel absorbs, redirects, and refracts the Western literary canon, including the pervasive images that colonial literature has produced about the Pacific.

Wendt explicitly extends his own work to a relational web among the many oral, textual, and mythological works that he brings into

dialogue. *Vela* takes readers on an eclectic journey that alludes to texts—varied in genre, form, and media—such as Homer's *Odyssey*, Dante's *Inferno*, *Batman*, and *The Mummy Returns*, but it remains anchored in an imaginative relation to the vital gestative body of Samoan mythology. Through a close reading of Wendt's first chapter, "The Adoption," I examine the responsibility between Vela and Alapati that develops through their ongoing mutually creative process of chronicling. I show that Wendt's tellers (and, indeed, Wendt himself) build pathways of relation in order to promote an open dialogue that continues in perpetuity with other chroniclers who adopt and are adopted into this same genealogy. Wendt dramatizes the challenges of developing a Pacific literature, maintaining a profound connection to one's traditional roots, and simultaneously voyaging outward, forging connections with other audiences and other aesthetic traditions.

What I refer to as a relational web is not unique to Wendt's work (or to Pacific literature in general). Julia Kristeva ([1974] 1984) asserts, "If one grants that every signifying practice is a field of transpositions of various signifying systems (an inter-textuality), one then understands that its 'place' of enunciation and its denoted 'object' are never single, complete, and identical to themselves, but always plural, shattered, capable of being tabulated" (60). Even a cursory consideration of *Vela* makes such an observation clear: neither the context nor the poetic subject and object can be located in a single person, place, thing, or time (just as the genre continues to shift), but each must be considered as plural contexts, subjects, and objects. This is a claim one could level (as Kristeva does) upon all forms of signification, literary or otherwise. In fact, Linda Hutcheon (1988) asserts that with the introduction of Kristevan theories of polyphony (as well as interventions by Barthes and Riffaterre), "a literary work can actually no longer be considered original; if it were, it could have no meaning for its reader. It is only as part of prior discourses that any text derives meaning and significance" (126). Such a postmodern sensibility inhabits the structure of many of Wendt's works and particularly the formally enigmatic *Vela*, on which Wendt worked for more than twenty-five years, incorporating ideas from an expansive array of memories and experiences as his life unfolded and he traveled both physically and intellectually.

In Wendt's text, I emphasize that the "web of relation" that *Vela* expands toward is a particularly intricate and captive one to which Wendt explicitly draws the reader's attention. If, as Hutcheon claims, "intertextuality replaced the challenged author-text relationship with

one between reader and text, one that situates the locus of textual meaning within the history of discourse itself" (126), *Vela*—with its particular focus on the in-between chronicler figure as hero—does not allow for an easy separation of such functional roles as reader, author, text, and character: each is brought into the history of discourse and made complicit in the doing as well as the telling. Being essentially intertextual, Wendt's novel resists a purely aesthetic reading or rather encourages aesthetic reading practices that consider both the narrative structure and the historico-political context in which a text is constructed.

Wendt himself defines the tataued "Post-Colonial body" as both a physical human body and a textual body of Pacific literature that proudly carries the markings of its cultural and terrestrial contexts, and is also shaped by a dialogic relation to global and national traditions:

> It is a body "becoming," defining itself, clearing a space for itself among and alongside other bodies, in this case alongside other literatures. By giving it a Samoan tatau, what am I doing, saying? I'm saying it is a body coming out of the Pacific, not a body being imposed on the Pacific. It is a blend, a new development, which I consider to be in heart, spirit and muscle, Pacific: a blend in which influences from outside (even the English Language) have been indigenised, absorbed in the image of the local and national, and in turn have altered the national and local. (Wendt 1999, 409–410)

All of the tellers in *Vela* (Alapati, Vela, and Nafanua) speak in narratives that are "tataued" in the Samoan tradition: the narratives are inked into their body tissues, they carry the patterns of traditional symbolic art forms passed down for generations, they represent mythical and genealogical (hi)stories, they spill blood and cause pain, and they have scarred-over mementoes of a painful past. On the other hand, the tales of the three tellers in *Vela* are all recorded by the poet Alapati (who is the only one with mastery over "the written script of the Albinos" [Wendt 2010, 6]), and thus, even though the adventures of these chroniclers connect with an epic mythological past, that temporal gap is bridged by direct contact (through Vela's adoption of Alapati) with living contemporary reality.

April Henderson (2010), in her article on Wendt's 1986 piece "The Contest"—a part of the verse saga that Wendt tentatively titled

"The Chronicles of Vela, the Cooked," and which he included as an early episode in *The Adventures of Vela*—argues that Wendt's use of epic verse is a powerful statement asserting that the eminence of Pacific mythological narrative is as grand a tradition as the Western canon has to offer. Perhaps more important, however, Henderson insists that the story also "crafts a profoundly hopeful vision of transnational cultural transmission, where inspiration and tools for survival are sought and adopted from beyond the Pacific, adapted, and deployed to fight very local, very personal battles" (293). Henderson's essay focuses on the relations between Vela—especially his use of "holy rock n' roller"–inflected oratory in order to defeat his opponent in "The Contest" (as well as its hip-hop-inflected 1993 theatrical adaptation by Paul and Justine Simei-Barton for the Pacific Theatre Company in Auckland, New Zealand)—and the contemporary Samoan and Pacific Islander hip-hop music scene. What Henderson observes as Vela's taking "inspiration from the non-Pacific present that invigorates a mythic Pacific past" (293) is, I argue, fundamental to Wendt's gesture in the larger work. While clearly cognizant of the passing down of stories from ancestors—adopted or otherwise—Wendt's *Vela* is poised to "invigorate a mythic Pacific past" by performing it to a wide and mixed audience that will ultimately appreciate its intertextual apparatus on different levels. Such a performance also produces a commentary in the opposite direction: Wendt's work gives an indigenized version of Western forms and texts. Moreover, in forging relations among Pacific and non-Pacific traditions, Wendt expands possible syncretic combinations for future artistic performance in a region where a sense of responsibility to so-called authentic traditions and fidelity to an "original version" can be stifling to contemporary artists faced with a plurality of conflicting influential and hortatory voices.

In fact, Wendt has repeatedly publicly denounced the scholarly search for "authentic" histories and mythologies within his works, promoting instead a more open aesthetic system in which history and mythology can—indeed, they must—be shaped in diverse ways for diverse combinations of performer, audience, and medium: "There are no original versions. As you know, in oral traditions or in any story form, you make up the stories, you change them to suit your audience. For instance, I take a lot of traditional Samoan and Polynesian mythology and include them in my novels. But they are not true to the originals. I even change the mythology to suit the purpose of the novel" (Wendt 1993, 53–54). Wendt nonetheless locates the mana of traditional (hi)stories in

their ability to perpetuate across time and space while enriching both the old and the new. He insists upon the necessity of such change, particularly—though not exclusively—for Pacific cultures:

> All cultures are becoming, changing in order to survive, absorbing foreign influences, continuing, growing. But that doesn't mean that they become any less Samoan or any less Tongan. We and our cultures have survived and adapted when we were expected to die, vanish, under the influence of supposedly stronger superior cultures and their technologies. . . . We have indigenised much that was colonial or foreign to suit ourselves, creating new blends and forms. We have even indigenised Western art forms, including the novel. (Wendt 1995, 3)

In *Vela,* Wendt dramatizes an instance of such indigenization through the multiple (and multidirectional) adoptions that bring about not only the (multimedia, multigeneric) chronicles of Nafanua, Vela, and Alapati, but also the lives of these characters which become imbricated with multiple literary, historical, material, political, and mythological traditions.

The narrative of Wendt's book is structured by the various familial relationships built among the tellers. In particular, the title of the first chapter of the book—"The Adoption"—elicits an understanding of family relations that are chosen, fostered, and more or less nurtured, rather than based on strictly biological relationships. In this first chapter, it is Alapati, the first narrator, who is adopted by Vela as both son and "chronicler / in the written script of the albinos" (6), but Alapati already understands their "mutual dependence" (4) when it comes to the telling, transmission, translation, recording, or creation of this tale—and Wendt makes it clear later what an important part of the story Alapati plays. By framing the narrative situation as a relationship, and more specifically as an adoption (a word with its root in the Latin optāre, to choose) rather than an adaptation (a word, not used in Vela, whose Latin root, aptere, means "to fit or make proper"), Wendt suggests that it involves a choice, a wish, an investment, and a sense of responsibility.

Moreover, the word "adoption" takes on specific nuances because of its location in the Pacific. Adoptions in many Pacific indigenous traditions are very often communally chosen or given as an honor to the adopting parents, rather than out of necessity for orphans. Indeed, sometimes adoptions even occurred between two adults for a variety of

reasons. For example, E. S. Craighill Handy and Mary Kawena Pukui (1998) describe the Hawaiian adoptive tradition of ho'okama (translated as "'making' someone else's child one's own" [71]) as "a relationship involving love, respect and courtesy, but not necessarily responsibility of any sort" (71). Alapati and Vela choose and accept their kinship, which perhaps makes it even stronger than biological paternity. While the relationship does not necessarily involve responsibility, it becomes clear that their emergent connection centers about a commitment that is created by and from the chronicles they relate (though the chronicles exceed the two of them). Wendt thus foregrounds the chronicles as an adoption that operates in two directions: Vela adopts Alapati as "his last disciple witness accomplice" (5), and Alapati adopts Vela as the object of his writing, imagination, and dreams. The stories that appear in *Vela* are not "authored" by either man; each teller carries the stories and contributes to them (as the stories contribute to each of their lives), but neither claims ownership over them—they respect, nurture, serve, protect, and love them.

Wendt begins the chapter with Alapati provocatively questioning the ontology of the two narrators/narratees/characters and their relationship: "Is Vela of my dreaming? Or am I the object of his?" (3). Alapati's opening questions (which are presumably subsequent to his hearing of the tale) immediately throw into doubt whether Vela—who is both the hero of Alapati's narrative and the fictional teller of the tale—is a creation of Alapati's dreams or if, on the other hand, Alapati is a creation of Vela's. Indeed, Wendt imagines both Alapati and Vela as the incipient subjects and objects of the dreaming and, despite the conspicuous conjunction "or" that he employs, Wendt does not suggest a clean binary opposition of these two possibilities but directs the reader to both in this situational mise en abîme. Rather than rendering his novel as the narrative of one man about another, Wendt imagines it as the singularity approached when two tellers imagine each other (and transitively imagine each other imagining each other, and so on). Ultimately, representations of both of these revered chroniclers appear in each other's tales, and they begin to see that, as Alapati notes, "Truth is we can't survive without each other" (3). Though we could defensibly call these two narrators homodiegetic, as they each appear as characters internal to the novel's storyworld, the term is not entirely adequate for these two unstable narrators that flutter in and out of the diegesis, sharing the task of transmission.

While he immediately pluralizes the reader's understanding of the book's narration through Vela's and Alapati's mutually constitutive

dreaming, Wendt simultaneously expands beyond the text. The dream exceeds the limits of the diegetic world in its intertextual reference to a butterfly dream described by fourth-century-BCE Chinese Taoist philosopher Zhuangzi (2013). He writes of a dream in which he was "a butterfly flitting and fluttering around, happy with himself and doing as he pleased. He didn't know he was Zhuang Zhou" (18). He then suddenly awakened and realized "he didn't know if he were Zhuang Zhou who had dreamed he was a butterfly or a butterfly dreaming he was Zhuang Zhou" (18). Like Zhuangzi, Alapati declares the reciprocity of any work of representation, fictional or not; writing about Vela causes Alapati to question the constitution of his own life. In turn, Wendt suggests that representations of Oceania—overpowered as they traditionally have been in the fantastic Orientalist imaginings of the West—shall always be entangled within a larger semiotic web.

Though the web is captive and pervasive, Wendt does not see it as necessarily disabling; in fact, he argues that the process of representation is an unending play of signs. In his 1976 landmark essay "Towards a New Oceania"—another clear hypotext for the *Vela* passage—Wendt explains that the complete scope of manifestations of Oceania can never be fully grasped: "whenever we think we have captured [Oceania] she has already assumed new guises—the love affair is endless. . . . In the final instance, our countries, cultures, nations, planets are what we imagine them to be. One human being's reality is another's fiction. Perhaps we ourselves exist only in one another's dreams" (Wendt 1976b, 49). As he does in the first line of *Vela*, Wendt emphasizes the subjective constructedness and reconstructedness of reality as it enters into people's consciousnesses through language. In the context of Oceania, Wendt's statement counters the static treatment that Pacific cultures have received from the West but does not underestimate its effects; while Oceania may be as any one of us imagines it from a particular instantaneous frame of reference, that frame can never be considered singular, and the collective imagination continues to change as people continue to imagine. Wendt describes the adoptive writing process as one with living and continuously gestative sources of support: "I belong to Oceania—or at least I am rooted in a fertile portion of it—and it nourishes my spirit, helps to define me, and feeds my imagination" (Wendt 1976b, 49). The situation for Vela and Alapati is similar: not the colonizing stance that many chroniclers of various stripes—anthropologists, historians, folklore collectors, and novelists—have taken with respect to imagining the Pacific, but an

ongoing multidirectional nonessentialist adoptive relationship with mutual respect.

Wendt's proclamation certainly leaves space for other currents to flow in, and Wendt's text—whether or not it is conscious of all its "butterfly dreams" or butterflies dreaming of it—connects to a web of intertexts, hypotexts, and paratexts that I shall not limit by attempting to define here. The novel contains imagery from outside its own understandings and challenges the assumption that there must be an originary dreamer/dreamee binary. Alapati clearly shows that he draws from an eclectic range of influences in the ways he presents his narrative. For instance, in a scene somewhat reminiscent of the sizable analeptic digression in Book 19 of the *Odyssey* prompted when Euryclea recognizes Odysseus after touching his scar, Alapati's identification of the surgical scars on his and Vela's bellies opens into a stream of mythological, cultural, and literary allusions—which Alapati calls "free-flowing symbolism" (4). He describes the "upright belly scar" as being "morse-coded / both sides with stitchdots a wicked centipede / permanently crawling upwards" (4) and then lists relations to "Camus' Sisyphus," "Odysseus tied to Rock and Eagle," "glad-eyed seers" from Yeats' poem "Lapis Lazuli," and "Maui in Hine's unforgiving tunnel" (4). Each of these referential images takes the reader down an ostensibly tangential path: Morse code is an American telegraph language transmission technology consisting of dots and dashes; centipedes are many-legged, often poisonous insects; in Camus' existentialist essay, which refers to ancient Greek mythology, Sisyphus—whom Camus describes as an "absurd hero"—is punished by being repeatedly forced to push a boulder up a hill, only to watch it roll back down; it was not Odysseus but Prometheus who was chained to a rock to have his liver eaten by an eagle and then regenerated daily as punishment for stealing fire from Zeus and giving it to mortals—Alapati's substitution of Odysseus is suggestive of a partial identity among voyaging, foresight, violence, and the healing process; Yeats' "glad-eyed seers" are "Chinamen" that are "carved in lapis lazuli," whom the poem's speaker imagines resting gaily during a steep mountain ascent; and Māui is a trickster demigod in Māori mythology whose final act consists of crawling up the vagina of the goddess of death, Hine-nui-te-pō, as she sleeps, in an attempt to gain immortality for humans and being crushed to death when she awakens and discovers his enterprise. Though they are separated in their origins by vast stretches of time and space, Alapati makes these references cohere in adjacency: there are common images of rocks,

bodies (and orifices), organs, ascents, arrogance, punishments, repetitive cycles, and (illicit) gifts to humanity. These stories all come together on Alapati's and Vela's bellies, the "Sacred Moa" or "Century's medal" (4)—the wound whose track marks articulate the stories of pride and pain of their journeys as well as the many other stories that have become intertwined with theirs.

Wendt's imagery is also specific about the geographical and corporeal place where the stories converge. The "Sacred Moa" refers directly to the land and people of Samoa, as Wendt explains:

> In the Samoan way, the center of the human being is the belly. It's called the moa, which means the center. So if you take Samoa, the name of my country, it's Sa and Moa, which means the sacred center. So when you refer to a human being's center, you're referring to that area loosely called the belly. And that's where your whole spirituality—the power of the language and the power of feeling—comes from. In some cultures, the center seems to be the head. (Wendt 1993, 52–53)

Thus, Alapati's series of allusions to stories that have left an imprint upon the two men is patterned upon the center of a corporeal, geographical, spiritual, linguistic, emotional, and cultural landscape that brings the stories different currency—in the sense of the stories' value, in their state of perpetual newness, and in the way they flow among audiences. The ongoing act of expressing and relating the past brings Alapati and Vela together and intertwines their stories as they continue their adventures in chronicling together.

Furthermore, Alapati makes it clear that even the stories he knows and brings to the relationship are not to be thought of as "original" but as constructed within a particular milieu and through relationships with particular people. For instance, Alapati describes that the image of Māui was one that the Māori actor and author Wi "Kuki Kaa fixed / into my vocabulary and [Pākehā poet James Keir] Baxter detailed in our coffee bar conversations" (4). By referring to these two well-known figures from Aotearoa, Alapati relates himself to the Māori myth. More than simply name-dropping, Alapati's statement gives the story he references a partial genealogy and provides information about the communicative context from which they emerged. Though the myth may have been passed down to Kaa and Baxter, it is in a particular time and place that Alapati learns the story of Māui from them, with, perhaps,

the added inflection of Māui's relevance as a trickster figure to the ongo-ing Māori resistance movement. In turn, rather than treating his own work as a closed and analytic unit, Alapati makes clear that his stories are situated in dialogue—not only with Vela, but also with ancient my-thologies and poems, and with Wendt's contemporaries.

Though the above-mentioned string of allusions is drawn com-pletely from canonical literary works and ancient mythologies, Wendt shows that Alapati and Vela's collaboration is also receptive of more current, popular, and mass-market sources that keep their dialogue in touch with contemporary reality. Alapati describes new discourses that continue to enter his vocabulary (and, figuratively, his body) as he "feasted on [his] son's science fiction collection" and his "daughters continued [his] conversion to [Barbara] Cartland / and the [romance publisher] Mills and Boon stable" (5). Clearly, Alapati's experiences are not limited to "high-brow" sources, and Vela, too, becomes interested in popular culture, insisting Alapati "tell him / all the stories about Dracula Batman and Batwoman who from then / on he referred to as his 'revered cousins'" (5), imagining a genealogical network among his flyingfox atua, Bram Stoker's popular novel, and the DC comic book se-ries Batman (not to mention the massive intertextual webs—including literature, television shows, movies, and video games—that extend from both the Batman and Dracula nodes). By expressing relations to popular sources, Wendt suggests that Vela is not confined by the arbitrary bound-aries separating literary and nonliterary works, especially when the non-literary genres enable the narrators to relate (or tell stories) to their relations—sons, daughters, and "revered cousins." Like the tradition of Pacific literature of which it is a part, Alapati and Vela's collaboration is continually able to make relevant "familial" connections with vibrant living traditions of the expressive culture of ordinary peoples.

Another aspect of popular genres—such as science fiction, ro-mance, horror, and comic books—to which Wendt relates his narrative is their often uninhibited exploration of topics generally considered ta-boo or grotesque, such as disease, violence, blood, gore, and sex. In-deed, in an earlier essay, Wendt speculates on a similar relation among the Samoan tradition of tattooing and these same topics: "I'm sure that one of the reasons why we're fascinated with tattooing is because it is to do with blood, human blood, with deliberately bleeding the body, the flying fox is the bat is Dracula is Batman is vampirism is leeching" (Wendt 1999, 409). In the storyworld of *Vela*, blood and other bodily fluids (as well as odors) flow across boundaries as dialogue flows across

conventional generic and class boundaries. Like "leeching" or "bleed-
ing the body," such a flow can be seen as at once a parasitic and thera-
peutic process—the word "leech" once referred to both a doctor and a
blood-sucking worm. In fact, the circumstance of Alapati and Vela's
first meeting is their coincidental convalescence in Moto'otua hospital
in Samoa: "Like me his lifelong duodenal ulcer had perforated / corrod-
ing poisons into his centre the surgeons slit / open and mopped out that
midnight" (4). A perforated ulcer is an extremely serious condition—
historically, it led to the deaths of such notable figures as Rudolph Valen-
tino, Rudyard Kipling, J. R. R. Tolkien, and James Joyce—in which diges-
tive fluids burn through a person's stomach lining and seep into the
abdominal cavity. Wendt, Alapati, and Vela—with, perhaps, "The other
perforated ulcers in our ward" (4) to whom Alapati refers synecdochically—
form a cluster of chronicler-artists for which the telling of tales is liter-
ally and figuratively written on the body: in tattoos; in scars of experi-
ence, "our Century's medal" (4); in lines of genealogical, biological,
cultural, and emotional connection. This often difficult, painful chroni-
cling process is, however, like leeching, a form of healing and renewal,
a place of cooperation, collaboration, and relation with an unexpectedly
wide and growing web of dialogue.

The bodies that Wendt portrays in *Vela* are overwhelmingly of the
"unfinished and open" variety—they very often explicitly belch, fart,
bleed, ejaculate, defecate, and even sniff toe jam. In the ulcer ward
where Vela and Alapati meet, Wendt illustrates, with an uncomfortable
degree of detail, patients' bodies suffering from "the same planet-wide
malady: the Sacred Moa bursting / to let us wear our Century's medal"
(4). While some readers will certainly cringe at the thought of surgical
slits, a bursting moa, or Vela being "found / bleeding from every ori-
fice" (4), Wendt counters images of death with the incidence of Alapati
and Vela's adoptive relationship being "born." In fact, Alapati narrates
that Vela's "first song is of the Va the Space between all things / like the
birth fluid holding all in the Unity-that-is-All" (10), which compares
amniotic fluid—a nurturing, gestative, reproductive medium connect-
ing from mother to child and a recurring motif in *Vela*—and the Sa-
moan mythical space that both separates and connects. Whether blood
flows out of a body or amniotic fluid flows into a newborn, it must travel
through the Va and it is therefore a means of communication, of com-
munion in an open stream. Epeli Hau'ofa ([1997] 2008)—in whose
memory Wendt dedicates *Vela* (along with Hone Tuwhare)—makes a
similar point about the ocean, which he sees as Pacific Islanders'

metaphorical "waterway to each other" and also their "route to the rest of the world" (55): "Simple recognition that the ocean is uncontainable and pays no respect to territoriality should goad us to advance the notion, based on physical reality and practices that date back to the initial settlements of Oceania, that our sea must remain open to all of us" (55). In keeping with Hau'ofa's vision, Wendt's novel imagines an environment where literary and cultural expressions flow in a productive widening current, while Wendt's work in Pacific literature tangibly promotes these flows in the real world.

Although Vela, with his scars, bleeding ulcer, and fancy for the smell of toe dirt, is easily identifiable as a grotesque character, he defies to a certain extent Mikhail Bakhtin's image of the grotesque body. Bakhtin ([1965] 1984) states that "one of the fundamental tendencies of the grotesque image of the body is to show two bodies in one: the one giving birth and dying, the other conceived, generated, and born" (26). The character of Vela—homosexual and immortal—neither procreates nor dies. This seems precisely the reason, however, that he depends so heavily upon Alapati for his release, renewal, and resurrection. While Alapati is no infant when he meets Vela and the relationship between the two men is not as simple as father-son, there is a definite sense that Vela (whose name means "cooked" in Samoan and who can thus never again be raw) cannot pass on until he has passed on or conceived of and given birth to the story that he carries within him. As Nafanua—the Samoan goddess of war and Vela's patron—says to him,

> for now Vela you'll roam the world training
> chroniclers who'll write down my life in their different languages
> out of them you'll select one who will return with you to be
> my chronicler in an even more terrible future Only then will I
> release
> you from your immortality. (272–273)

For Vela, the transmission of Nafanua's life, the (re)connection of "the remembered cord / that stretches across the abyss / of all that we've forgotten" (23), the act of teaching Alapati "the biology of language" (6), is literally a matter of life and death; the story grants him release and death, but it also guarantees his (and Nafanua's) resurrection in the birth, training, and continuance of these new chroniclers. Wendt (1976a) provides a similar juxtaposition of birth and death in his earlier

poem "Inside Us the Dead," in which the speaker compares his "polyne-sian fathers" to "turtles / scuttling to beach their eggs / in fecund sand, smelling / of the sea—the stench of dead / anemone and starfish" (7). As these ancestors/turtles acted to ensure that the environment that sur-rounds them—which contains the fertile remains of the dead and all their experiential scars—would enrich new generations, Vela passes on the tradition of chronicling, and Wendt passes on his own imagination of Pacific literature for it to be taken up in various ways. For instance, Tongan poet Karlo Mila (2010) writes, "Yes, every limb, / every bend / every bone / is a recollection of / who has been before" (382), directly re-sponding to Wendt's poem and the gestative influence that has produced a living poetic tradition.

Thus, Wendt's deployment of grotesque imagery operates on sev-eral levels. Human (or godlike) characters are seen to transgress bodily limitations (bleeding, swelling, protruding, ejaculating, giving birth) in a way that reveals the interconnectedness with the world and with each other that has been stifled by aspirations toward "civilization." The bodies of stories transgress traditional understandings of author-ship or empirical observation and chronicling, representing instead a fluid relationship between our two perforated narrators—this is espe-cially evident later in the novel after Alapati realizes, "For the first time in our life together / I was not to be a mere recorder of his telling but a participant / unprotected from the action and accepting / responsibility for whatever consequences eventuated" (226). Finally, the body of Wendt's text, which transgresses the boundaries of its own fictionality when Alapati remarks that it "has been accepted for publication" (276), promotes open flows among some wildly diverse forms, discourses, languages, and genres of writing.

Wendt's novel insists upon its analysis at the level of an utterance that is set in conversation with an incalculable multitude of other utter-ances. Bakhtin (1986) explains that if we consider a novel (or any work) at the level of the utterance, as opposed to the sentence level, "The work is a link in the chain of speech communion. Like the rejoinder in a dia-logue, it is related to other work-utterances: both those to which it responds and those that respond to it" (76). In bringing attention to the works to which Alapati responds, Wendt suggests that part of the purpose of entering such a dialogue is to continue drawing relations to other—perhaps unrealized—intertextual connections and to open channels for and promote yet unwritten texts to respond. In the context

of the Pacific, such a gesture is particularly salient to counter the persistent discourses of authenticity that call for indigenous writings to be confined to certain subjects and with certain genre conventions. These discourses of authenticity have been established by colonial literature, which Wendt (1995) notes "created a whole mythology about us" in which indigenous people were "seen as exotic, as peripheral, as 'extras' in the epic, as stereotypes or as noble and heroic forms of escape" (2). In the present situation in Oceania there is a robust and growing tradition—headed by writers like Wendt—of contemporary indigenous peoples' literatures that respond to the Western canon, reframing the place of indigenous people from the anthropological object of study to the speaking subjects.

Wendt's novel is fundamentally an open body of text whose adventures take it to the far reaches of its author's experiences and across the physical and imaginative connections (and disconnections) that he has identified over time. *Vela* presents the ultimate tangle of disciplines, genres, epistemologies, dreams, forms, and worldviews for any adventuresome chronicler looking for paths to transgress, but the separations among them are anything but clean (or industrial)—after all, as Alapati asserts, "too clean / a telling can strangle a tale" (170). As a work of expressive culture, *The Adventures of Vela* may not resonate with audiences who are accustomed to the new bodily canon, the civilized world in which narratives can be ordered, packaged, and sharply defined, but Wendt is clearly not interested in satisfying such demands. On the contrary, Wendt's novel, as I have begun to show, represents the continuing saga in the dream he had more than thirty years earlier of a "New Oceania" in which the cycle of birth and death continually renews and expands local understandings and promotes an ever-broadening engagement with forms from all over the world. The spaces of the Va, Vela sings, are "relationships that must be nursed and nurtured" (10), and Wendt is steadfast in his contributions to that very project. As Alice Te Punga Somerville (2010) points out, Wendt demonstrates his "commitments to the production of more and more writing; to a regional emphasis; to the promotion of complexity, nuance, and juxtaposition; and to the close links between writing, history, and politics" (254). Indeed, in *The Adventures of Vela*, Wendt accomplishes something very similar: he eradicates the boundaries and ready-made interpretations that conceal complexity, opens up bodies of expressive culture to many possibilities, and allows understandings to proliferate across the Va.

Note

Wendt lived in Aotearoa from 1953 to 1964 and from 1988 to 2004 and has lived there from 2008 to the present. Baxter died in 1972; Kaa died in 2006.

Works Cited

Bakhtin, Mikhail Mikhaĭlovich. [1965] 1984. *Rabelais and His World*. Trans. Hélène Iswolsky. Bloomington: Indiana University Press.

———. 1986. *Speech Genres and Other Late Essays*. Ed. Caryl Emerson and Michael Holquist. Trans. Vern W. McGee. Austin: University of Texas Press.

Handy, E. S. Craighill, and Mary Kawena Pukui. 1998. *The Polynesian Family System in Ka'u, Hawai'i*. Honolulu: Mutual.

Hau'ofa, Epeli. [1997] 2008. "The Ocean in Us." In *We Are The Ocean: Selected Works*. Honolulu: University of Hawai'i Press.

Henderson, April K. 2010. "Gifted Flows: Making Space for a Brand New Beat." *Contemporary Pacific* 22, no. 2:293–315.

Hutcheon, Linda. 1988. *A Poetics of Postmodernism: History, Theory, Fiction*. New York: Routledge.

Kristeva, Julia. [1974] 1984. *Revolution in Poetic Language*. Trans. Margaret Waller. New York: Columbia University Press.

Mila, Karlo. 2010. "Inside Us the Dead (The NZ-Born Version)." *Contemporary Pacific* 22, no. 2:281–282.

Somerville, Alice Te Punga. 2010. "Not E-mailing Albert: A Legacy of Collection, Connection, Community." *Contemporary Pacific* 22, no. 2:253–270.

Wendt, Albert. 1976a. "Inside Us the Dead." In *Inside Us the Dead: Poems 1961 to 1974*. Auckland: Longman Paul.

———. 1976b. "Towards a New Oceania." *Mana Review: A South Pacific Journal of Language and Literature* 1, no. 1:49–60.

———. 1986. "The Contest." *Landfall* 40, no. 2:144–153.

———. 1993. "An Interview with Albert Wendt: Following in Her Footsteps." *Manoa* 5, no. 1:51–59.

———. 1995. "Introduction." In *Nuanua: Pacific Writing in English Since 1980*, ed. Albert Wendt, 1–8. Honolulu: University of Hawai'i Press.

———. 1999. "Afterword: Tatauing the Post-Colonial Body." In *Inside Out: Literature, Cultural Politics, and Identity in the New Pacific,* ed. Vilsoni Hereniko and Rob Wilson, 399–412. Lanham, MD: Rowman and Littlefield.

———. 2009. *The Adventures of Vela*. Honolulu: University of Hawai'i Press.

Zhuangzi. 2013. *The Complete Works of Zhuangzi*. Trans. Burton Watson. New York: Columbia University Press.

When will I be content with my words?
When will I sound out my poem words?

FLORA DEVATINE
TRANSLATED BY JEAN ANDERSON

She writes with

. . . Sculptured words of her own making
Buried in the mud, beneath the gravel of the stream

She writes with

Words that fly on the beat of the cooing bird's wing
Words of existence, words of life wailing

Beneath the stones, beneath the leaves!

Words that are the blackbirds' piercing calls
Cannot swim worth a dime!

Words in the name of the father on mother earth
Memory words, weaving the name, origin and history!

She writes with

Words of cordyline roots
In the times of restrictions, prohibitions!

Pole words eloquent watchers
In ironwood along the crests of the mountains!

Words outward bound
Sailing in perdition
Struggling in the rising wind

Palmtree words
Sticks thrust
Into the coral slabs

Satire words
Glutted verses

Lute words
The singing years
To inscribe on solid ground! . . .

Stones blossoming with the whiteness of seafoam
In the blue of the setting sun,
Wavesplash between the rocks
Under the ocean's fires,
She writes.
And languishes where writing takes her
In the Other's language.

Writing is her journey through words,
Shell-splitting texts in her obsession,
Obstinately writing.

Where waves in stormclouds thunder,
Where lightning dashes in sobbing bursts,
Where torments cascade in whirlpools of seafoam.
Where mistily laps the lagoon of turmoil!

Contributors

Jean Anderson is an associate professor of French at Victoria University of Wellington, where she founded the New Zealand Centre for Literary Translation/Te Tumu Whakawhiti Tuhinga o Aotearoa in 2007. Her interests in Pacific francophone writing led her to work on Chantal Spitz's *Island of Shattered Dreams* (Huia Books, 2007) and Moetai Brotherson's *The Missing King* (Little Island, 2012), along with a number of shorter pieces published in the United States and the UK. She has also translated Mauritian writer Ananda Devi's *Indian Tango* (Host Publications, 2011) and cotranslated several of New Zealand writer Patricia Grace's novels into French.

Jeffrey Carroll is a professor of English at the University of Hawai'i at Mānoa, and currently department chair. He earned his degrees at Reed College, UH-Mānoa, and the University of Washington. He has published four books, including a novel and a study of blues music, and a monograph on the music writing of Kenneth Burke. His research interests include histories and theories of rhetoric, the American novel of the twentieth century, and the rhetoric of American popular music.

Gregory Clark teaches and writes about intersections of the rhetorical and aesthetic. He studies how the two work together in the formation of national identities. His book, *Rhetorical Landscapes in America* (University of South Carolina Press, 2004), examines how that happens in tourist experiences of iconic places in the mainland United States. His current project, *Civic Jazz*, forthcoming from the University of Chicago Press, explores the capacity of jazz music to advance a practical sense of democratic civic identity among those who encounter its display of

individuality in cooperation. Clark's work in Hawaiian music combines ideas about the rhetoric of place developed in *Rhetorical Landscapes* with ideas from his work on jazz about the capacity of music to shape identity. Clark is University Professor of English and associate dean of the College of Humanities at Brigham Young University in Provo, Utah.

Flora Devatine was born at Te Pari, Tahiti, in 1942. Throughout her long career she has devoted herself to her people and her culture. From 1968 to 1997 she taught Spanish and Tahitian at the Lycée-Collège Pomare IV in Pape'ete; a member of the Tahitian Academy (Te Fare Vana'a) since its founding in 1972, she has also been involved with a number of cultural and women's organizations. A poet and researcher, she taught at tertiary level (Université Française du Pacifique) from 1987 to 1995. Founding editor (2002–2007) of the literary review *Littérama'ohi*, she has worked tirelessly to promote Tahitian writing and for the recognition of a "Polynesian Consciousness." Her groundbreaking work *Tergiversations et Reveries de l'Écriture Orale: te Pahu a Hono'ura* was published in 1998 (Au Vent des Îles, Pape'ete).

Steven Gin is a PhD student at the University of Hawai'i at Mānoa. His interests include Pacific literature, comparative indigenous theory, narratology, and performance theory.

Kanaka 'Ōiwi poet, artist, scholar, and mālama 'āina advocate **ku'ualoha ho'omanawanui** was born in Kailua, O'ahu, and raised in Kaipuha'a, Wailua (Homesteads), Kaua'i. She is an associate professor in English at the University of Hawai'i at Mānoa specializing in Oceanic literatures and indigenous literacy, with a special focus on traditional mo'olelo and place-based learning. She is a former Ford Foundation and Carnegie-Mellon Fellow. She has widely published both critical essays and creative writing in Hawai'i and abroad (the United States, the Pacific, and Europe). She is a founding and chief editor of *'Ōiwi: A Native Hawaiian Journal.* Her first book, *Voices of Fire: Reweaving the Literary Lei of Pele and Hi'iaka,* was published by the University of Minnesota Press.

Lisa King is a Munsee/Euro-American scholar and assistant professor of English at the University of Tennessee, Knoxville, and her work is an interdisciplinary endeavor situated between rhetoric and composition studies and American Indian and Indigenous studies. She has re-

searched and taught in Kansas, Illinois, Hawai'i, and now Tennessee, and her scholarship follows two strands: first, tracing the relationship between and functions of rhetorical and material cultural practices in the context of Indigenously based or affiliated museums, and second, theorizing a pedagogy of rhetorical sovereignty and cross-cultural alliance in the composition classroom. Her scholarship has appeared or is forthcoming in journals such as *American Indian Quarterly, Pedagogy, Rhetoric Review,* and *JAC*.

Selina Tusitala Marsh is a poet and scholar and teaches Pacific literature and creative writing in English from the University of Auckland. She is currently writing a book about the first published Pacific women poets. Her second poetry collection, *Dark Sparring* (2013, Auckland University Press), explores the relationship between death, the Tuvalu dance, fa'atele, and muay Thai kickboxing. She most recently performed her poetry at the London Olympics Poetry Parnassus Event.

Born and raised on Maui, **Brandy Nālani McDougall** is of Kanaka Maoli (Hawai'i, Maui, O'ahu, and Kaua'i lineages), Chinese, and Scottish descent. She is the author of a poetry collection, *The Salt-Wind, Ka Makani Pa'akai* (Kuleana 'Ōiwi Press, 2008), the cofounder of Ala Press and Kahuaomānoa Press, and the costar of an amplified poetry album, *Undercurrent* (Hawai'i Dub Machine, 2011). In 2012, she was awarded the national Richard Braddock Award for a critical article on kaona and Hawaiian rhetoric she cowrote with Georganne Nordstrom. Her scholarship and poems have been published in journals and anthologies throughout Hawai'i, the Pacific, and Turtle Island. A Ford post-doctoral and Mellon-Hawai'i fellow, she is an assistant professor of Indigenous studies in the American Studies Department at the University of Hawai'i at Mānoa.

Dan Taulapapa McMullin is a poet and painter with an MFA in painting from Claremont Graduate University. He was recent artist-in-residence at the De Young Museum San Francisco, and Oceania Arts Center Suva. His new book of poems, *Coconut Milk,* was published by University of Arizona Press in 2013. More on his work at www.taulapapa.com.

Since 1982, **Nā Maka o ka 'Āina** (The Eyes of the Land), the independent video production company founded and directed by **Joan Lander**

and **Puhipau**, has produced award-winning documentaries on Hawai'i and the Pacific for distribution in the educational arena and broadcast/cablecast on public and commercial television networks in the United States and throughout the world. Documenting traditional and contemporary Hawaiian culture, politics, history, language, and the environment, Nā Maka o ka 'Āina is committed to giving voice to the movement toward recognition of Hawaiian sovereignty. Major programs include *Act of War—The Overthrow of the Hawaiian Nation, Mauna Kea—Temple under Siege, Stolen Waters, Pele's Appeal, The Tribunal, Kaho'olawe Aloha 'Āina,* and *Mālama Hāloa—Protecting the Taro.* More than ninety-two programs are available on DVD at www.HawaiianVoice.com. Nā Maka o ka 'Āina can also be contacted at: PO Box 29, Nā'ālehu, HI 96772–0029, 808-929-9659, namaka@interpac.net.

Georganne Nordstrom is an assistant professor of English at the University of Hawai'i at Mānoa where she is Director of Composition and Rhetoric and Director of the Writing Center. Her research interests include place-based rhetoric, critical pedagogy and composition, and the intersections between theory and praxis. Her current research specifically focuses on rhetoric in Hawai'i as it is employed to both resist and promote colonization and oppression. Georganne's recent publications examining kaona as a Hawaiian rhetorical strategy and the rhetorical work of writing in Hawai'i Creole English (pidgin) have appeared in *College Composition and Communication* and the anthology *A Brief History of Rhetoric in the Americas.* She is the recipient of the 2012 Braddock Award for the article "Ma ka Hana ka 'Ike (In the Work Is the Knowledge): Kaona as Rhetorical Action," a collaboration with Brandy Nālani McDougall.

Jonathan Kay Kamakawiwo'ole Osorio, a well-known musician of Hawaiian music, is a past director and now professor of Hawaiian studies at the Kamakakūokalani Center for Hawaiian Studies in the Hawai'inuiākea School of Hawaiian Knowledge at the University of Hawai'i at Mānoa. He has authored and coauthored several books on Hawaiian Kingdom politics, music and history, and contemporary political society in Hawai'i, including *Dismembering Lāhui: A History of the Hawaiian Nation to 1887* (University of Hawai'i Press, 2002). He serves on several boards of nonprofit organizations that focus on the environment and performing arts. He and his wife, Mary, are parents of five children and live in Pālolo Valley.

Chelle Pahinui is a lecturer at the University of Hawai'i at Hilo College of Business and Economics. Her area of specialization is sustainable tourism product development and marketing. Chelle holds an MS in agribusiness and an MBA and is working toward her PhD in hospitality, tourism, and marketing. She is also the executive director for a small cultural and arts nonprofit where she works with her husband, Cyril Pahinui, a master Hawaiian musician, to bring Hawaiian music programming to communities throughout the Hawaiian Islands and internationally. Through this work, she has come to believe that success comes from experience and knowledge, and that transformative learning occurs when students become personally engaged with the material and perceive the subject matter to be directly relevant to their lives. With the rest of her time, she enjoys scuba diving, surfing, flower arranging, graphic design, and, most recently, developing film projects.

Born and raised on O'ahu, **Carl F. K. Pao** earned a BFA at the University of Hawai'i at Mānoa in 1994, with an emphasis in ceramics (Outstanding Senior Ceramic Student Award). He received his MFA with first-class honors in 1999 from Elam School of Fine Arts at the University of Auckland,. Aotearoa, before returning to Hawai'i in 2000 to take his current teaching position at the Kamehameha Schools' Kapālama Visual Arts Department. An artist who exhibits locally and abroad, he has served as artist in residence at Australian National University's College of Asia and the Pacific, arts editor for *The Contemporary Pacific*, and co-owner/operator of the Lodestar Collective Gallery. He lives with his wife and daughter in Honolulu.

Craig Santos Perez is a native Chamorro from the Pacific Island of Guåhan/Guam. He is the cofounder of Ala Press, costar of the poetry album *Undercurrent* (Hawai'i Dub Machine, 2011), and author of three collections of poetry: *from unincorporated territory [hacha]* (Tinfish Press, 2008); *from unincorporated territory [saina]* (Omnidawn Publishing, 2010), a finalist for the LA Times 2010 Book Prize for Poetry and the winner of the 2011 PEN Center USA Literary Award for Poetry; and *from unincorporated territory [guma]* (Omnidawn Publishing, 2014). He is an associate professor in the English Department at the University of Hawai'i, Mānoa, where he teaches Pacific literature and creative writing.

Michael Puleloa, PhD, was born on Majuro in the Marshall Islands and raised on Moloka'i in Hawai'i. He has taught English at Kapi'olani Community College and the University of Hawai'i at Mānoa. He is currently an English teacher at Kamehameha Schools, Kapālama, where he is also the adviser for *Ho'okumu*, the school's student literary journal. He has received awards for both his poetry and prose and has published in various literary journals in Hawai'i.

A firm commitment to the perpetuation of the Hawaiian language and culture has led **Dr. Kalena Silva** to studies in both Western and Hawaiian educational settings. Born and raised in Honolulu, Silva graduated from the Kamehameha Schools and earned a BA and an MA in ethnomusicology at the University of Hawai'i at Mānoa and a PhD in music at the University of Washington. He learned Hawaiian chant and dance from several prominent teachers, including Māiki Aiu Lake, Ka'upena Wong, Kau'i Zuttermeister, and Lōkālia Montgomery, and graduated in 1973 as a *kumu* hula from the Hālau Hula o Māiki. Silva is a professor of Hawaiian studies at the University of Hawai'i at Hilo, where through the medium of Hawaiian, he teaches undergraduate and graduate courses in Hawaiian performing arts, language, and literature.

Jo Smith (Kāi Tahu, Kāti Mamoe, and Waitaha) teaches in the Media Studies Programme at Victoria University of Wellington. Her published work examines the sociopolitical power of media technologies with a primary focus on how colonial histories inform contemporary media practices. Her home discipline is film and media studies; however, she researches across three interrelated fields (indigenous, postcolonial, and settler colonial studies) to ask new questions about the ways media technologies, institutions, and aesthetic practices help shape notions of identity, nationhood, and community.

Alice Te Punga Somerville (Te Ātiawa) is an associate professor of Pacific literatures at the University of Hawai'i at Mānoa. Born and raised in Aotearoa/New Zealand, she received her PhD in English and American Indian studies from Cornell University and taught Māori, Pacific, and Indigenous literature for several years at Victoria University of Wellington. Her first book, *Once Were Pacific: Māori Connections to Oceania* (University of Minnesota Press, 2012), explores Māori connections with the Pacific. She is now working on two other projects: "Kānohi

ki te Kānohi: Indigenous-Indigenous Encounters" and "Ghost Writers: The Māori Books You've Never Read." She also writes the occasional poem.

Chantal Spitz was born in Tahiti in 1954. Her controversial 1991 book *Île des Rêves Écrasés* was the first Tahitian novel ever published, and part of an important cultural revival. She has been involved with *Littérama'ohi* since its inception, supporting the diversity and richness of French Polynesian writing. Her other works, *Hombo: Transcription d'une Biographie* (2002; 2012; the story of a young man whose life is thrown into disarray by the clash of cultures), *Pensées Insolentes et Inutiles* (2006; a collection of critical essays), and *Elles, Terre d'Enfance, Roman à Deux Encres* (2011; an intergenerational novel), demonstrate her development of a highly individual style that blends genres and uses French in innovative ways.

Haunani-Kay Trask is an Indigenous leader in the Native Hawaiian sovereignty movement. She has authored four books, including *From a Native Daughter: Colonialism and Sovereignty in Hawai'i*, widely considered a masterpiece of contemporary resistance writing. Trask is a major Hawaiian poet, combining the traditional lyric Hawaiian voice within the political realm. She has published two collections of poetry, *Light in the Crevice Never Seen* and *Night Is a Sharkskin Drum*. Trask was coproducer and scriptwriter of the award-winning documentary *Act of War: The Overthrow of the Hawaiian Nation* (1993). Trask is now a retired professor of Hawaiian studies, University of Hawai'i at Mānoa.

Mililani Trask is a leader of the Hawaiian sovereignty movement and a political speaker and attorney. Trask founded Nā Koa Ikaika o Ka Lāhui Hawai'i, a Native Hawaiian nongovernmental organization advocating Hawaiian sovereignty. She was a member of the Indigenous Initiative for Peace, helped author the United Nations Declaration on the Rights of Indigenous Peoples, and was elected vice chair of the General Assembly of Nations of the Unrepresented Nations and Peoples Organization.

Albert Wendt is acknowledged internationally as one of the Pacific's major fiction writers, poets, and academics. His story "First Class" is from his latest collection of short stories, *Ancestry*, published in 2012 by Huia Publishers and the University of the South Pacific Press. His new

collection of poetry, *From Manoa to a Ponsonby Garden,* published by Auckland University Press, also came out in 2012. He is emeritus professor at Auckland University and lives with his partner, Reina Whaitiri, and their dynamic cat, Manoa, in Ponsonby, Auckland.

Steven Winduo is a writer-scholar from Papua New Guinea. His three previous collections of poetry are *Lomo'ha I am, in Spirit's Voice I Call* (South Pacific Creative Arts Society, 1991), *Hembemba: Rivers of the Forest* (Institute of Pacific Studies, USP & Language and Literature Department, 2000), and *A Rower's Song* (Manui Publishers, 2009). *Detwan How?: Poems in Tok Pisin and English* (UPNG Press and Manui Publishers, 2012) is his fourth collection of poetry. His short story collection is *The Unpainted Mask* (UPNG Press and Manui Publishers, 2010). Winduo has recited his poetry in Papua New Guinea, Australia, New Zealand, Fiji, Canada, Minnesota, and Hawai'i. He is a graduate of the University of Papua New Guinea, University of Canterbury, New Zealand, and the University of Minnesota, in the United States. He is a senior lecturer in literature at the University of Papua New Guinea.

Production Notes for Carroll, McDougall, & Nordstrom / *Huihui*
Cover design by Julie Matsuo-Chun
Composition by Westchester Publishing Services
 with text in Scala Pro and Scala Sans Pro and display in Christiana
Printing and binding by Sheridan Books, Inc.
Printed on 60 lb. House White, 444 ppi.